The Situationist International

The Situationist International

A Critical Handbook

Edited by Alastair Hemmens
and Gabriel Zacarias

First published 2020 by Pluto Press
345 Archway Road, London N6 5AA

www.plutobooks.com

British Library Cataloguing in Publication Data
A catalogue record for this book is available from the British Library

ISBN	978 0 7453 3890 3	Hardback
ISBN	978 0 7453 3889 7	Paperback
ISBN	978 1 7868 0544 7	PDF eBook
ISBN	978 1 7868 0546 1	Kindle eBook
ISBN	978 1 7868 0545 4	EPUB eBook

This book is printed on paper suitable for recycling and made from fully managed
and sustained forest sources. Logging, pulping and manufacturing processes are
expected to conform to the environmental standards of the country of origin.

Typeset by Stanford DTP Services, Northampton, England

Simultaneously printed in the United Kingdom and United States of America

Contents

PART II: KEY CONCEPTS

Introduction:
The Situationist International
in Critical Perspective

Alastair Hemmens and Gabriel Zacarias

The central premise of the current book is that a radical shift in our understanding of the history and theory of the Situationist International (1957–72) is under way. For a very long time, the historical details and even the very content of Situationist activity remained poorly understood and something of a mystery. The Situationist International (SI) was a fringe subject that, thanks to its marginal status, retained an aura of esoterism and mythos that occasionally drew the interest of certain artists and political activists on the far left who looked to it for inspiration. Most famously, it was whispered, that the group had predicted, or at least been a major source of inspiration for, the May '68 student uprisings in France. Others rumoured that the group was more of an extremist avant-garde or political cult that purged its members for a lack of ideological purity. No term perhaps embodies better such misunderstanding and half-truths than the history of 'Situationism'. The Situationists anticipated the emergence of the term in the 1950s and gave it an entirely negative definition. It was, they said, a 'word without meaning': 'There is no such thing as Situationism, a term which would signify a doctrinal interpretation of existing facts.'[1] Indeed, the very notion of 'Situationism', the Situationists wrote, is 'evidently conceived by anti-Situationists'.[2] The Situationists wanted no part, in a direct criticism of many contemporary Marxist groups and previous avant-gardes, in the development of an ideology that demanded uncritical adherence and conceptual narrowness. Later, in the early 1960s, the term 'Situationism' became associated, equally negatively, with attempts by artists within the SI (who were soon after excluded), to hitch their careers to the development of the Situationist International as another moment in the history of aesthetics. Such attempts were put down with the phrase: 'There is no such thing as Situationism, nor a Situationist work of art.'[3]

However, although the Situationists themselves rejected 'Situationism', the use of the term became almost inevitable after 1968 when it came to be associated with the most radical tendencies within contemporary youth counterculture and political contestation. For those students who had taken part in May '68, and indeed anyone influenced by the 'events', a 'Situationist' was simply someone, anyone, who rejected all authority (but without being an anarchist), and who criticised commodity society (but without being a Marxist). 'Situationism' appeared, to the uninitiated, to be a kind of new political position between these two traditional left-wing tendencies. The fact that the Situationists had originally emerged from the artistic avant-garde, and in some cases perhaps that it was an actual revolutionary organisation with its own history, was largely unknown to them. Equally, when, several decades later, the group's roots in the artistic avant-garde came to light, 'Situationism' was mistakenly understood as another '-ism' in the history of art, like Dadaism or Surrealism. The Situationists, as such, were simply acclaimed as the very last avant-garde, while the 'political' and 'theoretical' critique of commodity society was, for the most part, marginalised or ignored.

Nevertheless, as the Situationists' texts have become more widely available, in both French and a variety of other languages, Situationist theory and practice has gradually come to be seen as far richer and more profound than originally thought. It can no longer be simply pigeonholed as another '-ism' in the history of art nor as a mere expression of 1960s youth contestation. Guy Debord's *The Society of the Spectacle* (1967), in particular, has increasingly come to be regarded as an important work of critical theory in its own right. 'Situationism', which could perhaps be understood today as the history of misunderstandings and misappropriations that have been heaped upon the SI, seems to be on its way out. We might even suggest that, although the battle is by no means over, the Situationists may yet survive 'Situationism'. Moreover, we could say, with some confidence, that we have learned more about the SI in the first two decades of this century than we ever did in the latter half of the twentieth.

The problem remains, however, that this new mass of knowledge and the critical interest that comes with it, as welcome as it may be, remains diffuse and uncoordinated. Indeed, there are few fields of research that have produced such differing opinions and been undertaken on such an independent basis by researchers in such a variety of fields. Our objective in this book is to bring a balanced perspective to the SI that may provide the basis for a more complete understanding and, ideally, greater consensus

on how to move forward. In so doing, we hope to present a new under-standing of the Situationists, to reconsider the SI critically, in a manner that both breaks with some of the misconceptions of the past, such as the reductive understanding of the 'Spectacle' as a mere critique of the media, and that addresses specific issues, such as race and gender, which were often previously neglected. In order to demonstrate that such a goal is, indeed, a necessity, however, we must delve deeper into the history of the SI and its critical reception.

* * *

The Situationist International was founded in 1957 by a small and het-erogeneous group of European artists based mostly in Paris. Its review, *Internationale situationniste*, published from 1957 to 1969, became the main organ for the diffusion of its revolutionary ideas and practices. The Situationist International, although at first formed mainly of artists, was from the very start concerned with the radical critique of capitalist society and the development of proletarian revolution. Art, rather than an end in itself, was to be 'superseded', to be abolished as a separate activity and integrated into the totality of everyday life. Later, the artistic dimension became incorporated into a more fully developed critical theory of capital-ist society as a form of total alienation, a world dominated by an economy that had become autonomous from qualitative human need, where humanity no longer had control over its own creative powers and that, through consumerism, which artificially expanded what was considered 'necessary', prevented the producers from freeing themselves of work. Perhaps most importantly of all, the Situationists rejected the authori-tarianism of the various workers' states, parties and unions in favour of wildcat strikes, workers' councils and other forms of autonomous prole-tarian radicalism.

The radicality of the Situationists' ideas found a receptive audience among young people who were eager to transform a post-war society dominated by patriarchal structures and a strict bourgeois morality that did not reflect their own values. The Situationists, indeed, first came to public attention thanks to their participation in the 'Strasbourg Scandal' of 1966. The SI was invited, by several students at the University of Strasbourg, to help organise a series of increasingly radical provocations that ultimately led to several expulsions and the publication, using up the entirety of the student union's funds, of a pamphlet, *On the Poverty of Student Life*, that exploded onto the political youth scene.[4] Practically

overnight, the Situationists found themselves at the centre of an international media frenzy. From Amsterdam to New York, the SI was cast as a shadowy revolutionary organisation on the fringes of society, engaged in the corruption of French youth. Surrealism, despite being a household name at this point, had never earned for itself such a formidable reputation for political subversion. Such was the media circus that Gallimard, France's most important publisher, immediately reversed its decision to reject the manuscript of *The Revolution of Everyday Life* by the Belgian Situationist Raoul Vaneigem.[5] The book was finally released in the winter of 1967 alongside Guy Debord's *The Society of the Spectacle*, published by Buchet-Chastel.

The first major moment in the reception of the Situationist International was, as such, in the run-up to, and aftermath of, what we now know as the 'events' of May '68. Both books were reviewed side by side, over the winter, in all of the major national newspapers and even on *Le Masque et la plume*, Radio France's premier literary discussion programme.[6] Commentators were unable to deny the evident literary verve that characterised Situationist writing, but the arguments of the Situationists were so out of the ordinary as to be hard for most mainstream audiences to grasp on a more than superficial level. The more conservatively minded media was, moreover, on hand with the usual arguments in favour of the 'forces of order'. One reviewer, for *Le Nouvel observateur*, simply described the texts as 'terrorist bibles'.[7] Once the occupations broke out in Paris, extracts from these books, along with other Situationist slogans began to appear in the form of graffiti all over the Latin Quarter. One long extract from *The Revolution of Everyday Life* appeared in bold letters daubed onto the courtyard of the Sorbonne University: 'People who talk about revolution and class struggle without referring explicitly to everyday life, without understanding what is subversive about love and what is positive in the refusal of constraints – such people have a corpse in their mouths.'[8] However, although we can imagine many of these acts of graffito must have been spontaneous, we also know that the Situationists were producing a fair amount of graffiti themselves. Suffice it to say that Debord and Vaneigem suddenly found themselves to be best-selling authors and, for many contemporary observers, the books became the embodiment of all that was most radical about May '68.

The actual extent of Situationist influence on the 'events' has, almost from the day the occupations ended, been the subject of much heated debate. The Situationists and the Enragés – radical students, such as René

Riesel, closely associated with the SI – were present at key flashpoints: the universities of Strasbourg, Nanterre and the Sorbonne. They took an active role in provocations and, later, the occupations themselves. Their greatest historical impact, however, is probably in the far more nebulous and less easily documented radicalising role that they played for a French youth that was already on the verge of open revolt. Even here, our own historical distance might skew our understanding, as, despite the evident theoretical superiority we recognise in Debord today, it was arguably Raoul Vaneigem's work that was the most widely influential, not least because it was far more accessible to a general readership.[9] The SI wrote up its own account of its involvement in a text created immediately after the events while in exile in Belgium, *Enragés and Situationists in the Occupation Movement* (1968), authored in the main by René Viénet.[10] However, although the French police kept close tabs on the group, official and, later, academic accounts of the occupations largely reduced Situationist involvement to a footnote or simply overlooked the SI altogether. Indeed, until relatively recently, the Situationist role in May '68 remained, and still remains to some extent, something of a major lacuna in most historical accounts of the occupations movement.[11]

In the period after May '68, Debord argued that recent public interest in the SI had had a negative effect on the internal dynamics of the group. It was suggested that certain members had lost interest in active participation in the development of the group's activities and were, instead, resting on their laurels. At the same time, the SI had gained a number of obsequious hangers on, whom he termed 'pro-Situs', that, he argued, were not genuinely interested in serious participation. Disagreements over the future direction of the SI, often referred to as the 'orientation debates', led to a series of resignations and exclusions of core members, including Raoul Vaneigem in 1970. Not long after, Guy Debord finally announced the self-dissolution of the Situationist International with a detailed account of recent events, *The Real Split in the International*, in 1972.[12] It was Debord, from this time on, who was to shape much of the future reception of the Situationists. His account of the collapse of the group in *The Real Split*, for example, would become the main historical reference point for researchers going forward. Likewise, Debord went on to play a major role in the Champs Libre (later Lebovici) publishing house, which published the first history of the SI, Jean-François Martos' *Histoire de l'Internationale situationniste*, in 1989.[13]

At the same time, or rather in the 1970s and early 1980s, certain Situationist ideas took on a surreptitious second life through their, albeit largely unacknowledged, influence over post-structuralist authors such as Alain Badiou, Jean-Luc Nancy and Jean Baudrillard,[14] who found in Debord's description of the 'Spectacle' a particularly apt metaphor for an image-obsessed, consumer society (even if such readings, as we discuss in chapter 10 of the current book, are, if not entirely without basis, far too reductive). Equally, the SI's proletarian politics and critique of everyday life came to influence new movements, including autonomist Marxism and new strains of Anarchism, such as the ecologically minded social critique of Murray Bookchin. Thanks to Malcolm McLaren, manager of the Sex Pistols, the Situationists even had an influence over the emergence of punk and, later, the Manchester music scene of the 1980s.[15] It is also worth recalling that, although the group itself dissolved in 1972, 'Situationist' activity as such did not stop. Debord continued to write books, most notably *Commentaries on the Society of the Spectacle* (1988),[16] and to make films, including *In girum imus nocte et consumimur igni* (1981) and, for television, *Guy Debord, son art et son temps* (1994).[17] Raoul Vaneigem, likewise, proved to be a most prolific author after his resignation from the group in 1970. His later works include *The Book of Pleasures* (1979) and a utopian novel *Voyage à Oarystis* (Journey to Oarystis) (2005).[18] Although most research into the Situationists quite rightly focuses on the post-war period, no account of the SI would be complete without reference to these later works.

It was only at the very end of the 1980s and the start of the 1990s that well-researched academic retrospectives on the Situationist International began to appear in earnest. The first of these was a work of cultural history, *Lipstick Traces: A Secret History of the Twentieth Century* (1989) by Greil Marcus, published, quite fittingly, in the same year as any aspirations for a Marxist state collapsed with the Berlin wall.[19] Marcus traced the voice of Johnny Rotten back to the 'secret history' of the inter-war avant-garde and, later, the Situationist International. Indeed, it was Marcus who seems to have first picked up on the strong influence that the Situationists would have on the emergence of punk in the UK. Then, in 1992, two different books devoted to the SI were published that opened up very different critical perspectives. The first of these was *The Most Radical Gesture: The Situationist International in a Postmodern Age* (1992) by Sadie Plant.[20] Plant had picked up on the connections between the work of post-structuralist authors such as Baudrillard and the ideas of the Situationists. However,

although her work had the merit of being the first sustained study devoted to the Situationists in English, Plant failed to draw out the strong distinctions between these largely incompatible theoretical frameworks. Notably, the fact that Debord saw his critical theoretical perspective as precisely a paradigmatic argument against the underpinnings of Structuralism, but not of the purely 'linguistic' sort pursued by post-structuralism. In contrast, 1993 saw the publication in Italian of *Guy Debord* by Anselm Jappe (later published in French in 1994 and English in 1995).[21] Jappe was really the first to subject Situationist theory and practice to a rigorous and sustained critical analysis. Until this point, neither Debord nor the Situationists as whole had been taken seriously as coherent Marxian theorists. Jappe showed, however, that, not only was Debord a theoretical powerhouse but that he also in many ways anticipated the rediscovery of the most radical aspects of Marx's critical theory, specifically, his critique of commodity fetishism as form of quasi-autonomous domination of social life by the economy (rather than, as in traditional Marxism, simply a veil of appearances that hid bourgeois exploitation). Jappe played an important role, therefore, in revealing the full extent of the theoretical and philosophical importance of Situationist theory.

The death of Guy Debord in 1994 sparked a new wave of public and academic interest in the Situationists. It includes, and started off a fashion for, a series of biographies of Debord in French and English that were variously literary, intellectual, cultural historical, journalistic and even, occasionally, salacious in character.[22] Indeed, the mid-1990s marked the point at which Debord definitively became the focus of research into and debates about the SI as a whole. This is not, however, to say that such a Debord-centred approach is not perfectly valid – Debord was undoubtedly the main animator of the group and his achievements largely unmatched – it is only to underline the fact that the new focus on Debord marked a distinct shift in our overall image or reception of the SI. The French publishing industry, at the same time, began to catch on to the new and growing interest in material relating to the Situationists. In 1997, for example, Arthème Fayard published a facsimile print of the entire run of *Internationale situationniste* in a single volume.[23] At the same time, the Allia publishing house began to produce a series of memoirs of various Situationists and associated figures, along with new editions of unpublished and long out-of-print texts.[24] In France, as in the UK and the United States, it was becoming much more fashionable to talk about Debord in the mainstream media and in the academy.[25] Debord was increasingly recognised

as a great innovator, a philosopher and French stylist. Although he has yet to receive the Pléiade treatment, Debord's main oeuvres were published together as a complete edition by Gallimard in 2006.[26] One more significant moment was the publication of Guy Debord's correspondence in a series of eight volumes published by Arthème Fayard between 1999 and 2010.[27] Mainstream recognition of Debord seemed to culminate in 2009 when the Minister of Culture officially labelled his archives a 'national treasure' in order to raise the funds to stop them being sold to Yale University. The archives have since become part of the permanent collection of the French National Library and served as the basis for a large publicly funded exhibition, *Guy Debord, Un Art de la guerre*, in 2013. The most important part of the archives consists in Debord's collection of reading notes, gathered over decades, that give researchers a great deal of insight into who and how he was reading.[28] We are only just starting to see new academic studies based on these materials, some of which have informed important reference points for chapters of the current book. More new research is certain to come from the studies of other Situationist's archives, many of which are now located in the Beinecke Library of Rare Books and Manuscripts at Yale University.[29]

Nevertheless, despite the growing mainstream and academic interest in Debord and the Situationists, there is still a very real lack of consensus over how the Situationist International should be approached and understood. Many artists and academics have treated, and continue to treat, the SI primarily as an art movement, that is, as just another moment in the aesthetical development of the history of the artistic avant-garde. Such an approach is not without merit as the SI certainly did emerge in large part out of that history, as an attempt to bring new life to the demands of Dadaism and Surrealism. However, the driving political and critical theoretical basis of the group is all too often overshadowed or even goes simply unmentioned in such approaches. It is a perception that is reinforced by the nature of art exhibitions, which tend to focus solely on the physical objects produced by the SI, and not their concepts or theoretical texts.[30] A landmark moment in the recognition of the SI by the art world occurred as early as 1989, with a comprehensive exhibition that took place at the Georges Pompidou Centre in Paris, and which subsequently moved to the Institute of Contemporary Arts in London and Boston.[31] Another key event was the retrospective of Guy Debord's films shown at the 58th Venice Film Festival in 2001, the first public screening of these films since 1984.[32] In recent years, it has even become quite fashionable for artists to refer to

the SI. The 56th Venice Biennale in 2015, for instance, provided a host of such examples. Samson Kambalu exhibited a project based on the archives of the Italian Situationist Gianfranco Sanguinetti. Vincent Meessen, similarly, gave audiences a video devoted to the Congolese members of the SI.[33] Visitors could even buy a brick, sold by the well-known artist Rirkrit Tiravanija that read, in Chinese, 'NEVER WORK', a phrase that was originally coined by Guy Debord in a piece of graffito in 1953. The latter is perhaps a perfect example of how capitalism is able to safely incorporate an artistic critique of labour back into itself.[34]

It might be objected that surely any mainstream recognition or academic study of the Situationist International represents what the Situationists would call a 'recuperation' of the group. Either the SI no longer holds any radical potential or such recognition actively participates in a process of denuding the group of its potency. These kinds of criticisms have some basis in reality. It is now certainly considered mostly 'safe' to study and talk about the Situationists and, as we have suggested, some approaches, quite unintentionally in most cases, have presented a rather deradicalised version of the group. However, as Anselm Jappe hints in the Preface to his most recent edition to his *Guy Debord*, we could equally interpret the attention and interest the group has garnered of late as a social recognition of the importance of the SI, even if the full meaning of that importance is often poorly understood.[35] It is also the case that it would be wrong to cling to Situationist theory and practice, and its history, as though there had been no theoretical and practical developments, no history, since the 1960s. If we are to stay true to the critical spirit of the Situationists, to avoid a doctrinal 'Situationism', we cannot simply repeat what they said and did. Rather, we must take up and develop their call for an emancipatory social movement that takes seriously the most radical aspects of their revolutionary project: the abolition of work, the state and the commodity.

In spring 2016, France saw the emergence of one of the most radical social movements in its recent past. Mass protests erupted against government plans to make sweeping changes to existing labour legislation. These protests quickly escaped the control of trade unions and led to the occupation of the Place de la République – a traditional rallying point for the left in Paris – where hundreds of people gathered daily to take part in the general assemblies that made up the 'Nuit Debout', or 'Up All Night', movement. On the paving stones of the square, someone had painted, in another reference to the Situationists and May '68, the phrase: 'Moi, travailler? Jamais' ('Me, work? Never!'). On certain boulevards, rocked by violent

protests, some protesters took to removing the large advertising panels that adorn Parisian bus stops and replaced them with quotations from Guy Debord's *The Society of the Spectacle*. These references to the Situationists, once again appearing spontaneously at the heart of a radical movement in the centre of Paris, had come as something of a surprise to observers who had, upon hearing of Debord's designation as a 'national treasure', concluded that he had now been definitively institutionalised. The fact that the Situationists continue to be a constant source of reference and inspiration for protests on the streets of Paris, however, and increasingly the world over, seems to belie such an idea. Academic, even mainstream recognition, of the Situationists is not necessarily in contradiction with its survival as a subversive force. On the contrary, given the gap that separates us from the contexts and concepts that shaped the 1960s, taking the time to 'rethink' the Situationists can help us better understand the radicality at the core of their social critique.

* * *

Each of the chapters in this book seeks to furnish some degree of introduction for the uninitiated into key contexts and concepts as well as to provide new critical perspectives and analyses from which to understand the Situationists. Our intention, as such, is to provide a volume of research that is both accessible and wide-ranging while, at the same time, being grounded in the latest findings and bringing together some of the leading researchers in the field. In Part I, Anselm Jappe's chapter on 'Debord's Reading of Marx, Lukács and Wittfogel' (chapter 1) draws on the Bibliothèque nationale de France (BnF) archive of reading notes that Debord compiled on these authors in order to contextualise how they came to inform his critical perspective. His research demonstrates Debord to have been quite the scholar, engaged in detailed, close reading, and concerned with the basic categories of Marxian theory. Krzysztof Fijalkowski's 'The Unsurpassable: Dada, Surrealism and the Situationist International' (chapter 2) draws out the strong affinities and divergences that defined the fractious relationship between the Situationists and their Dadaist and Surrealist forebears. What emerges, despite theoretical divergences and mutual recriminations in print, are the personal connections and moments of collaboration between these movements thanks to the artistic, radical and intellectual village that existed in post-war Paris. Fabrice Flahutez's chapter, likewise, explores the continuities between Lettrism and the Situationists through Debord's approach to film (chapter 3). Both movements,

through seeking to realise art in everyday life – in large part by negating the passivity and separations of cinema – sought to create a more passionate, creative, existence. Tom Bunyard's chapters on the Hegelian Marxist context and the concept of the 'realisation of philosophy' (chapters 4 and 17) provide a much-needed introduction to and exploration of the significant impact of Hegel's philosophy on Debord and Situationist theory. Bunyard stresses the importance of Hegelian notions of 'historical time' to Debord and the need for philosophy to no longer merely 'interpret' the world, but, following the famous thesis of Marx, to 'change it'.

Anthony Hayes offers a detailed contextualisation of the Situationists' critical relationship to the history of the international workers' movement (chapter 5). Hayes examines, in particular, the importance of the Socialism or Barbarism group to the development of Situationist analyses of actually existing socialism as well as the meaning that the call for 'workers' councils' had for the SI. Anna Trespeuch-Berthelot (chapter 6) provides a rigorously researched historical account of the Situationist involvement in the occupation movement, focusing, in particular, on the material ways in which Situationist ideas circulated during the 'events' and their later reception in 1970s counterculture. Sophie Dolto and Nedjib Sidi Moussa (chapter 7) correct a long-existing lacuna in the field with a thorough analysis of Situationist engagement with political issues beyond Europe – including the Algerian War of Independence and the Black civil rights movement – and an account of the important contributions of members with ties to North Africa and the Congo. What emerges is that the Situationists, far from being a purely Eurocentric revolutionary movement, were highly engaged with anti-colonial struggles, albeit from an internationalist perspective that has now fallen out of fashion in contemporary left-wing politics. Ruth Baumeister (chapter 8), likewise, tackles another historical lack in our understanding of the SI: the historically neglected contribution of female Situationists – in particular, Jacqueline de Jong and Michèle Bernstein – and the group's overall approach to gender. Baumeister demonstrates, moreover, that, although undoubtedly not a central focus, modern gender relations were certainly a subject of Situationist critique, particularly the way in which post-war capitalism both promoted the role of the housewife and commodified the female body through its advertising imagery. Michael Löwy (chapter 9) concludes our section on key contexts with an exploration of the place of the Situationists in the tradition of 'Revolutionary Romanticism'. What emerges is that, while also being a decidedly 'modern' movement, the SI was also decidedly 'anti-modern' in its cham-

pioning of modes of life and values that capitalism was fast erasing in the name of 'progress'.

Part II of the book examines concepts that are key to understanding the Situationists. It opens with a joint chapter by the editors on the concept of 'Spectacle' (chapter 10). We insist, in this chapter, that the category of 'spectacle' should be understood as both a particular and a general concept depending on the context in which Debord employs it. The theory of spectacle cannot therefore be reduced to a media theory, although the media can be understood as a particular instance of 'spectacle'; rather, it is a general theory of a society in which mankind has been reduced to a passive role in the production of its own existence by the dictatorship of a quasi-autonomous economy that has escaped our control and develops for itself. Gabriel Zacarias goes on to examine the concept, and practice, of the 'constructed situation' (chapter 11), exploring its genealogy in, among other sources, Brechtian theatre and Huizinga's notion of 'play', and its goal of breaking the subject out of the passive role it has been reduced to in the Spectacle. Craig Buckley provides an overview of the Situationist critique of urbanism and forays into architecture with the concept of 'unitary urbanism', encompassing the notion of 'psychogeography' and the practice of dérive (chapter 12). Alastair Hemmens, in turn, provides an analysis of the roots of the Situationist call for the 'abolition of alienated labour' in the young Marx and the work of Schiller (chapter 13). Here the 'critique of work' emerges as a clear point of demarcation between the Situationists and other competing radical, and not so radical, positions. Gabriel Zacarias' chapter on 'détournement' (chapter 14) explores the full range of the concept, which can be understood as a strategy in the struggle against the reification of language, and its application to the visual arts, in particular, through an analysis of the paintings of Asger Jorn and the films of Guy Debord and René Viénet.

Michael Gardiner (chapter 15) examines the Situationist concept of 'everyday life' and its relation to the work of Henri Lefebvre, equally indicating some limitations in the group's approach to the theme, in particular, its problematic notion of 'authenticity'. Alastair Hemmens' chapter on 'radical subjectivity' focuses on the work of the Belgian Situationist Raoul Vaneigem (chapter 16). Hemmens explores how the Situationists took on the challenge of championing the subject in the name of revolutionary agency and individual autonomy. However, he also shows some of the stark problems with the approach to subjectivity adopted by Vaneigem, not least its explicit celebration of narcissism. Patrick Marcolini (chapter

18) provides a detailed analysis of the concept of 'recuperation' touched upon in this introduction. He demonstrates that although the Situationists elaborated the concept at a theoretical level, it was already a common enough notion by the early 1960s to be talked about in the newspapers. Moreover, Marcolini explores the extent to which the Situationists themselves could be said to have been 'recuperated' by capitalism and suggests that this was partly the result of the group sharing certain aims with its enemies. Bertrand Cochard (chapter 19) concludes our volume with an examination of the internationalism of the Situationist International. Internationalism was as much a political stance, rooted in the nineteenth-century origins of the workers' movement, as it was a material reality for the SI in the international distribution of its membership. Cochard, moreover, provides some important insight into the organisation of the SI and how it confronted the historical tension between centralised and devolved revolutionary organisation.

* * *

A note on translation: despite the evident critical interest in the Situationists in the English-speaking world, there remains a paucity of translations. Currently, there are three published collections of Situationist texts in English: Kenn Knabb's *Situationist International Anthology*, first published in 1981 and revised and expanded in 2006, Tom McDonough's *Guy Debord and the Situationist International: Key Texts and Documents* (2002) and *The Situationists and the City* (2010).[36] Together these collections provide English readers with access to a good selection of important texts by Debord and from *Internationale situationniste*. Where possible, therefore, we have tried to refer to these existing translations. These editions, however, are by no means exhaustive. Although there are indeed many more 'unofficial' translations that can be found online, which are no doubt a useful resource, the nature of the internet means that these can be changed or disappear and they vary greatly in quality. They do not, as a result, lend themselves to an academic volume such as this and we have therefore tried to avoid them where possible. Even the existing 'official' translations, as excellent as they may be for most purposes, can pose problems for the researcher. They do not always reflect the latest research and, due to the diffuse nature of the translation efforts to date, what is considered worth preserving in the original (Hegelian terminology, for example) is not always agreed upon. In certain cases, therefore, we have provided our own translations from the French editions and adapted existing transla-

tions with the note 'translation changed' while still providing a link to a pre-existing English translation. Finally, the editors felt it important to bring together, for the very first time, the best research in both French and English. Alastair Hemmens has therefore translated, from the French, chapters 1, 3, 6, 9, 18 and 19.

Notes

1. 'Définitions', *Internationale situationniste (IS)*, no. 1 (June 1958): 13.
2. Ibid.
3. These words were spoken by Belgian Situationist Raoul Vaneigem at the 5th Conference of the SI in Gothenburg in 1961, 'La cinquième conférence de l'I.S. à Göteborg', *IS*, no. 7 (April 1962): 26–7.
4. The Situationist International and Students of the University of Strasbourg, *On the Poverty of Student Life: Considered in its Economic, Political, Psychological, Sexual, and Especially Intellectual Aspects, with a Modest Proposal for Doing Away with It* (1966).
5. Vaneigem recounts this, and how the book had been refused by no less than 13 publishers in total, in a footnote to the preface to the second French edition of the book. Raoul Vaneigem, *Traité de savoir-vivre à l'usage des jeunes générations* (Paris: Gallimard, 1992), p. 10.
6. *Le Masque et la plume*, Radio France, 14 January 1968.
7. François Châtelet, 'La dernière internationale', *Le Nouvel observateur*, 3 January 1968.
8. The original passage can be found in Raoul Vaneigem, *The Revolution of Everyday Life*, trans. Donald Nicholson-Smith (London: Rebel Press, 2006), p. 26.
9. This is at least the opinion of one veteran of '68 who was also a one-time friend of Debord: John Michel Mension, *The Tribe*, trans. Donald Nicholson-Smith (San Francisco: City Lights Books, 2001), pp. 123–4.
10. René Viénet, *Enragés and Situationists in the Occupation Movement, France, May '68*, trans. Richard Parry and Hélène Potter (London: Rebel Press, 1997).
11. For a book that has to some extent addressed this lacuna, see Michael Seidman, *The Imaginary Revolution: Parisian Students and Workers in 1968* (New York: Berghahn Books, 2004).
12. Situationist International, *The Real Split in the International*, trans. John McHale (London: Pluto Press, 2003).
13. Jean-François Martos, *Histoire de l'Internationale situationniste* (Paris: Champs Libre, 1989).
14. See Patrick Marcolini, *Le Mouvement situationniste: une histoire intellectuelle* (Montreuil: L'Echappée, 2012), pp. 231–48.
15. See Andrew Hussey and Will Self, *Guy Debord: La Société du spectacle et son héritage punk* (Paris: Globe, 2014).
16. Guy Debord, *Comments on the Society of the Spectacle*, trans. Malcolm Imrie (London: Verso, 1998). Unfortunately, the English title of this edition is an

incorrect translation, as the original title is a '*détournement*' of *Commentaries on the Gallic War* by Julius Caesar. Debord, particularly in later life, liked to refer to military strategy.

17. A complete edition of all of Debord's cinematic works was published for the first time as a DVD in 2005. Guy Debord, *Œuvres cinématographiques complètes* (Neuilly-sur-Seine: Gaumont Video, 2005). An English translation of the filmscripts also exists, Guy Debord, *Complete Cinematic Works: Scripts, Stills, Documents*, trans. Ken Knabb (San Francisco, CA: AK Press, 2003).

18. Raoul Vaneigem, *The Book of Pleasures*, trans. John Fullerton (London: Pending Press, 1983), *Voyage à Oarystis* (Blandain: Éditions de l'Estuaire, 2005).

19. Greil Marcus, *Lipstick Traces: A Secret History of the Twentieth Century* (London: Faber and Faber, 2001).

20. Sadie Plant, *The Most Radical Gesture: The Situationist International in a Post-modern Age* (London: Routledge, 1992).

21. Anselm Jappe, *Guy Debord*, trans. Donald Nicholson-Smith (Oakland, CA: PM Press, 2018).

22. These include, among others, Len Bracken, *Guy Debord: A Critical Biography* (Venice, CA: Feral House, 1997); Andrew Hussey, *The Game of War: The Life and Death of Guy Debord* (London: Jonathan Cape, 2001); Andy Merrifield, *Guy Debord* (London: Reaktion Books, 2005); Vincent Kaufmann, *Guy Debord: Revolution in the Service of Poetry* (2001), trans. Robert Bononno (Minneapolis: University of Minnesota Press, 2010); Christophe Bourseiller, *Vie et mort de Guy Debord* (1999) (Paris: Plon, 2001); Jean-Marie Apostolides, *Guy Debord: le naufrageur* (Paris: Flammarion, 2015).

23. Situationist International, *Internationale situationniste, édition augmentée* (Paris: Arthème Fayard, 1997).

24. These distinctive neon-coloured editions include, but are not limited to, a complete re-edition of the Lettrist International journal *Potlatch* (Paris: Allia, 1996), Situationist International, *Textes et documents situationnistes 1957–1960* (Paris: Allia: 2004) and, more recently, a series of interviews with Raoul Vaneigem, *Rien n'est fini, tout commence* (Paris: Allia, 2014).

25. Another important contribution to the discussion at this time came from two former Situationists from the UK, Donald Nicholson-Smith and Timothy Clark, who, in an article 'Why Art Can't Kill the Situationist International', in a special issue of the journal *October* (vol. 79, winter 1997) devoted to the group, criticised contemporary attempts to reduce the SI's legacy to a form of post-structuralism or to treat it simply as an art movement.

26. Guy Debord, *Œuvres* (Paris: Gallimard, 2006).

27. Guy Debord, *Correspondance*, vols 0–7 (Paris: Arthème Fayard, 1999–2010).

28. Parallel to the 2013 exhibition, the French National Library organised a symposium about Debord's archives, which resulted in the publication *Lire Debord – avec des notes inédites de Guy Debord*, ed. Laurence Le Bras and Emmanuel Guy (Montreuil: L'Échappée, 2016). At present, Le Bras is also organising the publication of Guy Debord's reading notes in the collection 'La Librairie de Guy Debord', see: Guy Debord, *Stratégie*, ed. Laurence Le Bras, with a preface by Emmanuel Guy (Montreuil: L'Échappée, 2018); Guy

Debord, *Poésie, etc*, ed. Laurence Le Bras, with a postface by Gabriel Zacarias (Montreuil: L'Échappée, 2019).

29. The Beinecke Library has acquired the archives of key figures of the SI, such as Jacqueline de Jong, Gianfranco Sanguinetti and, more recently, Mustapha Khayati, Attila Kotányi and Raoul Vaneigem.

30. At the same time, it is, of course, equally important to rediscover the SI's artistic past, which likewise, can often be overlooked in the more politically motivated side of the discussion.

31. See *On the Passage of a Few People through a Rather Brief Moment in Time: The Situationist International, 1957–1972*, exhibition catalogue, ed. Elizabeth Sussman, Musée national d'art moderne, Centre Georges Pompidou, Paris, France, 21 February–9 April 1989, Institute of Contemporary Arts, London, 23 June 23–13 August 1989, the Institute of Contemporary Art, Boston, MA, 20 October 1989–7 January 1990.

32. Debord had forbidden any public showing of his films after the assassination of his producer and friend Gérard Lebovici in 1984.

33. Meessen's work is an excellent source for discussion of members of the SI that have so far received very little attention (an issue that we have also sought to address in the present volume). Further discussion of Mbelolo and Lungela, for example, can be found in Meessen's edited volume, *The Other Country/ L'Autre Pays* (Brussels: WIELS, 2018), in particular, Pedro Monaville's chapter, 'On the passage of a few Congolese through the Situationist International', pp. 57–65.

34. A subject explored, with explicit reference to the SI, in Luc Boltanski and Eve Chiapello, trans. Gregory Elliott, *The New Spirit of Capitalism* (1999) (London: Verso, 2007).

35. Jappe, *Debord*, p. ix.

36. Situationist International, *Situationist International Anthology*, ed. and trans. Ken Knabb (Berkeley, CA: Bureau of Public Secrets, revised and expanded edition 2006); *Guy Debord and the Situationist International: Texts and Documents*, ed. Tom McDonough (Cambridge, MA: MIT Press, 2002) and *The Situationists and the City*, ed. Tom McDonough (London: Verso, 2010).

PART I

Key Contexts

1

Debord's Reading of Marx, Lukács and Wittfogel: A Look at the Archives

Anselm Jappe[1]

In his autobiography, *Le Temps des méprises* (1975), the philosopher Henri Lefebvre, a fellow traveller of the Surrealists and, later, the Situationists, writes of how he visited André Breton around 1924.[2] Breton had pointed to a copy of Hegel's *Science of Logic* (1816) that was lying on the table and said, disdainfully, 'Have you even read *that*?' Lefebvre adds – perhaps not without some justification – that he doubted Breton himself had read beyond the first few pages. It is quite likely that the Surrealists' use of Hegel, as important as it may have been, was not based upon a very deep, first-hand, knowledge of his work. The ill-intentioned might insinuate that Debord himself, who never claimed to be a great scholar – and who, as is well known, tackled reification with walking and not with 'big books and lots of papers on a big table'[3] – had only a fragmentary, second-hand knowledge of Marx and Hegel, in particular, the most difficult texts, such as *Capital* (1867). Debord, we might reasonably imagine, had a more 'poetical' (even 'genial') attitude, quoting, from memory, those passages that most stood out to him. We can hardly think of him engaged in the monkish labour of compiling thousands of reading notes. Nevertheless, the archives recently acquired by the Bibliothèque nationale de France (BnF) demonstrate that Debord was by no means a stranger to this kind of dedicated patient study.

Debord organised these reading notes, written upon record cards, into folders, one of which is entitled 'Marxism'. It contains extracts and notes on the work of Marx and around fifty other works by different Marxist authors. The scope of extracts from each individual work varies from a sentence to quotations that cover as many as 24 record cards. These cards are never dated. However, they all seem to date from the period from

around the end of the 1950s to perhaps the start of the 1970s at the latest (although it is possible Debord had already finished compiling them by the time of the publication of his seminal work, *The Society of Spectacle*, in 1967). In fact, a good number of these cards relate to the preparation of *The Society of the Spectacle*. They often carry, for instance, the abbreviation 'Pour SduS' in order to denote phrases that could undergo *détournement* or be used as epigraphs in the book. Sometimes they also read 'Pour IS', to denote phrases that could be used, or *détourné*, in *Internationale situationniste* (the group's main organ), and occasionally 'Pour Asger' in reference to his friend, the Danish artist, Asger Jorn. Only a selection of these proposed extracts would actually find their way into the final manuscript of the book. Sometimes, more infrequently, Debord also develops some ideas of his own in these notes that have been inspired by his reading; though, there are far fewer summaries of the texts in question than there are straightforward extracts.

Some of the authors quoted that are particularly worth mentioning are: Ludwig Feuerbach, Bruno Bauer, Antonio Labriola, Eduard Bernstein, Sidney Hook, Georg Lukács (*Goethe and his Age, History and Class Consciousness*), the writings of Rosa Luxemburg, Paul Frölich's book on Luxemburg, Karl Korsch (*Marxism and Philosophy*), L. Shapiro, Ante Ciliga, Georges Plekhanov, a number of books by Henri Lefebvre, Bruno Rizzi, Dionys Mascolo, Max Raphael, and Kostas Papaïoannou. Other 'Marxist' authors, such as Herbert Marcuse and Wilhelm Reich, are found in the file marked 'Philosophy, Sociology'.

As for Marx, Debord owned a copy of his complete works that was translated by Jacques Molitor and published by Éditions Alfred Costes between 1920 and 1930.[4] Although this translation is hardly used today, Debord evidently thought highly of it and he had it partially reprinted by the Champ Libre publishing house in 1981. Debord also owned a copy of Marx's complete correspondence in nine volumes by the same publisher.[5] He would later acquire the first two volumes of the Pléiade edition of the complete works published in the 1960s and edited by Maximilien Rubel.[6] Debord also took several extracts from Rubel's biography of Marx as well as from a number of his essays. In Debord's library, moreover, we find other writings by Marx in different editions (the oldest of which dates to 1900). These include *The Economic and Philosophical Manuscripts* (1844), *A Contribution to the Critique of Political Economy* (1859) and a copy of the first volume of *Capital* in three volumes; all of which were published by Éditions Sociales between 1957 and 1962. The works of Marx accordingly

make up one of the most complete collections to be found in Debord's personal library (at least as it was left upon his death in 1994).

Debord equally owned a copy of the complete works of Friedrich Engels (published by Costes between 1936 and 1952). In the folder marked 'Marxism', there is also a small black notebook, 82 pages in length, in which, in a very neat hand, Debord has reproduced extracts from nearly all of the early works of Marx (some dozen in total). These include everything from his doctoral thesis comparing the different philosophies of Democritus and Epicurus (1841) to *The German Ideology* (1846). Debord additionally read both lesser known texts and the rather more difficult *A Critique of Hegel's Philosophy of Right* (1844). Debord copied out the latter (which is, moreover, one of Marx's most brilliant works of style), almost in its entirety. However, the longest extracts are from *The Economic and Philosophical Manuscripts*, phrases from which appear throughout the work of Debord. The fact that Debord does not make any comments in the notebook, and makes no reference to *The Society of the Spectacle*, suggests that it represents a preliminary, or foundational, reading that precedes his preparations for writing the book.

There is plenty of evidence, therefore, that Debord had detailed first-hand knowledge of the early Marx. There is, however, no evidence (at least in the reading notes) of a similar systematic reading of his later works. All that can be found are isolated phrases and short paragraphs taken from a variety of Marx's works that were transcribed for use in *The Society of the Spectacle*. Moreover, Debord often lifts these phrases of Marx (and Hegel) from the works of other authors. Here, as elsewhere, his reading is 'targeted' and, so to speak, utilitarian: he is searching for anything that could help him elaborate the theory of the spectacle. For a deeper understanding of Marx, Debord relies heavily upon the work of Henri Lefebvre (whose company he kept from 1960 to 1962) and Kostas Papaïoannou (five of whose books are found in Debord's library and whose anthology, *Marx and the Marxists* (1965),[7] was described in *Internationale situationniste* in 1966 as a 'superior borderline case' of 'research with no use'). Debord takes, from Lefebvre's *Problèmes actuels du marxisme* (1958), a diagram entitled 'The Fundamental Concepts and Categories of Marx's Thought'. Debord adds to it, in different ink, the comment: 'He [Lefebvre] seems to have forgotten the *commodity*.' However, this is almost the sole mention of the commodity form that can be discerned in Debord's reading notes. Nothing precise can be found on abstract labour, fetishism, value and, even less so, on capitalism's tendency towards crisis. As was commonly the case among

his contemporaries, Debord remained essentially a reader of the 'young' Marx who was thought to be the more 'revolutionary' Marx, whereas the Marx of *Capital*, and the critique of political economy, was thought to bear the stain of resignation, reformism, determinism and scientism.[8] Be that as it may, Debord was highly attuned to Marx's style and to the flamboyant phrases that are scattered throughout his early works.

Of all the Marxists (or rather 'pre-Marxists') that Debord read, Ludwig Feuerbach receives his particular attention. *The Society of the Spectacle* opens with a quotation from Feuerbach and his place in the genealogy of the concept of spectacle remains under-examined to this day. Some of the authors that Debord studied, such as Karl Korsch and Bruno Rizzi, go on to be cited in his work, but there are others, such as the Italian Marxist Antonio Labriola and his book *In Memory of the Communist Manifesto* (1895), whose work he clearly read, but of whom he makes no mention. Extracts, short ones, from Lenin and Trotsky mix with quotations from Ante Ciliga's *Lénin et révolution* (1948).[9] Debord also made one or two notes on each of the three books by Georges Sorel that he read. Alongside Henri Lefebvre and other French Marxists, notable attention is given to *Karl Marx et Friedrich Engels: Leur vie et leur œuvre*, vol. 1 (1955) by Auguste Cornu (a Marxist so orthodox that he would later go on to teach in the German Democratic Republic where he died in 1981). It was in this volume that Debord found a reference to a book which had been almost completely forgotten, *Prolegomena to a Historiosophy* (1838) by August Cieszkowski, which was later republished by Champs Libre at his behest. The notes contain extracts from the work of Lucien Goldmann. Equally, several pages are devoted to *Studies on Marx and Hegel* (1955) by Jean Hyppolite (whose classes Debord attended at the Collège de France).[10] Unsurprisingly, there is no reference to Althusser nor Sartre. Marcuse, on the other hand, earns Debord's attention, though he finds himself classed in a different file.[11] Another surprising find is notes on Max Raphael, a Marxist German art historian, who is hardly known in France despite the fact that his work had already been translated.

The two most extensive sets of notes refer to Lukács' *History and Class Consciousness* (originally published in 1923 and translated into French for the first time in 1960), and *Oriental Despotism* by Karl August Wittfogel (originally published in 1957 and translated into French in 1964).[12] In my book *Guy Debord*,[13] I analyse the profound influence that Lukács, and his 'cursed' book, exerted upon Debord, in particular, on how he understood the relationship between reification and the division of labour, modern

and bureaucratic capitalism, class consciousness and the commodity form, and the central role that the passive 'contemplation' of a pre-fabricated world plays in bourgeois society. From Lukács, Debord took the idea that revolutionary activity essentially embodies a rupture with this contemplative attitude. Debord greatly admired the emphasis that Lukács placed upon the commodity form, his rejection of nearly all of the Marxists of the Second International, his rehabilitation of Marx's Hegelian roots and his assertion that Marxian theory ought to lead to immediate revolutionary action, and not submission to some supposedly gradual and inevitable evolution. Debord devotes no less than 18 pages of extracts and another two record cards to Lukács. These latter, in the main, relate to the first half of the book. The notes refer to phrases for *détournement* or direct quotation. Several of them are accompanied by comments. In the margins of a record card on a passage from page 33, for example, Debord writes, 'For the chapter on "Ideology" [a clear reference to *The Society of the Spectacle*]: the work of *making concrete* and *illustrating* in the spectacle the false consciousness that Georg Lukács describes is missing'. He stresses that the spectacle realises within the 'spectator consciousnesses' Lukács' intuitions about the false consciousness that arises out of a contemplative attitude.

Debord also transcribes a passage from *Capital* that Lukács cites in his own book: 'A merchant could buy every commodity, but labour as a commodity he could not buy. He existed only on sufferance, as a dealer in the products of the handicrafts.' Debord adds: 'SduS. The qualitative change to *commodity-labour* is capitalism (the real triumph of the commodity) and it continues everywhere *as such*.' Further, he quotes Lukács: 'in pre-capitalist societies legal institutions intervene *substantively* in the interplay of economic forces'. Debord adds: 'For SduS (Cf. the bureaucracy in power as a *return* to pre-capitalist conditions of exploitation in a society of capitalist production).' A different passage from *History and Class Consciousness* prompts Debord to write: 'SduS, cite this on the Leninist bureaucracy in power, coming across it at the exact moment where Lukács is writing *about the bourgeoisie!*' Another passage is similarly commented upon: 'As to the meaning of these words, the entire struggle between theory and ideology. The Bolshevik made the proletariat struggle against itself by entrusting the struggle to a *specialised representation*, therefore, to the police. In this way, the ideological alienation of the proletariat has struggled against its own being.'

These notes, like the notes on Wittfogel, show us what *détournement* meant to Debord. It was not meant to be a quote, nor a fragment – as

was the case for Walter Benjamin for whom new meaning was supposed to emerge from the constellation of fragments – nor stylistic ornamentation. It is, rather, a form of *rewriting*. It extracts a new meaning from the original; a meaning that both has the potential to be more profound and can even be torn from the original against its will. This is the case here. Lukács argues that the Communist Party empowers workers to break out of the passivity to which the bourgeoisie and revisionist Marxism has condemned them. Debord, in contrast, argues that all that these allegations require is to undergo a *détournement* in order to show that the Bolshevik Party also organises the same proletarian passivity for its own interests.

Debord imparts his analysis of Lukácsian thought rather briefly, and without the use of *détournement*, at the end of thesis 112 in *The Society of the Spectacle*. As such, the argument is already well known. What is most surprising, however, is the discovery in these archives of the important role that the work of Karl August Wittfogel played in the genealogy of *The Society of the Spectacle*. In the 1920s, Wittfogel, a German Sinologist, was closely associated with Korsch, Lukács and the future theoreticians of what would become the Frankfurt School. Prosecuted by the Nazis, Wittfogel was forced to flee into exile in the United States and became an anti-communist. In 1957, he published his major work, *Oriental Despotism*, which hinged on the concept of 'hydraulic empire': the earliest great civilisations (China, India, Mesopotamia and Egypt) were born in river valleys around large irrigation works. These latter required a heightened degree of organisation that gave birth to the powerful caste of technicians and priests who tended to extend their control over the whole of society. Wittfogel believed the Soviet Union and Communist China were successors to this ancient form of totalitarianism, against which he wished to mobilise Western democracy.

Debord refers to Wittfogel only rather critically in *Internationale situationniste* and he is not mentioned at all in *The Society of the Spectacle*.[14] We know that Debord recommended the book to Mustapha Khayati from a letter from May 1965, contained in his *Correspondence*, with the warning to read it 'with blindingly obvious caveats'. His review in *Internationale situationniste* no. 10 criticises Wittfogel for writing an apology for the West.[15] However, over 17 pages of tightly written notes, in which commentary combines closely with extracts and paraphrasing – which is quite unusual – we get the impression that Debord gained a lot of ideas from the book, even if they were often contrary to his own. The Debordian

'stew' is more clearly seen here. Debord appears to agree with Wittfogel that feudalism, based upon a fragmentation of power and the separation between religious and political power, was profoundly different from the absolute power of the hydraulic states. One of the reasons that Debord may have had a relatively positive image of the feudal society is the idea of this weakness of the feudal state faced with a society with many centres of power. Nevertheless, in contrast to Wittfogel, Debord sees a return to the absolute power of hydraulic societies not only in the East, but also in the West: the victory of the bourgeoisie has finally led to an all-powerful state governed by a technical and bureaucratic class without which society appears to be unable to survive. This caste sets itself above the legal owners of the means of production and it relies upon an ideology that is omnipresent. Debord, in this vein, refers explicitly to cybernetics, which would be the contemporary equivalent of the dikes and irrigation canals of Ancient Egypt. Debord finds in Wittfogel a theory that emphasises the centrality of the state, of bureaucracy and of ideology; areas that he believed had been neglected by Marx and Marxists. He concludes therefore at the bottom of one of the extracts: 'Wittfogel gets to the heart of the problem of the state *and* of the economic development of humanity. One can only criticise him (and understand him) from the position of present-day radicalism.'

Before finalising his notes on the liberty and revolt of Saint-Domingue (summarised in *IS*),[16] Debord indicates many passages from Wittfogel that he wished to use in *The Society of the Spectacle*. He ties them to chapters such as 'The Economic Foundations of the Spectacle' or 'Décor' which eventually took other names. Here Debord mixes extracts and observations: 'The bureaucrat exploiters of post-colonial countries do not play the "transformer role" of the Soviet bureaucracy. Why? Because the industrial base does not call for such bureaucracies that exist only *through the practical oppression and the spectacular models* of Western and Eastern powers.' Moreover, he makes a number of interesting digressions, such as the phrase: 'Freud has enlarged the field of Stirner.'

Those who control, possess: that is the central idea that Debord takes from Wittfogel. Debord operates a *'détournement'* of Wittfogel therefore, by bringing his study into dialogue with contemporary conceptions of capitalism. Capitalism, at this point in time, was no longer imagined to embody the 'anarchy of the market' that is caused by the continual clash between private owners. Instead it was thought to consist of a bureaucratic management that, it was believed, had eliminated capitalist crises, to the point of abolishing all freedom. Although most 'orthodox' Marxists con-

tested these positions, they were, nevertheless, advanced by such authors as Karl Polyani, Max Horkheimer, Friedrich Pollock, Bruno Rizzi, James Burnham, Lewis Mumford and the Socialism or Barbarism group. The genealogy of the concept of spectacle owes nothing to the 'media theory' that was being developed in the 1960s. Rather, it had two very important sources of influence: Marx, by way of Lukács, and the theory of 'planned capitalism', in which the bureaucracy situates itself, in the East and the West, at the centre of society. The archives fully support this impression.

Notes

1. A version of this chapter was originally published as 'Debord, lecteur de Marx, Lukács et Wittfogel', in Laurence Le Bras and Emmanuel Guy (eds), *Lire Debord* (Paris: L'Échappée, 2016), pp. 281–91.
2. Henri Lefebvre, *Le Temps des méprises* (Paris: Stock, 1975).
3. In the *roman à clef*, *All the King's Horses* (1960), trans. John Kelsey (London: Semiotext(e), 2008), by Michèle Bernstein, Debord's first wife, this phrase is used to characterise Gilles, a fictionalisation of Guy Debord. It was used again in the dialogue between two cowboys in the tract, 'The Return of the Durutti column', created in 1966 by Strasbourg University students close to the SI.
4. Debord's own version was the nine-volume reprint published between 1947 and 1953.
5. *Œuvres complètes de Karl Marx*, *Correspondance K. Marx–Fr. Engels* (Paris, Alfred Costes, 1931–1947).
6. The Pléiade edition was published in Paris by Gallimard (1965 vol. 1 and 1968 vol. 2).
7. *Marx et les Marxistes*, texts chosen and introduced by Kostas Papaïoannou (Paris: Gallimard, 1965).
8. This is a very debatable reading of the 'late' Marx, but this is another question entirely.
9. Anton Ciliga, *Lénine et révolution: Les 'Maîtres' du pays. Qui commande en URSS?*, trans. Guy Vinatrel (Paris: Spartacus, 1948, re-published in 1978).
10. Jean Hyppolite, *Études sur Marx et Hegel* (Paris: M. Rivière, 1955).
11. For a comparative reading of Marcuse and Debord, see Gabriel Zacarias, '*Eros et civilisation* dans *La Société du spectacle*: Debord lecteur de Marcuse', *Illusio*, 12–13 (2014): 329–43.
12. Both of these books were published in French for the first time in the 'Arguments' series produced by Éditions de Minuit.
13. Anselm Jappe, *Guy Debord*, trans. Donald Nicholson-Smith (Oakland, CA: PM Press, 2018).
14. Debord does, however, employ his term 'Oriental despotism' in thesis 177 in *The Society of the Spectacle*, trans. Ken Knabb (Berkeley: Bureau of Public Secrets, 2014), p. 94.
15. *Internationale situationniste*, no. 10 (March 1966): 72–3.
16. Ibid., p. 10.

2

The Unsurpassable: Dada, Surrealism and the Situationist International

Krzysztof Fijalkowski

Anyone encountering the history and ideas of the Situationist International (SI) soon grasps that Dada and Surrealism are two of the major – perhaps even the most significant – currents informing its development; and that both were roundly criticised and rejected as the SI carved out its own situation in its time and place. References to them are legion in Lettrist and Situationist writings, whose key concepts often have direct antecedents in Dada and especially Surrealist practices, while significant aspects of these movements' tactics as collective, political endeavours are found in the day-to-day activities of the Lettrist International (LI) and SI. Sporadic, fractious but meaningful encounters between Surrealists and Situationists before, during and after the lifespan of the SI show that, in practical as well as conceptual terms, the two movements share features that, in some respects, suggest as much commonality as distinction. Is this more than just footnotes, or another way to grasp what remains elusive about the SI? At stake here is the extent to which we might see it as located within or against the debates and engagements of its time: as continuation or break in the threads of a particular intellectual history, as unitary and coherent, or as complex and divergent. Under scrutiny is the idea that what these movements share is found in whatever lifts them out of the frameworks within which they are commonly viewed, notably the familiar repertoire of the Western avant-gardes, and that makes them a concerted cry of revolt, a claim for what remains tangible and meaningful within something one might not be ashamed to call real life.

Indeed, to effectively set Dada, Surrealism and the SI into correspondence, it is necessary, against the grain, to stop seeing the first two as cultural movements, and understand them instead as fundamentally

philosophical proposals, albeit a philosophy as critical practice in which poetry (in its most generous sense), revolt and liberty are conjoined in a speculative becoming. The extent to which any can be treated as specifically *artistic* endeavours is a key to what links and divides them, particularly given the extent to which, by the 1950s, Surrealism had become equated in the mainstream imagination with a circle of painters (Dada's legacy by this point already being firmly in the hands of art institutions). In denying the eventuality of the term 'situationism', defined as meaningless in the opening issue of *Internationale situationniste*, the SI surely has in mind the corrosive popularity that befell Surrealism during the 1930s, as its representations – especially those promoted by exhibitions and the media – percolated everywhere into culture, in the face of the call in André Breton's Second Manifesto at the start of that decade for the movement's 'profound, veritable occultation'.[1] As though to armour itself against such an eventuality, the SI's categorical rejection of any activity that might be seen as art or literature is conveniently summed up in Guy Debord's often-cited positioning of the movement's intentions: 'Dadaism sought to abolish art without realising it; Surrealism sought to realise art without abolishing it. The critical position since elaborated by the Situationists has shown that the abolition and realisation of art are inseparable aspects of a single transcendence [*dépassement*] of art.'[2] Given that much of the SI's borrowings from both movements came not from their art but from their theoretical texts and critical positions, this dismissal seems a touch disingenuous, even if by 'art' Debord has all of the creative arts in mind. His critique of Surrealism here, in particular, really relates to its wider legacy and *reception*, rather than to its original core imperatives; but if the LI and SI broadly dismissed what had become of Dada and Surrealism, in many respects they nonetheless both condoned and incorporated many of their central tenets and attitudes into their own aspirations.

This interactive positioning of Dada, Surrealism and the SI faces difficulties in confronting like with like. All three work through intricate networks to bring together individuals from diverse backgrounds and specialisms. All focus on collectivities that are both open to newcomers and temporary or more lasting external collaborations but are also closely supervised for ethical infractions (the dialectic between passionate friendship and quarrelsome breaks being just one characteristic the LI and SI inherited from the earlier movements). Strategies for communication forums and channels of fast-flowing critical expression that could be activated and diverted on demand are common to all: journals, tracts,

manifestos; diatribes and rowdy interventions; events, meetings and complex, sometimes messy, intrigues. All three are consciously and expansively transnational, both in terms of journeys and exchanges, but also in terms of alliances and global ambitions (accompanied, it goes without saying, by a total disdain for nationalism of any colour).

But what distinguishes them? Dada burned brightly but only briefly in the period during and just after the First World War, its insistent fuss belying a limited membership; by the time the future SI members were discovering it, this would not only have felt like ancient history, but indeed the 1950s was a period in which Dada, against all its anti-art detonations, was well on the way to recuperation by historians, curators and 'neo-Dada' pretenders in Europe and America. Surrealism, in contrast, in many ways presents an entirely different order to either Dada or the SI: its extreme longevity (now almost a century of activity), its spread around the world, participants numbering in many hundreds, and engagement on multiple fronts of activity, make it a far larger phenomenon. Founded in France in the early 1920s, Surrealism itself emerged in part through its turbulent experience of Paris Dada. But if Surrealism's heyday in France was the 1930s, and its scattering to the winds during the war made it easier to consider the movement's work as done, a lively reformed group consisting largely of young new recruits (who were thus of the same generation as the LI / SI membership) nevertheless remained active on the Paris scene throughout the 1950s and 1960s; it was this continued Parisian Surrealist group that was the principal target for the LI's and SI's persistent and sometimes frankly *ad hominem* attacks.[3] The post-war Surrealist group in France was characterised by a complex and vulnerable political position: having rejected Party communism, and largely outgrown the Trotskyist links forged in the late 1930s, it was now developing alliances with anarchist and other independent radical political causes;[4] yet it was also characterised by a fresh emphasis on magic, myth and the occult, themes derided by the group's adversaries, and the LI / SI in particular. But, since its first decade, Surrealism had been an international phenomenon, with each local group establishing its own positions and priorities, some markedly distinct from those in France.[5] So, as we shall see, if viewed through the eyes of Surrealism in Paris, the SI appears a bothersome rival, seen from Brussels in the 1950s, Prague in the 1960s and 1970s, or Madrid in the present century, affinities between Surrealist and Situationist theses may be as prominent as differences.

Divergences, convergences

The crucible of the LI in Isidore Isou's Lettrist movement, with its emphasis on the breakdown of language, the negation of art and a highly visible programme of manifestos and public interventions, not to mention Isou's personal identification with Dada theorist Tristan Tzara, ensured that a trace of Dada would always remain in the DNA of the SI.[6] More significantly, the emergence of the SI is also criss-crossed by significant encounters and skirmishes with Surrealism. Parisian Surrealism's history of first an engagement with, then a *dépassement* of Paris Dada supplied a model that in turn allowed the LI and SI to present themselves as logical successors to the now redundant positions of a Surrealism that had originally been an 'intelligent and honourable enterprise'.[7] At other moments, the argument was for a more radical break in this sequence: the 1958 Situationist essay 'Amère victoire du surréalisme' sees the movement as 'unsurpassable' (*indépassable*), since it prolongs an art and poetry already negated by Dada: each move beyond Surrealism returns to the problems faced at its outset.[8] This logic was perhaps one of the reasons why the LI and SI laid frequent and deliberate claim to precursors who, as they well knew, were either also established as key Surrealist ancestors (de Sade, Fourier, Ferdinand Cheval or the Dada idols Arthur Cravan and Jacques Vaché) or as early but rejected group members (Giorgio de Chirico and Antonin Artaud).

Surrealism and individual Surrealists are repeatedly cited in the LI journal *Potlatch* – much more regularly than, for example, Existentialist currents around Sartre and Camus or the positions of the Parti Communiste Français (all far more visible and powerful in France than Surrealism in this period).[9] Of all its contemporaries in Paris of the 1950s, it was thus Surrealism that presented the LI with its most proximate, urgent and authoritative adversary – a relationship one might be tempted to characterise as 'Œdipal', were it not for the extent to which Freudian psychoanalysis is both overdetermined in Surrealism and seen as irrelevant by the LI.[10] The founding of the SI is similarly marked by its need to define itself against the movement. Debord's address to the conference in Cosio d'Arroscia in July 1957, at which the SI was launched, the 'Report on the Construction of Situations', cites Dada's destruction and Surrealism's subsequent revolt as two key conceptual markers for the movement, both of which are now to be surpassed. The new journal, *Internationale situationniste*, was notable for devoting the two opening essays of its first issue (June

1958), and the first essay plus another substantial text of its second, to the problem of Surrealism. Establishing a symmetry of hostility, the opening essay of the new Surrealist journal *Bief*, launched that November, ended on a sideswipe from poet Benjamin Péret at the SI with its 'ambiguity and confusion'.[11]

Debord's contribution to the public debate on 'Is Surrealism Dead or Alive?' a few days later was calculated to irritate the group, which sent a delegation to disrupt it. His speech, recorded on tape and accompanied by guitar music, conceded that the answer was no – its members were, after all, still alive – but that, despite its once progressive positions, today it remained 'thoroughly boring and reactionary'.[12] 'Report on the Construction of Situations' acknowledges that Surrealism 'is much richer in constructive possibilities than is generally thought'; but the central weakness of the movement, Debord argues, is its inability to fulfil its programme as the result of its obsession with the unconscious and the limited resources of automatism (defining characteristics of Surrealism from its First Manifesto), and its subsequent collapse into spiritualism: 'The error that is at the root of Surrealism is the idea of the infinite richness of the unconscious imagination. The cause of the ideological failure of Surrealism was its belief that the unconscious was the finally discovered ultimate force of life'.[13] Debord characterises Surrealism as a movement that was revolutionary in its inception, one that 'succeed[ed] in catalysing for a certain time the desires of an era', but that from the 1930s onwards lost its relevance and critical purchase as its influence spread beyond its immediate control.[14] As 'Bitter Victory of Surrealism', the first text in *Internationale situationniste*, argued, Surrealism had fatally succeeded, yet without changing anything: on the contrary, the wider world had caught it up, re-forging Surrealism's innovations into new tools for capitalism.[15] Thus the SI broadly accepted and acknowledged Surrealism as founded on revolutionary bases, codifying and systematising the radical negation that Dada just before it had unleashed without knowing how to convert into action, but rejected both those aspects of Surrealism liable to sink into idealism – the unconscious, myth and magic – and those doomed to recuperation by the hegemonic order: art and literature. Subsuming the 'artistic' and the 'poetic' instead into everyday life, the SI wished to retain from Surrealism only that materialist, activist *élan* that had characterised the movement in its first decade, and its focus on daily lived experience. Everything since that point, all its participants, were beyond the pale, and it is noticeable that whenever the LI or SI view the movement in a positive

light 'Surrealism' gets the credit; whereas, if individual Surrealists are cited, it is almost always with the aim of denigrating them.

Naturally, the reality of the relationship is not so straightforward. French intellectual circles of the 1950s made Paris a village, so it is no surprise that there were some direct connections between the two groups. Young Surrealist writers Georges Goldfayn and Gérard Legrand, for example, knew Debord and Gilles Ivain socially in the early 1950s.[16] These relations were serious enough that in August 1954 the two groups considered a common action: a protest against dignitaries in Charleville planning a monument to Arthur Rimbaud. Attempts to draw up a collective statement foundered on the LI's insistence on expressing a Marxist position on class conflict, and the debate degenerated into catty exchanges in their respective journals. A tract was published bearing the signatures of both groups, but in a classic *détournement* the LI reprinted a withering assessment of the affair on the back of some copies of it.[17] While the LI concluded that Surrealists were constitutionally unable to abandon the comforts of literature for action, the Surrealists, doubting whether the LI had ever intended to see the project through, were left with an image of agitators from 'an intellectual gangster tendency', unruly and potentially violent.[18]

Much as it disintegrated into jibes and recriminations, the falling out centred on political theory, with the LI reading Surrealist positions as reticent and self-satisfied, while Surrealists in their turn viewed the LI's subscription to Marxist doctrine as, at best, a stage in a journey they had long since left behind and, at worst, a collusion with the Stalinism they had opposed since the mid-1930s.[19] The experience produced a hardened attitude so that French Surrealist journals during the late 1950s and 1960s rarely allude to the LI and SI (whereas Surrealism is frequently referenced by contemporary LI and SI publications), and Surrealism overlooked the possibility that SI politics could be nuanced and critical – to the point where the SI would eventually denounce those Surrealists who in 1967 made the trip to Havana for the Salon de Mayo in support of Castro's Cuban regime.[20] Just as importantly, this line of fracture effectively obscured the extent to which both groups shared a claim to a much less contingent and more relevant antecedent in the shape of utopian socialist philosopher Charles Fourier (1772–1837), 'discovered' by Breton during the war and rapidly promoted to a leading position in the movement's pantheon but also repeatedly referenced in SI writings. Fourier's model of a passionate, poetic community in which daily life could be transformed by the creative

re-forging of social relations and structures is a key strand of the thought of the SI and post-war Surrealism alike.

Friction over political orientations was why another major intersection between Surrealism in France and the LI / SI, this time in the arena of the visual arts, was also framed from the outset in terms of divergences. Several artists, notably Asger Jorn, came to the LI via their experience of the short-lived but influential international art grouping CoBrA. While CoBrA incorporated several concerns that should have brought it close to Surrealism – automatism, spontaneity, childhood, play and *art brut* – its own background was in part the equally short-lived Revolutionary Surrealism circle formed just after the war in explicit opposition to Surrealist 'orthodoxy'. A crucial point of disagreement distinguished these two: sympathy to Party communism, advocated by the Revolutionary Surrealists as a necessity in the changed climate of the 1940s but rejected absolutely by those around Breton. Unsurprisingly, artists and writers associated with Revolutionary Surrealism were viewed with the highest suspicion by Surrealists in Paris. Jorn was not a member, but had been a communist while participating in the Helhesten artists' group in occupied Copenhagen during the war that incorporated many aspects of Surrealism. Though he met Breton in 1947, his contacts and affinities would have largely precluded dialogue with French Surrealism.

Relationships with Surrealism in Paris formed the background for the most direct collusion between Situationists and Surrealism: collaborative action between LI members around *Potlatch* and Belgian Surrealist Marcel Mariën with his journal *Les Lèvres nues* (published 1953–58, with LI contributions between 1955 and 1957).[21] This coincided with the formulation of SI precepts leading to its launch in July 1957, and took the form not only of the first publication in *Les Lèvres nues* of several foundational SI texts, but of jointly signed tracts and co-authored agitation events. True, *Les Lèvres nues* was an unusual Surrealist journal: its direction lay almost entirely in the hands of Mariën alone, gathering contributions from a deliberately limited selection of co-conspirators, notably the theorist and writer Paul Nougé.[22] Like many Belgian Surrealist publications it was at the same time serious and caustically humorous, unafraid of provocative statements and oriented well away from anything deemed art or literature, all traits that would have been attractive to the LI and Debord, whose relationship with Mariën was for a while lively and cordial. Surrealism in Belgium, moreover, had a long history of independence from its Parisian counterpart, particularly in the post-war period when differences of per-

spective soured to outright hostility. For Debord and his colleagues, then, *Les Lèvres nues* offered a means to access at a discreet distance what still looked relevant in Surrealism, without the compromise of engaging its Parisian representatives – indeed, with the added promise of irritating them into the bargain.

More than merely offering an expedient platform for the LI, however, *Les Lèvres nues* displays many aspects that are strikingly similar in tone and content to LI / SI positions, for the most part already in place before Debord and Mariën decided to make common cause, and grounded in established Belgian Surrealist tactics. 'The clearest feature of [Surrealist commitment] in relation to literature,' claimed Nougé in issue 1, 'is perhaps detachment, a certain detachment. [...] And we consider possible the discovery of a new means which would cause us to relegate writing to the background and maybe abandon it altogether because of its far too limited effectiveness.'[23] Mariën was already deploying striking *détournements* such as the 1955 collage of perverted brand advertising images and slogans (like 'Coca-Cola: For a Quicker Death'),[24] but he was also prioritising topics such as cinema or anti-clericalism that were also familiar themes for the LI. *Les Lèvres nues* hosted the first publication of a number of key texts by Debord, including 'Introduction à une critique de la géographie urbaine', 'Théorie de la dérive' and (with Gil Wolman) 'Mode d'emploi du détournement'. Quirky, facetious and acerbic, *Les Lèvres nues* pursued an intransigent line on liberty, politics and culture, including an overt anti-colonial agenda (a recurrent theme in Surrealism as a whole), that in many ways anticipates the tone and graphic style of *Internationale situationniste*.

Party walls

Underwriting this alliance is the parentage of several SI concepts in Dada or Surrealist practice. Insofar as it is based both upon corrosive anti-art strategies, which combine critical with subversive attitudes, and upon a Hegelian dialectic that harnesses the energy of ideology deflected towards its own negation, the tactic of *détournement* draws upon both Dada and Surrealist antecedents. Among the first, examples such as Berlin Dada (in particular the work of Hannah Höch and John Heartfield) adopt an apparently flippant technique that cannibalises mass media sources in order to expose their underlying assumptions and, at the same stroke, ridicule the claims of art and culture. Jorn's *Modifications* from the turn of the 1960s, in

which found amateur paintings are defaced, had a specific reference point in Marcel Duchamp's graffiti-scrawled Mona Lisa *LHOOQ* (1919).[25] Surrealist collage, though more poetic and allusive in its intentions, also often appropriated mass media materials along with re-purposed text. Breton, who was snipping newspaper headlines into poems in the early 1920s, had used the specific word *détournement* in 1929, in the context of Max Ernst's collage novels.[26] The 1930s collages by Georges Hugnet featured images and slogans from magazine advertising, while later that decade Léo Malet was tearing out sections of street posters to reveal latent meanings beneath. Just as significant, however, is the manner in which the LI and SI would locate the conceptual origin of *détournement* in the writings of Lautréamont ('plagiarism is necessary'), the ancestor who, perhaps above all others, stood as guarantor for the origins of Surrealism in the late 1910s.

The most explicit relationship between Surrealist and SI concerns is in their prioritisation of the city, the street and what would come to be a defining Situationist activity, the *dérive* and its attendant discipline psychogeography. Organised or spontaneous promenades, already a feature of Paris Dada, loom large in Surrealism's mythology, with its restless curiosity about the layers of memory, meaning and encounter that saturate urban space. If the specific term is not often deployed (though we might note Phillipe Soupault's novel of 1923, *À la dérive*), the idea of the walker cast on the currents of the pavement, of a purposeful availability quite distinct from Baudelaire's dandy *flâneur*, is characteristic of Parisian Surrealism from its earliest years. That this is a process driven by desire is common to both movements, albeit that while this desire seems held at arm's length by the Situationist, seeking a more constructive and critical experience, for the Surrealist the city stroll has the character of a *quest*, often driven by an obsessive search for that tantalising other who might answer the walker's dreams. Thus the promenade in Breton's narratives *Nadja* (1928) and *Mad Love* (1937) navigates a stage-set for meaningful and intimate encounters activating a passionate geography.[27] Eroticism, liberty, play and crime are all aspects of the Surrealist city that are also echoed in the SI's fascination with its environment, affinities nodded to early on in Debord's list of psychogeographic 'ancestors' (including Breton, Vaché and Pierre Mabille) in clear reference to the famous list of precursors in the first Surrealist Manifesto.[28]

Just as the Situationist *dérive* took careful note of environments, Breton's texts supplement walks with observations, details and visual evidence. Surrealist photography is especially rich in testimonies of the city, from

images of Paris by Brassaï and Jacques-André Boiffard (not forgetting earlier ones by Atget) to the acute urban documentation by several generations of Czechoslovak Surrealists since the 1930s.[29] The most striking example of this approach remains Louis Aragon's *Paris Peasant* (1926), an intricate near-documentary account of two Parisian spaces: the soon to be demolished Passage de l'Opéra arcade, and the Buttes Chaumont park, both subject to extensive investigation in search of a 'modern mythology' in the minutiae of urban everyday life.[30] Aragon was among the most gifted writers of early Surrealism, and elsewhere his intense, provocative style had much that anticipates the tone of SI writings, particularly those of Raoul Vaneigem; yet Situationist theses of the *dérive* never credit him, presumably since by the post-war era he was a Stalinist *littérateur*, reviled by the Surrealists but equally of no discernible value to the SI.

Urbanism and architecture are a major concern for the SI but rather less central to Parisian Surrealism, more interested in poetic or subversive interpretations of monuments and buildings (as with the 1933 enquiry into the 'Irrational Embellishment of a City' published in *Le surréalisme au service de la révolution*).[31] The specifically urban location of de Chirico's metaphysical paintings from the years just before the founding of Surrealism, depicting deserted squares and arcades pregnant with anticipation and enigma, was a key influence in the development of Surrealist painting but is also highlighted several times by Situationists for depicting the eloquent absence at the heart of modern existence.[32] While no Surrealist project matches the scope of Constant's *New Babylon*, a seam of architectural aspiration runs through Surrealism, from the paintings and writings of Chilean artist Matta (an architect by training who worked briefly for Le Corbusier), via projects by Austrian architect Frederick Kiesler to an interest in the spontaneous efflorescence of Ferdinand Cheval's *Ideal Palace*, extolled by Surrealists and the SI alike. While few proposals were feasible, the Parisian Surrealist group of the 1950s boasted no fewer than four qualified architects, of whom Bernard Roger's plans for erotically charged pavilions or an underwater cinema can be set alongside Constant's work as evidence of a shared desire for an architecture of pleasure and possibility.[33]

Inevitably, the congruence between Surrealist and Situationist interests can only be laid out here in very broad terms; many can be perceived above all in Vaneigem's *Revolution of Everyday Life*, a book likely to be found on the shelves of many Surrealists today.[34] Just as Debord had done before him, Vaneigem repeatedly references Dada and especially Surrealism,

securing yet distancing himself from what he reads as a now anachronistic set of positions. But as well as the repeated acknowledgement of shared precursors (Fourier, de Sade and especially Vaché, alongside pointed citation of Artaud) certain prominent themes, particularly in the book's final section, are immediately familiar for Surrealism. Play is located as central to revolutionary action but is also a sovereign value for Surrealism, which in several respects placed ludic strategies at the heart of everyday life. Even more significant for Surrealism, love and eroticism, as revolutionary principles and the means to wreak revenge on bourgeois morality while affirming the lived moment and subjective experience, are highlighted by Vaneigem as key ideas. Anti-clericalism, a consistent theme in LI and SI provocations, is equally present in Surrealism as a sustained and non-negotiable position. Finally, there is the problem of language, both as a battlefield on which concepts and debates are established and unfold, but also a domain in constant peril of recuperation by hegemonic forces. Here lies one of the major distinctions between the two movements, in the shape of their divergent understanding of poetry. Where both place it centrally, insisting on an expanded definition of poetry that sees it as a community concern (Lautréamont's dictum 'Poetry must be made by all') and anchoring it in material rather than idealist frameworks, the SI sees the authentically poetic as something that has surpassed literature to be absorbed into situations and everyday existence, where Surrealism, which might under certain circumstances endorse this view, nevertheless remains committed to the writing of poems, to an intimate language as bearer of enchantment and revelation.

Nevertheless, moments can be observed that bring the two much closer together. One example is a joint declaration by French and Czech Surrealists 'The Platform of Prague' of 1968, written against the backdrop of repressive post-war Western and Eastern blocs, in which rescuing language from recuperation, and the assertion of play and revolution, are established as central concerns, in terms that at least partially evoke the contemporary priorities of the SI.[35] A second was the proposed development in Paris of 'Surrealist events' in June 1969, interventions intended to take place across a network of public spaces 'to *immediately* transform any given aspect of life' and conceived, as one of the instigators Alain Joubert acknowledges, as an attempt to rekindle the fervour of the previous spring.[36] While history tends to credit the SI alone with helping to fuel the fires of popular revolt in May '68, at best seeing this moment as the

Paris Surrealist group's swansong, since it was to fragment the following year,[37] Parisian Surrealists also experienced May '68 with an unparalleled intensity.[38] Their journal L'Archibras continued publication of incendiary material during 1968, falling foul of the authorities; members joined action committees, artists designed posters, and above all Surrealists took to the streets and barricades, experiencing these – just like the Situationists – as a vivid realisation of their most cherished desires.[39] While work remains to be done to uncover the hidden connections and echoes between the two groups at the crucial moment of the mid to late 1960s, there is some evidence that Surrealism and the SI were not the impermeable sides they are usually painted. Joubert, one of a handful of Surrealist group members taking the SI's ideas seriously at this time, advocated that Surrealists 're-appropriate' in their turn concepts the SI had itself drawn from Surrealism, and would recall: 'The Situationists … *relayed* our principal ideas in the terms of their own language, *formulated* our common objectives in a language that was theirs alone; ultimately they presented themselves as our nearest allies, whether they liked it or not.'[40] In later years Debord corresponded with a number of former Surrealists, notably Annie Le Brun, whose polemical writings might in several respects be compared to Situationist positions.[41]

Around the world, and in the wake of the break-up and partial recomposition of the Parisian group, later Surrealist collective activities sometimes adopted positions that resonate with Situationist ideas, albeit generally seen as the prolongation of historical Surrealist theses and along a shared trajectory of revolutionary Romanticism.[42] The long-standing Chicago group is a good example of Surrealist attitudes that are also open to collaborative political action and affiliation with complementary movements.[43] Activism, *dérives*, the merging of theory and everyday life are prominent features of current Surrealist groups in locations such as Madrid, Stockholm, Leeds and indeed Paris. The first two of these are particularly notable for having expressly (though perhaps not ruthlessly) abandoned artistic practice as too recuperable by markets and institutions to be viable. The Madrid group's journal *Salamandra*, in publication since 1987, collects texts and documents in strategies of thematic debate (often generated around public events that echo something of the notion of constructed situations), passionate and critical geographies, and militant action. The stories of these multiple intersections remain to be gathered and retold.

Notes

1. André Breton, 'Second Manifesto of Surrealism', in *Manifestoes of Surrealism*, trans. Richard Seaver and Helen R. Lane (Ann Arbor, MI: University of Michigan Press, 1972), p. 178 (translation slightly modified).

2. Guy Debord, *The Society of the Spectacle*, trans. Ken Knabb (Berkeley: Bureau of Public Secrets, 2014), thesis 191, pp. 102–3. This is a *détournement* of an extract from Marx's *Critique of Hegel's Philosophy of Right*: 'Philosophy cannot be made a reality itself without the abolition of the proletariat, and the proletariat cannot be abolished without philosophy being made a reality.' *Marx and Engels Complete Works* (London: Lawrence and Wishart, 1975), vol. 3, p. 187.

3. The fact that historians have only recently turned their attention to Surrealism in the post-war era has contributed to the way in which it has often been presented by commentators in terms of an historical rather than contemporary relationship to the LI and SI.

4. While activism is not as visible in post-war Surrealist journals as it is in LI/SI publications, it nevertheless constitutes a significant part of French Surrealism's history in this period; see for example the political writings and speeches in André Breton, *Mettre au ban les partis politiques* (Paris: L'Herne, 2007), or José Pierre, *Surréalisme et anarchie: les 'billets surréalistes' du Libertaire* (Paris: Plasma, 1983).

5. For example, the Surrealist group formed in Bucharest during the 1940s explored visual media, but saw the temptations of art as eroding Surrealism's principles, and advocated its dialectical destruction and surpassing; indeed, Debord specifically mentions this group, in his 'Report on the Construction of Situations and on the International Situationist Tendency's Conditions of Organization and Action' (1957) in *Situationist International Anthology*, trans. Ken Knabb (Berkeley, CA: Bureau of Public Secrets, revised and expanded edition 2006), pp. 25–43.

6. On the LI's own evaluation of Lettrism as a form of Dada, see 'Pourquoi le lettrisme?', *Potlatch*, no. 22 (September 1955); reprint: Lettrist International, *Potlatch* (Paris: Allia, 1996), p. 98.

7. The editors, *Potlatch*, no. 14 (November 1954); reprint, p. 51.

8. SI, 'Amère victoire du surréalisme', *Internationale situationniste (IS)*, no. 1 (June 1958): 3.

9. See for example the index of cited individuals in the 1996 reprint, where Breton (p. 151) is by far the most frequently featured name in the journal.

10. As Michèle Bernstein would later recall, 'There was the father we hated, which was Surrealism. And there was the father we loved, which was Dada. We were the children of both', cited in Greil Marcus, *Lipstick Traces: A Secret History of the Twentieth Century* (London: Faber and Faber, 2001), p. 181.

11. Benjamin Péret, 'La Poésie au-dessus de tout', *Bief*, no. 1 (November 1958).

12. Guy Debord, 'Contribution to the Debate: "Is Surrealism Dead or Alive?"', in Situationist International, *Guy Debord and the Situationist International: Texts and Documents*, ed. Tom McDonough (Cambridge, MA: MIT Press, 2002), pp. 67–68. Recording available at https://www.youtube.com/watch?v=PlH5yX3FBHY (accessed 4/5/2018). The Surrealists' indignant

account declines to mention by name either the SI or Debord, 'a formerly Isouist ragamuffin'; Gérard Legrand, 'Les Faux-Parleurs', *Bief*, no. 2 (December 1958).

13. Debord, 'Report on the Construction of Situations', p. 28.

14. Ibid., pp. 19–20.

15. SI, 'Amère victoire du surréalisme', p. 3.

16. Correspondence between Debord and Goldfayn, for example, indicating both collective divergences but a clear *entente* between the two men, dates from 1953 (online archive at http://www.notbored.org/debord.html, accessed 4 May 2018). Writing to another former Surrealist group member Annie Le Brun (ibid., 9 October 1992), Debord mentions 'Georges Goldfayn has written me a note, and I have responded to him. I am happy that this dialogue has been renewed, after thirty-six years. We are loyal people.'

17. For the texts, archive documents and commentary, see Jérôme Duwa, *Surréalistes et situationnistes, vies parallèles* (Paris: Editions Dilecta, 2008), pp. 34–40 and pp. 119–46; the texts were previously reprinted, also with commentary (this time from the Surrealists' perspective alone) in *Tracts surréalistes et déclarations collectives 1922–1969*, ed. José Pierre, vol. 2, *1940–69* (Paris: Eric Losfeld, 1982), pp. 133–4 and pp. 359–63.

18. Jean-Louis Bédouin to Adrien Dax, reproduced in Duwa, *Surréalistes et situationnistes*, pp. 140–1. Duwa's study gives a detailed account of the relationships between the SI and French and Belgian Surrealism, and relates the Rimbaud *débâcle* supported by archive documents.

19. Among the scholarship that considers the respective positions of French Surrealism and the LI / SI within wider post-war political and intellectual contexts, one might highlight Peter Wollen, 'Bitter Victory: The Art and Politics of the Situationist International', in Elisabeth Sussman (ed.), *On the Passage of a Few People through a Brief Moment in Time*, exhibition catalogue, Musée national d'art moderne, Centre Georges Pompidou, Paris, France, 21 February–9 April 1989 and elsewhere, pp. 20–56. Mikkel Bolt Rasmussen's 'The Situationist International, Surrealism, and the Difficult Fusion of Art and Politics', *Oxford Art Journal* 27(3) (January 2004): 365–87, situates the movements in broader political context, while Emmanuel Rubio's 'Du surréalisme à l'IS, l'*Esthétique en héritage*', *Mélusine*, 28 (2008): 95–124, deals with their relationship with Marx and Hegel. For a fuller but rather idiosyncratic argument, see Louis Janover, *Surréalisme et situationnistes au rendez-vous des avant-gardes* (Paris: Sens et Tonka, 2013).

20. SI, 'Familiers du Grand Turc', *IS*, no. 12 (September 1969): 90–91.

21. For accounts of this relationship, see for example Xavier Canonne, *Surrealism in Belgium, 1924–2000* (Brussels: Mercatorfonds, 2007); Guy Debord, *Lettres à Marcel Mariën*, ed. François Coadou (Paris: La Nerthe, 2015); Duwa, *Surréalistes et situationnistes*, pp. 51–81; Yalla Seddiki, 'Les Lettristes, Les Lèvres nues et les détournements', *Mélusine*, 28 (2008): 125–35. For the LI texts themselves, see *Les Lèvres nues*, facsimile reprint (Paris: Plasma, 1978).

22. The story of the journal, including the LI's collaboration, is told in Marcel Mariën, *Le Démêloir* (Brussels: Les Lèvres nues, 1978).

23. Paul Nougé, 'La Solution de continuité', *Les Lèvres nues*, no. 1 (1954), cited in Canonne, *Surrealism in Belgium*, p. 123.

24. Reproduced in ibid., p. 120.

25. For a discussion of this relationship, see for example Tom McDonough, *The Beautiful Language of My Century: Reinventing the Language of Contestation in Postwar France, 1945–1968* (Boston, MA: MIT Press, 2007), pp. 20ff.

26. Seddiki, 'Les Lettristes', p. 134. Breton would later make a collage using comic book-style captions on a found image, *Tragic, In the Manner of Comics* (1943), reproduced in Jean-Michel Goutier (ed.), *André Breton: Je vois, j'imagine* (Paris: Gallimard, 1991), p. 69.

27. David Pinder explores in detail the relationships and cross-overs between Surrealist promenades and Situationist *dérive* in 'Urban Encounters: Dérives from Surrealism', in *Surrealism: Crossings/Frontiers*, ed. Elza Adamowicz (Oxford/Bern: Peter Lang, 2006), pp. 39–64. Among the sources exploring this theme one can single out Michael Sheringham, *Everyday Life: Theories and Practices from Surrealism to the Present* (Oxford: Oxford University Press, 2006), which contains chapters on Surrealism and the SI.

28. Guy Debord, 'Exercise de la psychogéographie', *Potlatch*, no. 2 (June 1954); reprint, p. 12 – 'André Breton is naively psychogeographic in the encounter.' Emmanuel Rubio argues that it was Ivan Chtcheglov's enthusiasm for Surrealism's interest in the city that encouraged Debord to develop ideas that, in other respects, he might have been expected to reject along with other 'outmoded' aspects of Surrealism ('Du surréalisme à l'IS', pp. 113ff).

29. See for example Ian Walker, *City Gorged with Dreams: Surrealism and Documentary Photography in Interwar Paris* (Manchester: Manchester University Press, 2002); Krzysztof Fijalkowski, Michael Richardson and Ian Walker, *Surrealism and Photography in Czechoslovakia: On the Needles of Days* (Farnham: Ashgate, 2013).

30. Louis Aragon, *Paris Peasant*, trans. Simon Watson Taylor (London: Pan, 1980).

31. The LI would explicitly answer this game in 1955 with their own, more prosaic but also more achievable 'Project for the Rational Embellishment of the City of Paris', opening the city for free play and casual interventions: *Potlatch*, no. 23 (October 1955); reprint, pp. 110–11.

32. See for example Raoul Vaneigem, *The Revolution of Everyday Life*, trans. Donald Nicholson-Smith (London: Rebel Press, 2006), pp. 145–6.

33. See Krzysztof Fijalkowski, 'Architecture', in Michael Richardson et al. (eds), *The International Encyclopedia of Surrealism*, vol. 1 (London: Bloomsbury, 2019), pp. 404–8.

34. Vaneigem's work is already being referenced, for example, in Philippe Audoin's article 'Singes de nature', *L'Archibras*, no. 6 (December 1968). Vaneigem's later book *A Cavalier History of Surrealism* (1977), originally published under the pseudonym Jules-François Dupuis, is a detailed indictment of the movement's inherent availability for recuperation but nevertheless also establishes the extent to which he saw it as a crucial expression of the 'terminal phases of the crisis of culture'; Jules-François Dupuis, *Histoire désinvolte du surréalisme* (Nonville: Paul Vermont, 1977), p. 7.

35. Collective declaration, 'The Platform of Prague' (1968), in *Surrealism Against the Current: Tracts and Declarations*, ed. and trans. Michael Richardson and Krzysztof Fijalkowski (London: Pluto, 2001), pp. 58–66.

36. Alain Joubert, *Le Mouvement des surréalistes, ou, Le Fin Mot de l'histoire: Mort d'un groupe, naissance d'un mythe* (Paris: Maurice Nadeau, 2001), pp. 99–100.

37. Indeed the SI specifically derided Surrealism's lack of commitment to the events: see SI, 'Familiers du Grand Turc'.

38. See for example testimonies from Joubert (*Le Mouvement des surréalistes*, pp. 228 and 256ff) and Claude Courtot (in Jérome Duwa, *1968, année surréaliste. Cuba, Prague, Paris* [Paris: IMEC, 2008], pp. 229–40).

39. For a collection of relevant materials and key players, see Duwa, *1968*, pp. 173ff. The artist Jean Benoît, for example, faced the riot police with a bag of skulls to hurl at the CRS.

40. Joubert, *Mouvement des surréalistes*, pp. 307–8. Guy Flandre, another member of the group in this period, related to me on several occasions that there were younger Surrealists who petitioned for actual collaboration with the SI at this point.

41. See the letters reproduced in Guy Debord, *Correspondance*, vol. 7 (Paris: Arthème Fayard, 1999–2010); relevant books by Le Brun include *Appel d'air* (Paris: Plan, 1988) and *Reality Overload: The Modern World's Assault on the Imaginal Realm* (2004), trans. Jon E. Graham (Rochester, VT: Inner Traditions, 2008).

42. Scholar of Surrealism Michael Löwy, for example, sees both Surrealism and the SI as direct inheritors of this revolutionary Romanticism, and posits the SI as a 'dissident wing of Surrealism'; Michael Löwy, *Morning Star: Surrealism, Marxism, Anarchism, Situationism, Utopia* (Austin: University of Texas Press, 2009), p. 98. See also chapter 9 of this book.

43. See for example the evidence of the volume edited by Franklin Rosemont and Charles Radcliffe, *Dancin' in the Streets! Anarchists, IWWs, Surrealists, Situationists & Provos in the 1960s – As Recorded in the Pages of the Rebel Worker & Heatwave* (Chicago: Charles Kerr, 2005).

3
Lettrism

Fabrice Flahutez

Although serious academic study of Lettrism in France and abroad only really began a few years ago, it has quickly become recognised as a crucial movement through which the history of art in the post-war period can be reread.[1] The renewed interest in the Lettrists, moreover, has given birth to a rather strange historiography. First, critics hold that Lettrism is a direct descendant of Surrealism in order to underline that Lettrism in many respects represents a continuation and development of Surrealism's theoretical and sculptural legacy. Isidore Isou, the group's leader, undoubtedly contributes a great deal to this view of his own place in history as he explicitly describes his work as a direct continuation of many aspects of Surrealism and, in particular, its appropriation of the fantastical literary and artistic heritage of the nineteenth century. Isou argues, in other words, that Lettrism represents the realisation of the entire history of modernity. Secondly, historians argue that Lettrism gave birth to Guy Debord and the Situationist International (SI). Those wishing to emphasise the historical importance of Isou point to the fact that Debord was, for an anecdotal two hundred days, a member of his group. In order to be of historical importance, it appears that Lettrism needed to give rise to the revolutionary ideas of Guy Debord. In short, Lettrism, rightly or wrongly, willingly or not, is caught between Surrealism (and Dada) and the Situationist International. History traps it like a vice. Lettrism is defined as a moment of post-war reconstruction, rather than the very end of history, the creation of an ideal society, which is what Isou himself had wanted.

We have already seen, in the previous chapter, the great debt that the SI owes Surrealism, but what about its debt to Lettrism?[2] How and to what extent did Lettrism influence Situationist thinking, ideas and practice? Isidore Isou wrote many texts attacking the Situationists. Likewise, the Situationists made a number of comments criticising the 'old Lettrist right'. These sources allow us to better understand the shared roots and reference

points of these two movements that were as much bound by blood to one another as they were mutual antagonists.[3] Debord perhaps puts it best in a letter to Wolman from June 1953: 'Isou certainly had a significant role in [our] adventure as he introduced avenues for *rupture* and gave us weapons … and I think that the future *will see* Isou, but from a different perspective from that of Isou himself. Systems never succeed in passing themselves on *entirely*.'[4] On the other hand, Debord was apparently quite piqued by the work of Robert Estival, who describes him as a kind of hybrid of Breton and Isou.[5] Debord therefore flits almost schizophrenically in his writing between laying claim to the legacy of Breton and Isou while, at the same time, taking great pains to underline everything that distinguishes him from these two otherwise foundational figures. Similarly, in 2000, Isou published a collection of caustic texts, *Against the Situationist International*, written on and off since the 1960s, which speaks to the implicit continued importance of the SI for Lettrism.[6] Now that some time has passed, we can perhaps better appreciate the passion, youth and energy that characterised these two authors, a fact to which these comments and texts attest.

In 1951, the Lettrists released a number of films that had a profound effect upon Debord and, as such, could be said to mark the start of the relationship between Lettrism and the future Situationist: Isidore Isou's *Venom and Eternity* (first shown at the Cannes film festival in the spring of 1951), Maurice Lemaître's *Le Film est déjà commencé* (1951) and Gil J Wolman's *Anticoncept* (February 1952). Debord takes the framework and some key ideas from these films for his first piece of avant-garde cinema *Howling in Favour of Sade* that followed soon after (also in 1952). Specifically, Debord adopts the radical technique of using a soundtrack that is disconnected from the film image. At the time, it was a rather unusual technique, but it is one that has since gained a certain popularity. Debord, moreover, accentuates the break between sound and image in his film to such a point that he almost entirely suppresses the visual aspect by simply showing us a black screen.[7] Nevertheless, Isou's filmography, like that of Lemaître and Wolman, clearly has a direct influence on Debord. A little over a decade later, the Situationists would claim that *Howling in Favour of Sade* represents 'a negation and supersession of the Isouian concept of "discrepant cinema"'.[8] Debord, as a result, obviously admits to the immense debt that he owes to the films of Isou, Wolman and Lemaître. The disconnect in his films between off-screen voices and biographical or *détourné* images allowed Debord to reinvigorate cinematic form.

To date, however, critics have not sufficiently insisted on the foundational role played by Lettrist film in these developments. In his later films, Debord infuses the relationship between on-screen images, voiceovers and subtitles with significant, essential and, arguably, critical meaning.[9] Nevertheless, although Debord may have distanced himself from Isou, one can spot, throughout his work, a certain Lettrist influence. First, as Zacarias finds:

> in a note dated 12 October 1968 under 'cinema' that might have been used 'for *The Society of the Spectacle film* for example', Debord still seems to be influenced by the Isouian idea of 'discrepant editing', envisaging the 'repetition of certain *spoken sequences* [...] with *different images* (+ perhaps different subtitles?)' or 'perhaps, inversely, repeat some image-sequences with different words'.[10]

Secondly, we might also add that the images that Debord appropriates and submits to *détournement* in his own films echo the pieces of film lifted from the rubbish bins of the army's cinematic service that Isou and Lemaître had used in their respective films of the period. These films employ the practice of reusing existing materials just as the Surrealists had once reused found objects to produce highly poetic collages. Third, and finally, Debord's work, like that of Isou and Lemaître, contains a strong biographical element. On the one hand, the films are conceived of as having their own trajectory and their own life, but on the other hand they are also imbued with aspects of the authors' biographies, which gives them a certain melancholic dimension. We might find an historical forerunner in Breton, Éluard and Man Ray's aborted film project 'Attempt to Simulate Cinematic Deliria', from August 1935 at Montfort-en-Chalosse, in which the poets themselves take centre stage.[11] As the project was abandoned, it is unlikely that Isou or Debord ever caught wind of it. Nevertheless, the self-insertion of the author into the film image would go on to have a certain influence and can be seen in both Isou's *Venom and Eternity* and Debord's *In girum imus nocte et consumimur igni*.

Outside of the cinema, Debord and Isou also echo one another in their radicalism. Isou wishes to establish a certain end of history with Lettrism leading to an eternal and paradisiacal society. The SI, in contrast, call for 'situations' and, in a certain sense, for all artefacts of culture to be dissolved into life itself. In other words, for both the Lettrists and the Situationists, the audience, or even audiences, are not understood in traditional terms,

rather they become active elements in the apparatus generated by the creator or simply people who have rediscovered the key to an everyday life that promises unalienated exaltation. Moreover, for both Isou and Debord, the position of the artist had fizzled out and had found itself relegated to an obsolete category as eminently bourgeois. For Isou, the artist became a creator who inserted himself into an entirely new hierarchy; whereas, for Debord, the artist dissolved himself into the anonymity of the social body. They both, undoubtedly, wanted to transform the very notion of the 'artist'.

Another way in which we might link the Lettrists and the Situationists is the way in which they approach intervention in the real world. Isidore Isou, for example, took up Dadaist scandal by physically disrupting a performance of Tristan Tzara's *La Fuite, poème dramatique en quatre actes et un épilogue*[12] on 21 January 1946 at the Vieux-Colombier theatre. Such spectacular action was a means of giving life back some of its energy and preventing the audience from coming to the reading with a purely passive attitude. The following day, Maurice Nadeau, the future historian of Surrealism, reported on the incident in an article that appeared on the front page of the French newspaper *Combat*: 'Lettrists Heckle Tzara Reading at Vieux-Colombier'. The paper describes the whole affair in an ironic tone but, nevertheless, records it. This, apparently gratuitous, act was a continuation of the Dada and Surrealist gesture. However, it was also to prove a model for Lettrist and Situationist intervention in the real world. The Situationists shared this propensity for intervening in public debates; it could even be thought of as a hallmark of sorts. Moreover, it might even be argued that it was an action of this sort, one undertaken by Guy Debord in particular, that led to the formation of the Lettrist International.[13]

The scandal in question is the result of an attack against a press conference held by Charlie Chaplin at the Ritz Hotel on 29 October 1952 around the release of his film *Limelight* that would be released two days later. A leaflet entitled 'An End to Flat Feet' was distributed that lambasted Chaplin as a 'sinister and self-interested old man' who cast the shadow of a 'cop', while criticising him further for his greed and lasciviousness.[14] The International Lettrist review, which published this tract in its first edition in November 1952, did not miss the opportunity to highlight a text by Isidore Isou, Maurice Lemaître and Gabriel Pomerand published in the newspaper *Combat* that criticised the action.[15] Debord wished to show Isou's bad faith by placing the two texts side by side. Apart from the quarrels between the two groups, without a doubt initiated by Isou in order to discredit Debord,[16] the goal was to demonstrate that these kinds of intervention in the real

world were already part of a long history that stretched from Dada to the Situationists by way of Surrealism and the Lettrists. The SI adopted this mode of action as an almost obvious corollary to its writing and theorising.

Another important point of comparison might also be the attention that each of these groups pays to the appropriation of space through forms that rehabilitate the act of wandering. The Situationist *dérive*, or drift, is rooted as much in its Lettrist heritage as in the fertile ground of Surrealism. Consider the way in which Isou, in *Venom and Eternity*, wanders along the Boulevard Saint-Germain or the 'deambulations' of the character in *Closed Vision* (1952) by Marc'O (the pseudonym of Marc-Gilbert Guillaumin). These examples demonstrate that, for these artists, walking aimlessly was tantamount to a semantic reading of the urban landscape.[17] The practice of *dérive* is clearly the product of this long and complex history of understanding space as the site in which the self is constructed.

Isou, in an article published in the journal *Ion*, suggests the importance of real space as the very grounds for cinema in an interesting way, drawing an interesting link between *Venom and Eternity* and *Howling in Favour of Sade*:

> We spoke a lot about *Venom and Eternity* at the Cannes festival. The day of the screening we were claiming that the film didn't even exist.... Marc-Gilbert Guillaumin and Guy-Ernest Debord would willingly and concretely realise its absence. They came up with the idea of going to the director of the ciné-club, who had already screened several works by our group, and telling him about an even more sensational creation. The title had already been chosen: *Howling in Favour of Sade*. They would have sent invitations, made posters and called journalists. They would have brought reels for another film in order to reassure the director who, moreover, would take us at our word. Then, when the screening was about to start, Debord would climb onto the stage and give a short introduction. He would have simply said, 'There is no film.' I thought about taking part and linking the theory of pure constructive debate to their scandal. Debord would have had to say: 'Cinema is dead. No more films can be made. Let's debate instead, if you like' (at any rate, as the debate itself would be presented as the work, the journalists present would have had to record the première of a new form of art [*œuvre*]).[18]

This little digression by Isou in *Ion* leads him to conclude, moreover, that what he is describing is the first work of cinematographic debate and

that he will have it printed like a screenplay or synopsis. Marc'O, for his own part, details the many ways of organising putting on a show, transforming the room into a double screen cinema, an aquarium cinema, an electoral cinema, a travelling cinema, a nautical cinema and so on.[19] What is being described here therefore is the extension of the realm of cinema; what Debord describes as a '3D psychology' that permits the 'conditioning of the spectator'.[20] These accounts are not merely anecdotal but are part of a more profound change in the way in which these artists understand the real. For them, the real is to be re-appropriated in whatever manner it may be. For Isou, Debord, Lemaître, Wolman, Marc'O, the cinema of the past will be destroyed in favour of a new cinematographic experience that summons the real into being. For Isou, as he theorised in *L'Art infinitésimale* (1960), this participative reality will lead to a 'super-temporal art'. For Debord, this re-appropriation of reality would materialise from 1957 onwards in the 'construction of situations' (see chapter 11).[21] In other words, what unites Lettrism and the Situationist International is the attempt both to struggle against the emergence of a reified society and to re-enchant the world.

Notes

1. See, for example, Frédérique Devaux, *Le Cinéma lettriste: 1951–1991* (Paris: Paris expérimental, 1992); Fabrice Flahutez, *Le Lettrisme historique était une avant-garde* (Dijon: Les presses du réel, 2011); Frédéric Acquaviva, *Lemaître: une vie lettriste* (Paris: Éditions de la Différence, 2014); Kaira Cabañas, *Off-screen Cinema: Isidore Isou and the Lettrist Avant-garde* (Chicago: University of Chicago Press, 2014); Frédéric Alix, *Penser l'art et le monde après 1945: Isidore Isou, essai d'archéologie d'une pensée* (Dijon: Les presses du réel, 2017); François Coadou (ed.), *Fragments pour Isidore Isou* (Paris: Art Book Magazine, 2017); Frédéric Acquaviva, *Isidore Isou* (Neuchâtel: Éditions du Griffon, 2018); Fabrice Flahutez, Julia Drost and Frédéric Alix (eds), *Le Lettrisme et son temps* (Dijon: Les presses du réel, 2018).

2. See also Fabrice Flahutez, 'L'héritage surréaliste, la lecture de Breton', in Laurence Le Bras and Emmanuel Guy (eds), *Guy Debord: Un art de la guerre* (Paris: BnF/Gallimard, 2013), p. 46–8.

3. Marc Partouche's introduction to Isidore Isou's *Contre l'Internationale situationniste* (Paris: HC-d'arts, 2000) is particularly useful for understanding this issue. The very acrimony between the two groups actually contributed to linking them together within the history of what is called more generally the history of the historic avant-garde.

4. Letter from Guy Debord to Gil J Wolman 25 June 1953 in Guy Debord, *Correspondance*, vol. 0 (Paris: Arthème Fayard, 1999–2010), pp. 28–9.

5. Emmanuel Guy analyses this very well in '"Par tous les moyens, même artistiques": Guy Debord stratège modélisation, pratique et rhétorique stratégiques', unpublished doctoral thesis (Université de Paris 13 and Université de Paris Nanterre, 2015), p. 239.

6. It is worth noting that Isou's book appeared after the death of Debord in 1994. Isou had proposed a collection of this kind to Champ Libre in 1979. A copy of the letter is published in the book, pp. 347–8 and in Champ Libre, *Correspondence* (Paris: Éditions Champ Libre, 1981), vol. 2.

7. See Fabrice Flahutez, Dan Fabien Danesi and Emmanuel Guy, *La Fabrique du cinéma de Guy Debord* (Arles: Actes-Sud, 2013) and Fabien Danesi, *Le Cinéma de Guy Debord* (Paris: Paris-Expérimental, 2014).

8. See Guy Debord, 'Fiche technique pour *Hurlements en faveur de Sade*' (1964) in *Œuvres* (Paris: Gallimard, 2006), p. 73.

9. See Guy Debord, 'Critique de la séparation, Fiche technique', in *Œuvres*, p. 556.

10. Gabriel Zacarias, 'Expérience et représentation du sujet: généalogie de l'art et de la pensée de Guy Debord', unpublished PhD thesis (Université de Perpignan Via Domitia and Università Degli Studi di Bergamo, 2014), p. 379.

11. The project was developed by Man Ray, Breton and Éluard while writing the screenplay. The photographs would be reproduced in 'Essai de simulation du délire cinématographique', *Cahiers d'art*, nos 5–6 (1935): 137.

12. Tristan Tzara, *La Fuite, poème dramatique en quatre actes et un épilogue*, Paris, Théâtre du Vieux-Colombier, 21 janvier 1946 (Paris: Gallimard, 1947).

13. It is important to point out that already, in June 1952, Debord and Wolman had founded the Lettrist International in Brussels, which points to an effective break with historical Lettrism.

14. The tract is reproduced in *l'Internationale lettriste*, no. 1 (November 1952), with the text by Isou in which he distanced himself from the troublemakers. See also, Greil Marcus, *Lipstick Traces: A Secret History of the Twentieth Century* (London: Faber and Faber, 2001), pp. 340–1.

15. The text appeared in *Combat*, 1 November 1952 and is signed by Isou, Lemaître and Pomerand. However, in Maurice Lemaître, 'Mise au point dans l'affaire Chaplin', *Carnets d'un fanatique, dix ans de lettrisme* (Paris: Jean Grasset, 1959), p. 166, Pomerand's name does not appear and the text is only signed by Jean Isidore Isou and Maurice Lemaître. It should be said that, since July 1956, Lemaître had already said goodbye to one of Isou's first collaborators. See *Front de la jeunesse*, no. 10 (July 1956), reproduced in Maurice Lemaître, *Carnets d'un fanatique*, p. 172.

16. A short note refers to this: see Isou, *Contre l'Internationale situationniste*, p. 93 'My disagreement with the Situationist who was my disciple was due – contrary to what he later claimed: 1) to a purely productive, practical and anecdotal reason and 2) was provoked by myself.'

17. It should be noted that *Venom and Eternity* and *Closed Vision* have the same foreign producer in Vickman, who would be the American distributor and translator from 1952 of *Soulèvement de la jeunesse* and extracts of *Ion* in Hollywood. See Léon Vickman, 'Lettrisme, a New Philosophy from Paris', *Pendulum* (California Institute of Technology, Pasadena, fall 1952): 12–25.

18. Isidore Isou, 'Appendice sur le débat passé et futur du ciné-club', *Ion*, no. 1 (Paris, April 1952): 147–8.
19. Marc'O, 'Le cinéma nucléaire ou l'École Oienne du cinéma', *Ion*, no. 1 (Paris, April 1952): 253–84.
20. Guy Debord, 'Prolégomènes à tout cinéma futur', *Ion*, no. 1 (Paris, April 1952): 217.
21. Both theoretical turns recognised their Surrealist heritage. Isou dedicated *L'Art infinitésimal – l'art super-temporel; suivi de: Le poly-automatisme dans la méca-esthétique* (Paris: Aux escaliers de Lausanne, Omnium de presse et d'édition, 1960) to André Breton in the following way: 'To André Breton, beyond our disagreements, with my unending esteem' (see: www.andrebreton.fr/work/56600100840401) and in Guy Debord's 'Rapport on the Construction of Situations', in *Œuvres*, p. 313, Debord highlights the importance of Surrealism for his own thought (see also chapter 2).

4

The Situationists, Hegel and Hegelian Marxism in France

Tom Bunyard

Introduction

My aim in this chapter is to introduce and discuss the influence of Hegelian philosophy on the Situationist International's (SI's) theoretical work and activity. The chapter includes a general overview of Hegel's ideas, and shows how the SI drew on some of the 'existential' themes within his writings that had been foregrounded by the French reception of his work (chiefly: temporality, self-constitutive activity, and the experience of alienation). By explaining Hegel's influence, I hope to clarify some of the SI's central theoretical claims, particularly those that were expressed during the 1960s, when the group's ideas became more explicitly linked to Hegelian and Marxian concepts. This will require a primary focus on the work of Guy Debord – the group's primary theorist, and certainly the most overtly Hegelian of its members – but the chapter's more general observations should still be relevant to readers who are interested in other aspects of the SI's work.

Some of the issues addressed in this chapter are taken further in chapter 17, which discusses the SI's appropriation, and idiosyncratic re-figuration, of Marx's early comments on the need for the 'realisation [*Verwirklichung*]'[1] of philosophy in praxis. The motif of 'realising' philosophy (and indeed of superseding all other such forms of contemplative detachment) bears direct relation, within the SI's work, to many of the Hegelian themes that I shall outline below. My aim here, however, is simply to introduce those themes, and to present them in a manner that will, I hope, prove accessible to readers who are relatively unfamiliar with Hegel's philosophy. I should begin, then, by explaining that philosophy's relevance.

Hegel and the Situationists

Commentators on the SI often distinguish distinct periods in the group's history: an early, avant-garde phase is often distinguished from a later, more militant, and more theoretical period, within which Debord's ideas tended to orient the group's activity. Such distinctions come on good authority as, in 1968, Debord himself made a similar distinction. In a text titled 'The Organization Question for the SI', he identified not two, but rather three distinct periods in the SI's development. The group's first phase of activity, he claimed, had 'centred around the supersession of art',[2] and ran from '1957 [to] 1962':[3] that is, from the year in which the SI was founded, to the year in which the group ejected all members who refused to renounce working in the traditional plastic arts. That split inaugurated a second period, in which priority was given to the development of revolutionary social theory (that is, the theory of 'spectacle'; see chapter 10). Debord's text announces that that second period was over, and that a third was just beginning. It was written in April 1968, and, with Debord's characteristic prescience, it declares – just one month before the occupations movement began – that the SI was about to enter a new phase: one in which the group's ideas would no longer be 'confined to a marginal underground' and would begin 'appearing in the streets'.[4] Rather than focusing on theory, the group would now be concerned chiefly with the actualisation (or indeed the 'realisation') of theoretical ideas in real struggle.

I think it is possible to contend that Hegel's work inflects all three of these periods, albeit via Debord's defining influence on the group's central concepts and aims. I shall try to justify that contention by commenting on each of these periods in turn, starting with their initial, avant-garde phase.

Debord developed many of the SI's key concepts long before the group even existed. He was advocating the construction of situations as a means of superseding modern art as early as 1952,[5] and ideas such as the *dérive*, psychogeography and *détournement* were all devised during his time with the Lettrist International (1952–57). All of these ideas are characterised by themes of movement, change, and transformation in time (whether this be in terms of drifting through the city in the *dérive*, the alteration and re-contextualisation of meanings in *détournement*, or the transformation of lived experience in the constructed situation). In addition, all were conceived as means of addressing what Debord, and later the SI, referred to as a condition of cultural 'decomposition': a state of cultural arrest, held to have followed from the failure of a potential unification of art and life

at the beginning of the twentieth century. In Debord's view, art, at that time, was tending towards its own abolition as a separate sphere via the efforts of the avant-garde, and it had also come close to forming common cause with an ascendant workers' movement. That potential combination of the self-abolition of both art and class society could have ushered in an entirely new social modality; yet that potential was lost, during the 1920s and 1930s, due to the reduction of 'Marxism' to a science of bureau-cratically managed labour, and to the triumph of the commodity. Since then, culture had entered a period of stagnation, due to the arrest of that stifled development (hence the notion of cultural 'decomposition'). This could only be remedied through the unification of art and life via the con-struction of situations, and through the revolutionary inauguration of an entirely new mode of social existence: one in which 'everyone', as the SI later put it, 'will be a Situationist'.[6]

These early ideas are characterised by an enthusiasm for movement, change, and the enrichment and invigoration of lived time. In addition, they are also marked by an antipathy to social formations that tend to arrest or stifle such dynamism, and which lock lived experience into stan-dardised patterns of behaviour (according to Debord, the construction of situations would replace a mode of life made up of experiences and inter-actions that 'are so undifferentiated and so dull that they give the definite impression of sameness').[7] In this regard, they form the basis for Debord and the SI's later, and overtly Hegelian-Marxian, critique of 'spectacular' society.

It would be a mistake, however, to contend that these ideas actually stemmed from Hegel, or that they descended directly from Marx. Instead, they grew from Debord's early engagements with the legacy of Surrealism, and from his participation in the Parisian avant-garde of the 1950s. Yet even so, there is a Hegelian current running through this material.

The Surrealists had been fascinated with change, transformation and the supersession of divisions (chiefly, the division between dream and reality, but also that between art and life). These interests had led them towards Hegelian philosophy.[8] This is because Hegel's work was construed, within the French tradition, as a philosophy of *change*. As we shall see later, Hegel was seen to have offered a philosophy that contained, within an osten-sibly conservative shell, a peculiarly *mobile* mode of thought that stood opposed to any form of arrest,[9] and which offered a means of thinking the dissolution of fixed divisions and boundaries (an assessment that was bolstered by its proximity to Marx's own diagnosis of Hegel's work).[10] We

can contend, then, that there were tacit Hegelian ingredients – or, at the very least, material that was inherently suited to later Hegelian development – within the SI's founding concepts.

This compatibility with Hegelian ideas was exacerbated by the importance of temporality to Debord and the SI's ideas. Partly due to the general ambience and influence of existential philosophy in France, Debord's interest in the construction of situations, and in dynamic change, was closely tied to ideas about temporal experience (see chapter 11). These ideas were particularly suited to French Hegelianism's characteristic emphasis on temporality and self-constitutive activity, and thus amenable to the reformulations that they would undergo in the group's second phase.

The origins of the SI's second period can be discerned in the beginnings of Debord's mature theoretical work. When using the term 'mature', I mean to indicate the material that he produced from the late 1950s onwards, which is when he began to engage seriously with Hegel and a Hegelian Marx. Two of the major influences that informed this new orientation were Lukács' *History and Class Consciousness* (which had begun to appear in partial French translation from 1957 onwards),[11] and Debord's short-lived friendship with Henri Lefebvre (a relationship that ran from 1960 to 1962, although Debord certainly read Lefebvre's work before 1960). Like Lukács, Debord developed a version of Hegelian Marxism that emphasised history, change, and movement in time; and like Lefebvre, he did so while remaining close to elements of both Surrealism and Romanticism. The new conceptual framework that this afforded would form the foundation for his theoretical claims throughout the rest of his life. It allowed the elaboration of his own and the SI's earlier avant-garde ideas about temporal movement and experience, and it brought greater clarity and urgency to the more militant aspects of those ideas.

That increased militancy was due to Debord's arrival at a conceptual position that entailed fierce critical opposition to all instances wherein social processes become frozen into fixed, static formations. This position emerged from a synthesis of several key influences. First, it drew on existential philosophy's emphasis on self-constitutive activity in time. Secondly, it developed that notion of self-creation through Hegel's emphasis on the transformative and historical dimensions of such activity. And, thirdly, it conceived the ability of human agents to conduct such activity through Debord's reading of Marx's early Hegelian writings.[12] Marx's early work contends that the social relations of a given society generate its collective power to act, and to determine its own future. It also

points out that flawed social relations can alienate their inhabitants from the capacity to direct their collective powers coherently, collaboratively and self-consciously. Taken together, these three lines of influence (Existentialism, Hegel and Marx) fostered a view of human temporality and social existence that had clear political implications. These implications can be schematised as follows: (a) human beings are temporal and social creatures; (b) their capacity to govern and direct their own lived time is determined by the social structures that they inhabit; (c) their freedom, *qua* self-determinacy, thus requires social formations that allow them to direct their own lived time freely and self-consciously. This entails that (d) social structures that undermine collective self-determinacy, and which involve modes of domination, must undermine the ability of these human agents to direct their own lived time. But because those social structures are themselves the products of social activity, such instances of domination amount to (e) the subordination of human agents to concentrations of their own collective power. When this occurs, these agents become (f) mere 'contemplative' observers of their own collective existence, insofar as they merely play out roles and patterns of behaviour that suit the needs of such bodies of power.

These ideas would receive their clearest expression in 1967's *The Society of the Spectacle*, which describes a society that has become completely characterised by this problematic, due to its total domination by the social forms of capital (we should note here that Debord once remarked, in a letter to a reader of that book, that 'one cannot fully comprehend' its claims 'without Marx, and especially Hegel').[13]

The Society of the Spectacle is perhaps best understood as an account of a society that has become separated from its own history. This is because when Debord uses the term 'history', as he so often does in his mature theory, he is not just referring to the discipline of studying the past. Instead, 'history', in his usage, tends to mean a self-conscious awareness of actions and experiences in time. 'History', in other words, is something that is to be *made* through future-oriented activity. The problem posed by spectacular society is that it effaces and undermines that possibility. Yet while *The Society of the Spectacle* is by far the most important and definitive version of this idea, its beginnings were already apparent in the early 1960s (Debord had, in fact, been using the term 'spectacle' since the mid-1950s, but the concept only really began to fully cohere around 1960).[14] As he put it in 1961:

History (the transformation of reality) cannot presently be used in everyday life because the people who live that everyday life are the product of a history over which they have no control. It is of course they themselves who make this history, but they do not make it freely or consciously.[15]

During the 1960s – and thus during the second phase of the group's activities – the SI as a whole became increasingly centred around the theory of spectacle's diagnoses and prescriptions. Yet Hegel is also relevant to the third period of Situationist activity that Debord announced in 1968: that in which the group's ideas would leave the theoretical underground, and begin 'appearing in the streets'.

The Hegelian aspects of the ideas involved here are discussed in chapter 17, which discusses the SI's idiosyncratic interpretation of Marx's remarks concerning the 'realisation of philosophy'. Here, we should simply note two primary issues. First, the need to unite theory and practice in a condition of praxis is a central feature of the Hegelian-Marxian tradition that Debord's work draws upon. Secondly, Hegelian philosophy not only informed Debord's theoretical views concerning the *need* for such praxis: in addition, it also influenced his ideas about the actual *conduct* of such praxis. For Debord, part of the salience of Hegel's 'dialectical' philosophy lay in its ability to think change and conflict in time. This, incidentally, is why Debord's Hegelian Marxism is so closely connected to his interest in strategy (he in fact once remarked that 'to think dialectically and to think strategically' is 'the same thing').[16]

To sum up: all of the aspects of Hegel's influence that we have touched on so far have one common theme: Hegel, for Debord – and, by extension, for the SI – offered a means of thinking historical change, and of theorising the collective agency that creates such change. This view of Hegel's philosophy was very much informed by the French intellectual context of the time.

Hegel and the Young Marx in France

Debord's and the SI's engagement with Hegelian philosophy was heavily inflected by the lasting impact of debates that took place in the early twentieth century. In 1935,[17] the young Marx's overtly Hegelian *Economic and Philosophic Manuscripts of 1844* had appeared in French (this is a text in which Marx set out some of the ideas that I referred to above). The

Manuscripts' concerns with alienation and collective historical agency fostered the idea that the young Marx's work might be characterised by a youthful, romantic, and decidedly Hegelian spirit that had become lost, to a degree, in Marx's later writings. The view thus developed that a young, Hegelian Marx might contain – or at least afford insight into – the radical core of Marx's later, more 'scientific', writings. This supposition was given further impetus and interest by the degree to which Marx's early account of alienated labour seemed to challenge the bureaucratically managed labour of the USSR,[18] and by the Party's general wariness towards Hegel.

Attention was also being paid, at this time, to Hegel's own newly published early writings.[19] Here too, commentators explored the idea that these early texts might contain a degree of vitality and energy that had become obscured in Hegel's later work. Hegel's early texts are marked by a decidedly romantic emphasis on 'life', 'love' and dialectical movement, and they place such movement in opposition to fixed, static forms. The suspicion thus developed that this same dynamism might not only underlie, but could even challenge and threaten the austere finality of Hegel's own mature philosophy. This interest was coupled to a more general trend, in France, towards focusing on Hegel's *Phenomenology* and *Philosophy of History*, rather than on his *Science of Logic*, or indeed the seemingly totalising 'system' presented in his *Encyclopaedia of the Philosophical Sciences*. French Hegelianism became marked by an interest in setting the continual, 'negative' 'unrest' experienced by consciousness in the *Phenomenology*, and the unfolding dilemmas and struggles of the *Philosophy of History*, against the apparent finality and conclusion of the Hegelian system.

By the 1950s, the general prominence of Hegelian, Marxian and existential ideas had provoked a reaction. The most relevant element of this reaction was Althusser's desire to purge Marxism of Hegel and humanism. The position adopted by Debord and the SI during the late 1950s and 1960s stood in sharp opposition to Althusserianism[20] (Debord's remarks on the 'frigid dream of structuralism'[21] should be read in this light, and so too should his more general comments on the errors of treating Marx's work as a 'science').[22] It also contrasted with post-structuralism's own subsequent antipathies towards Hegel and Marx.

We can contend, then, that Debord's and the SI's relation to Hegel was informed by the following factors: first, a romantic, existential and *Phenomenology*-centric reading of Hegel was still in the air in France; secondly, so too was the idea that a young Hegelian Marx might carry an

implicit critique of the official, bureaucratic Marxism of the USSR; and, thirdly, the attractiveness of such material was amplified by the degree to which it also ran counter to the academic fashions of the day. The SI's turn towards a romantic and Hegelian Marx was thus closely linked to their turn away from both academia and the Marxism of the Party.

We should now look at some of the technicalities of Debord's and the SI's use of Hegel. Before we can do so, however, I shall sketch out a general overview of Hegel's central claims, while foregrounding aspects that are of particular relevance. I hope that this will not seem too didactic; and I hope that it will also be understood that it is certainly not intended to function as a definitive statement about the nature of Hegel's work. My aim is simply to outline a version of Hegel's work that will help us to make more sense of its connection to the SI's claims.

Hegel's philosophy

One of the central motifs of Hegel's metaphysics is the relation between subject (associated with thought, experience and agency) and object (associated with the object of consciousness, that is, the thing that one thinks about and consciously acts upon). The way in which he uses this terminology can be introduced by thinking about ourselves. We are both subject and object at the same time: we are experiential agents (subjects), but we are also physical entities in the world (objects). This idea is closely connected to Hegel's conception of self-consciousness. I am self-conscious insofar as I, as a subject, take myself as the object that I consciously think about and know. Likewise, I am free when I, as a subject, direct and determine my own objective existence. By extension, I suffer a lack of freedom when my ability to determine my own affairs is undermined (perhaps because I inhabit social relations in which my agency is dominated and restricted by others in some way). Freedom and self-consciousness are closely connected for Hegel, because one cannot fully determine oneself if one does not understand one's own objective existence (for example, if I have a distorted view of my own circumstances and so on).

Armed with this terminology, we can now begin to address Hegel's formidable metaphysics; and perhaps the best way to introduce the latter's scope is by way of two simple observations. We human beings are part of the universe; we are also conscious of the universe. It seems possible to propose, therefore, that in some very minimal and restricted sense, the universe becomes conscious of itself through us: *being* becomes aware

of itself through *human* beings. Hegel's metaphysics, traditionally under-stood, offers a highly sophisticated version of that simple contention. It does so because it presents reality itself as both subject and object at the same time.

In Hegel's philosophy, the universe (*qua* subject) becomes aware of itself (*qua* object) through the mediation of human subjects, who take themselves, and ultimately the nature of being as a whole, as their object of enquiry. Because we human subjects are elements of the universe, there is a strong sense, for Hegel, in which the universe is really attaining an understanding of itself through us. Remarks such as these can, however, be misleading. Hegel is not saying that the universe is some sort of self-aware person. Instead, he is really concerned with *reason*.

Hegel holds that, despite their ostensible distinction, subject and object share an essential identity. This is because reason, for Hegel, does not just exist in our minds. Instead, it is the very fabric of reality itself ('nature', he writes, 'is an embodiment of reason',[23] as 'reason is the substance of the universe').[24] Or, to phrase this using more appropriate terms: Hegel thinks that being has a fundamental rational structure, and he uses 'being' to refer not only to objective reality, but also to the being of thought (because thought, after all, 'is' in some sense). This entails a conception of reason that can seem rather close to a kind of pantheism: for just as a pantheistic God exists throughout all being, so too does Hegelian reason. Hegel calls this 'God' the 'Absolute'.

The Absolute is a strange concept, and its peculiarity is closely connected to that of Hegel's idea of reason. In Hegel's view, reason is not a static structure (it is not, for example, just a fixed system of rules). Instead, it is inherently *mobile*. For Hegel, every positive identity (for example, 'A') is always linked to negative difference ('A' can only be positively identified as 'A' through its negative distinction from 'B'). Moreover, static, positive identities (for example, this particular idea or object) always exist in a constant, negative process of becoming (ideas and objects change, pass away, and give rise to new formations).

Now, if the Absolute is reason, and if reason is characterised by this continual, 'negative' movement, then the Absolute must itself be in constant motion; and if the Absolute is the structure of being, then reality itself must be in continual flux. Hegel's account of reason is, therefore, an account of the 'logic' that drives a changing universe.

This means that understanding reason entails grasping the dynamism of existence itself. Furthermore, if reason is dynamic – if it determines itself

to change and develop, and to take on new forms, according to its own intrinsic rationale – then it is, in Hegel's view, a kind of subject (because 'subjecthood', for Hegel, is associated with freedom and self-determinacy). The Absolute, then, is both subject and object at the same time. It is a fundamental logic (subject) that determines itself to take objective form as concrete reality (object). In doing so, it generates *human* subjects (objective instantiations of this logic); and according to Hegel, we human subjects, as rational agents, have determined ourselves, throughout the course of the history of the world, to a point at which we have finally become capable of taking the true nature of reason itself as our object of philosophical enquiry. By grasping that ultimate object, the human subject realises its fundamental identity with the generative power that drives reality itself, and thus sees that subject and object are truly one (in effect: we realise that we are one with 'God'). Hegel's own philosophy purports to offer just such an understanding; but in order to explain this, we need to turn to his philosophy of history.

Like Debord and the young Marx, Hegel does not think that there is any such thing as a fixed human nature. In his view, we are continually engaged in acting upon the world, and through doing so, we continually change both our environment and our own selves. Such changes take place in time. In consequence, he holds that we are fundamentally historical creatures: to know ourselves is to know our own history.

Hegel also holds that the ways in which we think and act are always articulated by the social structures of the societies and cultures that we create and inhabit. These shared structures are the patterns of thought, belief, and behaviour that articulate any given culture's collective life. Human history, for Hegel, is thus composed of a variety of such modes of thought and action, all of which are tied to particular societies and particular contexts. The term that Hegel uses to describe these changing patterns of thought and social activity is 'Spirit' (*Geist*: a term that is sometimes translated as 'mind'). All of the forms of Spirit that have existed throughout history are moments of the 'World Spirit' (*Weltgeist*), which is perhaps best thought of as human historical existence in general – albeit understood as a single overarching subject whose instantiations are the particular cultures and civilisations of the world. Just as our individual lives are moments of the particular Spiritual community that we inhabit, so too, on the grand scale, are such Spiritual formations moments of the World Spirit.

Every form of Spirit is composed of a set of conceptual and practical norms which serve to render a community's world and action intelligible to its members, and which thus structure that community's culture and interactions. This is because Spirit – in keeping with the metaphysics outlined above – is essentially *reason*; and as we also saw above, history, for Hegel, has been a path towards greater political instantiations and philosophical comprehensions of reason. This path is not conceived as some kind of smooth, effortless elevator towards greater rationality. Reason, for Hegel, develops and moves through negation and contradiction. In history, this takes the form of conflict and struggle (Hegel in fact describes history as the 'slaughter-bench at which the happiness of peoples' has been sacrificed).[25] Yet order slowly emerges through the chaos and confusion, and Hegel thinks that it is legitimate to compare societies along the route. Some societies, to put it very bluntly, can be seen, from Hegel's perspective, to be 'better' than others. This is because they have afforded clearer and more effective instantiations of reason. In doing so, they have provided greater degrees of *freedom* to their citizens.

Hegel associates greater rationality with greater freedom because he thinks that we use reason, via the social structures of Spirit, to order our affairs. The more rational those structures become, the more we – as rational agents – are able to determine ourselves according to our own rational nature. This allows *self*-determinacy, and thus freedom (as opposed to the *un*freedom which Hegel associates with external determination). And because these structures are social and interpersonal, the freedom at stake here must be a kind of *collective* self-determination. Such freedom would not be afforded by structures that involve the subordination of particular individuals to external dictates from other particular individuals, or indeed by circumstances in which many such individuals are dominated by the shared social formations that they create and inhabit. They must, in consequence, provide a unification of the universal (the social whole) with the particular (individual agents) via the creation of a context in which the operation and organisation of the former arises organically from the free actions and interactions of the latter. This would amount to 'the embodiment of rational freedom'[26] in a genuinely rational political state.

Hegel's philosophy of history describes Spirit as having struggled, throughout the past, towards the creation of such a state of affairs; and while there are grounds to dispute this view,[27] he is often understood to have seen the bourgeois society of his own day as embodying this con-

ception of rational freedom (Debord certainly read him in this way). Bourgeois society is thus located at the apex of Spirit's labours, or is at least cast as having come sufficiently close to that apex as to enable Hegel's philosophical claims.

Spirit has three primary elements: art, religion and philosophy. In Hegel's view, all three are means by which a culture expresses what it deems and determines to be true about human life. All three, therefore, have one common object; and, by extension, they have all addressed that same object throughout history. All have offered variously blurry and confused intimations of the one fundamental truth that Spirit has always been fumbling towards: namely, the God-like reason of the Absolute. And because philosophy is the clearest of these modes of thought, the philosophy that emerges at the apex of Spirit's historical labours is, in effect, the *final* philosophy, because it grasps the Absolute in its truth. Hegel, with seemingly outrageous presumption, appears to have cast his own philosophy as affording this insight.

I shall return to that rather vexed notion of finality shortly. First, however, we should connect the ideas described here to Debord and the SI's work.

Subjects and objects

As I hope to have indicated, Hegel's philosophy revolves around the idea of a conscious subject slowly coming to realise that the object that it had misrecognised as an independent other is, in truth, its own self. Subject and object are one, although they initially appear as distinct. This separation entails forms of *representation*, because Spirit finds itself confronted with 'picture thoughts' (*Vorstellungen*) of the deeper truth accessed via philosophy (for example, religious depictions of God are *Vorstellungen* of the Absolute). The basic problematic of Debord's mature concept of spectacle is a Hegelian conception of the separation of subject from object, articulated via just such a notion of representation (and *Vorstellung*, we might add, was translated as *représentation* in the translation of the *Phenomenology* that Debord used).[28] This is phrased, in Debord's work, in terms of the separation of human agents (subject) from their own objective activity and collective power (object): a separation that arises when a collectivity fetishistically identifies its collective powers and capacities with its own constructs (such as God, kings, economic structures and so on), and then treats those constructs as independent locales of power. Thus, in effect,

the theory of spectacle refigures the Hegelian Absolute as the capacity of human agents to generate and direct their own history: a capacity that *appears* as a separate object, via distorted and misrecognised 'Spiritual' formations, but which is, in truth, an aspect of the subject that confronts and 'contemplates' it. Yet where Hegel supersedes such alienation through philosophical knowledge, the supersession of spectacular separation requires the revolutionary destruction of these fetishistic social constructs.

Like Hegel, Debord and the SI presented the possibility of actualising such freedom as historically contextual, and as the product of a long history of struggle and development. I have argued that the basic problematic of spectacle is the subordination of human agents to alienated concentrations of their own collective power. Quite clearly, this issue is not restricted to capitalist society alone. In fact, Debord explicitly identifies forms of spectacular separation throughout the past: 'all separate power', he claimed, 'has been spectacular',[29] and when developing this point in his letters, he traced this problematic all the way back to classical antiquity.[30] This problematic, however, was held to have reached an identifiable and resolvable extreme within the SI's era due to the 'complete colonisation of social life'[31] by the commodity. Modern society was thus presented as a moment that had brought to the fore a predicament that had been present throughout the past. This can be explained by returning to Debord's existential-Hegelian preoccupation with temporality.

Like Hegel and the young Marx, Debord understood humanity's capability for self-determinacy to have been instantiated in more or less adequate ways in differing socio-historical circumstances. The 'temporalization of humanity', Debord writes (that is, the way in which time, history and the potential for the latter's creation is understood), is always 'brought about through the mediation of a society',[32] and different societies, in his view, have afforded their citizens differing levels of awareness of their ability to shape their own temporal experience (the correspondence with Hegel's philosophy of history should be readily apparent). *The Society of the Spectacle* traces a succession of these social formations throughout the past, beginning with the earliest human communities, and progressing all the way up to Debord's present.[33] In doing so, it argues that humanity's ability to shape its own existence has grown enormously throughout the past because it has been gradually augmented by a host of technological and cultural developments. Debord also contends, however, that the possibility of consciously directing that ability has become increasingly removed from its producers. This narrative serves to frame Debord's own

society as a grand revolutionary crux, located at the apex of this line of developing power: as a point at which humanity's power to shape its own history is both greater and more alienated than at any other time in the past (or, as he puts it: 'people [...] produce every detail of their world with ever-increasing power'; yet the 'closer their life comes to being their own creation, the more they are excluded from that life').[34] The society of the spectacle, in other words, had brought the long-standing problematic of spectacle to its full, identifiable – and potentially resolvable – expression. From this perspective, the task of the modern revolution, and the manner in which it must correct and go beyond the efforts of the past, stood clearly revealed: for it could now be seen that this task was not just the reclamation of the means of production, as in traditional Marxism, and that it could not be reduced to a demand for more equal distribution, as in so many of the struggles of the past. Instead, it had become a demand to take possession of the means of producing *life itself*. 'Historical time', to quote one of Debord's letters, was thus revealed to be 'both the milieu and goal of the proletarian revolution'.[35]

These issues bear a direct relation to the conception of revolution that the SI began to advance during the early 1960s. The modern proletariat, they claimed, were not simply those who had been separated from the means of independently maintaining their own existence, as had been the case for Marx. Instead, the 'new', modern, proletariat was composed of all those within modern society who have been separated from the means of independently *directing* their existence: all those who, 'regardless of variations in their degree of affluence',[36] have 'no possibility of altering the social space-time that society allots to them'.[37] Contemporary revolutionary struggle was thus envisaged as a demand, on the part of all who were thus 'estranged from history', to actually '*live* the historical time' that their social activity enables.[38]

This serves to illustrate the ways in which Hegelian and Marxian ideas refigured the SI's earlier concept of the constructed situation. The ambitions associated with the latter had given rise to a vision of 'communism' that amounted to a condition of free, collective historical self-determinacy. And this condition was clearly conceived as a form of subject-object unity: for it was described as a condition in which 'the subject of history' (humanity, albeit a humanity that had been brought to this level by the agency of the 'new' proletariat) would have 'no goal [*n'as pas d'objet*] other than the effects it works upon itself', and would thus 'exist as consciousness of its own activity [*conscience de son jeu*]'.[39]

But is it not possible to identify a contradiction here, or at least a tension of some sort? As we saw above, in Hegel's philosophy, subject-object unity can seem to be associated with finality, resolution, and the conclusion to Spirit's historical labours. Debord and the SI, on the other hand, appear to have refigured such unity as the ground of an open future. This, I will now argue, was informed by their engagement with the French reception of Hegel's work.

French Hegelianism

Debord once described Hegel as having adopted a 'paradoxical stance'.[40] On the one hand, his philosophy is ostensibly conservative, and seems to endorse the Western 'bourgeois' state. It presents itself as a 'final' philosophy that indicates – by the very fact of its existence – that Spirit's historical labours have reached, or have at least approached, their final culmination. Yet on the other hand, it is also a philosophy of change, transformation, and constant movement. It describes constant, restless movement, but seems to lock that movement into a philosophical system that appears to bring history to a close.

The identification of such a 'paradox' has led many writers to try to extract this dynamism from the system in which it is housed. This is typically attempted by rejecting or deferring the conclusive subject-object unity that closes that movement (examples could include Adorno, Bataille or Lefebvre). In marked contrast, however, Debord and the SI's position appears to involve reframing that figure of arrest (subject-object unity) as a condition of permanent, self-determinate movement.

This means that their ideas bear another strong resemblance to Lukács' *History and Class Consciousness*. For Lukács, the proletariat, *qua* subject, must come to recognise that the seemingly independent and immutable objective social world that confronts it – and indeed its own objective situation within that world – is really the result of its own collective activity. By taking itself as its own object, the proletariat could then comprehend its own agency, and recognise that its social world is susceptible to alteration through that agency. Lukács' book thus describes the supersession of a state of alienation (that is, the proletariat's separation from the results of its own activity) via the emergence of a condition of self-determinacy, through which the proletariat becomes the 'identical subject-object of history',[41] that is, the self-conscious, subjective author of its own objective historical existence.

As we have seen, Debord's position in works such as *The Society of the Spectacle* is very close to this view, although it departs from Lukács' justification of the Party, and from his comparatively traditional notion of class (in place of a centralised Party, the SI advocated workers' councils; and in place of a traditional notion of class emancipation, their concerns centred around the existential poverty of the 'new' proletariat). His adoption of this model was, however, also inflected by currents and echoes within the broader milieu of French Hegelianism.

These currents can be ordered here into three themes in French Hegelianism: (1) interpretations that place dialectical movement in opposition to Hegelian 'closure', and that do so by emphasising temporality and history; (2) interpretations that emphasise that 'closure' by stressing that Hegel declared history to have ended; and (3) interpretations that chime with Lukács' re-figuration of subject-object unity, and which present such unity not as the end of dialectical movement, but as its very ground.

Perhaps the most important figure in that first line of interpretations was Jean Wahl. Wahl's influential *Le Malheur de la conscience dans la philosophie de Hegel* of 1929 focused on the 'unhappy consciousness' described in Hegel's *Phenomenology*: a form of consciousness that exists in perpetual pursuit of a resolution that continually eludes it. Wahl's reading placed the unhappy consciousness at the centre of Hegel's book, and even indicated that the continual unrest that it exemplifies might threaten or undermine its final resolution. In doing so, Wahl's account laid 'Hegelian foundations', to quote Michael Kelly, for a 'nascent existentialist movement'[42] (indeed, Sartre would later remark that 'human reality' is 'by nature an unhappy consciousness').[43] Yet French Hegelianism not only informed existential philosophy: in addition, it was also influenced by it in return.

Heidegger's emphasis on the temporal dimensions of 'being' is significant here, and a strong Heideggerian current can certainly be found in the reading advanced by Alexandre Koyré. In 1934, and while building on Wahl's work, Koyré contended that the human experience of temporality necessarily undermined Hegel's apparent claims concerning history's conclusion. If 'time is dialectical and constructed *from out of the future*', Koyré wrote, then 'it is – whatever Hegel says – eternally unfinished'.[44] There is no clear evidence to show that Debord engaged with such claims directly, but it seems safe to contend that his ideas were informed by the continuing echoes of this material: for he too indicates, in a Hegelian-existential vein, that human temporality undermines any notion of historical finality.

The 'central aporia of the [Hegelian] system', he once remarked, is 'that time has not ended'.[45]

Debord's readiness to present Hegel as having declared such an end no doubt stemmed from the enormous influence that Alexandre Kojève had on the French reception of Hegel (again, there is no evidence to show that Debord engaged with Kojève directly, but his work would have been hard to avoid). During the 1930s, Kojève delivered a series of seminars at the École pratique des hautes études in which he presented a reading that drew heavily on both Heidegger and Marx's recently published early writings. This reading is largely responsible for the enormous importance accorded to the *Phenomenology*'s 'master and slave' relation within the continental tradition, and – above all – for the notion that Hegel had announced the 'end of history'. In essence, Kojève read the *Communist Manifesto*'s contention 'the history of all hitherto existing society is the history of class struggle'[46] into Hegel's philosophy of history, and then viewed that struggle through the relation between master and slave. On this idiosyncratic reading, history, so understood, comes to an end when that relation is resolved. The struggle towards that resolution is the work of reason in history, which reaches completion with the expression of a philosophy that truly grasps reason's historical nature. Hegel is thus viewed as having articulated the logic of historical movement, but also as having concluded that movement through the very enunciation of that logic.

The Hegel that Debord *criticises* in texts such as *The Society of the Spectacle* is certainly a Kojèveian figure (for example, 'in order to speak, [Hegel's philosophy] must presuppose' that 'history is already complete').[47] Yet the Hegelian themes that Debord *used* in his theoretical work stem from the work of two further Hegel commentators: Jean Hyppolite, and Kostas Papaïoannou. Debord attended Hyppolite's lectures, and owned several of his books. He also clearly read Papaïoannou, as he recommends one of the latter's texts on Hegel in his personal correspondence. So why were these two writers attractive?

First, Hyppolite's work had the virtue of stressing the sense in which Hegelian resolution is not an 'immobile synthesis',[48] but is instead properly conceived as a condition of continual motion and 'unrest'. The Absolute, according to Hyppolite, 'continually divides and tears itself apart',[49] and constitutes an 'inexhaustively creative activity'.[50] Consequently, subject-object unity means recognising that such creative power and potential is not the preserve of a distinct objective other (an external God, for example), but rather the truth of Spirit itself. Hyppolite's interpretation, therefore,

correctly describes Hegel's philosophy as having set out a permanent condition of perpetual change. As I have tried to show above, Debord can be read as having refigured that condition in socio-political terms, recasting it as the 'communism' that would be afforded by the supersession of spectacular separation. Something very similar can be found in Papaïoannou's work, which is perhaps why Debord endorsed it. For Papaïoannou, the full, self-conscious expression of the Absolute is a political project. The 'vehicle of the Absolute', he claims, is 'the people',[51] and he even talks of the 'communal work [*l'œuvre commune*] of the Absolute'.[52] Once again, this is very close to the position that I have ascribed to Debord.

We can conclude, then, with the following contentions. Hegel was a major influence on Debord's and the SI's work, albeit an influence that was filtered through Surrealism, the young Marx, Existentialism, and some of the primary currents in French Hegelianism. His philosophy greatly informs the theory of spectacle and, on the reading advanced here, a reworked version of his metaphysics forms the basic template for the SI's idiosyncratic identification of communism with the collective enrichment of lived historical time.

Notes

1. Karl Marx, *Early Writings*, trans. Tom Nairn (Middlesex: Penguin, 1975), p. 257.
2. Guy Debord, 'The Organization Question for the SI' (1968), in Situationist International, *Situationist International Anthology*, ed. and trans. Ken Knabb (Berkeley, CA: Bureau of Public Secrets, revised and expanded edition 2006), p. 382.
3. Ibid.
4. Ibid.
5. Guy Debord, Œuvres (Paris: Gallimard, 2006), p. 46.
6. SI, 'Manifeste', *International situationniste* (IS), no. 4 (June 1960): 37.
7. Debord, 'Report on the Construction of Situations', in *Situationist International Anthology*, p. 40.
8. Writers like André Breton and Georges Bataille are of particular significance here. For example, Breton once remarked that Surrealism took 'the "colossal abortion" of the Hegelian system' as its 'point of departure' (André Breton, 'The Second Manifesto of Surrealism', in Charles Harrison and Paul Wood [eds], *Art in Theory: 1900–1990* [Oxford: Blackwell, 1996], p. 447), and that 'it is Hegel whom we must question about how well-founded or ill-founded Surrealist activity in the arts is' (quoted in Bruce Baugh, *French Hegel: From Surrealism to Postmodernism* [New York: Routledge, 2003], p. 55).
9. Thus Breton: 'It seemed to me impossible to assign limits … to a thought [i.e. that of Hegel] definitively formed for negation and the negation of the negation' (quoted in Baugh, *French Hegel*, p. 56).

10. See Karl Marx, *Capital*, vol. 1, trans. Ben Fowkes (London: Penguin, 1976), p. 103.

11. *History and Class Consciousness* began to appear in French translation from 1957 onwards (Michael Kelly, *Hegel in France* [Birmingham: Birmingham Modern Languages Publications, 1992], pp. 99–100), but a complete translation of the book was not published until 1960.

12. This is an important point: when Debord's Hegelian Marxism is addressed, it is often assumed – largely due to the influence of contemporary theoretical enthusiasms – that his primary reference point was the Marx of *Capital*; yet as he himself acknowledged, almost all of the references to Marx in his most important theoretical work, *The Society of the Spectacle* (trans. Ken Knabb [Berkeley: Bureau of Public Secrets, 2014]), were taken from Marx's early writings (Guy Debord, *Correspondance*, vol. 4 [Paris: Arthème Fayard, 1999–2010], p. 140).

13. Ibid., p. 454.

14. Some of the first significant uses of the term can be found in Debord's 'Report on the Construction of Situations' of 1957, in *Situationist International Anthology*, p. 40, where it is employed as a means of denoting the failings of modern culture and entertainment. By 1960, however, it was being employed as a means of describing modern culture as a whole, see 'The Use of Free Time' (1960), in *Situationist International Anthology*, pp. 74–5; and by 1961, it had developed into the concept that would eventually be elaborated in 1967's *The Society of the Spectacle* (for example, 'modern capitalism ... organises the reduction of all social life to a spectacle' ('Instructions for an Insurrection', in *Situationist International Anthology*, p. 86).

15. SI, 'Perspectives for Conscious Changes in Everyday Life' (1961), in *Situationist International Anthology*, p. 93.

16. Bibliothèque nationale de France, NAF 28603, Notes de lecture; Stratégie, histoire militaire, Box 2; dossier 5; 'strat'; January 1977.

17. *The Economic and Philosophical Manuscripts of 1844* were published in German in 1932, but the text had been made available for consultation since 1927. Sections of the text appeared in French from 1929 onwards, and an edition that omitted the first manuscript was published in 1935. A full edition appeared in 1962.

18. For example, Henri Lefebvre, one of the initial translators of the *Manuscripts*, was careful to point out that 'we cannot confine the use of the concept of alienation to the study of bourgeois societies'; Henri Lefebvre, *Dialectical Materialism* (London: Jonathan Cape, 1968), p. 16.

19. Hegel's early theological writings were published in 1907, and his Jena manuscripts appeared in 1921, 1931, and 1932.

20. Guy Debord, *Correspondance*, vol. 7, p. 212.

21. Debord, *Spectacle*, thesis 202, p. 108.

22. See theses 80–90 in ibid., pp. 34–42.

23. Georg Wilhelm Friedrich Hegel, *The Philosophy of History* (New York: Dover Publications, 2004), p. 12.

24. Ibid., p. 9.

25. Ibid., p. 21.

26. Ibid., p. 47.
27. See Jon Stewart (ed.), *The Hegel Myths and Legends* (Evanston, IL: Northwestern University Press, 1996) for useful commentary.
28. Debord used Hyppolite's translation of the *Phenomenology* (Debord, *Correspondance*, vol. 4, p. 65).
29. Debord, *Spectacle*, thesis 25, p. 8. 'The root of the spectacle is that oldest of all social specializations, the specialization of power' (Debord, *Spectacle*, thesis 23, p. 18).
30. Debord, *Correspondance*, vol. 4, pp. 455–6.
31. Debord, *Spectacle*, thesis 41, p. 16. Translation changed.
32. Ibid., thesis 125, p. 68.
33. See Ibid., chapter 5.
34. Ibid., thesis 33, p. 11.
35. Debord, *Correspondance*, vol. 4, p. 79.
36. SI, 'Ideologies, Classes and the Domination of Nature', in *Situationist International Anthology*, p. 141.
37. Ibid.
38. Debord, *Spectacle*, thesis 143, p. 79. Emphasis in the original.
39. Ibid., thesis 74, p. 32. Translation changed.
40. Ibid., thesis 76, p. 33.
41. Georg Lukács, *History and Class Consciousness*, trans. Rodney Livingstone (London: Merlin, 1971), p. 197.
42. Kelly, *Hegel in France*, p. 33.
43. Jean-Paul Sartre, *Being and Nothingness*, trans. Hazel Barnes (London: Routledge, 2003), p. 114.
44. Alexandre Koyré, *Études d'histoire de la pensée philosophique* (Paris: Gallimard, 2006), pp. 188–9; see also Baugh, *French Hegel*, p. 27.
45. Debord, *Oeuvres*, p. 1536.
46. Karl Marx and Friedrich Engels, *The Communist Manifesto*, trans. Samuel Moore (London: Penguin, 2002), p. 79.
47. Debord, *Spectacle*, thesis 76, p. 33. Translation changed.
48. Jean Hyppolite, *Logic and Existence*, trans. Leonard Lawlor and Amit Sen (Albany: State University of New York Press, 1997), p. 183.
49. Jean Hyppolite, *Studies on Marx and Hegel*, trans. John O'Neill (London: Heinemann Educational Books, 1969), p. 7.
50. Jean Hyppolite, *Introduction to Hegel's Philosophy of History*, trans. Bond Harris and Jacqueline Spurlock (Gainesville, FL: University Press of Florida, 1996), p. 37; this phrase is taken from Hippolyte's comments on Hegel's early ideas about God.
51. Kostas Papaïoannou, *Hegel* (Paris: Société d'édition les belles lettres, 2012), p. 77.
52. Papaïoannou, *Hegel*, p. 88.

5

The Situationist International and the Rediscovery of the Revolutionary Workers' Movement

Anthony Hayes

When the Situationist International (SI) was established in July 1957 the primary aim of the Situationists was the experimental extension of previous cultural avant-gardes – notably the Dadaists and Surrealists – in a revolutionary-critical register. Rather than merely repeat or extend the formal artistic production of their predecessors, the Situationists proposed to 'utilize all the arts and modern techniques' in a new type of experimental activity.[1] This activity proposed to overcome the split between, on the one hand, the utopian desire of the Dadaists and Surrealists for a social order more conducive to artistic play, and on the other hand their tendency to become stuck in the impasse of the elaboration of artistic products (paintings, poems, literary works and so on). Thus, the SI proposed the 'hypothesis of the construction of situations' and its experimental verification by way of 'unitary urbanism'.[2] From the outset Situationists like Asger Jorn and Guy Debord posed such experimental activity as necessarily a moment of a broader contestation allied with, and evoking the need for, proletarian revolution. The new terrain marked out for the Situationist project was not simply that of an abstract cultural experimentation but, more pointedly, one of contesting the 'bourgeois idea of happiness' promulgated amidst the development and rapid expansion of consumer goods aimed at a working-class audience in the wake of the Second World War.[3] Identifying such a terrain as growing in significance, particularly as it appeared to some as an answer to the problem of the immiseration of workers, the Situationists further posed the need to engage in 'ideological action' aimed at combating the bourgeois idea of happiness among the

revolutionary left.[4] Indeed, the early SI's critique of the 'vast industrial sector of leisure', aimed at 'stupefying' and submitting the working class more thoroughly to the circuits of capital, would soon develop into their distinctive critique of work.[5]

Despite these first steps toward formulating a critique of orthodox conceptions of work and leisure in capitalist societies, the SI at its founding can be considered as holding to a variant of the 'orthodox' or 'traditional' Marxist conception of proletarian revolution.[6] As the historian Jean-François Martos mordantly noted some years later, the SI only 'eliminated the last traces of Trotskyist influence' by 1961.[7] Thus, in the founding 'Report on the Construction of Situations' (1957), Debord's critique of the 'workers states' of the East, albeit dominated by a 'profoundly distorted' conception of Marxism, was redolent of Trotsky's theory of the 'degenerated workers' states'.[8] Indeed, this orthodoxy was matched by the relative orthodoxy of the SI's conception of what constituted a cultural avant-garde. In the first issue of *Internationale situationniste*, Debord characterised the group as, 'a coalition of workers in an advanced sector of culture, or more precisely as a coalition of all those who demand the right to work that the present social conditions fetter; thus, as an attempt at organising professional revolutionaries in culture'.[9] Such a conception was little more than a reassertion of similar proclamations by the Surrealists, particularly after the latter group's break with Stalinism in 1935.[10] Where the SI differed from its predecessors was the way it conceptualised the artistic means to be used and the goal aimed at. The question was not so much one of extending the notion of what constituted art but rather one of using any and all artistic means to the end of charting a beyond to capitalist and artistic alienation – embodied in the 'hypothesis of constructed situations'.

* * *

Nonetheless, the transformation of the SI into the self-proclaimed 'new type' of revolutionary organisation began almost from the inception of the group – though this transformation became retrospectively clearer between 1960 and 1962.[11] Two main pivots helped to propel the SI along this path. First, there was an internal dispute, initiated by Constant Nieuwenhuys, over what should constitute the chief focus of present Situationist activity. Although this dispute initially revolved around the question of what role the 'traditional arts' should play in Situationist experimentation, it soon developed into Constant and other members of the Dutch section of the SI calling into question the present possibility of a proletarian, anti-capitalist

revolution.[12] Indeed, and despite the effective impasse in 'unitary urbanist' experimentation with the resignation of Constant in June 1960, the resolution of the question of the role of art, and the SI's relationship to the present possibility of proletarian revolution would not be finally resolved until the first quarter of 1962.[13]

It was, however, another process – by no means completely separate from the internal dispute regarding art – that would have more far reaching impact upon the group's future direction. In May 1958, on the verge of the SI publishing the first issue of its journal, military leaders in Algeria staged a coup against the civil authorities there, further threatening metropolitan France with military action.[14] This coup led directly to the end of the Fourth Republic and the accession of General de Gaulle to the presidency of a new, Fifth Republic. Of significance for the SI and indeed for the fate of proletarian contestation in France and elsewhere, was the almost complete absence of an autonomous working-class opposition to the coup. Certainly, there was the beginning of a mass opposition, as witnessed by the 'anti-fascist' mobilisations and the demonstration of around 200,000 in Paris on 28 May.[15] But a concerted effort to organise opposition outside of parliament was undermined by the paralysing political compromises and vacillation of the French Communist Party (PCF) and its affiliated trade union confederation, the CGT.[16] The SI's initial assessment of May 1958 did not go beyond a Trotskyist analysis.[17] The chief problem identified was the question of revolutionary leadership and the inability of the Stalinists to provide it.[18] In their follow up, published in the second issue of *Internationale situationniste* (December 1958), the SI was still concerned with the relationship between the proletariat and its 'leadership', and the inability of the former to exert pressure upon its erstwhile parliamentary representation.[19] However, it was their assessment of what was lacking in the response of their anti-Stalinist contemporaries – and indeed what these erstwhile critics shared with not only the Stalinists but the vast bulk of bourgeois politics – that the SI sketched a vision of their future. In short, they charged these comrades with sharing a bourgeois conception of the 'good life', namely that the poverty of everyday life was simply a question of the amelioration of material want in its mundane sense (along with the expansion of 'leisure-time' away from work).[20] As the SI would later phrase this, '[t]here is no revolutionary problem of leisure, of an emptiness to be filled, but a problem of free time – of freedom all the time'.[21]

It was precisely this questioning of the everyday nature of the revolutionary project, and its coincidence with the ambitious project of

experimenting with the 'hypothesis of the constructed situation', that would bring the SI – and Guy Debord in particular – into contact with the Socialisme ou Barbarie group (SB). SB had its origins in the French Trotskyist movement of the immediate post-war period. Cornelius Castoriadis and Claude Lefort had formed an oppositional tendency in the Trotskyist Parti Communiste Internationale (PCI) in 1946, based largely on Castoriadis' developing critique of the nature of the Soviet Union. Castoriadis, a young Trotskyist militant from Greece, had become increasingly disillusioned with the official Trotskyist critique of the Soviet Union and Stalinism. Lefort, a young Trotskyist and philosophy student in France, had rallied to Castoriadis' perspective shortly after the latter had escaped from Greece to France in late 1945.[22] By 1948 Castoriadis and Lefort had decided to exit the PCI, and early the following year their faction now constituted a separate Marxist organisation.[23] Key to their split from the PCI was the rejection of Trotsky's belief that the Soviet bureaucracy was merely a parasitic layer superimposed upon the USSR's socialist economic base.[24]

In an early article – appropriately entitled 'Socialisme ou barbarie' – Castoriadis outlined a distinctive critique which would remain with the group to its end. He argued that a counter-revolution had taken place in the Soviet Union such that a new 'exploiting stratum' had arisen – the bureaucracy – overseeing the collective exploitation of the Russian proletariat in the interests of the bureaucratic management of Soviet society.[25] Further, Castoriadis believed that the process of bureaucratisation was itself the result of a longer term tendency in capitalism and the class struggle.[26] On the one hand, capital had tended toward greater concentration and bureaucratisation since the nineteenth century. On the other hand, the struggle of the working class against capitalist exploitation – to the extent that its revolutionary impetus was defeated – tended to be adapted to the exigencies of the emerging bureaucratisation of capitalist life. Witness the partial realisation of nineteenth-century working-class demands for the 'nationalisation of the means of production and exchange, economic planning and the coordination of production on an international scale', not only in the Soviet East, but increasingly in the war-time and post-war 'welfare' capitalism of the West.[27] Most significantly, Castoriadis argued that the development of bureaucratic means, particularly the transformation and suspension of private ownership via nationalised and corporate forms of ownership, had tended to supplant the hierarchy of capitalist and worker with that of the bureaucratic 'directors' (*dirigeants*) and 'executants' (*exécutants*) of production (often both salaried, but with markedly

different wage rates and also different relationships to the means and process of production).[28] Such a development posed more clearly the potential for workers to directly take over the management of production, insofar as this division was itself a refinement of capital's need to simultaneously solicit and block the active participation of workers in production. The revolutionary solution to such Castoriadis called 'worker's management of production', but later more pointedly the 'self-management of production' (*autogestion*).[29] Indeed, SB's early embrace and emphasis of working-class self-management of production brought them closer to a council communist perspective.

Despite the patently councilist perspective of self-management, the majority of SB continued to hold to a vanguardist conception of political organisation, that owed its lineage to the Trotskyism the group had in large part thrown off. Indeed, this tension became the subject of a brief discussion between Castoriadis and the ageing Dutch council communist, Anton Pannekoek. Pannekoek had been a central figure of council communism when it vied with Bolshevism for the soul of the revolutionary proletarian movement that had emerged in the wake of the Russian and German Revolutions of 1917 and 1918.[30] Alerted to the significance of SB's critique by Cajo Brendel, Pannekoek, in a series of letters, urged Castoriadis to fully embrace a 'councilist' perspective by rejecting the lingering vanguardism which SB subscribed to.[31] Pannekoek and Brendel's intervention at this point – 1953 – failed. Nonetheless, SB was far from being united over the question of vanguardism. For instance, Claude Lefort came to embody the more anarchistic and 'spontaneist' perspective of the councilists against Castoriadis' political Trotskyism. Indeed, Lefort and Henri Simon would lead a split in late 1958 that led to the formation of the Informations et correspondances ouvrières (ICO) group, as a direct consequence of disagreements over the group's practice during the May 1958 crisis.[32] Debord and the SI would later come to reject both alternatives. Whereas they would broadly sympathise with the 'councilists' of ICO, they rejected the group's conflation of revolutionary organisation with the alienation and authoritarianism implicit in the Trotskyist model.[33]

Both the SI and SB were challenged by the May crisis of 1958 and its aftermath. As a direct consequence, by the end of 1959 Debord would repudiate the Trotskyist idea of an existing revolutionary movement (albeit 'degenerated' or 'deformed').[34] At the same time, Castoriadis turned to formulating his critique of the 'de-politicisation' and 'privatisation' of the working class as an explanation for not only the absence of a mass

working-class opposition in May but also the almost complete absence of a mass, popular opposition to the French state's brutal war in Algeria.[35] A first sketch of Castoriadis' theory was published in a SB internal bulletin in 1959;[36] but it was its longer elaboration, 'Modern Capitalism and Revolution', published between December 1960 and December 1961 over three issues of the journal that would more controversially cement it.[37] Certainly, the changes in the SB group after the May crisis in part contributed to the SI becoming more receptive to the group. But it was the fortuitous contact and resulting friendship of two members of both groups which helped to cement a brief confluence.

Sometime toward the end of 1959, or the beginning of 1960, Debord met the 'social-barbarian' Daniel Blanchard.[38] Over the following months, Debord and Blanchard collaborated on a document, grandly entitled 'Preliminaries Toward Defining a Unitary Revolutionary Program' (hereafter 'Preliminaries'), which attempted to bring the core ideas of the SI and SB into a fruitful communion. For instance, the Situationist conception of the 'spectacle', replete with its division of modern life into 'actors' and passive 'spectators' was made functionally equivalent to the 'directors' and 'executants' of SB.[39] Nonetheless, the document betrays a certain tension between the SI and SB. In contrast to SB's orthodox conception that it is work itself that is the distorted and alienated essence of the human, Debord was beginning to more clearly pose that the *spectacular* representations of life – whether as work or leisure – were crucial to understanding the modern structures of alienation.[40]

Shortly after the publication of 'Preliminaries', Debord joined the SB associated political organisation Pouvoir Ouvrier (PO) sometime in the autumn of 1960. Debord would participate in all of the mundane glory of the political militant while a member, which no doubt contributed to his later criticisms of political militancy.[41] Most significantly, for the future direction of the SI, he participated in an SB-organised trip to Belgium, alongside Castoriadis and other comrades, shortly after the general strike over the winter of 1960–61 (more popularly known as Hiver '60). At the end of 1960 the Belgian government attempted to introduce what would now be called an austerity programme: the 'loi unique'. This legislation promised sweeping cuts to the public service, new taxes aimed at the working class, and cuts to the state pension coupled with a rise in retirement age. In the face of a parliamentary left which downplayed the political and economic nature of these 'reforms', as well as the very limited and tightly controlled industrial action organised by the national

trade union confederation, a wildcat general strike broke out. Very quickly the strike spread and developed an insurrectionary character.[42] The ostensible cause – the 'loi unique' – was forgotten amidst the establishment of strike committees and confrontation with the official left and trade union movement. Perhaps most striking of all, and commented upon by many participants and observers, was the way the rebellious and festive nature of the strike overflowed the purely economic concerns which sparked it. Considering the extent of this wildcat general strike – 700,000 on strike six days after its inception – the official left worked hard to rein it in. The national trade union confederation gave ground to those members agitating for leadership of the strike and, from the day after the high point, the wildcat was incrementally taken control of by the national trade union confederation. In little more than three weeks the potential for a revolutionary insurrection was squandered.[43]

The interpretation of the experience of Hiver '60 provides a hitherto little remarked upon dividing line between the SI and SB. In the defeat of Hiver '60 Castoriadis chiefly saw the weakness of the working class, its bureaucratic 'privatisation' undermining any possibility of a unitary political contestation. Despite remarking upon the significance of the festive nature of the wildcat general strike – and, indeed, betraying the influence of Situationist ideas upon him – Castoriadis saw little significance beyond the absence of a unifying, mass political organisation along the model of PO.[44] Debord, on the other hand, saw in the festive, playful quality of the strike the real success of the movement – thus, 'the question of power was posed, and beyond this the true nature of workers' power'.[45] From the experience of the strike the SI not only developed their conception of the festive, playful revolution against the rule of work. It was also the pivot of their critique of SB's conception of what constituted a political revolutionary organisation and, further still, the unbidden hierarchy within SB. Within three months of his trip to Belgium with SB, Debord had resigned from PO. In the meantime, and perhaps even more significantly for the SI's future direction, a participant of the wildcat strike in Belgium had joined the group: Raoul Vaneigem.

The difference between SB and the SI (or at least that between Castoriadis and Debord) resolves to one of where to locate the level of revolutionary consciousness and contestation: at the level of the 'lived' (*vécu*) or at the level of representation. In contrast to Marxist orthodoxy, SB championed proletarian 'autonomy' and the struggle 'from below'. Nonetheless, SB continued to emphasise the yardstick of vanguardism established by Lenin

and Trotsky – albeit in a critical register. But, as Debord was beginning to understand, this perspective ignored the emergence of a unified or 'generalised' perspective of revolutionary struggle from amidst proletarian experience itself.

In his brief passage through SB Debord had come to find that the residual Trotskyist vanguardism of SB and PO encompassed – and to an extent masked – what Debord considered an 'unavowed division' within SB itself: that between the theorist leaders of the group and their mostly younger, often student disciples, aka the *militants de base* (rank and file militants).[46] The irony that the division of directors and executants existed within SB itself was not lost on Debord. It would figure as model for what the SI would later call the ideology of 'militantism'.[47] Refusing the militant model of leaders and disciples, the SI came to believe that the revolutionary organisation, in order to fully engage critically with the alienated present, must likewise embody the critical rejection of capitalist hierarchy in its own, collective practice.[48] In contrast to Castoriadis' pessimistic assessment, the promise of Hiver '60 was precisely its festive qualities beyond work, as well as the aggressive rejection of the politics of representation (at least initially). Here was 'the poetry of the proletariat rediscovering its everyday life, rediscovering the veritable substance of class struggle: the self-management of everyday life'.[49] Later, the group would speak of the implied destiny of 'means and ends', arguing that it was not enough to put off the question of the transformations of everyday life to the day after the revolution.

Without a doubt the SI benefited from their encounter with SB.[50] For instance, the SI took over aspects of SB's theoretical arsenal largely unchanged – notably the critique of bureaucratic state capitalism.[51] Additionally, when formulating the conception of 'recuperation', the SI drew not only upon their own critique of the commercial appropriation of avant-garde culture, but also SB's critique of the bureaucratic incorporation of working-class struggle into the capitalist state and market. However, the SI's appropriation of elements of SB's critique cannot be understood without explicit reference to the Situationist notion of critical appropriation – which is to say, *détournement*. If we consider the central question of the nature of proletarian revolution, particularly the SI's taking up of the demand for 'workers' councils' and 'self-management' (*autogestion*), the critical aspects of their *détournement* become stark. For instance, Debord would later draw attention to the ambivalence of the demand for workers' councils. On the one hand he hailed them, in the words of

Marx on the Paris Commune, as 'the political form at last discovered in which the economic emancipation of labour could be realised'.[52] On the other hand, he spoke of the actual history of councils in the twentieth century as 'no more than a brief sketch' of a form that poses problems 'rather than providing a solution'.[53] That workers' councils were the spontaneous product of revolutionary proletarian self-activity was their most important quality.[54] To limit them to the mere self-management of production as it existed (or was inherited from capitalism), or to submit them to the political rule of a party as was the case with the Bolsheviks after October 1917, was to misapprehend willingly – or not, as the case may be – their revolutionary significance: the extension of the principle of self-management to the entirety of everyday life.

The question of proletarian self-organisation was thus not just the pivot upon which the influence of SB on the SI turned but, more importantly, the precise content of the latter's break with their erstwhile educators. Where SB had justly elevated proletarian autonomy in the realm of production, and so too the consequent potential and historical instances of the self-management of production, the SI called into question the Marxist doxa that 'production' or 'labour' was the essence or aim of such self-production. Given the reductive nature of proletarianisation – that is, the reduction of the potential for activity to labour-power for sale – the SI argued that the revolutionary supersession (*dépassement*) of such could not be equivalent to its mere self-management. Instead, self-management – insofar as it is a principle of the revolutionary contestation of the everyday reality of capitalist alienation in its entirety – necessarily poses a terrain of operation beyond the alienating division of labour and leisure-time. Thus, the SI would come to oppose their conception of 'generalised self-management' (*autogestion généralisée*) to the more limited notion of the self-management of production.[55] As Vaneigem would argue, some years later, the SI 'revalorised' its artistic critique against SB's reduction of self-management to labour and production.[56]

* * *

The year following Hiver '60 and the close encounter with SB was an intense one for the SI. It is often remembered for the split with the refractory artists of the group in February and March 1962. In the seventh issue of the SI's journal (April 1962) the group outlined its ambitious project for a new revolutionary movement. Two central arguments were made. First, against those commentators who saw only integration and the

success of contemporary capitalism, the SI argued that one can find the potential basis for a new revolutionary project in the everyday experience of proletarian rebelliousness – whether manifested in wildcat strikes, the blossoming of juvenile delinquency, or the 'wave of vandalism against the *machines of consumption*'.[57] Further, and against SB's conception of political militancy and organisation (and, indeed, political militancy tout court), it was this experience that was the real basis of a dialect of avant-garde organisation. As the SI would later phrase it, evoking Marx, 'within the various problematics of modernity, *a mass of new practices [...] are seeking their theory*'.[58] For the SI, contra the ICO in particular, the role of revolutionary organisation was precisely one of formulating and circulating this theory. In this sense, groups like the SI were actual moments of the emergence of a more general revolutionary contestation, rather than an exogenous political leadership waiting to lead the class (after the fashion of the Trotskyists, the Marxist-Leninists, as well as SB's conception of political leadership). Secondly, and related precisely to the insufficiency of the 'abstentionism' of the ICO as much as the hierarchical 'political militancy' of SB and the Trotskyist-Leninists, the SI argued that in order to better understand the present needs of proletarian contestation one must turn to a disabused re-examination of the 'classical workers movement' (c. 1845–1937). Importantly the SI insisted that such an examination – with an eye to its contemporaries attached to orthodox and heterodox conceptions of the workers movement – should begin with the following premise: that '[t]he apparent successes of this movement are [in fact] its fundamental failures (reformism or the establishment of a state bureaucracy), [whereas] its failures (the [Paris] Commune or the [1934] Asturian revolt) are its most promising successes so far, for us and for the future'.[59]

The first fruits of this re-examination were the notorious theses on the Paris Commune.[60] By the early 1960s the Paris Commune of 1871 had come to be seen by many on the revolutionary left as a type of preliminary sketch of a workers' revolution. A corollary of this belief was that the Russian Revolution of 1917 best represented a successful workers' revolution in contrast to the Commune's failure. However, this belief, itself the work of Lenin and the later predominance of the Bolshevik interpretation on the revolutionary left, was called into question by the Situationists.[61] Debord, Vaneigem and Attila Kotányi lauded the Commune as the 'biggest festival of the nineteenth century'.[62] Against prevailing opinions that retrospectively judged the Commune as a historical failure, or at best as an 'outmoded example of revolutionary primitivism', the SI proposed to

examine it as 'a positive experiment whose whole truth has yet to be redis-covered and fulfilled'.[63] In this sense, the SI emphasised the Commune as a lived experience rather than mere historical residue; as the crux of a struggle over the possibility of a new world amidst the drag and inertia of the old. Indeed, one 'must not forget that for those who really lived the event, the supersession [of capitalism] was *already there*'.[64] The failure, then, of the Commune was seen not in terms of military defeat but rather its succumbing to the 'force of habit': the respect for bourgeois legality; the resurrection of Jacobinism; and so, the complicity of revolutionaries 'who merely *think about* revolution, and who turn out to still *think like* the defenders' of the old order – in short, all the nightmares of the past weighing upon the living.[65] This analysis of the Paris Commune would become the point of departure for the SI's re-examination of the Russian Revolutions of 1905 and 1917, the Spanish Revolution of 1936–7 and, later, the German Revolution of 1918–19.[66] Common to their reassessment was the idea, first posed in the Petrograd Soviet of 1905, that the workers' council was the finally discovered form of revolutionary proletarian self-organisation implicitly present in the debacle of the Paris Commune. In the councils, Debord wrote, the revolutionary proletarian movement becomes its own product, and that product is nothing but the revolution-ary proletarians themselves: that is, the self-management of everyday life as means and ends.[67] In a vocabulary borrowed from Marx by way of Georg Lukács and Johan Huizinga, Debord wrote that proletarians and their activity, having being rendered an *alienated object* (capital and wage labour), become explicitly and consciously what they are already implic-itly and unconsciously: the *subject of history*, which is 'nothing other than the living producing themselves and becoming masters and possessors of their own world – which is to say *fully conscious of the play* of their history and existence'.[68]

Despite the proletarian practice of the *soviet* – which is to say the workers' council – the radical theorists were slow to discover it.[69] Debord would later argue that the question of revolutionary organisation was the 'most neglected' and thus the 'weakest aspect of radical theory'.[70] In the wake of the Commune, and the initial extreme difficulty faced by anar-chists and socialists in the triumphant bourgeois reaction, the lineaments of a more contemporary leftist organisational practice arose – which is to say the *recuperation* of the revolutionary movement through its legitimate representation in the bourgeois political state and para-state (for instance the growing respectability of trade unions). The Bolshevik answer to the

patent opportunism and accommodation of social democracy was perhaps initially more opaque in its ideological excess. Though the Bolsheviks rallied to an internationalist perspective in the face of the collapse of the Second International into a pro-war, pro-nationalist perspective in 1914, Debord would write that Lenin was nonetheless 'a faithful and consistent *Kautskyist*'.[71] Even when considering Lenin the coquette of Hegelian dialectics – and his calling into question his 1902 belief that workers were only capable of a social democratic consciousness, not a revolutionary one – one must recall that he never wavered from an implicitly hierarchical ideology, that is, that the revolutionary class needs to be *led*.[72] The Bolsheviks inherited a form of Jacobinism from the nineteenth-century workers' movement that had itself been inherited from the bourgeois revolutionaries of 1792. Instead of social democracy's respectable 'professors educating the working class' and the elevation of worker representatives into the heady heights of the 'labour-union bureaucracy as brokers of labour-power', the Bolsheviks deployed cells of cadres, led by intellectuals become 'professional revolutionaries' to the extent that they were otherwise denied a career by the brutal, semi-feudal primitivism of Czarism and early Russian capitalism.[73] In the uncompromising intransigence of the Bolshevik cadres and cells, Debord wrote that the 'profession of the absolute management' of Stalinist bureaucrats was already writ.[74]

The SI's rejection of statist hierarchy – whether through their appropriation of the radical implications of Marx's critique of *ideology* and Bakunin's critique of the state, alongside their rejection of the *ideologies* of Marxism and anarchism – made their critique and proposal to launch a new revolutionary movement attractive to many young anarchists in France in the mid-1960s. Indeed, the sclerosis and antiquarian focus of what passed for an official anarchist movement in France in the 1960s matched the malaise and historical fetishes of the orthodox Marxists (and a good many of the heterodox ones too).

In contrast to incipient Marxist orthodoxy, anarchism emerged from the Paris Commune as the bearer of an intransigent revolutionary project. Unlike the social democrats, or even the Bolsheviks who contested *duma* (the Czarist parliament) elections, the anarchists mostly refused the capitalist state altogether. In opposition to the Marxist conception of the dictatorship of the proletariat raising itself to state power – albeit, 'temporarily' in anticipation of its 'withering' – Bakunin argued that such a conception risked becoming the basis for a new bureaucratic ruling class:

a dictatorship of the most knowledgeable. This did not stop Bakunin from indulging in an authoritarian conspiracy to seize control of the First International, alongside an elite of the 'most revolutionary'.[75] Nonetheless, it is the critique of the state and hierarchy that becomes largely lost, or transformed out of recognition, in the official, statist 'Marxism' founded with the Second International six years after Marx's death. So, organised anarchism remained the province of the critique of statist alienation in the face of the Marxist embrace of a purported revolutionary conception of state power.

The French Anarchist Federation (FA) was founded in 1945.[76] It traced its lineage through the pre-war Union anarchiste, and support for the CNT-FAI (Confederación Nacional del Trabajo – Federación Anarquista Ibérica) in the Spanish Revolution and Civil War. Surrealists like André Breton and Benjamin Péret had been members of an affiliated group and published in the FA's paper, *Le Monde libertaire*. A split in the early 1950s had led to a breakaway communist-anarchist group under the FA's original secretary, Georges Fontenis, and the refoundation of the FA under the hand of Maurice Joyeux in 1954. However, Fontenis' group, the Libertarian Communist Federation (FCL) itself split over the question of participating in elections. Those who rejected this electoralism formed Revolutionary Action Anarchist Groups (GAAR) and published the journal *Noir et Rouge*.

In the early 1960s a younger generation of anarchists came into conflict with the FA's old guard. In 1962, the GAAR initiated a communist anarchist tendency in the FA: the Anarchist Communist Groups Alliance (UGAC). However, they were excluded from the federation in 1964, and a 'hysterical anti-Marxism' was left in its wake (particularly embodied in the leading old guard figure: Maurice Joyeux).[77] Around the same time, at the end of 1963, a new 'youth space' was organised in the FA. Among these young anarchists were avid readers of not only *Le Monde libertaire* and *Noir et Rouge*, but also *Socialisme ou Barbarie* and *Internationale situationniste*.

In 1966, members and sympathisers of the young anarchist René Fugler's circle at the University of Strasbourg contacted the SI. The resulting pamphlet and scandal, *On the Poverty of Student Life*, helped to propel the SI into public consciousness, playing the role of *hors d'oeuvre* to May 1968.[78] Fugler had become attracted to the Situationist critique of work and their evocation of the playful critique of the alienation of the capitalist city (that is, 'unitary urbanism'). While involved with *Le Monde libertaire*, and as a direct result of dealing with Marxian ideas and history, Fugler's group would leave the FA in late 1966, accused of being Marxists

by Joyeux and others of the FA old guard. Similar problems arose for other young anarchists around the question of the SI and its purported Marxist conspiracy against the FA – notably future Situationists René Riesel's and Christian Sébastiani's Sisyphé group.[79] Maurice Joyeux's claims of a Marxist conspiracy within the FA with the SI as the puppet master reached a delirious peak at the Bordeaux congress of the FA in May 1967. Here he outlined his paranoid hypothesis under a title that ironically evoked Lenin: 'L'Hydre de Lerne ou la maladie infantile de l'anarchie' ('The Learnean Hydra, or the infantile disorder of anarchism'). As the SI would comment some months later, 'there has never been any sort of "situationist conspiracy" aimed at smashing the Federation [...]. Our episodic reading of the deplorable Le Monde libertaire did not lead us to suppose that the SI had the least audience in it.' In this regard, On the Poverty of Student Life caused a surprise: various members of the FA appeared to approve of it.[80]

More and more members of the FA were finding it hard to stomach Joyeux's paranoia and pointedly non-libertarian leadership, leading them to form a breakaway second Anarchist Federation in the wake of the Bordeaux congress. Additionally, the three anarchist groups most influenced by the SI broke away to form the Situationist inspired Anarchist International (IA).[81] The IA, however, was itself short-lived.[82] One reason that contributed to its brief passage was the uneven level of engagement with the Situationist project. To the criticisms of one member of the IA, Loic Le Reste, who called upon the SI to fuse with his group, the Situationists responded that on the contrary, 'we are clearly partisans of the *multiplication of autonomous revolutionary organisations*'.[83] Pointedly drawing upon their experience with SB and the dubious legacy of Trotskyism, the SI noted that their refusal of disciples or 'recruits' in favour of welcoming individuals here and there embodied an organisational form which they opposed to the hierarchical and 'mass' politics of the Trotskyists.[84] The idea of 'the multiplication of autonomous revolutionary organisations', coupled with the SI's argument that such an organisation must 'refuse to reproduce within itself any of the hierarchical conditions of the dominant world', offered an alternative to both the hierarchical dreams of the Trotskyist-Leninists and the loose federalism behind which the FA hid its incoherence and unavowed hierarchy of the old guard.[85] As the SI reminded the GAM (Makhno Anarchist Group of Rennes) and IA, 'we believe our practical activity is located, inseparably, as means and ends' in such an organisational form.[86] Hence, unlike the Trotskyists, and even some anarchists, the object was to contribute to the practice of gen-

eralised self-management, in the Situationist sense of the term. And that end, as Situationist practice in the present (and unlike the hierarchical and conspiratorial groupuscules) anticipated the 'means and ends' of revolutionary self-organisation and self-emancipation.

<p style="text-align:center">* * *</p>

The 'crisis' in French anarchism between 1966 and 1968 was in fact a symptom of a larger historical movement – the re-emergence of revolutionary contestation. Debord, on the eve of May 1968, noted that the SI itself had 'emerged from the silence that previously concealed it', precisely as a result of this 'movement that is haltingly beginning' – a movement, moreover, that the SI had been 'supporting and pointing out for many years'.[87] Indeed, we can consider that, by the turn of 1967, the SI had in large part established the Situationist critique it would enter battle with the following year.[88] Consequently, Debord argued in April 1968 that the SI 'should now concentrate less on theoretical elaboration […] and more on the communication of theory, on the practical linkup with whatever new gestures of contestation appear'.[89]

When this debate on the organisation question resumed the following year, after the 'more pleasant and instructive' occupations movement of May 1968, the debate became framed in terms of presenting such questions as the SI's critique of work and their critical appropriation of self-management in terms of promoting the need for a *situationist* councilist organisation.[90] Perforce, such an organisation was not merely the reassertion of the 'councilism' of Pannekoek, SB or ICO – and even less that of the Bolshevik conception of soviet power. Perhaps most remarkable was that, in the face of the failure of May 1968 to manifest an autonomous proletarian revolutionary power (despite the patent radicalisation left in its wake), the SI more clearly conceived of the need for an organisation question beyond their earlier, perhaps vaguer statements regarding the disappearance of the revolutionary avant-garde at the moment of its success.[91] With the old mole of revolutionary contestation once more emergent, the question now was more clearly one of an appropriate organisational strategy of contestation.

May 1968 can be retrospectively judged the high point of the SI's practice. However, in the face of such success the SI itself became overwhelmed with its inability to clarify its new strategic orientation. The Situationists clearly provided much of the explicit critical poetic content of the May movement, as well as being key players in its 'detonation'.[92] In

the wake of May, the terms 'situationist' and *'enragé'* became synonymous with the most extreme manifestations of this movement. Such success became emblematic of the spread of Situationist ideas and influence throughout the European and global movements that emerged in the wake of the French May – notably the 'Hot Autumn' of Italy in 1969 and its aftermath.[93] But such 'success' also figured more immediately – and destructively – in the spectacular recuperation of the Situationists. Indeed, the SI was itself overwhelmed by both its success and its attempt to reorient on this basis. Soon after September 1969, in which both the last issue of its journal was published and its last conference was held in Venice, the SI was immersed in its 'orientation debate' which ground on interminably through 1970 and into 1971.[94] By that year's end, only Debord and Gianfranco Sanguinetti remained to officially wind up the group early the following year.[95]

Nonetheless, the SI's influence was immense, particularly amidst the reawakening revolutionary movement of 1968 and after. Today, no serious reckoning of May 1968 in France can omit the extent of the influence of Situationist ideas upon this social upheaval.[96] Similarly, their ideas – alongside those of SB and others – were taken up by revolutionaries in Japan, Italy, Spain, Germany and beyond through the 1960s and 1970s. Indeed, the SI's critique of work, as too their conception of generalised self-management, laid the groundwork for the rediscovery and elaboration of both the negative and positive content of revolutionary proletarian critique in the 1970s and beyond.

Notes

1. Lettrist International, 'The Alba Platform' (1956), in Situationist International, *Situationist International Anthology*, ed. and trans. Ken Knabb (Berkeley, CA: Bureau of Public Secrets, revised and expanded edition 2006), p. 22.
2. Guy Debord, 'Report on the Construction of Situations', in *Situationist International Anthology*, p. 40.
3. Ibid., p. 43.
4. Ibid. See also, Situationist International, 'L'effondrement des intellectuels révolutionnaires' (Collapse of the Revolutionary Intellectuals), *Internationale situationniste (IS)*, no. 3 (June 1958): 8–9. Note that Debord here used 'ideological' in the orthodox Marxist sense, as opposed to his, and the SI's later embrace of the critique of ideology in 'Marx's sense of the term' from c. 1961.
5. Debord, 'Report on the Construction of Situations', p. 39.
6. I use the term 'orthodox' to contrast the dominant forms of Marxism throughout the twentieth century – namely, those tracing their lineage from

the social-democratic Second International and the Marxist-Leninist Third International – from the 'heterodox' forms of Marxism, such as the council communist and other more libertarian forms of Marxian communism. Moishe Postone has also referred to the former as 'traditional' Marxism. More recently, Michael Heinrich has called this 'worldview' Marxism. See, respectively, Moishe Postone, *Time, Labor and Social Domination: A Reinterpretation of Marx's Critical Theory* (New York: Cambridge University Press, 1993); Michael Heinrich, *An Introduction to the Three Volumes of Karl Marx's Capital* (2004), trans. Alexander Locascio (New York: Monthly Review Press, 2012).

7. Jean-François Martos, *Histoire de l'internationale situationniste* (Paris: Champ Libre, 1989), p. 143. See also, Situationist International, 'Instructions for an Insurrection' (1961), in *Situationist International Anthology*, pp. 84–6; letter from Guy Debord to André Frankin, 19 February 1961; 'Un moraliste', *IS*, no. 11 (October 1967): 57–8.

8. See Leon Trotsky, *The Revolution Betrayed* (1937), trans. Max Eastman (New York: Dover Press, 2004).

9. Guy Debord, 'Theses on Cultural Revolution', in *Guy Debord and the Situationist International: Texts and Documents*, ed. Tom McDonough (Cambridge, MA: MIT Press, 2002), thesis 4, p. 62. Translation modified.

10. For instance, see the 'Manifesto for an Independent Revolutionary Art' (1938), signed by André Breton and Diego Rivera (though more likely written by Breton and Leon Trotsky). For the Surrealist break with the Stalinists, see André Breton, 'On the Time When the Surrealists Were Right' (1935), both in *Manifestos of Surrealism* (Ann Arbor: University of Michigan Press, 1982). Breton would go on to reassert precisely such a parallel relationship, though this time with the Anarchist Federation in France, in the early 1950s. See Miguel Amóros, *Les Situationnistes et l'anarchie* (La Taillade: Éditions de la roue, 2012), pp. 21–2; Michael Löwy, *Morning Star: Surrealism, Marxism, Anarchism, Situationism, Utopia* (Austin: University of Texas Press, 2009), pp. 25–6.

11. Debord would later say that the SI lacked 'coherence' before 1962. See letter from Guy Debord to Juvénal Quillet, 11 November 1971. All translations of Debord's letters are taken from notbored.org.

12. For more detail on this dispute, see Anthony Hayes, 'How the Situationist International Became What It Was', unpublished PhD thesis (Australian National University, 2017), chapter 3, *passim*.

13. Ibid., chapter 4, *passim*.

14. For more on the May 1958 coup and crisis and the SI, see Mikkel Bolt Rasmussen, 'The Spectacle of de Gaulle's Coup d'État: The Situationists on de Gaulle's Coming to Power', *French Cultural Studies*, 27(1) (2016).

15. Philip Williams, 'How the Fourth Republic Died: Sources for the Revolution of May 1958', *French Historical Studies*, 3(1) (Spring 1963).

16. SI, 'Une guerre civile en France' (A Civil War in France), *IS*, no. 1 (June 1958): 32. (*Situationist International Online* translation used.)

17. For a contemporaneous English language assessment redolent of such Trotskyism, see Ted Grant, 'France in Crisis', originally published in *Socialist Fight*, 29 May 1958.

18. The situation on the left was extremely polarised, with the non-Stalinist parties and unions wary of entering into the 'popular unity' the PCF was calling for. As the SI pointed out, the PCF 'until the end, remained the victim of the unique process of intimidation with which the Right minority had continuously imposed its politics: the myth of a Communist Party working to seize power'. Despite this myth, which harked back to a communist party that perhaps *never was*, the PCF and the allied CGT worked hard throughout the crisis to demonstrate that they were 'the best defender[s] of the parliamentary regime *and nothing more*'. SI, 'Une guerre civile en France', p. 32. Translation modified.

19. See SI, 'L'effondrement des intellectuels révolutionnaires'.

20. Which is not to say that the SI dismissed the amelioration of material poverty, but rather opposed the reduction of the revolutionary project to the bourgeois conception of such.

21. SI, 'The Use of Free Time' (1960), in *Situationist International Anthology*, p. 75. Translation modified.

22. A good short account of SB that covers the meeting of Castoriadis and Lefort: Marcel van der Linden, 'Socialisme ou Barbarie: A French Revolutionary Group (1949–65)', *Left History*, 5(1) (1997).

23. Cornelius Castoriadis, '"The Only Way to Find Out If You Can Swim Is to Get into the Water": An Introductory Interview [1974]', in *The Castoriadis Reader*, ed. David Ames Curtis (Oxford: Blackwell, 1997), pp. 3–4.

24. For the classic elaboration of this theory, see Trotsky, *The Revolution Betrayed*, trans. Max Eastman (New York: Dover Press, 2004).

25. Cornelius Castoriadis, 'Socialism or Barbarism' (1949), in *Cornelius Castoriadis, Political and Social Writings* vol. 1, *1946–1955*, ed. David Ames Curtis (Minneapolis: University of Minnesota Press, 1988), p. 103.

26. Ibid., pp. 76–106.

27. Ibid., p. 79.

28. Ibid.

29. Ibid., pp. 94–104. The term 'self-management' (*autogestion*) appears to be taken up by SB in the wake of the Hungarian Revolution, and the Hungarian workers' demand for 'working class self-management of the factories'. See Socialisme ou Barbarie, 'Questions aux militants du P.C.F.', *Socialisme ou Barbarie*, no. 20 (December 1956–February 1957): 76.

30. For Pannekoek's most exhaustive presentation of council communism, see his work *Workers' Councils* (1948/1950) (Oakland, CA: AK Press, 2003), first published shortly before his correspondence with Castoriadis.

31. This was explicitly drawn out in Anton Pannekoek's correspondence with Castoriadis in 1953. See Asad Haider et al., 'The Castoriadis–Pannekoek Exchange', *Viewpoint Magazine* (2011, 2013).

32. ICO: originally 'Informations et liaisons ouvrières' until 1960.

33. For more on the SI's later critique of the ICO, see SI, 'Lire ICO' (1967), *IS*, no. 11 (October 1967): 63–4. Situationist International Online. The roots of this critique can be found in Debord's early hostility to the 'spontaneists' of SB before the 1958 split. See letter from Guy Debord to André Frankin, 8 August 1958.

34. See the critical comments on Asger Jorn's conception of the avant-garde in 'Le sens du dépérissement de l'art' (The Meaning of Decay in Art), *IS*, no. 3 (December 1959): 71–84.

35. For more on the SI and Algeria, see chapter 7 in this volume. For SB's critique of the Algerian war, see: Jean-François Lyotard, *Political Writings*, trans. Bill Readings and Kevin Paul Geiman (Minneapolis: University of Minnesota Press, 1993); Jean Amair et al., *A Socialisme ou Barbarie Anthology: Autonomy, Critique, Revolution in the Age of Bureaucratic Capitalism*, ed. David Ames Curtis (London: Eiris, 2018).

36. *Bulletin intérieur*, octobre 1959, cited in Bernard Quiriny, 'Socialisme ou Barbarie et l'Internationale situationniste: notes sur une "méprise"', *Archives et documents situationnistes*, no. 3 (2003), p. 51.

37. Briefly, Castoriadis argued that as a consequence of the developing process of the bureaucratisation of capitalist production – that is, into the direction and execution of production – the socialisation of the working class was further split between a positive, and in part active political socialisation in the workplace and the increasing 'privatisation' of life beyond this (a life, moreover, increasingly dominated by an isolating consumerist perspective). Alongside of this – and reinforcing this 'de-politicisation' and 'privatisation' – was the increasingly specialised and alienated political life of the capitalist state. Thus, Castoriadis postulated that the absence of a broader, political opposition to the May crisis of 1958 was a direct consequence of such privatisation and de-politicisation. For more on this see the first part (in particular) of Cornelius Castoriadis, 'Modern Capitalism and Revolution' (1960–61), in *Cornelius Castoriadis, Political and Social Writings*, vol. 2, *1955–1960*, ed. David Ames Curtis (Minneapolis: University of Minnesota Press, 1988). Castoriadis would later consider this the work that crystallised his growing discomfort and ultimate break with Marxist orthodoxy. See Cornelius Castoriadis, 'General Introduction' (1972), in *Cornelius Castoriadis, Political and Social Writings*, vol. 1, *1946–1955*.

38. Daniel Blanchard, 'Debord, in the Resounding Cataract of Time', in *Revolutionary Romanticism: A Drunken Boat Anthology* (San Francisco, CA: City Lights Books, 1999), pp. 223–36. Also see, Hayes, 'How the Situationist International Became What It Was', chapter 7 and appendix three.

39. Pierre Canjuers (Daniel Blanchard) and Guy Debord, 'Preliminaries Toward Defining a Unitary Revolutionary Program', in *Situationist International Anthology*, part I, thesis 7, p. 390. For Debord's first formulation of a critique of the 'spectacle', see Debord, 'Report on the Construction of Situations'.

40. Canjuers and Debord, 'Preliminaries', part I, theses 3 and 7, pp. 388, 390.

41. See Phillipe Gottraux, *'Socialisme ou Barbarie': Un engagement politique et intellectuel dans la France de l'après-guerre* (Lausanne: Editions Payot, 1997), p. 224, fn. 96.

42. For instance, the possibility of mutiny in the army was feared enough that police were used to prevent the fraternisation of soldiers and striking workers. See, Alastair Hemmens, 'Le Vampire du Borinage: Raoul Vaneigem, Hiver '60, and the Hennuyer Working Class', *Francosphères*, 2(2) (2013): 142–3.

43. Indeed, even by the reformist standards of the parliamentary left and trade union leaders the strike was wasted. The loi unique was passed with no amendments in February 1961.

44. For those willing to read Castoriadis by way of the Situationists, the influence of the latter upon the former is patent in the third section of 'Modern Capitalism and Revolution' (1960–61), pp. 294–5. See also Hayes, 'How the Situationist International Became What It Was', Appendix 3: 'Whose Spectacle?'

45. Letter from Guy Debord to André Frankin, 24 January 1961.

46. Guy Debord, 'To the Participants in the National Conference of "Pouvoir Ouvrier"', 5 May 1961, notbored.org. Translation modified. A sort of first draft of his critique of spectacular hierarchy can be found in an article Debord wrote for circulation within PO and SB: Debord, 'For a Revolutionary Judgment of Art' (1961), in Situationist International Anthology.

47. The first published instance of this critique can be found in SI, 'Instructions for an Insurrection', in Situationist International Anthology, pp. 84–6. Debord would also recommend that this article 'must be seen as a critique of the positions of PO' – and so, too, SB. Letter from Guy Debord to J.-L. Jollivet, 8 December 1961, www.notbored.org/debord-8Dec1961.html. Translation modified.

48. As Debord would later phrase it, 'the revolutionary organisation must learn that it can no longer fight alienation with alienated means'. Debord, The Society of the Spectacle, trans. Ken Knabb (Berkeley: Bureau of Public Secrets, 2014), thesis 122, p. 64. Translation modified.

49. Raoul Vaneigem, 'Raoul Vaneigem: Self-portraits and Caricatures of the Situationist International' (2014), translated and détourné in 2015 by Not Bored from the French Rien n'est fini, tout commence (Paris: Allia, 2014).

50. For an account of this encounter which sympathises with SB's perspective, see Stephen Hastings-King, 'L'Internationale Situationniste, Socialisme ou Barbarie, and the Crisis of the Marxist Imaginary', SubStance, 28(3), issue 90 (1999).

51. But even here, the SI attempted to refine and improve their appropriation – as befits their notion of détournement. For instance, in their conception of the 'diffuse', 'concentrated' and ultimately 'integrated' spectacles. See Debord, Spectacle, theses 63–5, pp. 25–7. See also Debord, Comments on the Society of the Spectacle, trans. Malcolm Imrie (London: Verso, 1998), thesis 5, pp. 11–13.

52. Debord, Spectacle, thesis 116, pp. 62–3. Translation modified.

53. Ibid. Translation modified.

54. 'With the power of the councils [...] the proletarian movement becomes its own product, and this product is nothing other than the producers themselves'. Ibid., thesis 117, p. 63. Translation modified.

55. Here, the SI's conceptualisation of generalised self-management as opposed to the more limited, 'productivist' conception, draws upon Debord's distinction of the 'limited' and 'generalised' conceptions of cultural avant-gardes. See letter from Guy Debord to Robert Estivals, 15 March 1963.

56. Vaneigem, 'Self-portraits and Caricatures'.

57. SI, 'The Bad Days Will End', in *Situationist International Anthology*, p. 108. Interestingly, the SI explicitly cite an incident from Hiver '60 as an exemplary instance of the 'summit of consciousness' that the workers gained, in which strikers in Liège attempted to destroy 'the machinery of the newspaper *La Meuse* [... thus] attacking the *means of information* held by their enemies'. Ibid., pp. 108–9. Translation modified.

58. SI, 'Ideologies, Classes and the Domination of Nature' (1963), in *Situationist International Anthology*, p. 139.

59. SI, 'The Bad Days Will End', p. 110.

60. Notorious for their later relationship to the SI's break with Henri Lefebvre. See Situationist International, 'Into the Trashcan of History!' (1963), notbored. org; Situationist International, 'Reasons for a Reprint' (1969), notbored.org.

61. The 'orthodoxy' that the SI was rejecting can be found in Vladimir Lenin, *State and Revolution* (1907) (London: Aziloth Boooks, 2017).

62. Guy Debord, Attila Kotányi and Raoul Vaneigem, 'Theses on the Paris Commune' (1962), in *Situationist International Anthology*, thesis 2, p. 398.

63. Ibid., thesis 4.

64. Ibid., thesis 11, p. 401. Translation modified.

65. Ibid., theses 8 and 9, p. 400.

66. For the most detailed Situationist critique of Russia and Spain, see Debord, *Society of the Spectacle*, chapter 4. For their most detailed criticism of Germany 1918–19, see René Riesel, 'Preliminaries on Councils and Councilist Organization' (1969), in *Situationist International Anthology*, pp. 348–62.

67. Debord, *Spectacle*, thesis 117, p. 63.

68. Ibid., thesis 74, p. 32.

69. Ibid., thesis 90, pp. 41–2.

70. Ibid.

71. Ibid., thesis 98, p. 48.

72. Compare and contrast: Vladimir Lenin, *What Is To Be Done?* (1902) in *Collected Works* (Moscow: Foreign Languages Publishing House, 1961), vol. 5, pp. 347–530 and *State and Revolution*.

73. Debord, *Society of the Spectacle*, thesis 98, p. 48.

74. Ibid.

75. Ibid., thesis 91, pp. 42–3.

76. Much of the following account of French anarchism in the 1960s and its relationship to the SI is drawn from Amorós, *Les Situationnistes et l'anarchie* (La Taillade: Éditions de la roue, 2012).

77. Ibid., p. 28. No doubt the hostility toward Marxian influences can also be attributed to the splits of the 1950s that resulted in the formation of the FCL and GAAR.

78. For the SI's account, see 'Nos buts et nos méthodes dans le scandale de Strasbourg', *IS*, no. 11 (October 1967): 23–31. A more recent account can be found in Miguel Amorós, 'Anatomy of a Scandal' (2018), libcom.org.

79. Apart from Sisyphé, other FA-affiliated groups which ran afoul of the paranoia included members of Maurice Joyeux's own Menilmontant Anarchist Group (GLM) such as Guy Bodson and Jacques Le Glou, the Makhno Anarchist

Group of Rennes (GAM), and the Anarchist Group at Nanterre University (GAN).

80. Situationist International, 'Splits in the A.F.' (1967), notbored.org. Translation modified.

81. That is, the Revolutionary Anarchist Group (GAR), the Menilmontant Anarchist Group (GLM) and the Makhno Anarchist Group of Rennes (GAM).

82. Nonetheless, some members of the IA would go on to form part of the Situationist-inspired Enragés of Nanterre (crucially important as detonators of May 1968), as well as the SI group Council for the Maintenance of the Occupations (CMDO) during the May 1968 movement. The SI's account of the Enragés, the CMDO and May 1968 can be found in René Viénet, *Enragés and Situationists in the Occupation Movement, France, May '68* (1968), trans. Loren Goldner and Paul Sieveking (New York: Autonomedia, 1992); SI [Debord], 'The Beginning of an Era' (1969), in *Situationist International Anthology*.

83. Guy Debord, Mustapha Khayati and René Viénet, 'Letter to the Rennes group of the Anarchist International', 16 July 1967, notbored.org. Le Reste was a member of the Makhno Anarchist Group of Rennes (GAM), and of the IA.

84. Ibid.

85. SI, 'Minimum Definition of Revolutionary Organizations', in *Situationist International Anthology*, pp. 285–6.

86. SI, 'Réponse aux camarades de Rennes' (Letter to the Rennes group of the Anarchist International), 16 July 1967, cited in Clark and Nicholson-Smith, 'Why Art Can't Kill the Situationist International', in *Texts and Documents*, p. 482. Translation modified.

87. Guy Debord, 'The Organization Question for the S.I.' (1968/69), in *Situationist International Anthology*, pp. 380–3.

88. For instance, both Debord and Vaneigem's books published that year had been elaborated over the course of the previous four years.

89. Debord, 'The Organization Question for the S.I.'

90. See Riesel, 'Preliminaries on Councils and Councilist Organization'.

91. For instance, as outlined in 'Ideologies, Classes, and the Domination of Nature' and 'Minimum Definition of Revolutionary Organizations', in *Situationist International Anthology*, pp. 285–6.

92. For the SI's account of its role in detonating May 1968, see both Viénet, *Enragés and Situationists in the Occupation Movement*, and Debord, 'The Beginning of an Era' (1969). See also, Michael Seidman, *The Imaginary Revolution: Parisian Students and Workers in 1968* (New York: Berghahn Books, 2004).

93. See, for instance, the work of the Italian section of the SI, notably the first and only issue of *Internazionale Situazionista* in 1969, as well as various leaflets circulated by the group in 1969 and 1970. Of course, like the Situationist influence in France and elsewhere, in Italy the influence extended well beyond the SI's official representatives and publications, notably among militants and participants in the various iterations of Italian *operaismo* and *autonomia*. Not to mention the continued work of Gianfranco Sanguinetti, most strikingly in the *Truthful Report on the Last Chances to Save Capitalism in Italy* (1975), trans. Bill Brown (Brooklyn, NY: Colossal Books, 2014), and

On Terrorism and the State (1979), trans. Lucy Forsyth and Michel Prigent (London: Chronos, 1982).

94. For more on the orientation debate, see the appendices in Situationist International, *The Real Split in the International*, trans. John McHale (London: Pluto Press, 2003).

95. J.V. Martin also remained one of the last Situationists standing at the end, but played little or no part in its closing.

96. See Seidman's *Imaginary Revolution*.

6

The Shadow Cast by the Situationist International on May '68

Anna Trespeuch-Berthelot

From anniversary to anniversary, journalists, essayists, historians, and even some Situationists themselves, have continued to re-evaluate the role played by the Situationists during the May '68 protests. In May 1978, the French philosopher Régis Debray took it upon himself to honour 'Vaneigem and Debord, the only true geniuses of May'.[1] In 1989, Guy Debord had the great satisfaction of reading a university thesis on 'The Situationists and May '68'. Not long after, Debord organised for the thesis to be printed as a book with the Gérard Lebovici publishing house. Pascal Dumontier, the book's author, argues that 'the originality of the situationists' resides in its 'extremist and avant-gardist core of total contestation'.[2] It is, moreover, not uncommon these days to read that the Situationists inspired the 'spirit of May '68'. The historian Emmanuelle Loyer, for example, sees in the slogans of May '68 an 'innovative language inherited from the "situs"'.[3] For another historian, Bernard Brillant, Situationist ideas have had an undeniable impact on society: 'the radicality of their protest, their disdain, their iconoclasm, their provocation and the insolence they demonstrated towards their elders championed the feelings of many young people'.[4] In 2013, even the conservative newspaper *Le Figaro* endorsed the idea that the Situationists had assumed responsibility for May '68: 'Debord often stated that it was he and his colleagues who kicked off the events of May '68.'[5] These posthumous discourses have formed a palimpsest that has contributed to obscuring, even concealing, the real role played by the Situationists in the French uprising of May–June 1968. That is to say, the actual role of the Situationist International (SI) has become confused with the more nebulous influence of Situationist ideas on the people who took to the streets during May and, later, with the memory of the event itself.

It is necessary therefore to reconsider the way in which the history and reception of the movement came to be problematically intertwined in the aftermath of May '68. This issue is part of the historical debate that has taken place over the 'long '60s' and broken with a certain essentialisation of the months of May and June 1968. The 'events' of '68 have to be placed in the context of a longer period in order to show that they were both the emergent and explosive face of underground refusal that gnawed away at Western society in the preceding two decades and the starting point for changes that these societies and their leaders in the 1970s increasingly felt to be more acceptable.[6]

The historical Situationists closed ranks during the spring of 1968. At the time, only Guy Debord, Raoul Vaneigem, René Viénet and Mustapha Khayati represented the organisation in Paris. Nevertheless, the Situationists had established a large number of connections in the anarchist milieu in the preceding years, in particular among students at the universities of Strasbourg, Nanterre, Nantes and Bordeaux. The Situationists became involved in the student protests thanks to the intermediary of the Enragés, a group of young militant anarchists that had formed on the fringes of the 'March 22 Movement', at Nanterre University. The appearance of one of these Enragés, René Riesel, on 6 May 1968, in front of the University Council was one of the sparks that would soon ignite the occupation of the Sorbonne on 13 May. A 'Situationist International–Enragés Committee' was formed the day after in the university building and took up residence in the Cavaillès Room (quickly renamed the Jules Bonnot Room in honour of the anarchist thief). René Riesel was elected that same night, 14 May, to the Sorbonne Occupation Committee by the General Assembly. Strengthened by this democratic legitimacy, the committee increased its external communications: diffusing tracts, *détourné* comics, slogans through loudspeakers and on the walls of the Sorbonne and, perhaps most audacious of all, *détournements* that defaced the oil paintings that hung on the walls of the venerable old lecture halls.

René Riesel lost his mandate after only four days of taking part in the 'Student Commune'. The situation was such that the 'Situationist International–Enragés Committee' decided to leave the Sorbonne. On 19 May its members migrated to a different locale, some 200 metres away from the Sorbonne and the Panthéon, on the rue d'Ulm. Here they took up residency in the basement of the National Pedagogic Institute, where they assembled together a group of just under thirty members under the new rubric of the 'Committee for the Maintenance of the Occupations'

(CMDO). The CMDO brought together the original group of old hands with contacts from the anarchist milieu, most notably, workers from the print and aviation industries, as well as some sympathising students and their friends. This geographical migration also marked a shift in the Situationist struggle away from the student world towards the cause of the working class. In a tract from 19 May, the CMDO states:

> The student struggle has now been superseded. [...] The future of the current crisis is in the hands of the workers themselves, if they manage to realise in the occupation of their factories that which the occupation of the universities could only sketch out.[7]

In an 'Address to all Workers' from 30 May, the CMDO calls upon workers to create councils, to organise themselves outside of the political parties and unions, and to revolutionise their everyday lives. But did the CMDO really play a major role in establishing links between the different factory occupations that spread out from the Sud Aviation occupation that occurred in the Nantais region on 14 May? Although the group requisitioned around a dozen cars for a 'liaison commission', these were mainly used for diffusing Situationist tracts and posters in the factories. The two other 'commissions', the 'printing commission' and 'procurement commission', printed CMDO publications and made sure the group was furnished with enough paper, petrol, food and wine, respectively.[8] CMDO members, moreover, certainly participated regularly in the workers' social movement. Christian Sebastiani, a young CMDO recruit, was, for example, arrested on 10 June while on a march at the Flins factory that had been organised by the National Union of Students of France (UNEF). René Viénet, similarly, took part in the student–worker action committee in university centre of Censier.[9]

The CMDO, however, had neither the logistical means, nor the numbers, nor even the necessary time, to do much more than spread propaganda. The French intelligence agencies, much like the press, paid very little attention to the CMDO in their inquiries and in the immediate account of events. Nevertheless, the Situationists and their comrades were under the impression that they were under constant surveillance. As one member, Jacques Le Glou attests:

> The days were packed. We started off with theoretical debates, then we went to give the CGT unionists a wallop and, on top of that, we had

the cops on our arses. We didn't sleep much, letters were nicked, tele-phones tapped, we were followed during the day. We had to move every night. Guy said that one day soon there would be a round up and we'd be the first, so we spread ourselves about, invented codes and names. It was a really hectic time, really subversive [...].[10]

Disturbed by this police threat, on 15 June 1968 the members of the CMDO decided to dissolve the group and to disperse. The Situationists found refuge in Brussels at the house of Raoul Vaneigem. There they put together their account of these insurrectional weeks, which appeared in November 1968 published by the prestigious publishing house Gallimard with the title *Enragés and Situationists in the Occupation Movement, France, May '68*.[11]

If, on the one hand, the direct political impact of the SI on the events of May–June 1968 was limited, on the other hand, the place that they occupy in the iconography and in the collective imaginary of this period, not only in France but also abroad is quite remarkable. Situationist ideas and slogans shocked and fascinated. Since its first publication in Strasbourg on 22 November 1966, the Situationist pamphlet *On the Poverty of Student Life* had circulated widely in French universities, as well as Italian and British ones. Readers were struck by the radicality of a discourse that argued 'the student in France is, after the policeman and the priest, the most uni-versally despised', that art is dead, that the university is the 'institutional organisation of ignorance' and that 'all of these lecturers [are] idiots' or even that peace in Vietnam is no more than a 'pontifical call to order'. Overturning the ideological reference points at the heart of the protest movement, the pamphlet often played the role of enticing a readership that quickly went on to other Situationist texts: specifically, the eleven issues of the *Internationale situationniste* (*IS*) journal that had come out before October 1967 and, later, the two essays that appeared in November 1967, *The Society of the Spectacle* by Guy Debord and *The Revolution of Everyday Life* by Raoul Vaneigem.

Evidence for the circulation of these ideas during May–June 1968 can be seen in the way in which formulations from these works popu-lated the visual and auditory universe of protesters in the form of Situationist-inspired slogans and graffiti. The Palais Universitaire Stras-bourg, for example, was adorned with two citations, written in large letters, taken directly from *The Revolution of Everyday Life*: 'We do not want a world where the guarantee of not dying from hunger is exchanged for

the certainty of dying of boredom' and 'Those who speak of revolution
without wanting to change everyday life have a corpse in their mouths.'[12]
In a September 1969 issue of *Internationale situationniste*, the Situationists
themselves claimed to have been the authors of a famous piece of graffiti,
'Never work', that had been photographed on a wall of the Port-Royal
boulevard in Paris (reproducing a gesture performed on the rue de Seine
by Guy Debord in 1953 and reprinted in the eighth issue of *IS* in January
1963). Walter Lewino, a close friend of the SI, who published the first pho-
tographic account of the inscriptions that appeared on the walls of Paris
between 1 and 16 May, made sure to note the 'situationist' inspiration of
those slogans, such as: 'Consume more, you'll live less' and 'Alienation
behind here'.[13] These slogans correspond completely with an aspect of Sit-
uationist critique, touching upon a cultural revolution that is envisaged on
the level of the subject, calling for passion, hedonism and creativity. They
are, in other words, the privileged themes of Raoul Vaneigem, which had
a large audience not only in France but also abroad, particularly in Italy.[14]

Contrary, however, to the image that has since been forged of them, the
Situationists themselves privileged more strictly 'political' slogans during
the May '68 occupations movement. They hammered home their critique
of the official left through menacing telegrams sent to the offices of the
Soviet and Chinese Communist parties: 'TREMBLE BUREAUCRATS
STOP THE INTERNATIONAL POWER OF THE WORKERS COUNCILS
WILL SOON TOPPLE YOU STOP'. Likewise, the majority of the watch-
words that the SI aimed at insurgents on a 16 May tract are largely
'political' in nature:

> Occupy the Factories. Power to the Workers' Councils. Down with Spec-
> tacular Commodity Society. Abolish Class Society. End the University.
> Live without Dead Time, Pleasure without Limits. Abolish Alienation.
> Death to Pigs. Also Liberate Those Four Who Were Condemned for
> Pillaging on 6 May.[15]

The reception of Situationist iconography suffers from the same
ambiguity. Having emerged from the artistic avant-garde, the Situationists
distinguished themselves from other political groups with aesthetic codes
that they had elaborated and honed since 1957, both to furnish a practical
critique of the 'spectacular-commodity system' and in order to escape the
process of recuperation by it.

The Situationists disseminated playful, sometimes self-referential, *détournements*. At the Sorbonne, for example, on 13 May, René Viénet defaced a portrait of Cardinal Richelieu with, in the form of a speech bubble, the words: 'Humanity will not be happy until the day when the last bureaucrat has been hanged with the guts of the last capitalist.' The next day, 14 May 1968, the Situationists posted up a *détournement* of a softcore porn image of a woman holding her breasts while whispering: 'Aaaahhh the Situationist International!!! Can permitted pleasures hold a candle to the far juicier, immeasurable, pleasures that are brought together through the breaking of social restrictions and the overturning of all laws?' The SI, moreover, claim to have created around fifty *détourné* comics. This form of expression would spread among their disciples outside of Paris. One such *détournement*, created by a group in Toulouse, shows Tarzan joining striking workers beneath a tagline taken from *The Revolution of Everyday Life*: 'Those who only do half a revolution dig their own graves ...' In June 1968, the CMDO even turned to writing songs in order to promote its main themes (including the Paris Commune of 1871 as festival, the con-demnation of political parties and unions, the glorification of a politicised *blousons noirs*, hedonism versus survival).[16]

Nevertheless, Situationist materials that had a wider circulation mostly share the more sober visual language of standard militant production. Nothing figures in the three CMDO texts of 16 May, in the 19 May 'Report on the Occupation of the Sorbonne', nor in the tracts that followed other than typewritten text. Likewise, the six signed CMDO posters contrast with the dominant spontaneity of the moment. Moreover, at the same time that the Decorative Arts and Beaux-Arts workshops were producing a long series of artisanal serigraphs on newspaper-quality paper (and, albeit more rarely, beautiful lithographs like those of Asger Jorn), the Situation-ists went instead with slogans in white type on a black background. These slogans, strictly rooted in the Marxist tradition, call for a complete over-turning of the political and social order:

> Power to the Workers' Councils. What can the revolutionary movement do now? Everything. What will it become in the hands of the parties and bureaucrats? Nothing. What does it want? The realisation of a classless society through the power of Workers' Councils.

The ambivalent image that the Situationist International gave of itself in its material production in the spring of 1968, between spontaneous

creativity and traditional Marxist militancy, came to define its reception in the years that followed. Although the SI sought to exist within the leftist constellation as a revolutionary councilist group, it was perceived more as the avant-garde of French counterculture. The Situationists sought to combat this misunderstanding, but it ultimately contributed to the decline of the group, which Debord finally dissolved definitely in 1972.

At the very moment when the Situationists' subversive activities started to be taken seriously by the French intelligence services, the SI became an empty shell. Debord, in *The Real Split in the International* (1972), blamed the group's collapse on those disciples who had been unable to understand the Situationist project correctly. Indeed, as is often the case with cultural transference, Situationist writings, the circulation of which accelerated in France and abroad after May '68, were subject to a number of misinterpretations. Although the SI had pushed for a councilist revolution through political action, a good number of its readers retained only its opposition to the dominant cultural order. In Dusseldorf, for example, a couple, Susi Schlueter and Stephan Holger, had a revelation upon reading *The Revolution of Everyday Life*. They found in it everything that they had experienced: 'work, survival, separation, fragmentation'.[17] Not only did they take on the task of translating and publishing *The Society of the Spectacle* and *The Revolution of Everyday Life* into German, they also founded a commune in an old farm in the south of France. The latter was understood as a 'kind of experimental castle', with Raoul Vaneigem taken as its main source of intellectual inspiration.[18] This unforeseen alchemy between Situationist critique and hippy communitarianism (in which freedom from consumerism and social mores dominated) completely escaped the control of the Situationists themselves. Likewise, Californian pro-Situationists, steeped in 1960s counterculture (psychedelic drugs, rock music, communitarian life and so on) developed a surprising interpretation of the Situationists. As Ken Knabb recounts, 'we sort of imagined the SI as really like a commune in the American sense, that is, a small thing where you share everything, and also perhaps in the American sense, these things mixed with a "group culture", group psychology where you debate …'.[19]

Beyond the pro-Situ circles, the post-'68 media reception of the SI created above all the image of a countercultural movement. Between 1971 and 1973, articles in the press multiplied. The SI was presented not as a revolutionary group but as an 'ancestor',[20] the theorists of the liberation of social mores that came out of May '68: those of desire, imagination, language, play, festival, creativity. The critique of culture and of everyday

life that they developed in the 1950s even became a source of national pride to the extent that it emerged before that of the Frankfurt School, which inspired Anglo-Saxon counterculture.

The signs that the SI spread in May '68 are above all ambiguous. The group carefully sought a third way between theory and practice, between revolution through culture and revolution through workers' councils. Between 1969 and 1971, it chose to become a revolutionary organisation among others, and it worked, like its sister groups, to make something out of May '68. Then it entered into an ineluctable crisis and was rediscovered, against its own will, as a countercultural movement. The inheritors of the 'spontaneity' of May stole from the SI its subversive tools without taking its theory and its revolutionary goals. The heritage that the Situationists handed down in 1972 therefore left itself wide open to the process of integration into dominant culture.

Notes

1. Régis Debray, *Modeste contribution aux discours et cérémonies officielles du dixième anniversaire [de mai 68]* (Paris: Maspero, 1978), pp. 66–7.

2. Pascal Dumontier, *Les Situationnistes et mai '68: théorie et pratique de la révolution (1966–1972)* (Paris: Ed. Gérard Lebovici, 1990; reprint Paris: Ivrea, 1995), p. 217.

3. Emmanuelle Loyer, *Mai '68 dans le texte* (Bruxelles/Paris: Complexe, 2008), p. 164.

4. Bernard Brillant, *Les Clercs de '68* (Paris: PUF, 2003), p. 73.

5. Sébastien Lapaque, 'Guy Debord, info ou intox?', *Le Figaro*, 26 March 2013.

6. See G. Dreyfus-Armand, R. Frank, M.-F. Lévy and M. Zancarini-Fournel (eds), *Les Années '68: le temps de la contestation* (Paris: Complexe/IHTP, 2000); Philippe Artières and Michelle Zancarini-Fournel, *'68, une histoire collective 1962–1981* (2008) (Paris: La Découverte, 2018); Ludivine Bantigny, *1968: de grands soirs en petits matins* (Paris: Seuil, 2018); Gerd-Rainer Horn, *The Spirit of '68: Rebellion in Western Europe and North America, 1956–1976* (Oxford: Oxford University Press, 2007).

7. CMDO, 'Rapport sur l'occupation de la Sorbonne', 19 mai 1968: Situationist International archives, first microfilm, dossier 'documents originaux', file '1968', International Institute of Social History (IISH), Amsterdam.

8. René Viénet, *Enragés and Situationists in the Occupation Movement, France, May '68*, trans. Richard Parry and Hélène Potter (London: Rebel Press, 1997), p. 168.

9. Yves Le Manach to Henri Simon, 5 February 2002. Le Manach archives, dossier 'Yves Le Manach supplément 2003', IISH, Amsterdam.

10. See Jacques Le Glou on *Tout arrive* (radio programme), France Culture, 12 October 2005.

11. Gallimard had published Vaneigem's *The Revolution of Everyday Life* the previous winter.

12. See Pierre Feuerstein, *Printemps de révolte à Strasbourg, mai–juin 1968* (Strasbourg: Saisons d'Alsace, 1968).

13. Walter Lewino, *L'Imagination au pouvoir: Photographies de Jo Schnapp* (Paris: Eric Losfeld éd., Le terrain vague, 1968).

14. See Luisa Passerini, 'Le mouvement de 1968 comme prise de parole et comme explosion de la subjectivité: le cas de Turin', *Le Mouvement social*, 143, special issue *Mémoires et Histoires de 1968* (avril–juin 1988): 39–74.

15. Comité d'Occupation de l'Université autonome et populaire de la Sorbonne, 'Mots d'ordre à diffuser maintenant par tous les moyens', 16 mai 1968, 19h: Situationist International archives, IISH, Amsterdam.

16. 'Chanson du C.M.D.O.', in *Pour en finir avec le travail*, CD 33 tours (éd. musicales du Grand Soir, distribution RCA, 1974, réédition E.P.M. musique en 1998), reproduced in Debord, *Œuvres* (Paris: Gallimard, 2006), p. 903.

17. Tony Verlaan's account of his meeting with the Projektgruppe Gegengesellschaft, addressed to all sections, 19 July 1970: Situationist International Archives (paper), dossier 'Editors; strategie debate; corr. with outsiders', file 'Corresp. with outsiders', IISH, Amsterdam.

18. Ibid.

19. Author interview with Ken Knabb, 9 October 2008.

20. 'Les grandes gueules de la petite Internationale Situationniste', *Actuel*, no. 3 (décembre 1970).

7

The Situationists' Anti-colonialism: An Internationalist Perspective

Sophie Dolto and Nedjib Sidi Moussa

Introduction

In 1997, two former members of the Situationist International (SI) commented on the legend created around one of its founders, Guy Debord, which tended to eclipse the political work produced by the group:

> Who would ever have thought [...] that the SI as pictured by established wisdom had time [...] for analyses of political events in the world outside? For example, the series of interventions in the evolving situation in Algeria, at the time of Ben Bella and Boumedienne, culminating in the long article 'Les luttes de classes en Algérie'.[1]

One might add: what is the lasting significance of these analyses and their history? In 2013, for example, the Guy Debord exhibition at the Bibliothèque Nationale de France was silent about his links with Algeria, which existed from the beginning of the Lettrist International (LI) up until his death in 1994. The contacts between the SI and groups involved in anti-colonial struggles, in the Congo for example, have also yet to be fully explored. The marginal space occupied by the SI in the political milieu and in the anti-colonial struggles of its time partially explains these grey areas. In fact, the group's activities rarely overlapped with those of major French workers' organisations, any more than they did with those of nationalist anti-colonial parties. This situation made the SI, despite its limited audience, a unique pole of attraction and convergence for individuals from colonised countries sharing its radical views, such as Algerians Mohamed Dahou and Abdelhafid Khatib, Tunisian Mustapha Khayati or

Congolese Ndjangani Lungela. Gathering first-hand information, these members formed opinions on anti-colonial struggles that contrasted with the mainstream leftist perspectives of the time, as well as with Communist and nationalist orthodoxies.

The decolonisation of Algeria, a major event in the twentieth century, particularly in France, constituted an obvious starting point for the SI's political formation. As the process unfolded, it remained a central issue for the group, but also a point of comparison for other theoretical analyses. Since the goal of this internationalist revolutionary group was to define the potentialities of the worldwide abolition of class society, neither Algeria, nor 'underdeveloped' countries, nor any country fighting for its emancipation had a monopoly over what 'the real movement that abolishes the current state of affairs' would look like. The history of the SI's relationship to anti-colonial movements is thus intrinsically linked to their analysis of modern capitalist society. This chapter, based on LI and SI publications, on Debord's correspondence and films, as well as on post-Situationist and left-communist texts, intends to retrace exchanges and perspectives developed within this current about and around anti-colonial issues, in order to help define the internationalist nature of their contribution.

1953–58: the Algerian Paris of the Lettrist International

Sources show that Debord and his companions were involved with the Algerian community from the creation of the Lettrist International (1952–58). Not only did they closely follow the unfolding political situation in Algeria and its anti-colonial movements, they were also eager to establish contacts with the Algerian diaspora in Paris. Rue Xavier-Privas, a small street in the Latin Quarter, bears the memory of these encounters,[2] since it hosted not only the headquarters of the Movement for the Triumph of Democratic Liberties (MTLD, the main Algerian independence party in 1953) but also a Kabyle bar where the LI had its 'committee room'. While other groups met with members of the North African community in their workplace, the Lettrists were interested in knowing and sharing their 'everyday life', as a 1953 text suggests: 'Just ask the Algerian workers at the Renault factory where their free time is, and their country, their dignity, and their wives. Ask them what they have to hope for. The social struggle must not be bureaucratic; it must be passionate.'[3] In Arab cafés and bars in the French capital, major venues of social and political interactions among the Maghreb diaspora, or during long nights of *dérive*, the

Lettrists crossed paths with various fringes of the North African popula-
tion, hoping in equal measure to share a *passionate life* with some of them,
or to build political alliances. The latter are mentioned in 'The Right to
Respond', where the LI calls for retaliation against the far-right riots of 14
July 1953 and urges alliances with the 'combative minority' of 'the North
African workers', whose 'street-fighting techniques are equal or superior to
those of highly trained paramilitary groups'.[4] They add knowingly: 'Many
neighborhood Algerian cafés filled with unemployed workers have been
spontaneously transformed into local headquarters.'

Mohamed Dahou is at the heart of the LI's Franco-Algerian exchanges.
The official director of the LI journal *Potlatch* from 1954 to 1955, he is a
central figure of the group and a controversial legend even makes him the
inventor of the term 'psychogeography'. In April 1953, along with Cheik
Ben Dhine and Ait Diafer, Dahou published the 'Manifesto of the Algerian
Group of the Lettrist International', which states:

> No one dies of hunger, thirst, or life. One dies only by giving up. […]
> We are now aware of the eminently regressive nature of all wage labour.
> The non-resolution of complex problems implies a waiting period
> during which any practical action is an act of cowardice because life is
> obliged to have an asymptotic and benevolent character.[5]

Despite its name, the text is more 'Lettrist' than 'Algerian'. In the political
context of 1954, it obviously signals the LI's support for the Algerian insur-
gents, but it does so on specific terms and conditions: anti-militarism,
self-organisation, and the critique of work. In a similar fashion, in
1954, Dahou released the 'Notes for an Appeal to the East', a powerful
anti-colonialist and anti-nationalist text which sets forth class-based
principles:

> It is necessary to go beyond any notion of nationalism. North Africa
> must liberate itself not only from foreign occupation, but also from its
> own feudal masters. We must recognise as our country any place where
> an idea of freedom we judge adequate prevails, and there only.[6]

At the beginning of the text, Dahou mentions the failure of the 1952
Egyptian revolution and the fact that its 'textile workers [were] shot
because of their "communism"'. He describes the opposition of 'rival
nationalisms' as a deceitful diversion by 'capitalist powers' and concludes:

'Our brothers are beyond issues of frontier and race. Some antagonisms, such as the conflict with the State of Israel, can be resolved solely by a revolution in both camps [...] What we must say to the Arab countries is this: "We have a common cause. There is no West confronting you."'

Dahou was the point of contact between Paris and the 'Algerian group' of the LI.[7] The most significant accounts of these exchanges followed the 1954 earthquake in Orleansville, 'the most Lettrist city in the world'.[8] The Parisian Lettrists, who went to Orleansville to help their comrades, witnessed the attitude of the French colonial state and denounced the 'official project to rebuild indigenous housing outside the city', which was nothing short of a 'premeditated ghetto'. The subsequent issue of *Potlatch* reported on the joint intervention of French and Algerian Lettrists, 'a very violent agitation'.[9]

In France, the LI's support for the Algerians' struggles left such concrete traces as their denunciation of the police's repression and intimidation strategies and their support for Pierre Morain, the first Frenchman imprisoned for his pro-Algerian engagement.[10] They denounced the 'caste of the respectable specialised anti-colonialists'[11] and bourgeois intellectuals who 'played the revolutionaries' but whose practical actions did not measure up to their writings, including the Algerian writer Kateb Yacine, 'an impostor' trying 'to establish his fame as a writer' in the midst of a combative political climate.[12]

1958–72: The Situationist International and the aftermath of Algerian independence

With the end of the LI and the birth of the SI, the Franco-Algerian ties dwindled. The 'Algerian section' of the SI is not mentioned after 1958, and Dahou and Khatib resigned from the group. But textual and biographical elements point to ongoing discussions among the SI around anti-colonial struggles in Algeria.

Although extremely critical of the French anti-colonialists 'unconditionally placed at the disposal of the NLF [National Liberation Front] leadership',[13] the SI did not openly critique Algerian nationalism between 1958 and 1962. On the contrary, they denounced the 'non-intervention' of the left. By signing the 'Declaration on the Right to Insubordination in the War in Algeria', Michèle Bernstein (then married to Debord) and Debord showed that it was crucial to support resolutely Algerian insurgents and imprisoned French anti-colonialists, despite the political perspectives of

other signatories, who 'in no way [stood] for some avant-garde politics'. They explain:

> But all those who in the circumstances declined to support the indivisible cause of freedom for the Algerians and for the indicted French intellectuals have, on the contrary, underwritten the fact that whatever claims they might make to be engaging with some kind of 'avant-gardism' deserve to be greeted in every case with nothing but laughter and scorn.[14]

However, after the proclamation of a ceasefire in Algeria and as the 'race for power' started among Algerian nationalist leaders, the SI became increasingly vocal about the movement's counter-revolutionary outcome. The gap between the euphoria of independence and the disarray caused by the rise of an authoritarian and repressive state is described in a text on the first months of independence and on the NLF's 'terrorist ideology of monolithism'. The text concludes:

> On 2 January [...] the Algerian Press Service revealed that the fighting in September had left more than 1,000 people dead. Two or three days later, the same agency corrected its mistake and reported about ten dead. These two figures in succession are enough to show that a modern state is now in place in Algeria.[15]

The 1965 pamphlet, 'Address to the Revolutionaries of Algeria and All Countries', following the overthrow of Ben Bella by Boumediene, states that 'revolutionaries are everywhere, but nowhere is there any real revolution', thus opposing those who, on the left, were still enthusiastic about Algerian independence. Furthermore, the critique of Ben Bella and his so-called revolutionary foreign policy led to a broader analysis of the take-over of struggles in colonised countries, in such forms as Fanonism, Castro-Guevarism, Nasserism, Titoism or Maoism, all ideologies in the service of 'new masters'. The SI thus began to work out a critique of Third Worldism:

> The problem of underdevelopment, which is fundamental, must be resolved on a worldwide scale, in the first place by the revolutionary domination of the irrational overdevelopment of productive forces stemming from capitalism's various rationalisations.[16]

In 'The Class Struggle in Algeria', the SI rejected the Leninist model that inspired the Algerian opposition and announces the opening of 'another period': 'the confrontation between the ruling class and the workers', where the latter would have to 'realize self-management'.[17] Eighteen months later, however, the SI considered that 'no revolutionary network has successfully taken form on the basis of offensive resistance in the self-managed sector', also admitting that their 'own direct efforts toward this goal have been extremely inadequate'.[18]

As the case of Algeria suggests, the question that lies at the heart of the SI's work on anti-colonisation is whether the emancipation of these countries could trigger, or at least coincide with, an internationalist revolution. Uncompromisingly critical of any attempt by underdeveloped countries to join the 'race to catch up with capitalist reification', the Situationists also denounced the passivity of the West regarding its own revolution:

> Apocalyptic fears or hopes regarding the movements of revolt in the colonized or semi-colonized countries overlook this central fact: the revolutionary project must be realized in the industrially advanced countries.[19]

According to Debord, the French left displayed 'the most striking excesses of incomprehension'[20] regarding Algeria and failed to achieve solidarity 'among revolutionaries' of both countries because it also failed to organise its own revolution. By contrast, actual 'communal action' could have brought insurgents from France and Algeria to build internationalist strategies.

The Situationist International and the Congo

Between 1960 and 1966, the independence of the Congo and its counter-revolutionary developments were another important focal point for the SI, mentioned regularly in the journal[21] and in Debord's films.[22] The fact that Belgium, the colonial power in the region since 1878, was one of the main centres of the SI, partly explains this interest. Debord's desire to establish ties with radical Congolese groups might be described as an attempt to internationalise the type of exchanges that existed between France and Algeria. But the Congo crisis as such also represented 'an essential experimentation with the revolutionary conditions in the Third

World'. In a letter to André Frankin, member of the Belgium Situationist group, Debord comments on the 'unfolding of the conspiracy' whereby the Kasai and Kivu provinces joined forces with Moise Tshombe's Katanga secessionists in 1960, supported by the Anglo-Belgium mining company UMHK, which had vital holdings in Katangese copper. Debord admires the attitude of Patrice Lumumba, first Prime Minister of the newly independent Democratic Republic of Congo (DRC), who made 'the right choice by always siding with the masses who overwhelmed him' but 'the most likely prospect is that those who have recently pushed for extended secession will have Lumumba assassinated [...] because it is all too clear that he will never accept the division of the Congo, of which he is the legitimate representative, into two equal parts'.[23] Lumumba's ability to act uncompromisingly in this moment is cited as a counter-example to the 'incomprehension' of 'non-intervention'. Recalling the avant-garde origins of the group, two texts focus attention on the 'poetry' of the Congolese revolution, arguing that 'realizing poetry means nothing less than simultaneously and inseparably creating events and their language'.[24]

Although Emmanuelle Chérel also mentions the presence of the Congolese Joseph M'Belolo M'Piko, who is said to have written a revolutionary chant in 1968,[25] only Ndjangani Lungela appears on the official SI members list, in its French section until 1967. Lungela probably took part in Debord's project to gather 'direct information' and 'make a pamphlet about the civil war in the Congo',[26] which eventually became the 1966 text 'Conditions of the Congolese Revolutionary Movement',[27] which remained unpublished however until 2006. Debord's correspondence does indeed mention contacts during the year 1965 with 'radical minorities in the Congo',[28] more specifically 'Muleleist students',[29] as well as 'a series of strokes of luck' in the group's 'relations with Sub-Saharan Africa',[30] and at least two[31] encounters with Anicet Kashamura, a former member of Patrice Lumumba's government. However, the collaboration with Kashamura did not succeed, and Debord wrote to Vaneigem that it was 'totally impossible to join forces with him [...] in a revolutionary proclamation'.[32] This suggests that Debord's initial hope was for the text to be co-written with Congolese radical contacts and circulated in the Congo, on the model of the 1965 'Address', which was launched in Algeria as a pamphlet before being published in France. The 1966 unpublished text on the Congo does in fact share the affirmative tone and the internationalist perspective of its 'Algerian' counterpart:

The revolutionary movement in the Congo is inseparable from a pan-African revolution, which is in turn inseparable from the real global abolition of all class division – the fundamental division in a form of society now spread across the whole earth and the root of all national and racial conflicts.[33]

Although the text was not published in 1966, a comparative analysis shows that significant parts were used for Khayati's 1967 'Setting Straight Some Popular Misconceptions about Revolutions in Underdeveloped Countries'.[34] The common passages illustrate the Situationists' intention to produce 'a vast work'[35] on the counter-revolutions of the 1960s, in which a 'local ruling class achieves a measure of independent domination, but solely for *itself*', all the while remaining under the sway of 'foreign powers' and 'subordinate to the aims of global industry'. Recalling the 'Address', Khayati's text states that 'the rush to catch up with capitalist reification remains the best road to reinforced underdevelopment', a perspective also present in *Révolution internationale*, which asserts that 'it is a hoax cleverly maintained by capitalist ideology … to present each nation of the Third World as a potential nineteenth-century England'.[36] In a letter to Béchir Tlili, Debord suggests that the only revolutionary option for a 'small country outside the two blocks' like the Congo or Cuba would be to 'expose publicly and completely its conception of world revolution, and thus to address the masses in the East rather than their rulers'.[37]

Israel and Vietnam, beyond anti-colonialism

From this global revolutionary perspective, the Situationists take stands on conflicts dividing the political class. In 'Two Local Wars',[38] Khayati describes the Arab-Israeli war as 'a dirty trick [played] on the good conscience of the Left'. He reiterates Dahou's 1954 affirmation that 'certain oppositions, such as the conflict with the State of Israel, can only be resolved by a revolution in both camps',[39] or that of the 1965 'Address': 'The repressive forces of the state of Israel can be undermined only by a *model of revolutionary society realized by the Arabs*.'[40] The first critique is directed against Zionism, 'the contrary of a revolutionary solution', which 'did not strive to abolish injustice, but to transfer it'. The text states:

The revolutionary workers' movement saw the answer to the Jewish question in proletarian community … the emancipation of the Jews

could not take place apart from the emancipation of humanity. Zionism started from the opposite [assumption].[41]

On the other hand, the text declares that the general situation in the region 'has been constantly maintained and aggravated by the surrounding Arab societies' and their ruling classes, which recuperated the 'armed insurgence of 1936–1939 and the six-month general strike' in Palestine. They made 'reactionary compromises' that had devastating effects, including the rise to power of Nasser and of a 'new exploiting class'. Nevertheless, Khayati puts his hopes in the 'future Arab revolutionary forces' and 'resolutely internationalist and anti-state' perspectives, which might 'dissolve the state of Israel while gaining the support of that state's exploited masses'. This position finds echoes in left-communist journals of the 1970s, such as *Guerre de classes*[42] or *La Jeune Taupe*,[43] which critique the mainstream left's support of Arab states, proclaiming the 'right of peoples to self-determination', when it should promote 'the radicalisation of the Arab peoples and, later, their fight to put an end to all kinds of exploitation'.[44]

Further on in the text, Khayati compares and opposes the Arab-Israeli war to the situation in Vietnam, where the peasants' liberation struggle was also recuperated for 'the interests of the rising state'. But in this case, the National Liberation Front's victories 'provoked the increasingly massive intervention of the Americans', which reduced the conflict 'to an open colonial war'. Khayati concludes:

It is first of all necessary to put an end to the American aggression in order to allow the real social struggle in Vietnam to develop in a natural way; i.e. to allow the Vietnamese workers and peasants to rediscover their enemies at home: the bureaucracy of the North and the propertied and ruling strata of the South. [...] The point is not to give unconditional (or even conditional) support to the Vietcong, but to struggle consistently and uncompromisingly against American imperialism. The most effective role is presently being played by those American revolutionaries who are advocating and practising insubordination and draft resistance on a very large scale.[45]

The Watts riots

A parallel can be drawn between the SI's writings on anti-colonial struggles and those on the revolts of black proletarians in the United

States, the most emblematic of which was 'The Rise and Fall of the "Spectacular" Commodity Economy', on the 1965 Watts riots. According to Debord, Watts foretold the 'crumbling of the social spectacle ruling at its American pole',[46] and represented a step towards the rebirth of a revolutionary momentum in developed countries. His analysis of the Watts riots as 'human protest against an inhuman life',[47] an 'escape [from one's] own servitude'[48] and a 'criticism in acts'[49] of modern society resonates with the 'Minimum Definition of Revolutionary Organisations' adopted by the 7th Conference of the SI in July 1966, which tied the 'supersession of the commodity system and of wage labor'[50] to a 'complete decolonization of everyday life'. This take on modern-day colonisation also resonates with Debord's 1966 text on the Congo:

It is important to understand that the colonisers were themselves colonised: at home, in their own lives, by virtue of all industrial society's powerful activity, which can, at any moment, turn like an enemy against the masses of workers who generate it, who never master it but who on the contrary are always mastered by it.[51]

According to Debord, Watts was therefore 'not a racial conflict', but a 'revolt' against 'a world of commodities' which subordinates everyone and everything to its logic. It affects black people as well as white people, but the necessity for the commodity and for the spectacle 'to be at once universal and hierarchical' leads to a 'universal imposition of hierarchy' which remains 'unacknowledged' because it is 'irrational'. This unacknowledged hierarchising process produces 'crazy ideas and grotesque values' namely 'racisms everywhere' and resembles 'modern-day colonisation':

The barbarians are no longer at the ends of the earth: they are right here – barbarised, in fact, by this very same forced participation in hierarchical consumption. The humanism cloaking all this is opposed to humanity, the negation of human activity and desires; it is the humanism of commodities, the benevolence of the parasitic commodity towards its host.[52]

African Americans are thus 'not alone' in this revolt against the commodity's 'inhuman humanism', because other strata of the American proletariat (including those who were 'advocating and practicing insubordination and draft resistance'[53] against the Vietnam war) are becoming increas-

ingly conscious that they are not 'the master[s] of [their] activity, of [their] live[s]'. According to Debord, 'this is why those whites who want to escape their own servitude must needs rally to the black cause'. But he adds 'not in a solidarity based on color, obviously, but in a global rejection of commodities and, in the last analysis, of the state'.[54]

Only a joint destruction of the commodity-form could break 'the economic and psychological gulf between blacks and whites'. Conversely, Debord foresees that 'if such an alliance were to be broken in response to a radicalization of the conflict, the upshot would be the development of a black nationalism and a confrontation between the two splinters exactly on the model of the prevailing system'.[55] He is especially critical of the Black Muslims' 'attempts to build a separatist or pro-African black nationalism', which offers 'no answer to the reality of oppression', and of the political agenda of the 'Black Power' star[56] (including Stokely Carmichael of the Black Panther Party) who are 'walking the tightrope between the vague and undefined extremism necessary to establish themselves at the head of the black masses [...] and the actual unavowed paltry reformism of a black "third party"'.[57]

Debord's critique resonates with that of *Pouvoir ouvrier*, which recalled in 1964: 'We were waiting for Malcom X to build a bridge between the struggle of the blacks and that of the oppressed workers, but apart from the violence with which he attacked the European colonialists in Africa and the American imperialism, his political analyses were non-existent or even racist',[58] or with *ICO*'s (*Informations Correspondance Ouvrières*) critique of the Black Panthers in 1972: 'No group, [...] whatever the acuity of its problems, has a privileged role in the future process of social transformation, [...] its struggle will only come to fruition if it fits into the struggle of all the oppressed.'[59] For them, as for the SI, none of these political groups had an actual revolutionary perspective, as they put forward a 'self-management of the existing world by the masses' for which the SI had criticised anti-colonial movements. In a similar fashion, Debord predicts that the black revolts in Watts, Detroit and Newark might be recuperated by a growing black political 'elite', 'like those that emerged out of the other American minorities (Poles, Italians, etc.)', thus reproducing the 'hierarchical conditions of the dominant world', rather than 'attack[ing] this world as a whole'.[60]

The SI's analysis of the social conditions of black people in America also echoes that of underdeveloped countries. Like *Révolution internationale*, which asserted that it was 'as illusory to conceive of a [capitalist system]

without underdeveloped countries as to imagine it without proletarians', the SI considers that the lower segments of the proletariat in developed countries are 'promised that, with patience, they will join in America's prosperity, but they realize that this prosperity is not a static sphere but, rather, a ladder without end'.[61] That perspective is emphasised nowadays by such groups as Endnotes, which writes: 'Inherited black disadvantage could only be overcome by challenging the basic workings of capitalist markets.'[62]

* * *

In 2015, Andrea Gibbons[63] rightfully pointed out that little is known about Dahou and Khatib's whereabouts after 1960. The argument she draws from this fact is however ill-informed. Large parts of the SI members' history are indeed unknown, and they will remain so unless they are actively dug out. But, as this chapter has tried to show, the LI's and SI's writings offer illuminating information about these groups' relationship to anti-colonial struggles and about their ties with members of colonised countries. Numerous texts from *Potlatch* and *Internationale situationniste* suggest that the Lettrists and Situationists were closely following and reacting to the unfolding political situations in Algeria and the Congo. Contrary to what Gibbons argues, they refused to close their eyes to the repression of revolutionary struggles, whether it came from the French colonial state, 'old feudal masters', or 'new exploiting classes'. But the SI's uncompromising internationalist perspective, in some regards at odds with current political views of the left, has been either forgotten or construed as a Eurocentric archaism, which might explain the enduring myth that the group was solely concerned with revolutionary movements in the developed world.

Notes

1. T.J. Clark and Donald Nicholson-Smith, 'Why Art Can't Kill the Situationist International', in *Guy Debord and the Situationist International: Texts and Documents*, ed. Tom McDonough (Cambridge, MA: MIT Press, 2002), p. 475.

2. SI, 'Proposals for Rationally Improving the City of Paris (1955)', in Situationist International, *Situationist International Anthology*, ed. and trans. Ken Knabb (Berkeley, CA: Bureau of Public Secrets, revised and expanded edition 2006), p. 12, 'Projet de statut économique du lettriste de base', in Guy Debord, *Œuvres* (Paris: Gallimard, 2006), p. 15.

3. Michèle Bernstein, André-Frank Conord, Mohamed Dahou, Guy Debord, Jacques Fillon and Gil J. Wolman, 'Le minimum de la vie', *Potlatch*, no. 4

(13 July 1954), reprint: Lettrist International, *Potlatch* (Paris: Allia, 1996), p. 17. Translated by the authors.

4. LI, 'The Right to Respond', *Potlatch* no. 4 (13 July 1954), reprint, p. 19. Translated by the authors.

5. Hadj Mohamed Dahou, Cheik Ben Dhine and Ait Diafer, 'Manifeste du Groupe Algérien de l'Internationale Lettriste', *Internationale lettriste*, no. 3 (August 1953). Translated by the authors.

6. Mohamed Dahou, 'Notes pour un appel à l'Orient' (Notes for an Appeal to the East), *Potlatch*, no. 6 (27 July 1954), reprint, p. 26. Translated by the authors.

7. LI, 'Nouvelle affectation', *Potlatch*, no. 1 (22 June 1954), reprint, p. 9.

8. LI, 'Les colonies les plus solides …', *Potlatch*, no. 12 (28 September 1954), reprint, p. 43. Translated by Bill Brown, accessed 12 April 2019, www.notbored.org/colonies.html.

9. LI, 'Après le séisme' (After the Earthquake), *Potlatch*, no. 13 (23 October 1954), reprint, p. 48. Translated by the authors.

10. LI, 'Les fellaghas partout' (Fellahin Everywhere), *Potlatch*, no. 17 (24 February 1955), reprint, p. 68.

11. LI, 'Rien d'étonnant' (Nothing Surprising), *Potlatch*, no. 26 (7 May 1956), reprint, p. 128. Translated by the authors.

12. Abdelhafid Khatib, 'L'expression de la révolution algérienne et l'imposteur Kateb Yacine' (The Expression of the Algerian Revolution and the Impostor Kateb Yacine), *Potlatch*, no. 27 (2 November 1956), reprint, p. 134. Translation by the authors.

13. Letter from Guy Debord to Patrick Straram, 10 October 1960, in Debord, *Correspondance*, vol. 2, *septembre 1960–décembre 1964* (Paris: Arthème Fayard, 1999–2010), p. 13.

14. SI, 'La minute de vérité', *Internationale situationniste (IS)*, no. 5 (December 1960): 5–7. Translated by the authors.

15. SI, 'Renseignements situationnistes', *IS*, no. 8 (January 1963): 66. Translated by the authors.

16. SI, 'Adresse aux révolutionnaires d'Algérie et de tous les pays', *IS*, no. 10 (March 1966): 43–9. Translated by the authors.

17. SI, 'The Class Struggles in Algeria', in *Situationist International Anthology*, p. 206.

18. SI, 'Three Postscripts to the Previous Issue', in *Situationist International Anthology*, p. 287.

19. SI, 'The Bad Days Will End', in *Situationist International Anthology*, p. 111.

20. SI, 'Communication prioritaire', *IS*, no. 7 (April 1962): 20–4. Translated by Reuben Keehan, accessed 13 April 2019, www.cddc.vt.edu/sionline/si/priority.html.

21. SI, 'Renseignements situationnistes', *IS*, no. 7 (April 1962): 51; 'Geopolitics of Hibernation', in *Situationist International Anthology*, p. 100.

22. Guy Debord, *Critique de la séparation* (1961) (Neuilly sur-Seine: Gaumont, 2005) DVD. As the film shows images of the 1960 Katanga secession riots, Debord's voice comments, 'This dominant equilibrium is brought back into question each time unknown people try to live differently.' Guy Debord,

Œuvres cinématographiques complètes (Neuilly-sur-Seine: Gaumont Video, 2005).

23. Guy Debord to Andre Frankin, 24 July 1960, in Debord, *Correspondance*, vol. 1. Translated by the authors.

24. SI, 'All the King's Men', in *Situationist International Anthology*, pp. 150–1.

25. Emmanuelle Chérel, 'The Intrigues of the Double Capture: The Counter-game at the Game of War' (in French), Penser depuis la frontière website, accessed 28 March 2019, http://penserdepuislafrontiere.fr.

26. Guy Debord to Mustapha Khayati, 21 December, 1964, in Debord, *Correspondance*, vol. 0, p. 238. Translated by the authors.

27. Debord, 'Conditions du mouvement révolutionnaire congolais' (Conditions of the Congolese Revolutionary Movement), in *Œuvres*, pp. 692–8.

28. Guy Debord to Chatterji, 7 January 1965, in Debord, *Correspondance*, vol. 3, p. 15. Translated by the authors.

29. Pierre Mulele was a member of Lumumba's 1960 government. After Lumumba's assassination, he led, with Antoine Gizenga, the 1964 'Simba Rebellion', based in Stanleyville, in opposition to the Congolese central government of Mobutu.

30. Guy Debord to Mustapha Khayati, 15 December 1965, in Debord, *Correspondance*, vol. 3, p. 95. Translated by the authors.

31. Guy Debord to Raoul Vaneigem, 29 November 1965, Guy Debord to Mustapha Khayati, 15 December 1965, *Correspondance*, vol. 3, p. 95, p. 102.

32. Letter from Guy Debord to Raoul Vaneigem, 29 November 1965. Translated by the authors.

33. Guy Debord, 'Conditions of the Congolese Revolutionary Movement'. Translated by the authors.

34. Mustapha Khayati, 'Setting Straight Some Popular Misconceptions about Revolutions in the Underdeveloped Countries', in *Situationist International Anthology*, pp. 281–5.

35. Guy Debord to Mustapha Khayati, 21 December 1964, in Guy Debord, *Correspondance*, vol. 0.

36. 'Les luttes de "libération nationale"' ('National Liberation' Struggles), *Révolution internationale*, no. 1 (December 1972): 12–16. Translated by the authors.

37. Guy Debord to Béchir Tlili, 8 September 1963, in Guy Debord, *Correspondance*, vol. 2, p. 254. Translated by the authors.

38. Mustapha Khayati, 'Two Local Wars', in *Situationist International Anthology*, pp. 281–5.

39. Mohamed Dahou, 'Notes for an Appeal to the East'. Translated by the authors.

40. 'Address to Revolutionaries of Algeria and of All Countries', in *Situationist International Anthology*, pp. 192–3.

41. Mustapha Khayati, 'Two Local Wars', pp. 257–8. Translation edited by the authors.

42. 'The Arab-Israeli Conflict: A Conflict for the Exclusive Benefit of Capital' (in French), *Guerre de classes*, no. 7 (January 1974): 3. *Guerre de classes*, edited by Daniel Guérin, was the journal of Organisation Communiste Libertaire.

43. 'Address to Proletarians and Young Arab and Israeli Revolutionaries against the War and the Proletarian Revolution' (in French), *Jeune Taupe*, no. 10

(June 1976): 17–18. *Jeune Taupe* ('Young Mole') was the journal of Pour une Intervention Communiste, which came out of a scission with Révolution Internationale in 1974.

44. 'The Arab-Israeli Conflict: A Conflict for the Exclusive Benefit of Capital'. Translated by the authors.

45. Mustapha Khayati, 'Two Local Wars', p. 262.

46. Guy Debord to Mustapha Khayati, 1 December 1965, Guy Debord, *Correspondance*, vol. 3, p. 97. Translated by the authors.

47. 'The Rise and Fall of the "Spectacular" Commodity Economy', in Guy Debord, *A Sick Planet*, trans. Donald Nicholson-Smith (Calcutta: Seagull, 2007), p. 41.

48. Ibid., p. 32.

49. Ibid., p. 14.

50. Debord, 'Minimum Definition of Revolutionary Organizations', in *Situationist International Anthology*, p. 285.

51. Debord, 'Conditions of the Congolese Revolutionary Movement'. Translated by the authors.

52. Debord, 'The Rise and Fall of the "Spectacular" Commodity Economy', p. 37.

53. Mustapha Khayati, 'Two Local Wars', in *Situationist International Anthology*, p. 262.

54. Debord, 'The Rise and Fall of the "Spectacular" Commodity Economy', p. 24.

55. Ibid., p. 33.

56. SI, 'Three Postscripts to the Previous Issue', in *Situationist International Anthology*, p. 286.

57. Ibid.

58. 'Malcom "X" in Paris' (in French), *Pouvoir ouvrier*, no. 66 (December 1964): 12. Translated by the authors.

59. 'The Evolution of the Black Panthers' (in French), *Informations Correspondance Ouvrières*, no. 118 (June 1972): 19–21.

60. SI, 'Three Postscripts to the Previous Issue', p. 286.

61. 'The Rise and Fall of the "Spectacular" Commodity Economy', p. 24.

62. John Clegg, 'Black Representation after Ferguson', *The Brooklyn Rail*, 3 May 2016, accessed 13 April 2019, https://brooklynrail.org/2016/05/field-notes/black-representation-after-ferguson.

63. Andrea Gibbons, 'Salvaging Situationism: Race and Space', *Salvage*, 30 November 2015. Accessed 15 April 2019, http://salvage.zone/in-print/salvaging-situationism-race-and-space.

8

Gender and Sexuality in the Situationist International

Ruth Baumeister

The Situationist International (SI) consisted of 72 members, of whom less than 10 per cent were women: Michèle Bernstein, Edith Frey, Jacqueline de Jong, Katja Lindell, Renée Nele, Gretel Stadler and Elena Verrone. Almost all of them entered the group as either the girlfriend, wife or family member of some of the male Situationists. They were active only during the first decade of the group's existence; from 1967 onwards, there were only men. In the reception of the SI, these numbers often lead to the presentation of the movement as a boys' club and, in so doing, the gender politics of the group's work have been overlooked. At the same time, the contributions of the various women involved have gone under-represented. The contribution of these women was manifold, stretching from writing in and editing the group's journals, the production of artworks and the curation of exhibitions to their participation at the meetings and conferences, where, among other things, they acted as interpreters. Not to be overlooked are less obvious activities such as being sparring partners to the male members in the discussions, supporting them emotionally or raising their children and/or earning money to make a living.

In today's reception of the SI, the Dutch artist and editor Jacqueline de Jong and the French writer and critic Michèle Bernstein are usually regarded as the two main female protagonists of the group. De Jong's affiliation to the SI is rather special because, unlike other members, she entered the group and worked with its members through various different channels. In the spring of 1959, she and SI co-founder Asger Jorn, who was 25 years older than her, became lovers. That same year, she met the German artist René Nele, who introduced her to the German section of the SI, *Gruppe Spur*, with whose members she started hanging out and collaborating. Through various sojourns at her parents' summer house in Ascona, de Jong was well acquainted with Italian. During a visit to Pinot

Gallizio's studio in Alba in summer 1960, she also became involved in the production of industrial painting and featured as the artist's model, dressing up in painted fabric. Moreover, given the fact that she took an internship at the Amsterdam Stedelijk Museum, where she assisted Sandberg, de Jong was acquainted with members of the Dutch SI section, such as the artists Armando and Constant Nieuwenhuys, who, in cooperation with two architects, ran the 'Bureau of Unitary Urbanism', developing ideas for a futuristic urban network, *New Babylon*, and preparing a large Situationist exhibition at the Stedelijk Museum in Amsterdam.

'All of Holland is yours!'[1] was the unexpected and overwhelming message she received from Debord in a letter, after the Dutch members of the SI were either excluded or resigned from the group. Subsequently, she was involved in the preparations for the fourth conference of the SI in London, in 1960. She amused herself drifting through London, frequently stopping at pubs, in order to find a proper conference venue.[2] Given her exceptional talent for mediation, combined with a command of almost all languages that were spoken within the SI (German, French, Italian, Dutch, English), 21-year-old de Jong's role at the conference reached far beyond merely interpreting. Supposedly, de Jong acted also as a member of the SI's central committee,[3] from 1960 to 1962, to which she reported on the development of the 'utopolis', an urban project that was meant to create several 'Situationist Castles' to be financed by the Italian industrial magnate Paolo Marinotti.[4]

To accompany the existing Situationist organs, *Spur*, the magazine of the German section of the SI, and *Internationale situationniste*, published in French, de Jong suggested another, English-language one, which she would coordinate and edit. The project was approved by the central committee in a meeting in Brussels in 1961, and she started conceptualising the first issue of *The Situationist Times*, a transdisciplinary, multilingual and cross-cultural magazine.[5] Upon the question as to whether or not Jorn influenced her as an editor of the magazine, de Jong retrospectively answered: 'Of course he did! He influenced me spiritually as well as practically in many ways, although he often denied that or did not agree.'[6] During this period, Jorn had already become an internationally recognised painter. He was selling well and was able to support the SI, not only with his own artistic and intellectual activities, but also financially. The latter was especially true for *The Situationist Times* and the film *So ein Ding muss ich auch haben* (I Must Have This Thing Too) (1961), on which de Jong

collaborated with Gruppe Spur. Describing her development as an artist during her ten-year relationship with Jorn, she concludes:

> After all those years I had made my own way, which actually was respected by Jorn. By separating at the end of 1969, I chose for being autonomous, something Jorn already in 1962 wanted me to be, but I did not feel it as an urgent development, only when I really found my way as a painter around 1964, I started in a way an outlook on art of mine, but until all this time very much in agreement with his views and opinions surely with frequent discussions. Jorn wanted me from the very beginning to be autonomous and not too much under his supervision, but being very young [20], I felt I needed in a way his supervision/ views and help to develop myself also as an artist.[7]

At the 5th Conference of the SI in Göteborg, Sweden, in 1961, together with J.V. Martin, Nash Kunzelmann and Debord, de Jong produced a collective painting where their heads were collaged onto the bodies of a cheerfully dancing group of peasants. Finally, however, the gap between the artists and the revolutionaries in the group became unbridgeable. Only a couple of months later, in February 1962, Debord expelled the Spur artists and, in solidarity with them, de Jong and the Scandinavian section also left the group. Consequently, by the time the first six issues of her magazine *The Situationist Times* appeared, she had already left the group.

Michèle Bernstein was the only woman among the founding members of the SI, and she stayed with the group for the exceptionally long period of ten years, from 1957 to 1967. Bored by her studies at the Sorbonne, she had started frequenting a bar called Chez Moineau in Paris during the early 1950s. There, she became affiliated with the Lettrist International, a circle of writers, artists and vagabonds, among them Guy Debord, whom she married in 1954. In an interview, when she was asked why she married Debord, Bernstein stated retrospectively:

> Guy and I [...] were married, I do not know why, now people do not marry, and in that time people would marry. Even a Situationist is sometimes the result of the way society is. [...] We were 22 and I left my room here and I went into the room with Guy, which was bigger and more in the Latin district. [...] We were a very open couple with the right to have little loves around.[8]

For the Lettrist International, she acted as an editor of the group's magazine *Potlatch* until the group fused into the Situationist International in 1957. During the decade of her involvement with the SI, she actively participated in the conferences, contributed as an author, co-author and image editor to *Internationale situationniste* and acted as a member of its editorial committee from 1963 to 1966. Her Situationist activities include a eulogy to Pinot Gallizio's 'Industrial Painting'[9] as well as relief models of battlefield scenes for the SI RSG-6 exhibition at gallery Exil in Odense in 1963, organised by the circle around the Danish artist and Situationist J.V. Martin. Her ability to write not only in her native language but also in English enabled her to introduce the SI to the Anglophone world, publishing an article in *The Times Literary Supplement* in 1964.[10]

Moreover, she financially supported her husband, Guy Debord,[11] who already in 1953 had painted the imperative: 'Ne travaillez jamais' (Never work) on a wall of the rue de Seine in Paris.[12] Bernstein earned her money as a journalist, in advertising and as the author of the novels, *All the King's Horses* (1960) and *The Night* (1961), which are today considered important examples of Situationist writing. Retrospectively, Bernstein described her role as the breadwinner in her relationship with Debord. This was also her motivation for writing the novels:

> The novel … we were so broke. [...] In that time, I was in a publishing house which did not pay very much, and for Guy, I added some little stamps and small things for the reviews, but that was not enough. So, I was looking through all the little novels in my house, because I had not a lot to do and I thought I could do that very well, but as a Situationist, I could not do it with my heart. So, I said to Guy I will make a novel with all the clichés, which are in fashion, etc. [...] And that will be a novel and without anybody recommending me, I sent it to the publisher. [...] But that was a joke, of course. And now, I have a lot of articles, without doing it on purpose. It was, sure, a way of thinking and doing which was situationist, but I did not do it on purpose. [...] I was infected with their ideas.[13]

When asked about how the success of these two novels subsequently impacted her career as a writer, she replied: 'Career does not count. I never had a career, I had some jobs, one after the other. But considering for me a career would make me laugh. The books were to bring in some money for Guy and myself.'[14] Her words seem to support Frances

Stracey's statement that 'Bernstein is perhaps not the best witness to her contributions to the SI [...] This may be recognised as a form of feminine self-effacement, perhaps induced by male self-assertion.'[15]

Through the publication of her books, Bernstein had established contacts with the prestigious publisher Buchet-Chastel which then made it possible for Debord to publish the first edition of his *The Society of the Spectacle* with them in 1967. Her second husband, Ralph Rumney, also once a member of the SI, described Bernstein's crucial position within the SI and her relationship with Debord as follows:

> To me, she is the most Situationist of all. She was the one in Cosio who picked everyone up on the fact that one does not say 'Situationism' but 'Situationist', because when it becomes an '-ism' chances are that it will turn into an ideology, a sect. She would surely deny this, but I had the impression that she had a certain authority over Guy. She used it sparingly, but at the right moments. She knew how to rein him in when he slipped into the worst kind of exaggerations. Between Guy and Michèle there was a serious, lasting complicity when they were together, and even afterwards.[16]

'Debord was a macho from southern France!', Bernstein says, when asked about gender roles within the SI in general and her relationship with Debord in particular.[17] Her statement proves, point blank, that the SI was not immune to the gender biases of its time. Nevertheless, when discussing gender politics with the SI, we should not be blind to the fact that the group wanted to change the world, to overthrow the existing power systems that, they believed, nurtured social separation and segregation. As their endeavour was total, any of their revolutionary acts could therefore not be restricted to the situation women, or any other group or minority. Thus, the SI's fight for a revolution was based on unconditional solidarity among the individual members, regardless of gender.

This does not mean, however, that Situationist theory and practice were indifferent or blind to the gender politics of their time. Photos of semi-nude or nude women, for example, were one of the leitmotifs of Situationist visual production in its journals, collages and films. In issue one of *International situationniste*, among definitions of key concepts of Situationist theory, writings on functionalist architecture, automation and the cultural revolution, seemingly out of place images of scantily clad, seductive women pop up. As Baum says of these images, 'Far from a

frivolous addendum to or a curious departure from an otherwise progres-
sive political and philosophical agenda, images of women were in fact one
of the many platforms from which the Situationists launched their rebuke
to capitalism and spectacle.'[18] Surprisingly, it was not a male member of
the group, but Michèle Bernstein who was responsible for the selection
and implementation of these photos, which were clippings from French
women's magazines, such as *Elle* (founded in 1944) and *Marie Claire*
(founded in 1945). These images were subject to 'minor *détournement*',
as they are taken out of their original context (such as advertisements
for a leisurely lifestyle, beach wear, holidays in the sun and so on) and
did not relate to the new context in any obvious or direct manner. The
new placement of the images renders them absurd due to the absence of
the commodities they were supposed to sell in the first place. And yet, it
did not exactly erase their initial purpose, as 'eye candy' for the reader;
rather, given the fact that these clash with the contents of the texts they
accompany, they trigger an alienating effect. Thus, the de-contextualising
of these images results in a deconstruction of their original meaning as
communicated in the relationship between text and image.

Frances Stacey, in her chapter 'The Situation of Women', lays out the
critical strategy lying behind the Situationists' appropriation, *détournement*
and re-use of these images. Stacey underlines the need to understand the
targeted audience as well as the meanings and codes the images implic-
itly convey. She elucidates the profound shift in France in terms of ideals
of femininity, from the 1940s 'femme au foyer', who would contribute to
the reconstruction of the *grande nation* through reproduction and being a
good housewife, to the 'super woman' of the late 1950s, who would keep
the household, educate children and simultaneously have a professional
career. Through this turn, women became a target audience as 'consumers
of household machinery' that was coming from the US and flooding the
European market from the late 1950s onwards. The reality of women's
everyday lives was banal and tedious though, and did not reflect what
was pictured in the shiny magazines or American movies of the post-war
period. Moreover, most households could not afford these commodities in
the first place. Stacey writes:

> In the 1950s, it was the category of 'woman' that the society of the
> spectacle subjected to the coercive and dissimulating drives of everyday
> life more heavily than any other, constantly projecting fantasy images

of the proper way to look, act, cook, etc. Images of women became the central site for the alienating machinations of the spectacle.

Thus, such *détourné* images must be read as a comment on the spectacle's techniques of everyday control and, ultimately, are more illustrative of the content of the texts that they appear alongside than might seem to be the case at first glance.

The ninth issue of *Internationale situationniste*, from August 1964, includes clippings of photos of women taken from porn magazines. As these images were socially provocative, they served *par excellence* to illustrate the SI's revolutionary texts. Other than in the first issue, these images were the results of the SI's 'excessive *détournement*', meaning that the recontextualisation of an inherently significant element takes on a different signification from the new context by additions, such as words, a speech bubble and so on. In the original context of the porn magazine, the porn star is usually silent and reduced to her purely visual appeal. However, by giving her a message in a speech bubble, she starts to speak to the viewer. Consequently, on the one hand, the privacy of the male gaze is interrupted, by setting the image into the forum of the group's journal, which is both public and ungendered. On the other, during the 1960s, when porn was breaking social taboos by unashamedly exposing bodies under the flag of sexual liberation, the female body was simultaneously turned into a sexualised commodity in the service of the porn industry, which represented the mass commercialisation of sexuality.[19] Thus, such loosening up of moral taboos consequently led to a process of re-disciplining, namely the control of the female body for purely monetary reasons. Rather than seeing pornography as a vehicle of sexual liberation, the SI conceived of it as yet another means to support the spectacle, because of its inherent commercialisation of sex.

Debord's films, most famously *The Society of the Spectacle* (1973), which uses such images in a similar manner, have also been an important part of the existing discussion around gender in the SI.[20] Another, overlooked experimental film, *So ein Ding muss ich auch haben* (1961), is also revealing. The film was conceived by Jørgen Nash,[21] Katja Lindell[22] and Asger Jorn from the Scandinavian section of the SI in collaboration with the Danish constructivist artist and experimental film director Albert Mertz. Featuring in the film beside Nash and Lindell were members of the German section of the SI (Gruppe Spur: Sturm, Zimmer, Fischer, Prem) as well as Jacqueline de Jong, Maurice Wyckart and Heike van de Loo.[23] It

was produced in early 1961, shortly before Asger Jorn left the SI and the same year the German Situationist art group Gruppe Spur was put on trial for blasphemy.

The film communicates its message neither through a plot, nor with language. It pictures everyday life in Munich during the 'Wirtschaftswun-der'[24] years in a series of disconnected scenes: men in a local beer hall, people buying kitsch paintings in the street, a family in their apartment, war ruins and functionalist architecture of the reconstruction period. Several passages are repeated, showing men cleaning the streets and a mass of people walking through the city. These rather static scenes are disrupted by artists, who are, in one moment, situated in the ruin of a bombed-out building playing dissonant melodies on flutes, in another moment, being chased around, or running through the city centre armed with guns they go all the way up to Feldherrenhalle, the famous site of 'Hitler's Beer Hall Putsch' in 1923.[25] It ends with a still that says 'suite', indicating that there is more to come.

The film was neither conceived as a commercial product, nor for the sake of a pure aesthetic experience. Museum Jorn, Silkeborg, holds an unpublished manuscript[26] in which Albert Mertz, Katja Lindell and Jørgen Nash describe their intentions for the film to Jorn, who financed it and, in collaboration with Jean Dubuffet, provided the soundtrack.[27] 'The idea to make a Situationist film here in Munich arose spontaneously. Its mode of production, the entire work around it must therefore also be spontane-ous in manner',[28] the trio declares. They further elaborate that this kind of spontaneity has nothing to do with the 'strong man's artistic body building which nowadays is very much appreciated by art snobs, galleries and art journals. [...] Instead, we think of following respectfully the course of time, the very moment, life's own rhythmic stream.'[29] Shining through the authors' words is the foundational basis of Situationist theory: a critique of the mechanisms of capitalist society (in this case the commercial art market) and the concept of alienation, which the SI aimed to fight by creating situations with spontaneous actions in everyday life. A letter from Mertz to Jorn, where the target audience and distribution of the film is discussed, supports this assumption. The film was directed against the advertising industry and consumption in general. The goal was to distrib-ute it internationally, especially in the US.[30]

The title *So ein Ding muss ich auch haben*[31] refers to a German expression which is used in the Danish language when one wants to express a strong desire to have a certain object or thing. The SI strongly criticised desires in

people that were prompted by the capitalist system through media, advertisements and so on.

> We must call attention [...] to the need to undertake an effective ideological action in order to combat the emotional influence of advanced capitalist methods of propaganda. On every occasion, by every hyper-political means, we must publicize desirable alternatives to the spectacle of the capitalist way of life, so as to destroy the bourgeois idea of happiness.[32]

Debord's statement from the 'Report on the Construction of Situations', the founding manifesto of the SI, evokes the concept of passion and desire as the working definition of the group's concept of revolution. If the goal was to revolutionise the existing system through the creation of situations in everyday life, that consequently meant awakening people's existing authentic desires and even creating new ones, because these were understood as the driving force behind the transformation of everyday life.

One scene from the film which echoes Debord's attack on 'bourgeois happiness' pictures a family in a post-war high-rise prefab housing complex. It is important to point out that the SI not only attacked desires that were triggered by the capitalist system and the mechanisms which suppressed the expression of authentic desires, they also aimed at the development of totally new desires through play (see chapter 11). In the first issue of *Internationale situationniste*, under the title 'Contribution to a Situationist Definition of Play', it says:

> Due to its marginal existence in relation to the oppressive reality of work, play is often regarded as fictitious. But the work of the situationists is precisely the preparation of ludic possibilities to come. One can thus attempt to neglect the Situationist International to the degree that one easily recognizes a few aspects of a great game.[33]

In this respect, quotidian spaces that provoked such desires played a decisive role.[34] As the manuscript signed by Mertz, Nash and Lindell reveals, this is precisely what they aimed to address in their film: 'the situationist idea about play as a vital element [...] of our actual situation in culture. We want to show in the film how the adult in his or her everyday conformist activities and in the way they treat children, try to either consciously or unconsciously exclude play, which is a vital element.'[35]

The film scene shows a little girl all alone on a balcony tied with a rope to the balustrade. She wants to jump but is held back by the rope, she can hardly look over the balustrade, her movement is bound to the few square metres of the balcony. Unlike her parents, who are wearing masks which hide their facial expressions, the child has a happy, excited expression on her face, more so even, when she spots her father in the street below, returning from work with a gift bag in his hands. The way both parents dress – the father elegantly like a businessman and the mother with a twinset and a pearl necklace[36] – identifies them as part of the bourgeoisie. When they meet at the door, they try kissing each other hello, but they are both wearing masks, which prevents them from doing so. Mechanically, 'like marionettes',[37] they move from cheek to cheek, over and over again and no matter how hard they try, they never get close. What was supposed to be a sensual, affectionate ritual turns out to be a Sisyphean endeavour. A cacophony of sounds and voices amplify the alienating atmosphere of this scene. Their actual feelings are hidden behind their masks, which make them appear at once emotionless and alienated from one another. Once inside, the father hands over the package first to the mother, who unwraps it. '[A] round, shiny ball comes to light. Excitedly, the mother is clapping her hands'[38] is how the scene is described in the filmscript. The mother's excitement over this object on the one hand recalls the desire, induced by mechanisms of capitalist consumption, hinted at through the film's title *So ein Ding muss ich auch haben*. On the other, it shows the man's role in having to provide such desire in the form of consumer commodities.

As the father hands over the ball to the girl, she starts playing with it by repeatedly throwing it down from the balcony. In the background appears an advertisement board for 'Persil',[39] a widely known German washing detergent. Apart from its political connotations, this small detail is most revealing when it comes to the situation of gender in post-war West German society. There is hardly any better example to illustrate the role of women and how their presence in advertisements is instrumentalised in order to promote sales strategies and increase the number of purchases as Persil adverts featured 'The White Woman' (Die weisse Frau) throughout many decades and are tightly connected to the image of women in German society. When the detergent first came out in 1907, it was promoted in print media as something to make washing easier and thus liberate women from the tedious work of doing the laundry. In 1956, a time when the worst adversities resulting from the Second World War had been overcome, advertisement spots were shown on television in order to

encourage people to consume and Persil was at the forefront of featured companies.[40] Looking at the covers of German women's magazines at that time, the burning question was how to catch a man and subsequently get married and devote oneself to being a good mother and loving wife.[41] This is not to ridicule women's issues at that time, but being unmarried was not only considered a problem socially, it also gave women fewer rights before the law and burdened them with all kinds of restrictions. Moreover, women who proved themselves through their independence, strength and strong will while men were away fighting now had to be reintegrated into their 'true and natural context' again, as housewives and mothers. The 1956 Persil campaign, with its picture of a perfect *hausfrau*, devoted to housekeeping and raising children, contributed to this social process.

With the rise of the second wave of feminism during the 1960s, when women postulated their rights to achieve a political, social and cultural life beyond the house and the family, the image of the woman as only mother and *hausfrau* started to lose ground. Right before *So ein Ding muss ich auch haben* was produced in early 1961, Persil came out with two new advertising campaigns. As Eleonora Pampado illustrates in her analysis of the 1956/1960/1961 campaigns[42] the role of the woman changes from the traditional image of the *hausfrau* (1956) to a modern woman (1960), whereby being modern in the latter case is directly connected to consumption. Asger Jorn had earlier warned that consumption driven by desire that people were indoctrinated with through advertisements that fused the interests of the capitalist system rather than people's authentic desires, would necessarily have an alienating effect:

We are talking here about 'acquired necessities'. Modern man is suffocating under a mountain of 'necessities' such as televisions, refrigerators, etc., while making himself incapable of living his true life. We are obviously not opposed to modern technologies, but we are against any notion of an absolute need for objects; in fact, we question their actual utility.[43]

Ivan Chtcheglov in his text 'Formulary for a New Urbanism', published in the first issue of *Internationale situationniste*, goes even further by highlighting the devastating effect this has on society in general when he states that 'A mental disease has swept the planet: banalization. Everyone is hypnotized by production and conveniences – sewage systems, elevators, bathrooms, washing machines.'[44]

What is striking about the family scene mentioned above is how the man finds himself in yet another hopeless, Sisyphean situation which is paralleled by the passivity of his wife. There is no real interaction between the child and the mother, the latter's role is characterised by absence and distant observation. She only monitors the girl for a brief moment when she opens the door from the living room to the balcony. Consequently, the girl is all alone, left to herself, literally incarcerated in the tight space of the balcony. Interestingly, although the 1956 and 1960 Persil advertisements show a man and a woman discussing the advantages of the detergent, in the 1961 version, the woman is absent, just like the mother in the film, except for when she receives the desirable object, the ball. Eventually, after having run up and down the stairs a great many times to fetch the ball for the girl, the father is completely exhausted and destroys it. He breaks down at the feet of his wife, takes off his mask and so does she, finally realising what has happened. Horrified, she starts shouting hysterically. The scenery changes, once again a cleaner is mechanically sweeping the street, but with the sound of the woman's sobbing and crying in the background.

In her analysis of women's visual representation in *Internationale situationniste*, Frances Stracey points out that most French households at the time did not have enough money to buy these goods, which put enormous pressure on men, who were expected to acquire these items to make their wives happy. Besides the situation of the businessman, described in the family scene above, there are two other settings portraying men in the film, which perfectly illustrate Stracey's claim and provide a strong alienating effect. In a local beer hall (*Gasthaus*) a group of male, blue-collar workers are pictured taking a break. While plates of food are being served in the background, the men drink one beer after the other, staring at the abundance of the meat and sausages hanging from the ceiling of the room with total indifference in their eyes. Their facial expressions are alienated, which is not surprising, given the fact that this is the generation of men who, not too long ago, had undergone famine when fighting in the war. The third group of men who repeatedly appear in the film are street cleaners, acting like robots, disconnected from their environment. Their work appears tedious, endless and meaningless. The look on their faces is bitter, staring at and questioning the world created by those they need to clean for: businessmen walking by with briefcases. With this scene, the film stresses class exploitation as a theme by exposing the social distinction pictured between those who serve and those who are served.

The next sequence pictures a gawking man, looking like a detective who is surreptitiously trying to observe something of everyday street life through the lens of a tiny camera. His target is a young, attractive woman, dressed in a tweed skirt, black woollen sweater and with a silver medallion around her neck. Self-assured, she approaches and smiles right into the camera. For a short moment, we can see her face close up before she seems to make a decision, her expression suggests delight and fearlessness. The scene is interrupted by what is called a 'cookie ballet' in the script. On a dark surface, different shaped cookies and cakes move to the sounds of a sobbing and heckling woman. Whether these are moans of erotic pleasure or agony remains unclear. They end with a loud cry and the film goes back to the detective with the camera. The self-conscious woman featured in the scene is Jacqueline de Jong.

Towards the end of the film there is a sequence where, in the mass of people moving through the streets, a group of armed gangsters, walk up to Feldherrnhalle, a historically charged location.[45] Among them is one woman and, apart from her fellows, whose faces are not recognisable, for a short moment, she stares right into the camera. The woman in question is Katja Lindell, whose involvement and artistic production within the SI, and the history of its reception – especially as a woman – is rather under-represented and therefore deserves a closer look. Lindell came to the SI around 1959/60 through Jorn and his brother, the Danish poet Jørgen Nash. The latter, she had met and fallen in love with at a Beatles concert in Paris. At that time, she was working for the Swedish German writer, artist and film director Peter Weiss[46] and script writer Brabro Boman[47] on the film *The Flamboyant Sex* (*Svenska Flickor i Paris*, 1961). Jørgen Nash, who was almost twenty years older, was taking time out by working for his brother as a secretary, recovering from the fact that his first wife, a photo model, had left him for another man. Lindell and Nash attended the 4th Conference of the SI in London where they made contact with the artists of Gruppe Spur, with whom they started collaborating more intensively. 'Once Katja showed up, things would start to get going,'[48] is how Spur member Helmut Sturm retrospectively remembered her impulsive and invigorating personality.

While still in Paris, Lindell became pregnant and the couple returned to Sweden where they married in March 1961. Already, in December the previous year, they had acquired Drakabygget, an abandoned farm in southern Sweden. Lindell came from the Swedish upper-class family[49] and the purchase of the farm was financed by her family trust. Jorn, who was

promised a studio during his stays in Scandinavia, also contributed financially. The place was meant to develop into an artist collective, away from Copenhagen's cultural establishment and in opposition to the emerging post-war consumer society. Soon, it became an outpost for the Situationists from the northern sections and was called 'Bauhaus Situationniste – Drakabygget – Örkellijunka'. It was conceived to be self-sufficient, sustained by agriculture and a horse-riding school, run by Lindell, who had been a passionate rider since her childhood. Anyone was welcome on condition that they would dedicate a certain number of hours per week to working on the farm, though the rest of their time was free for artistic experimentation. A photograph pictures Lindell on a field in workmen's clothes behind a horse drawing a plough. Life was simple and the farm was run with as little machinery as possible. Experimentation was not restricted to the arts, but comprised all aspects of human life and challenged established norms of capitalist consumer society, such as private property, the family, religion, morality and sexuality.

Apart from daily work on the farm, Lindell engaged with various mediums of cultural production during the period of her membership of the SI. She designed the cover and the typography for *Hanegal*, a selection of Danish poetry.[50] As the archival material on *So ein Ding muss ich auch haben* reveals, besides acting, she contributed decisively to the content development and also helped with practical issues, such as cost estimates, budgeting and so on. Most remarkable though are her contributions to the movement's literary production. She acted as a co-editor of the journal *Spur*, issues 5 and 6, she was one of the cosignatories of the Gruppe Spur Manifesto '*Avantgarde ist unerwünscht!*', in January 1961, and edited the first issue of *Drakabygget*, published in 1962. For the latter publication, she wrote an article criticising NATO and US atomic bomb tests in Los Alamos, she co-authored an open letter addressed to three Nordic poets with a plea to reinstall the tradition of large-scale public meetings that were obviously forbidden during German occupation and she gives a report on SICV,[51] criticising the predominance of classical over Scandinavian culture, demanding a re-evaluation of the latter. Her multifaceted activities attest to not only a strong sense of criticism towards the rising post-war consumer society and politics on a local as well as a global scale, but also speak of her awareness of the social significance of cultural production in general.

Despite her manifold activities within the SI, she disappears not long after. However, not only was she no longer an active member, she would

also not feature prominently in the history of the reception of the SI. The reason for that, I believe, lies in her sexual orientation. Even though Michèle Bernstein, retrospectively stated in an interview, when asked about her sexuality: 'I do not know if I was bisexual then, even though I looked like a boy and was thought to be a dyke. Later I became more one way',[52] and claimed that in the spirit of carefree experimentation, any sexuality was permissible within the SI, the reality in the everyday life of the case of Katja Lindell looked quite different. After all, the Situationist revolution was not supposed to take place in parliaments, university lecture halls or libraries, but in everyday life. Consequently, their revolutionary activities clashed with family traditions, conventions, rules and laws of society. Both Jorn and Nash grew up in a very religious context and their moral standards certainly did not live up to those of their mother, who was an active Protestant and obviously never gave up on trying to bring her sons back into the fold. 'Grandma did not like the fact that Katja changed her sex, oh no!', a member of the family once told me.[53] Another anecdote relates that, during one of her visits at Drakabygget, Jacqueline de Jong was locked up in an old shack because, at that time, Jorn was still married to his second wife, Matie, and he was not willing to confess to his mother that he had Jacqueline as a lover.[54]

What kind of woman was Lindell and how did she negotiate the expectations that she faced given the gender biases of her time? She obviously had no problem in defending herself against any inappropriate passes that were made at her. 'She once socked [a man] in the jaw, after he had touched her on her bottom when following her up a stair',[55] one of the guests at the farm recalls. The artist Mette Aare, who was a frequent visitor at Drakkebygget during the 1960s, still vividly remembers that she was a master of disguise:

> At the farm, Katja was walking around in a dirty parka jacket, her glasses were broken and fixed with plastic tape. At an exhibition opening in Copenhagen, all of a sudden though, surprisingly the opposite! The door opens and there comes freshly groomed and tarted up a high society lady dressed in a shiny white suit. Katja attracts the attention of the whole room and dominates the scene with her aura.[56]

In the course of the 1960s Nash and Lindell had three children together. When I asked Ole John,[57] who sojourned at the collective during those years, who took care of the children, he immediately answered: 'Nobody!

They were left to themselves in the playpen all day.'[58] Most obviously, being a good housewife was not compelling to Lindell, but neither was it to Nash. Certainly, Lindell did not fit any of the previously discussed female categories of the post-war period. According to Aare, the children were neglected and the place stank of urine. She concludes that Lindell failed as a mother and describes her as a witch, not in the negative sense though, but in admiring her intelligence, temperament and initiatives at the same time.[59] Lindell was originally educated as a journalist, but it was her interest in avant-garde film, which led her to Paris during the late 1950s. She spoke German, English, Swedish and Danish fluently, and in addition she studied French while staying in Paris with Nash. Freedom of sexuality was one of the aspects that constituted the collective at Draka-bygget and Nash and Lindell exercised it extensively, which resulted in a turbulent relationship with many fights.

During the second half of the 1960s, Lindell decided to become a man. The fact that she was a mother of three made it very difficult and she had to go abroad to undergo hormonal therapy and operations. Even though the marriage was bad and Nash had become involved with one of his students, the young artist Liz Zwick, the decision came as a surprise for him. They finally got a divorce, accompanied with many fights about money, children and property. In his memoirs, *Havefruemorderen krydser sine spor* (*Little Mermaid's Murderer Covers His Tracks*),[60] Nash retrospectively recounts their marriage, their life on Drakabygget and the many fights the couple had. Here, he ridicules Lindell's change of gender and, while doing so, presents himself as the worst kind of male chauvinist, hurt in his male pride. In 1970, Lindell publicly spoke about his change of gender and his initial concerns about how the children would take it in a newspaper article. He assures the reporter that they had much less problem with it all than most grown-ups.[61]

German artist Ottmar Bergmann recalled that during the early 1980s, when he arrived at Drakabygget, it was Nash and Zwick who ran the place and discussion of Katja Lindell was taboo.[62] These artists, who I spoke to personally, told me that they lost track of her. Undoubtedly her gender change not only created a rupture in both her personal and professional life but also led to the end of her artistic production. Whether the reason for the latter lies in the fights with Nash and the family, the break with the artists from around that time, or maybe in her own decision to start a new life, remains unclear. Most certainly though, it had consequences for the reception of her artistic works within the SI later on.[63]

Eventually, Peter Albert Lindell left Sweden and moved to northern Jutland, where he got married and started another horse-riding school in Frøstrup. The traces of this part of his life are not to be found in books and archives about the SI, but within the community of horseback riders in Jutland. One of his former pupils describes Peter as a 'very passionate and competent instructor. He was running the riding centre with a lot of love and just as much discipline. His didactic approach was very much advanced.'[64] As various oral histories within the community of horseback riders in Jutland reveal, Lindell in a way was still pushing boundaries, if not within the context of international avant-garde cultural production, then at least in the horse business. Blacksmith Jens Jakobsen once assured me that even though people laughed at Peter Lindell's unconventional way of running the riding school, and the way he spoke to and treated the horses, retrospectively he admits that Lindell was probably quite ahead of his time.[65]

Acknowledgement

My thanks for giving me access to source material as well as sharing their precious memories of everyday life to: Mette and Snild Aare, Ottmar Bergmann, Jaqueline de Jong, Carsten Nash, Ole John, Lone Mertz, Helle Brøns, Kaspar Riis Jensen, Jens Jakobsen and Preben Orts.

Notes

1. Letter from Guy Debord to Jacqueline de Jong, 6 July 1960, cited in Jacqueline de Jong, *Undercover in Art* (Amsterdam: Ludion, 2005), p. 108.
2. At this conference, the discussion about the actual value of art within the revolutionary programme that had already sparked off a vivid discussion at the Munich conference one year earlier, turned up again. And a split between artists around Gruppe Spur and members like Attila Kotányi and Raoul Vaneigem became obvious.
3. The central committee was a small board established at the London conference in order to make decisions in a more effective manner than in the large conferences.
4. Roberto Ohrt, 'Situationists: Everywhere or Nowhere', in de Jong, *Undercover in Art*, p. 114.
5. The magazine ran from 1962 to 1967, to a large extent financed by Asger Jorn. Noël Arnaud, who was experienced in the production of various avant-garde journals, acted as an editor for the first two numbers. *The Situationist Times* was thematically focused, for example on archetypes such as the spiral, the ring, the labyrinth. Due to its exciting combination of word, image and colour it was visually very appealing.

6. Jacqueline de Jong in an unpublished interview with the author, 20 May 2016.

7. Ibid.

8. Michèle Bernstein in an unpublished interview with the author, 9 February 2016.

9. Michèle Bernstein, 'Éloge de Pinot-Gallizio', in *Pinot Gallizio* (Paris: Bibliothèque d'Alexandrie, 1960), n.p.

10. Michèle Bernstein, 'About the Situationist International', *The Times Literary Supplement*, September 1964.

11. Bernstein and Debord were married from 1954 to 1972.

12. 'Never Work' was a demand to abolish any kind of paid work and a claim to the right to laziness at the same time. Debord's imperative, and his own refusal to work for money, were for him a means of refusing to contribute to the mechanisms of the capitalist system, which formed the basis of the Society of the Spectacle.

13. Michèle Bernstein in an unpublished interview with the author, 9 February 2016.

14. Ibid.

15. Frances Stracey, *Constructed Situations* (London: Pluto Press, 2014), p. 112.

16. Ralph Rumney, *The Consul* (London: Verso, 2002), p. 110.

17. Michèle Bernstein, in an unpublished interview with the author, 9 February 2016.

18. Kelly Baum, 'The Sex of the Situationist International', *October*, 126 (MIT Press, fall 2008), p. 24.

19. Stracey, *Constructed Situations*, p. 106.

20. See ibid., pp. 94–122; see also Baum, 'The Sex of the Situationist International', pp. 23–43.

21. Jørgen Axel Jørgensen, (b. 1920 in Vejrum, d. 2004), younger brother of Asger Jorn.

22. Ebba Maria Katarina Lindell (b. 1939 in Stockholm, d. 2013).

23. Heike van de Loo (1916–63) was the wife of Otto van de Loo, Asger Jorn's art dealer in Munich.

24. *Wirstschaftswunder*, literally 'economic wonder', refers to the economic boom in post-war West Germany.

25. Wolf Wirth shot the film, which was released the same year as his renowned documentary *Brutalität in Stein*, which elucidates the relationship between German National Socialist architecture and the ideology behind it. There are several underlying references to fascism in post-war West Germany in the film, which are not included in the discussion here.

26. Jørgen Nash, Katja Lindell and Albert Mertz, 'Tanker om den internationale situationistiske film' (Thoughts on Situationist Film), Munich 1961, n.p., unpublished manuscript, Museum Jorn, Silkeborg. Translated from Danish to English by the author.

27. The soundtrack is composed of fragments by Jean Dubuffet and Asger Jorn, *Musique Phénoménale*, 4 × Vinyl LP, Edizione del Cavallino, 1961 (recorded December 1960–March 1961).

28. Nash et al., 'Thoughts on Situationist Film'.

29. Ibid.

30. Letter from Albert Mertz to Asger Jorn, 17 June 1961, unpublished letter, Archive Sorø Kunstmuseum. Translated from Danish to English by the author.
31. The notion goes back to the satirical novel, *Siegfried von Lindenberg* (1779), by Johann Gottwerth Müller von Itzehoe, in which the author mocks the ignorance and despotism of the ruling class, but also the servility of their retainers.
32. Guy Debord, 1957, 'Report on the Construction of Situations' (1957), in *Situationist International Anthology*, pp. 43.
33. SI, 'Contribution to a Situationist Definition of Play', *Internationale situationniste (IS)*, no. 1 (June 1958), trans. Reuben Keehan, www.cddc.vt.edu/sionline/si/play.html.
34. 'To study everyday life would be a completely absurd undertaking unable to even grasp anything of its object, if this study was not expressly for the purpose of transforming everyday life.' Guy Debord, 'Perspectives for Conscious Changes in Everyday Life' (1961), in Situationist International, *Situationist International Anthology*, ed. and trans. Ken Knabb (Berkeley, CA: Bureau of Public Secrets, revised and expanded edition 2006), p. 90.
35. Nash et al., 'Thoughts on Situationist Film'.
36. In the modern film industry, costume directors often chose the twinset to portray a character's conservatism or frumpiness.
37. Nash et al, 'Thoughts on Situationist Film'.
38. Ibid.
39. In colloquial German, Persil is used metaphorically for the whitewashing of a person's consciousness. This dates back to the situation in West Germany after 1945, when alleged offenders of Nazi crimes would be released in sometimes rather questionable processes of de-nazification.
40. 'Kalenderblatt: 3 November 1956: "... und weiter nach der Werbung"', *Spiegel*, 3 November 2008, accessed 29 November 2019, www.spiegel.de/einestages/kalenderblatt-3-11-1956-a-947995.html.
41. 'Das Frauenbild der 50er, 60er und 70er Jahre im Spiegel von zeitgenössischen Zeitschriften und alter Werbung', magazine covers: 'Frau im Spiegel', 1955; 'Die Frau', 1947, accessed 29 November 2019, www.wirtschaftswundermuseum.de/frauenbild-50er-1.html.
42. Eleonora Pampado, 'Die Rolle der Frau in der Werbung rund um die 1960er Jahre', Universität Regensburg, SS 2012, pp. 8–20.
43. Asger Jorn, 'Image and Form' (1954), in Ruth Baumeister (ed.), *Fraternité avant tout*, trans. Paul Larkin (Rotterdam: 010 publishers, 2011), p. 254.
44. Gilles Ivain (alias Ivan Chetcheglov), 'Formulary for a New Urbanism', in *Situationist International Anthology*, p. 4.
45. The building was commissioned by King Ludwig I of Bavaria in 1841 in honour of his army. It was also there that Hitler's beer hall putsch ended in 1923 with the death of several people from Munich's police and Hitler's supporting Nazi party. After Hitler came into power the place became one of the memorial sites for the Nazis.
46. Peter Weiss (b. 1916 in Potsdam/Babelsberg, d. 1982 Stockholm), German Swedish film director.
47. Brabro Boman (b. 1918 in Göteborg, d. 1980), Swedish actress and scriptwriter, who explored women's issues and social conventions in her work.

48. Sturm, quoted by Ottmar Bergmann in a email to the author, 28 August 2018, translation by the author.

49. Lindells father had earlier been Swedish minister of justice and held the position of a governor during the 1960s. Her mother Manja, 20 years younger than her husband, was from a Jewish family from St Petersburg.

50. Jørgen Nash and J.V. Martin, *Hanegal: gallisk poesialbum* (Paris: Internationale Situationniste, 1961).

51. SICV: Scandinavian Institute for Comparative Vandalism, founded in 1961 by Peter Glob, Werner Jacobsen (National Museum of Denmark), Holger Arbman, (University of Lund, Sweden) and Asger Jorn.

52. Stracey, *Constructed Situations*, p. 113.

53. Franco Mazzuoccolo, Asger Jorn's son-in-law, in an unpublished conversation with the author, 17 September 2018.

54. Ottmar Bergmann in an email to the author, 4 January 2019.

55. Ottmar Bergman, ibid., reports a memory that Snild Aare told him, translation by the author.

56. Ottmar Bergmann in a mail to the author, 5 December 2018, reports a memory that Mette Aare told him, translation by the author.

57. Ole John Povlsen, (b. 1939–), Danish cinematographer.

58. Ole John in an interview with the author, 10 September 2019.

59. Lindell's step-son, Carsten Nash, confirmed this in an interview with the author, 24 August 2018.

60. Jørgen Nash, Little Mermaid's Murderer Crosses His Tracks (*Havefruemorderen krydser sine spor*) (Copenhagen: Jørgen Nash & Aschehoug, 1997), pp. 159–96.

61. 'Mother of Three Became a Man' ('Mor til tre er bliver mand'), *Berlinske Tider*, 19 May 1970.

62. Ottmar Bergmann in an email to the author, 28 August 2018, translation by the author.

63.

> Regarding Katja (Katarina)/Peter Lindell I found almost nothing during my research. [...]. I interviewed some of the people that was at Drakabygget during the time of the gender change but it's more or less just gossip. So I decided not to dwell on this for the exhibition. For me, the most interesting thing was Katja's contribution in the artistic field – the chicken wire box cover [...] for Hanegal and as one of the editors of the magazine *Drakabygget*.

As this note by Marika Reuterswärd, Director of Kristiansstad Konsthal, Sweden, reveals, the gossip about Lindell's change of gender made her decide not to go any deeper in her research about her, so that she consequently overlooked Lindell's contribution to the film, for example. Marika Reuterswärd in an email to the author, 20 April 2018.

64. Kaspar Riis Jensen, former riding student of Peter Lindell, shared his memories in an email to the author, 18 March 2019. Translation by the author.

65. Jens Jacobsen in an interview with the author, 18 October 2018. Translation by the author.

9

Revolutionary Romanticism in the Twentieth Century: Surrealists and Situationists

Michael Löwy

What is revolutionary Romanticism?

Romanticism is generally described in encyclopaedias and dictionaries as a nineteenth-century artistic and literary movement. It should, however, be understood as a much more wide-reaching and profound phenomenon: expressions of Romanticism can be found in the realms of philosophy, religion, law, political theory and historiography. Moreover, the history of Romanticism did not come to an end in 1830 or 1848. It continues to *this very day*. Romanticism should be thought of as a *vision of the world* that stretches across all cultural domains. Quintessentially, it is characterised by *the cultural contestation of modern capitalist civilisation in the name of certain values of the past*. That which Romanticism rejects in modern bourgeois, or industrial, society is above all the 'disenchantment of the world' (Max Weber), that is to say, the decline, or disappearance, of religion, magic, poetry and myth, and the coming into being of a world that is completely *prosaic*, utilitarian and commercial. Romanticism is a protest against mechanisation, abstract rationalisation, reification, the dissolution of communal ties and the quantification of social relationships. It makes this critique in the name of pre-modern social, moral and cultural values – presented as traditional, historical and concrete – and, in many respects, it embodies, a desperate attempt to 're-enchant the world'. Although Romanticism is manifestly a sensibility that is profoundly marked by nostalgia, it is not, for all that, any less an aspect of modernity: in a certain light, it could even be understood as *a cultural form in which modernity criticises itself*. As a vision of the world, Romanticism was born during the second half of the eighteenth century – Jean-Jacques Rousseau

could be thought of as its first great thinker – and it continues, in our own time, to be one of modern culture's principal forms of sensibility.[1]

At the end of the nineteenth century, German sociology systematically formulated a romantic nostalgia for the past by opposing the qualitative values of spiritual and moral *Kultur* and the organic and natural *Gemeinschaft* (community) against the purely quantitative values of industrial *Zivilisation* and the individualist and artificial *Gesellschaft* (society). Of course, the nebula of romantic culture is far from homogeneous. It contains many different currents, from conservative and reactionary Romanticism, which sought the restoration of the *ancien regime*, to 'revolutionary Romanticism', which took on the mantle of the conquests of 1789 (Liberty, Democracy, Equality) and which aimed at, not a *return* to the past, but a *detour* through a communal past towards a *utopian future*. Although Rousseau is one of the first representatives of this romantic sensibility, we also find it in Schiller, in the early republican writings of German Romantics (such as Schlegel), in the poems of Hölderlin, Shelley and William Blake, in the works of Coleridge, in the novels of Victor Hugo, in Michelet's historiography, in the utopian socialism of Fourier. Revolutionary Romanticism can also be found – at least partially – in the work of Marx and Engels, and in the work of other Marxists and Socialists such as William Morris, Gustav Landauer, Ernst Bloch, Henri Lefebvre and Walter Benjamin. Ultimately, it made a mark on some of the principal movements of cultural revolt in the twentieth century, such as Expressionism, Surrealism and the Situationist International.

Surrealism

Surrealism is perhaps the most striking and fascinating example of a romantic current in the twentieth century. It is, of all the cultural movements of the last century, the one which expressed most thoroughly the romantic aspiration to re-enchant the world. It is also the one which most radically embodied the revolutionary dimension of Romanticism. The spirit of revolution and social revolution – respectively embodied in the watchwords 'change life' (Rimbaud) and 'transform the world' (Marx) – were the pole stars which guided the movement from its beginnings, pushing it towards the permanent search for subversive cultural and political practices. At the cost of multiple ruptures and defections, the core of the Surrealist group around André Breton and Benjamin Péret in Paris never gave up its obstinate refusal of the established social moral

and political order – nor its autonomy which it guarded jealously, despite adhesion to or sympathy for different currents of the revolutionary left: first, Communism (Breton joined the French Communist Party [PCF] in 1927), then Trotskyism (Breton visited Trotsky in Mexico in 1938 and together they wrote the pamphlet *For an Independent Revolutionary Art*) and, finally, Anarchism (the Surrealists collaborated with the organ of the Anarchist Federation, then led by Georges Fontenis, *Le Libertaire*, between 1951 and 1953).

The Surrealist movement's opposition to modern capitalist civilisation is neither reasonable, nor measured: it is radical, categorical and irreducible. In one of their first documents, 'Revolution Now and Forever' (1925), its founders proclaim:

> Wheresoever Western civilisation reigns, all human attachments have ceased, with the exception of those whose sole reason for existence is self-interest, 'payment in hard cash'. For more than a century, human dignity has been reduced to the level of exchange value [...] We do not accept the laws of the Economy and of Exchange. We do not accept the slavery of Labour.[2]

Looking back many years later on the very beginning of the movement, Breton observes that: 'At this time, Surrealist refusal was total, absolutely incapable of letting itself be channelled into politics. We held all of the institutions upon which the modern world rests and which had just produced as a result the First World War to be aberrations and scandalous.'[3] This visceral rejection of social and institutional modernity did not, however, stop the Surrealists from referring positively to 'cultural modernity' – to which Baudelaire and Rimbaud claimed to adhere. The privileged objects of Surrealist attacks against Western civilisation were limited and abstract rationalism, realist platitudes and Positivism in all its forms.[4] From the 'First Surrealist Manifesto' (1924), Breton denounced the attitude that sought to banish 'under the colours of civilisation, under the pretext of progress', anything that hints of a chimera. In the face of this sterile cultural environment, he affirms his belief in the omnipotence of dreaming.[5] The search for an alternative to this civilisation would remain throughout the history of Surrealism, including in the 1970s, when a group of French and Czech Surrealists published (under the guidance of Vincent Bounoure) *La Civilisation surréaliste* (Paris: Payot, 1976).[6]

Breton and his friends never hid their profound attachment to the nineteenth-century romantic tradition, whether it be German (Novalis, Arnim), English (the gothic novel) or French (Hugo, Pétrus Borel). What is Romanticism for the Surrealists? Nothing seemed more detestable to them than the narrow academic approach that presented it only as a 'literary genre'. Breton spoke about this in a paper, 'The Romantics' Concept of Freedom', at a conference in Haiti in 1945: 'The image of Romanticism that scholars want us to accept is a *false* image. The way in which it is pigeonholed and categorised by nation prevents us from gaining an idea of the whole.'[7] In fact, for Breton, Romanticism is a *worldview* – in the sense of a *Weltanschauung* – that crosses nations and centuries:

> Is it necessary to make people see that Romanticism, as a specific state of mind and *mood*, the function of which is to establish in every respect a new general conception of the world, transcends these – very limited – aspects of feeling and saying which have been proposed after it [...]? Beyond the jumble of works that preceded or derived from it, most notably Symbolism and Expressionism, Romanticism imposes itself as a *continuum*.[8]

Surrealism is part of the long historical continuity of Romanticism as a 'state of mind'. Criticising the pompous official celebrations of a hundred years of French Romanticism in 1930, Breton comments in *The Second Manifesto of Surrealism*:

> we say, and insist on saying, that this romanticism which we are today willing to consider as the tail, *but then only as an amazingly prehensile tail*, by its very essence remains unmitigated in its negation of these officials and these ceremonies, and we say that to be a hundred is for it to be still in the flower of its youth, that what has been wrongly called its heroic period can no longer honestly be considered as anything but the first cry of a newborn child which is only beginning to make its desires known through us and which, if one is willing to admit that what was thought 'classically' before it came into being, was tantamount to good, undeniably wishes *naught but evil*.[9]

One cannot, at least in the twentieth century, think of a more categorical proclamation of the continued relevancy of Romanticism.

Nothing would be more wrong, however, than to conclude, from this explicit statement of allegiance, that the Romanticism of the Surrealists

is the same as that of the poets and thinkers of the nineteenth century. Rather, it is – in its methods, its artistic and political choices, its ways of feeling – something radically *new*, which belongs fully, in all its dimensions, to the culture of the twentieth century, and which can in no way be thought of as a simple reboot or, even worse, an imitation of earlier Romanticism.

Of course, the Surrealist reading of the romantic heritage of the past is highly selective. What attracts them to the 'gigantic facades of Hugo', to certain texts by Musset, Aloysius Bertrand, by Xavier Forneret, by Nerval, is, as Breton writes in 'Le merveilleux contre le mystère', 'the will for the total emancipation of mankind'. They likewise value the 'spontaneous hatred of the typical bourgeois', the 'will to absolute non-conformity with the reigning class' – the domination of which is 'a sort of leprosy against which, if one wishes to prevent the most precious human acquisitions from being perverted [*détournées*] from their meaning and from serving only to ever-further debase the human condition daily, brandishing the whip is not enough, rather one day it will require branding with irons' – that is found in 'a good number of romantic and postromantic writers' (such as Borel, Flaubert, Baudelaire, Daumier and Courbet).[10]

The same is true for the German Romantics. Breton fully recognises the 'rather confused and ultra-reactionary doctrine' expressed by Novalis in his essay *Europe or Christianity* (1799) or Achim d'Arnim's hostile position towards the French Revolution. This did not, however, stop their works, which were veritable thunderclaps, from shaking the very foundations of the bourgeois cultural order by questioning the separation between the real and the imaginary.[11] Their thought, in this sense, takes on a profoundly utopian and subversive dimension. In his philosophical fragments, for example, Novalis 'adopts for himself that which is the magical postulate *par excellence*' – and, although he does so in a way that excludes all limitations upon himself, 'It is up to us to ensure the world conforms to our will.'[12]

The Surrealist passion for pre-modern cultural forms and traditions is also selective. The Surrealists would without hesitation draw upon alchemy, Cabbalism, magic, astrology, the so-called primitive arts of Oceania and the Americas, and Celtic art.[13] All of their activities in this area had the aim of overcoming the limits of 'art' – as an institutionalised, ornamental and separated activity – in order to engage in the limitless adventure of re-enchanting the world. Nevertheless, like those revolutionaries who were inspired by the spirit of the Enlightenment, Hegel and

above all Marx, they were the most resolute and unmoving adversaries of the values which are at the heart of reactionary-romantic culture: religion and nationalism. As the Second Manifesto proclaims: 'Everything is still to be done, all means must be good for being employed to ruin the ideas of family, fatherland and religion.' Above the entrance to the lost paradise of Surrealism, in letters of fire, the well-known libertarian watchwords can be found inscribed: No Gods, no Masters!

The Situationist International

Despite the polemics and mutual excommunications, it is impossible not to notice the profound 'elective affinity' between Situationist attempts at cultural subversion and those of André Breton and his friends. As Gonzalvez rightly observes about the author of *The Society of the Spectacle*: 'The debt that Debord and his friend owed to Surrealism between the wars cannot be stressed enough: all that is necessary is to pick up any Surrealist tract, the smallest article in *Littérature*, or some Surrealist's correspondence to be convinced. The Situationists never highlighted this obvious lineage.'[14] Nevertheless, it is worth noting that, in his writings of the 1980s and 1990s, Debord would come to the defence of André Breton, denouncing the systematic negative application of the term 'Pope' to him as a 'contemptible ignominy'.[15]

There are obvious differences between Debord and Breton: the former is much more a rationalist and closer to the French materialism of the Enlightenment. What they share, however – other than the lofty poetical and subversive goal of overcoming the separation between 'art' and 'action', the haughty spirit of revolt, negativity and a refusal to submit to any authority – is the revolutionary romantic sensibility.

Debord always condemned and derided ideologies of 'modernisation', never, for a single instance, fearing the accusation of 'anachronism': 'When "to be absolutely modern" has become a special law decreed by some tyrant, what the honest slave fears more than anything is that he might be suspected of being behind the times.'[16] Furthermore, he never hid his fascination with certain pre-capitalist forms of community. Exchange value and the society of the spectacle dissolved any human community founded upon the direct experience of things, real dialogue between individuals and communal action to solve problems: the Greek *polis*, the medieval Italian republics, villages, local neighbourhoods and the taverns of the lower classes. Debord thus condemned the Spectacle as a 'society

without community',[17] implicitly adopting Ferdinand Tönnies' well-known distinction between *Gesellschaft* and *Gemeinschaft*.[18] In *Commentaries on the Society of the Spectacle* (1988), Debord recognises the bitterness of this loss: 'For the agora, the general community, has gone, along with communities restricted to intermediary bodies or to independent institutions, to salons or cafés, to workers in a single company.'[19]

An illustration of Debord's gothic Romanticism – in the sense of the English 'gothic novel' of the eighteenth century – can be found in his film *In girum imus nocte et consumimur igni*. Like his romantic forebears, Debord has only disdain for modern society: he ceaselessly condemns its 'dirty and lugubrious bad buildings', its technical innovations that usually only benefit their creators (*entrepreneurs*), its 'modernised illiteracy', its 'spectacular superstitions' and, above all, its 'hostile landscape' that reflects the 'concentration-camp-like inclinations of modern industry'.[20] He is particularly ferocious towards the Neo-Haussmannian and modernising urbanism of the Fifth Republic, which promoted the sinister adaptation of the city to the dictatorship of the automobile; a policy, according to Debord, responsible for the death of the sun, the darkening of the Paris sky by the 'false fog of pollution' that permanently covers the 'mechanical circulation ['circulation' in French also means traffic] of things in this valley of desolation'.[21] He could only reject therefore the 'present infamy in both its bureaucratic and bourgeois versions'. The only escape from these contradictions that he could see was 'the abolition of class and the state'.[22]

This revolutionary anti-modernism was accompanied by a nostalgic glancing back to the past – whether it was the 'ancient home of the king of Ou', reduced to ruins, or 1950s Paris, which had itself become – thanks to contemporary urbanism – a gaping ruin. The poignant regret for 'beauties which will never return', for epochs where 'the stars were not put out by the progress of alienation', for the attraction of 'ladies, nights, weapons, loves' of a lost age are found, like a subterranean murmur, throughout the entire text.[23] But, for Debord, it was not a matter of returning to the past. Very few twentieth-century authors have succeeded as well as Debord in turning nostalgia into an explosive force, into a poison-tipped weapon, against the existing order of things, into a revolutionary break towards the future. What Debord was seeking was not a return to a golden age, but a 'formula for overturning the world'.[24] The Situationists, as much as the Surrealists, played an important cultural role in the events of May '68, a revolt, which cannot be properly understood without reference to revolutionary Romanticism.

Notes

1. See Michael Löwy and Robert Sayre, *Romanticism Against the Tide*, trans. Catherine Porter (London: Duke University Press, 2001).

2. In *La Révolution surréaliste*, 5 (1925). The text is signed by a large number of artists and intellectuals, including Breton, Aragon, Eluard, Leiris, Crevel, Desnos, Péret, Soupault and Queneau.

3. Breton, 'La claire tour' (1951) in *La Clé des champs* (Paris: Pauvert, 1967), p. 42.

4. As Marie Dominique Massoni rightly notes, the Surrealists shared Romanticism's 'refusal to see the world as existing only on a logical, mathematical, useful, verifiable, quantifiable basis – in sum, a bourgeois basis'. Marie-Dominique Massoni, 'Surrealism and Romanticism', in Max Blechman (ed.), *Revolutionary Romanticism* (San Francisco: City Lights, 1999), p. 194.

5. Breton, *Manifestes du surréalisme* (Paris: Gallimard, 1967), pp. 19, 37.

6. A persistent rumour, which with time has taken on the crushing weight and granite-like consistency of a dogma, has it that Surrealism disappeared, as a movement and form of collective action, in 1969. In fact, although certain members of the Surrealist group in Paris (around Jean Schuster) felt it opportune to announce the dissolution of the group that year, others (around Vincent Bounoure) decided to continue the Surrealist adventure. In 2002, collective surrealist activity existed not only in Paris but also in Prague, Madrid, Stockholm, Leeds and Chicago.

7. André Breton, 'Evolution du concept de liberté à travers le romantisme' (1945), *Conjonction: Surréalisme et Révolte en Haïti*, 194 (June 1992): 82.

8. André Breton, 'Perspective cavalière' (1963) in *Perspective cavalière* (Paris: Gallimard, 1970), p. 227.

9. André Breton, 'Second Manifesto of Surrealism', trans. Richard Seaver and Helen Lane, in *Manifestoes of Surrealism* (Ann Arbor, MI: University of Michigan Press, 1972), p. 153.

10. André Breton, 'Le merveilleux contre le mystère' (1936), in *La Clé des champs*, p. 10 and 'Position politique de l'art' (1935), in *Position politique du surréalisme* (Paris: Denoel-Gonthier, 1972), pp. 25–6. For further analysis of the relationship between Surrealism and German Romanticism see K.H. Bohrer, *Die Kritik der Romantik* (Frankfurt: Suhrkamp Verlag, 1989), pp. 48–61. On the links between Surrealism, Romanticism and the students' revolts of the 1960s, see R. Faber, 'Frühromantik, Sur-realismus und Studentenrevolte, Oder die Frage nach dem Anarchismus', in R. Faber (ed.) *Romantische Utopie, Utopische Romantik* (Hildesheim: Gerstenberg, 1979), pp. 336–58.

11. André Breton, 'Introduction' (1933) in Achim d'Arnim, *Contes bizarres* (Paris: Julliard, 1964), pp. 18, 20, 21.

12. André Breton, 'Sur l'art magique' (1957) in *Perspective Cavalière*, p. 142.

13. As Massoni notes:

 the power of desire and the marvellous inclines them [the Surrealists] toward hermeticism, as with the Romantics before them. From Enter the Mediums to the canvases of Camacho or Stejskal the Surrealists follow

close behind the alchemist Eugène Canseliet and the esoteric tradition, divested of its occultist hodgepodge, very often in honor of the Romantics. Breton had inscribed on his tomb: 'I seek the gold of time.' The reference to Romanticism as well as to alchemy is obvious there (Massoni, 'Surrealism and Romanticism', in *Revolutionary Romanticism*, p. 197).

14. Shigenobu Gonzalvez, *Guy Debord ou la beauté du négatif* (Paris: Mille et Une Nuits, 1998), p. 22.

15. Guy Debord, *Considérations sur l'assassinat de Gérard Lebovici* (Paris: Éd. Gérard Lebovici), p. 57. See also *Cette mauvaise réputation* (Paris: Gallimard, 1993).

16. Debord, *Panegyric*, trans. James Brook (London: Version, 2004), p. 66.

17. Debord, *The Society of the Spectacle*, trans. Ken Knabb (Berkeley: Bureau of Public Secrets, 2014), thesis 154, p. 84. Translation changed.

18. The distinction between community and society is presented by Ferdinand Tönnies in his classical sociological work *Gemeinschaft und Gesellschaft*, from 1887.

19. Debord, *Comments on the Society of the Spectacle*, trans. Malcolm Imrie (London: Verso, 1998), thesis 7, p. 19. Debord also, in a similar context, idealises 'what it meant to be a judge, a doctor or a historian …'. Ibid., p. 20. For a legitimate critique of this 'romantic complacency' towards the law and medicine before the Spectacle , see Shigenobu Gonzalvez, *Guy Debord ou la beauté du négatif*, p. 49.

20. Debord, *In girum imus nocte et consumimur igni* (Paris: Éd Gérard Lebovici, 1990), pp. 193, 202.

21. Ibid., p. 212.

22. Ibid., pp. 220–1.

23. Ibid., pp. 217, 219, 221, 255.

24. Ibid., pp. 247–9.

PART II

Key Concepts

10

The Spectacle

Alastair Hemmens and Gabriel Zacarias

Introduction

First published in the winter of 1967, just months before the May '68 student uprisings, *The Society of the Spectacle* by Guy Debord is today rightly recognised as one of the most important works of anti-capitalist critique of the twentieth century. It is also, however, a book that remains opaque to many readers and that has inspired many erroneous readings even among critical theorists. Part of the reason for this is undoubtedly the fact that Debord uses an occasionally enigmatic and often baroque prose style that, with some important exceptions, generally eschews precise definitions and clear statements of intent. Debord was, after all, a heterodox thinker who combined avant-garde aesthetic considerations with revolutionary rhetoric and high theory. *The Society of the Spectacle*, moreover, is comprised of a series of theses that do not always follow logically from one another and these often take the form of *détournements*, subtle references, to other literary and critical-theoretical works. Debord generally does not try to meet his audience halfway and, especially for the uninitiated, it is often difficult to grasp exactly what is he is trying to say. It is perhaps not surprising that, as a result, *The Society of the Spectacle*, and in particular the notion of 'spectacle' itself, has sparked, even among critical theorists, a variety of contradictory interpretations that in many cases remain quite superficial. When Debord is evoked in mainstream publications, for example, it is more often than not as a kind of media theorist who is supposed to have described our 'image-obsessed age' and, these days, he is even seen as a critic of social media *avant la lettre*. Although such readings have some basis in reality – Debord was certainly interested in describing our empirical existence and the importance of images in our society – these kinds of readings are not only reductive, they also tend to overlook the fact that the critique found in *The Society of the Spectacle*

functions on a number of different levels of social reality, many of which are much more fundamental and cannot simply be reduced to a description of our adulation of celebrities, television and adverts. The notion of 'spectacle', that is to say, seeks to encompass a critique of both the particulars of the phenomenological reality of the post-war capitalist world, but also, and even more importantly, the *supra-sensible*, or *hidden*, and most fundamental, or general, forms of alienation that are the historical driving force behind these changes and from which we need to free ourselves.

Spectacle and commodity fetishism

As Bunyard demonstrates in chapter 4, Debord's thought is deeply rooted in the Hegelian tradition and, as a result, in the logic of dialectics. Much of the confusion surrounding his work results from the difficulty of following the dialectical movement of his argument which flits constantly from general concepts to particular phenomena. A term such as 'spectacle' might signify a general concept in one part of the text and an empirical fact in another. In thesis 10, for example, Debord writes that the concept of spectacle is a totalising one that 'interrelates and explains a wide range of apparent phenomena'.[1] However, in thesis 6, Debord also states that the 'spectacle' has 'particular forms' such as 'news, propaganda, advertising, entertainment'.[2] Moreover, although these latter examples refer to the media, Debord and, elsewhere, the Situationists more generally use the terms 'spectacle' and 'spectacular' to refer to many different types of empirical phenomena, such as workers' parties, unions and states; neither 'spectacle' nor 'spectacles' need necessarily therefore refer to images in the everyday sense. Readers of *The Society of the Spectacle* must discern for themselves the instances in which Debord uses the term to refer to the general concept or to particular empirical objects. Debord, in adopting this mode of presentation, wishes to underline that spectacles are a result of *the* 'spectacle' as a general form of social being. Although it is true that this rhetorical approach has undoubtedly contributed to the difficulty of understanding his argument, Debord is, nevertheless, quite consciously adopting the technique in order to emphasise, in true Hegelian fashion, that the particular, concrete or empirical reality that we inhabit is ultimately shaped or overdetermined by a more general, *hidden*, abstract form.

Debord, in adopting this dialectical mode of presentation, seeks to continue and to develop a mode of critical analysis that begins with Marx. Marx, at least as Debord understands him via Hegelian Marxism, argues

that in capitalist society human beings do not decide in advance what they are going to produce and under what conditions. Rather, workers produce commodities in order to realise an exchange on the market. Each particular object that is produced – be it a table or a car – ceases to exist as an individual object defined by its qualitative content – its use-value – and instead only counts as a greater or lesser quantity of socially necessary labour time – embodied in its exchange value or price. Marx sees this two-sided, concrete and abstract, nature of the objects produced in capitalist production as the essence of the 'commodity form' in which a social abstraction determines the social meaning of the concrete. The result is a quasi-autonomous abstract development, regardless of the concrete consequence for human life, because the realisation and accumulation of exchange value, a purely quantitative category, is the only goal of production. Debord, and other Hegelian Marxists, took this to mean that human labour and its products are alienated from the producers to serve the ends of a system of abstract generalised forms that have escaped their control. The concrete totality of the world in which we live is no longer therefore our own product but the result of the production of abstract wealth for its own sake. Because this system of oppression is rooted in the double-sided character of the commodity form, and because it embodies a projection and alienation of human powers onto something that we ourselves have created (like a materialised religion), Marx refers to capitalism as a system of 'commodity fetishism'.[3]

Debord makes the link between Marx's argument in *Capital* (1867) and that of *The Society of the Spectacle* (published exactly a hundred years later, in 1967) explicit in the very first sentence of the book: 'The entire life of those societies in which modern conditions of production prevail appears as an immense accumulation of *spectacles*.'[4] These words are a *détournement* of the opening lines of Marx's *Capital*: 'The wealth of societies in which the capitalist mode of production prevails appears as an "immense collection of commodities".'[5] The replacement of 'commodities' with 'spectacles' suggests that Debord fundamentally sees his general theory of 'spectacle' as a continuation of the theory of 'commodity fetishism' outlined in the first chapter of Marx's 'critique of political economy'. The general theory of 'spectacle' cannot therefore be understood simply as a 'theory of the media'. Rather it must be grasped as the continuation and development of the Hegelian Marxist critique of capitalism as an historically specific society constituted by 'commodity fetishism'. Interestingly, Situationist texts and statements often employ the term 'commodity society', in lieu

of or as a synonym for 'capitalism', in order to emphasise that the problem is not only the 'exploitation' of labour but also, and even primarily so, the total alienation of human life in the name of an abstract formal system of quantitative development. The point is not only that we are dominated by a ruling class – be it the bourgeoisie in the West or the state bureaucracy in the East – but rather that economic development for its own sake has taken the place of human agency. As Debord puts it in thesis 16 of *The Society of the Spectacle*: '[The spectacle] is nothing other than the economy developing itself for itself.'[6] In essence then, we could therefore say that, in Debord, 'spectacle', in the most general sense, takes on the same role that the 'commodity form' (and capital) does in Marx. The spectacle is the dictatorship of social life by the economy. We are reduced to its passive 'spectators'.

Spectacle as appearance, image and representation

What we see above is that 'spectacle' is, despite its visual connotations, a distinct concept rooted in the Marxian theory of commodity fetishism. The 'spectacle' is, at the most fundamental level, 'capital' as Marx understood it. Spectacle, as such, needs to be grasped as something separate from, and not merely synonymous with, the related visual terminology that frequently appears throughout Debord's work. Nevertheless, Debord is not simply repeating what Marx already said. Moreover, although the critique of the 'spectacle' cannot be reduced to a critique of the media, Debord is, as we mentioned above, undoubtedly concerned throughout his work with the idea of 'images', 'representation' and 'appearance'. The choice of the term 'spectacle', in other words, is a conscious one that seeks to say something about how commodity fetishism has shaped the concrete empirical world since the time of Marx. As Debord puts it in thesis 34, 'The spectacle is capital accumulated to such a degree that it becomes an image.'[7] Debord, in naming capital in the post-war era 'spectacle', seeks to describe therefore *how* the world of images has been transformed and *why* a certain relationship to images has become so central to capitalism in the second half of the twentieth century, that is, as a new phase in the runaway system of commodity fetishism or the 'dictatorship of the economy'.[8] The *supra-sensible* category of 'capital', Debord argues, has, over the course of the past hundred years, created a phenomenological reality full of empirical 'spectacles'. The existence of these 'spectacles', that is, the way in which empirical reality has changed, in turn forces us to rethink

'capital' as the ultimate 'spectacle' or 'spectacle' as a supra-sensible social category.

This link between spectacle (as capital) and the visual language of 'image', 'representation' and 'appearance' has been a point of confusion for many critics in the past, and part of the difficulty is that Debord often subverts the traditional meanings that these words have historically had in Western philosophy.[9] The 'spectacle' is the fundamental separation that has occurred as a result of the alienation of humanity from its activity and its products. It is, for the most part, also to be understood as an historically specific category (at least in its generalised form) and not as a logic that has defined all societies in all times and all places. In contrast, these other categories – image, representation and appearance – are just that: forms of appearance that, nevertheless, are manifest in everyday life. Images, representations and appearances are transhistorical forms that exist in all societies. However, they have not always had such great importance to society and, more importantly, they have only relatively recently taken on the generalised 'spectacular' form that they adopted in post-war capitalism. In many ways, therefore, the image occupies, in the society of the spectacle, the place that the commodity is thought to have occupied in the first phase of capitalist development. Debord believes that the commodity was an object that was exchanged in pre-modern societies, but which had only a very limited scope in overall social reproduction. In capitalism, however, the commodity came to mediate all social life and became the focus of bourgeois society. Debord argues that, today, the economy has developed to such an extent that now images have become the prime mode of socialisation. These images, however, are not simply any sort of image. Just as the commodity form transforms a table into an abstract social object with 'metaphysical subtleties', so the spectacle form transforms the image, a particular type of object, into something with a social significance that it did not have in previous forms of society.

We usually think of images as representations of objects. These representations, moreover, differ in aesthetic form and technique as historical development leads from one society or epoch to another. The 'spectacular image', however, is a specific kind of image that bears an historically determinate form. (Here, in analogy to Marx, we might speak of the 'spectacle form' of the image). Such an image embodies something that goes beyond its social functions – representative function for modernity, ritual function for traditional societies – or that which we could call the use-value of the image. The image under its spectacular form is also 'phantasmagorical'

and fetishistic in character, as are objects under the commodity form. For they seem to retain as intrinsic qualities those characteristics that can only be understood as part of the social process that generates them – and which remains *hidden*. As happens with commodities, this image is formally subsumed; it is no longer an image that serves a concrete purpose and that is attached to that purpose, but a replaceable image, equivalent to any other.

The same light might be shed on the concept of 'representation'. The term 'representation' can be found in Debord's text in its common meaning, that is, as re-presentation of something. The representation of an object can take place in the mind of the subject as the apparent manifestation of a present object, or as a recollection of an absent object. It can also take place outside consciousness, exteriorised in the medium of the image. This is why Debord frequently compares art to memory as a work of art can be understood as a material and external recollection of something that has been seen or experienced by its maker. Nevertheless, we find in the text a specific notion of representation that refers to the society of the spectacle, that which Debord terms 'independent representation'.[10] It is with that meaning that the word is used in the opening thesis of the book: 'Everything that was directly lived has receded into a representation.'[11] In that case, the representation has lost its connection to life, and the objects it portrays no longer refer to any concrete experience, past or present.

Spectacle and philosophy

Nothing confuses philosophers more than the use Debord makes of the notion of 'appearance', a key notion in the tradition of Western philosophy. The term might be found in Debord's text denoting the traditional opposition between appearance and essence; as it can also be evoked in the phenomenological sense of the apparent manifestation of the objective world to the consciousness of the subject of knowledge. But it could also refer to the series of representations materially produced in the separate sphere of the spectacle. All of this might seem confusing, but it is not a matter of conceptual imprecision. An additional difficulty might come from the traditional meanings of terms that might be subverted in Debord's text. The terms 'appearance' and 'image', for instance, have frequently been used as synonyms in Western philosophy. From Descartes to Kant, the presupposition was that the material world was only apprehensible through its apparent manifestations to subjective consciousness. In other words,

the subject of knowledge could not grasp reality as an irreducible fact. On the contrary, the world would unveil itself only through the mediation of its images, that is, the appearance of its objects as apprehended by the mind's eye. Philosophy would thus mean speculative philosophy. But what are we to make of such philosophical paradigms when we find ourselves in front of an objective world that is already composed of materially produced images? What are we to make of speculative philosophy when all experience is mediated by images that are equally part of the sensible world? That problem is addressed by Guy Debord in the nineteenth thesis of *The Society of the Spectacle*:

> The spectacle inherits the *weakness* of the Western philosophical project, which attempted to understand activity by means of the categories of vision, and it is based on the relentless development of the particular technical rationality that grew out of that thought. The spectacle does not realize philosophy, it philosophizes reality, reducing everyone's concrete life to a universe of *speculation*.[12]

Similar to the Frankfurt School theorists, Debord notes here how Western reason has reduced itself to mere technical rationality, achieving the domination of nature but betraying its broader claims for human emancipation.[13] His understanding, however, is different from that of Horkheimer, Adorno and their peers. Debord believes that our progressive domination of nature has developed so closely in dialectical relation with the progress of knowledge that we have essentially created a speculative material world. The society of the spectacle therefore realises the *de facto* existence of appearances as the sole form of mediation through which we can access the objective world. Philosophy claimed that the world could only be known through its images, its forms of appearance, but now such images are industrially produced and widely circulated to serve the purpose of abstract wealth creation. The sensible world itself essentially becomes an appearance. The subject can no longer directly access the objective world, rather a series of images, of apparent phenomena, are offered to delight the spectator's eyes.

Many commentators, especially philosophers, have referred to Debord as a metaphysician or as a late Platonist.[14] This, however, is completely incorrect. Metaphysics is surely present in Debord's theory, but not because the author adopts it. What happens in fact is that the world he intends to describe has become itself metaphysical. The intertwining of the sensible

and the supra-sensible that Marx had identified in the commodity form, unfolds in the images of spectacular society. In this sense, denouncing the spectacle as false does not mean clutching at a Platonic notion of truth – for it is the 'world of ideas' that has come down to earth. In other words, Debord is not arguing in favour of idealism, but rather denouncing the world of ideas in its attempt to take possession of the material world: '[in spectacle] the sensible world is substituted for a selection of images that is above it, and that at the same time presents itself as the sensible par excellence'.[15]

Spectacle and class consciousness

Besides its direct dialogue with Marxian philosophy, Debord's theory is also marked by the intellectual debates of his time. A major influence in his understanding of capitalist society came from reading Georg Lukács' 'forbidden book', *History and Class Consciousness*, which was rediscovered in France at the turn of the 1960s.[16] In his theory of 'reification', Lukács sought to understand the relationship between objective and subjective transformations in modern capitalism. Significant changes in the way objects were produced implied equally meaningful changes in the subjective consciousness of producers. The rationalisation and growing division of productive activities in the modern industrialised system – Lukács was thinking specifically of Fordism – meant individual producers could no longer apprehend the entirety of the production process. Not only that, but individual workers were rationally integrated into the production process as pieces of a machine, and their activities were reduced to standardised and pre-calculated movements. This meant that, with the progress of industrialisation, workers' activities became 'less and less active and more and more *contemplative*'.[17] Consciousness played little or virtually no role in action, and the worker became only a spectator of production. Debord employs the concept of 'spectacle' therefore to argue that the alienating, passively contemplative, characteristics that Lukács observed in the production process had now become a general feature of the whole of modern society. The separation of consciousness and action, the 'contemplative character' of the producer, would find its logical continuity outside of work in the consumption of modern leisure and cultural goods. Moreover, in the same way that producers, according to Lukács, were increasingly unable to recognise the commodities they produced as the product of their own labour (due to rationalisation of production), so too did the rest of the

world as a whole find it seemingly impossible to recognise that the totality of the social world, and its history, was the product of its own activity. Instead, just like the production process, society appeared as a closed system governed by seemingly immutable and unquestionable natural laws. What Marx had referred to as a 'second nature'.

The scenario thus described might seem excessively grim. However, in depicting a world of profound alienation, both Lukács and Debord sought to assert the absolute necessity and even the imminence of revolution. As the title of his book suggests, Lukács' goal was to demonstrate that class consciousness and historical transformation are one and the same. Reification, although it was the basis for alienation, is also what made workers potentially revolutionary as they could only become 'subjects', truly in control of their own lives, by overthrowing the social conditions that objectified them. The proletariat therefore could be understood as the privileged 'subject of history' because it needed to transform society as a whole in order to realise itself as a free agent. Lukács was therefore profoundly Hegelian in his reasoning. His understanding of class consciousness evoked a notion of final resolution in which the separation of subject and object would be overcome. The proletariat, for him, is the 'identical subject-object of the social and historical processes of evolution' because 'its own class-aims' (that is, its subjective purposes) are simultaneously 'the conscious realisation of the – objective – aims of society'.[18] Significantly, this argument implied that the realisation of the working class would also mean that it would cease to exist as such. Such an idea was obviously displeasing to the ruling Communist Party, which drew its legitimacy from the claim that it was the official voice of class consciousness. As a result, it had no intention of overcoming the objective existence of the working class and therefore suppressed any argument, such as Lukács', which threated the basis of its continued rule. Lukács, who did not want to be at odds with the Party, withdrew his argument.[19]

The Situationists would employ the same Hegelian schema that is found in Lukács. Revolution, for them, also relied on the self-realisation, and self-abolition, of the proletariat as a class, believing subjective consciousness and objective transformation to be two sides of the same coin. This also implied the intertwining of theory and praxis, for consciousness was only attainable through the practical process of changing objective conditions; and it is in this practical dimension that the Situationists diverged from Lukács. In thesis 112 of *The Society of the Spectacle*, Debord overtly criticises Lukács for seeing the Communist Party as the organisational form

in which the relation between theory and practice could be mediated, that is, where proletarians would cease to be spectators and become instead conscious political actors. Lukács, Debord quips, was instead describing 'everything the party was *not*'.[20] Debord sees the Party as a separate entity that makes decisions about collective existence in the name of class and often does so against its real interests. The Party, with its bureaucratic and centralised structure, tended necessarily to become a form of representation independent of the workers themselves, that is, a form of spectacle. The Situationists opposed Party organisation and supported, in its place, a federation of workers' councils (soviets), which they believed was the only way of ensuring that people have direct effective communal control over the life that they are living.[21]

Spectacle and time

The Situationists also depart from Lukács in another key respect that addresses a problem more clearly rooted in their own historical context. A key issue that was a matter of frequent debate in the modernisation boom of the 1950s and 1960s was that of automation. Many observers foresaw a future of fully automated material production. This belief, largely shared by members of the Situationist International (SI), rested upon the idea that 'labour' is the natural result of necessity, rather than an historically specific social form that serves no other purpose than abstract wealth production. Automation, it was thought, would lead to a society in which people would not have to work and instead could devote themselves to other pursuits. Drawing on Marx, the Situationists saw all social life, in any society, as divided into a 'realm of freedom' and a 'realm of necessity' (see chapter 13). The realm of freedom would grow with the development of productive technology and the domination of nature, which liberated 'free time' that permitted societies to engage in forms of social existence not strictly limited to material survival. Modern capitalist society, however, reaches the point where labour, and the realm of necessity, are reduced to such a great extent that it has to constantly recreate the problem of survival to justify economic development. It engenders an artificial realm of necessity, a permanent creation of pseudo-needs, in order to maintain the system of commodity production. As Debord states, 'the abundance of commodities [...] amounts to nothing more than an *augmented survival*'.[22] The society of the spectacle is therefore the false claim that technological development and the domination of social life by the economy, the exigen-

cies of survival, are still a necessity. In this sense, Situationist theory can be understood as an argument against the specific way in which capitalist society has responded to the immense increase in productivity that characterised the second and, then burgeoning, third industrial revolutions.[23]

The Situationists therefore believed that the issue of automation, the reduction of 'necessary labour', placed the relationship between history and class consciousness under a new light. It was no longer a question of simply who controlled the means of production, but who had control over the free time, time outside 'necessary labour', that had been created through technological development. False consciousness therefore consisted in an insufficient understanding of the material possibilities for freedom from work brought about by automation. In this way, the society of the spectacle is the 'preservation of the unconscious in the practical changes in the conditions of existence', that is, the possibilities for social transformation, not so much through propaganda, but simply through the artificial extension of the 'realm of necessity' as 'augmented survival'.[24] As another Situationist, Raoul Vaneigem, puts it in more popular terms, the need to drink is replaced by the 'need' to drink Coca-Cola.[25] The result is that all of the liberated time that has been released by the revolutionising of the production process, which could allow for a 'free' or 'historical' usage of time, is simply devoted to the reproduction of more of the same. Time remains reduced to the form of 'commodity-time', as Debord terms it, the quantitative measure of abstract value, instead of being the qualitative flow of lived experience. In this sense, if spectacle is false consciousness, it is above all 'the false consciousness of time'.[26]

The problem of time had then a central place in Debord's theory, as we saw in chapter 4 also, and in Situationist thought in general.[27] Just as Marx sees the expropriation of the means of production as the precondition for the emergence of capitalism, so too Debord speaks of the 'violent expropriation of [workers'] time' as the original 'precondition' for the emergence of the society of the spectacle.[28] The Situationists therefore seek to win back the time that is expropriated and alienated by capitalist production. This implies, as a result, a major shift of revolutionary theory in relation to the traditional Marxism of the workers' movement. Traditional Marxism sees the collectivisation of the means of production as essentially the sufficient condition for overcoming capitalist alienation (which is understood almost purely in terms of property relations). Under such a revolutionary schema, however, production as such remains untouched, even venerated, and, as a result, so does the most fundamental, underlying, abstract logic

of capitalism as a destructive system of commodity fetishism. The Situationists, in contrast, take an existential turn. Revolution, for them, consists in the directly democratic questioning of the very use of time, all time, beyond its submission to the perpetual cycle of the production and consumption of commodities. Automation, because it was at that time believed to be the key to eradicating 'necessary labour', forces revolutionary theory to confront the effectively obsolete nature of a society founded upon 'labour'. Labour cannot, as is the case in traditional Marxism, serve as the basis for a positive, revolutionary identity for the working class. Rather, as we explore in chapter 13, the true revolutionary position, the Situationist position, is to be anti-work.

Integrated spectacle

Debord would not revise his theory until two decades later with the publication of *Commentaries on the Society of the Spectacle* (1988). Written on the occasion of the twentieth anniversary of May '68, *Commentaries* begins with a bitter assessment of the failure of the May movement. Debord, nevertheless, does not renounce the central tenets of his previous work. On the contrary, he argues that what has since come to pass is only the further development of the very logic that he had identified in *The Society of the Spectacle*: 'in all that has happened in the last twenty years, the most important change lies in the very continuity of the spectacle'.[29] In other words, the Spectacle has pervaded everyday life as never before and, in so doing, made the tyranny of the economy more visible than ever. Debord does, however, note one important shift in the way in which spectacular societies had come to be governed on a global scale. Already, in the 1960s, he had denounced the false division between East and West during the Cold War, arguing that the world was already unified under the rule of modern spectacular capitalism. He coined, in this context, the terms 'concentrated spectacle' and 'diffuse spectacle' to describe differences in governance between Communist and Western capitalist states.

'Diffuse spectacle', originally identified with Western capitalism, is characterised by the seductive abundance of commodities and consumer culture mirrored in the apparent freedom to choose between lifestyles and political representatives. 'Concentrated spectacle', in contrast, and which reigned in the so-called socialist or communist countries, concentrated all spectacular identification in a single, dominant, political leader and maintained capitalist reproduction chiefly through the mediation of the state

and its accompanying ruling class of bureaucrats. However, by the time of the publication of *Commentaries* in 1988, the year before the fall of the Berlin Wall, Debord had already concluded that the distinction between 'diffuse' and 'concentrated' spectacle was outdated. He foresaw in its place a new form of spectacular power, the 'integrated spectacle', built upon the foundations of the victory of 'diffuse spectacle', but also inheriting many of the core features of 'concentrated spectacle'. This 'integrated spectacle' would unite the apparatus of the police state, continuous control over the population and secrecy over key political decisions with the merely apparent democratic freedom and seductive power of the mass consumption of commodities. Such an 'integrated' form of spectacle would become, from henceforth, the dominant form of governing spectacular societies throughout the globe, meaning, in other words, a generalisation of formal democracy while, at the same time, suppressing civil liberties.

The general concept of 'integrated spectacle', however, does not refer solely to the empirical forms of spectacular power. Debord also uses it to refer to a deeper, structural, dimension of the society of the spectacle: the relationship between reality and representation. The distinction was central to his theory in 1967. Debord had argued, as we have seen, that the society of the spectacle is chiefly characterised by the growing remoteness of representation, its increasing distance from real, lived, experience. Everyday life diverges from its on-screen representation in much the same way as the class interests of workers diverge from those of its official representation in political parties and trade unions. Twenty years later, however, Debord claims that the spectacle has come to reshape reality so completely according to its own logic that it has seemingly rendered the former distinction between reality and representation obsolete. The notion of an 'integrated spectacle' would therefore also account for this major shift:

> For the final sense of the integrated spectacle is this – that it has integrated itself into reality to the same extent as it was describing it, and that it was reconstructing it as it was describing it. As a result, this reality no longer confronts the integrated spectacle as something alien.[30]

Debord provides several empirical examples of 'integrated spectacle' to support the idea of a generalised collapse in the distinction between representation and reality. He refers, for example, to the restoration of historical cities, public monuments and art works. For Debord, the refurbishment

of historical city centres – in particular the practice of 'facadism', that is, the destruction and modernisation of the interior of a building while preserving its surface appearance, which became prominent in Paris in the 1980s, as well as the restoration of Renaissance frescoes to give them brighter colours – indicate a society that prizes these objects solely as consumable items, designed for postcards and holiday snaps, to promote the tourism industry. Debord criticises specifically 'the replacement of the Marly Horses in the place de la Concorde, or the Roman statues in the doorway of Saint-Trophime in Arles, by plastic replicas. He also evokes the recent 'restoration' of the ceiling of the Sistine Chapel in the 'colours of a cartoon strip' (which was, indeed, highly criticised by many art historians at the time).[31] These examples of, or rather, consequences of, 'integrated spectacle' demonstrate how unimportant the real, authentic, object itself is for society. Everything is replaceable and matters almost exclusively for its appearance rather than its material qualities.

What is being described here is, once again, the universalisation of the commodity form and, with it, the subjugation of concrete reality to the abstract paradigm of value. A common mistake is to see the new phenomenological changes that Debord describes in the *Commentaries* as the result of the spread of image-based culture. Debord, however, is still referring to the structural development of capitalism as an historically specific, dialectical and material process of social reproduction. The world is becoming increasingly abstract because capitalism is a form of society based upon the accumulation of abstract wealth. The need for economic growth, which is abstract and quantitative in character, leads to a loss in the social importance of the concrete, qualitative, world. Reality itself can only be conceived, transformed and experienced, within the confines of the spectacle, according to abstract economic criteria. When, therefore, Debord states that the modern restoration of historical façades and frescoes is done in such a manner as to better fit the photographic register of tourists, he is not only referring to the dissemination of images and the popularisation of photography. He is also, even primarily, describing the fact that today every aspect of lived experience is shaped first and foremost by the mediation of the commodity form. The restoration of historical cities and monuments is now chiefly oriented towards the economic criteria of mass consumption instead of the traditional paradigms of beauty and authenticity that had previously been central to the preservation of artistic and historical knowledge.

This 'falsification of the world', likewise, implies a commensurate and drastic loss of social knowledge. The situation of the modern wine industry is an example Debord raises to justify his assertion. Debord notes that the production of wine had been radically altered, since his childhood, in order to serve the tastes of the international consumer market. The same wines, that is to say, were adapted for modern consumer tastes (often sweeter and containing less tannins), destroying traditional viticulture. A new type of wine expertise therefore had to be invented in order to make these essentially new products, French wines aimed at mass consumer and international markets, recognisable to consumers. Such expertise is at odds, however, with a true critical and historical knowledge. It exists solely to justify and promote a changing reality; it is a discourse that seeks to attenuate in some way the strangeness of a profoundly transformed world. These changes, moreover, also raise important question about the possibility for the emergence of a critique of the spectacle. In the past, the power of the spectacle rested in its monopoly over appearances. It mediated what could be known by selecting what could be shown and dictating the manner in which it was shown (Stalin editing out his enemies from historical photographs, for example, or an advert showing a housewife who solves all her problems by buying a brand of washing machine). All that was necessary to demonstrate the falsehood of the spectacle as a representation of the world was to provide evidence of its partial nature or deceptive character, that is, its fundamental inadequacy as an accurate representation of the world (the original photograph or the real boredom and frustration of the 1950s housewife despite the purchase of the washing machine). If, however, as a result of generalised commodification, reality itself has essentially become so completely mediated by abstract representation that it becomes almost impossible to distinguish between representation and reality, it is no longer possible to criticise the spectacle simply by pointing out discrepancies between the two. The Paris Marais district is a *literal* façade now. That is now the Paris in which people exist. The damage is done. Debord is telling us that the spectacle has successfully reshaped reality to such an extent that the implication is that we can no longer found a critique on the opposition between reality and representation. The only critical stance left to us then is perhaps seeking to understand the internal logic of the spectacle: identifying and explaining its essentially fetishistic, destructive and tautological character.

Conclusion

The concept of the 'spectacle', as we have argued, is fundamentally rooted in the Hegelian Marxist understanding of capitalism as a system of commodity fetishism. Debord uses it as both a general category, where it stands in for 'capital', and as a particular mode of describing certain types of empirical objects and relationships that are given the form of 'spectacle' at a particular point in the development of the history of modern societies. This is a crucial point because the importance of Debord is not simply that he described a society obsessed with images and commodities. Anyone living in the 1950s and 1960s, from a Catholic priest to an ultra-left anarchist, could have made, and did make, such observations. Indeed, there was a great deal of discussion of these changes throughout society, all of which were generally interpreted in the largely superficial terms of the 'Americanisation' of culture or the emergence of 'mass' culture. Rather, Debord is important precisely because he attempts to explain the fundamental roots of these changes and how it is in the fundamental nature of capitalism to bring about such a transformation of society through this period of its historical development. *This* is why Debord is an important figure in the history of ideas rather than just one commentator on contemporary events among many others. The spectacle is a fundamentally Marxian concept rooted in a critique of the supra-sensible reality that shapes the phenomenological world and, *at the same time*, a way of speaking about that supra-sensible reality that is rooted in a critique of the sensible phenomena – in particular, the rise of mass media, modern workers' states and mass consumption – that defined his age and our own.

This remains true for the *Commentaries*. Although the second book is written in quite a different style, adopting a prose style that has more in common with classical moralism than Hegel or Marx, the social critique is still rooted in the same dialectical theoretical framework. The examples that Debord employs seek to illuminate the deeper logic of capitalism as an historically specific social system of abstract accumulation; and, as a result, many of his arguments, like those of Marx, remain relevant to this day, despite the many empirical changes that have taken place in phenomenological reality since 1967 and 1988. Indeed, this seems especially true of his concept of 'integrated spectacle' in the age of smart phones with integrated cameras, constantly connected to 'social' networks, in which, at a real, material level, reality and representation have become essentially

indistinguishable. These transformations are not, as is so often banally stated by most commentators, the result of a technological novelty, but are due to the development of the supra-sensible world of abstraction, the incessant and pointless turning of £100 into £110, that has come to shape our material reality.

If images are so often felt to be more real, or at least more attractive, than real life, it is because real life has already lost its substance, the concreteness that rendered it unique. Integrated spectacle emerges as the ultimate phase of capitalist development, understood as the becoming abstract of material reality itself. The more the world is produced as an abstraction the more representation becomes indistinguishable from reality. We might say, in a *détournement* of Debord's original opening lines of 1967, that, in the age of social media, that which is directly lived is already experienced as representation. The spectacle remains, therefore, an important category for critical theory to the extent that it helps us to understand and to communicate the fact that contemporary changes in our phenomenological reality – live-streamed acts of terror, social media, the internet and perhaps even certain tendencies on the left that continue many aspects of the traditional workers' movement – are a product of the dictatorship of human life by the economy.[32] In other words, although much has changed since 1967, and since 1988, we still very much live within the society of the spectacle.

Notes

1. Guy Debord, *The Society of the Spectacle*, trans. Ken Knabb (Berkeley: Bureau of Public Secrets, 2014), p. 10. Translation changed.
2. Debord, *Spectacle*, thesis 6, p. 3. Translation changed.
3. For further discussion of the Hegelian Marxist reading of Marx in Debord, see Anselm Jappe, *Guy Debord*, trans. Donald Nicholson-Smith (Oakland, CA: PM Press, 2018), pp. 5–19.
4. Debord, *Spectacle*, thesis 1, p. 2. Translation changed.
5. Karl Marx, *Capital*, vol. 1, trans. Ben Fowkes (London: Penguin, 1990), p. 125.
6. Debord, *Spectacle*, thesis 16, p. 5. Translation changed.
7. Ibid, thesis 34, p. 11. Translation changed.
8. The phrase appears in 'Thèses sur l'I.S. et son temps' (1971), thesis 16, in Debord, *Oeuvres* (Paris: Gallimard, 2006), p. 1100.
9. For an overview of the place of categories of vision in twentieth-century French philosophy, see Martin Jay, *Downcast Eyes: The Denigration of Vision in Twentieth-century French Thought* (Berkeley, CA: University of California Press, 1994).
10. Debord, *Spectacle*, thesis 18, p. 6. Translation changed.

11. Ibid., thesis 1, p. 2.

12. Ibid., thesis 19, p. 6.

13. See notably Theodor Adorno and Max Horkheimer, *Dialectic of Enlightenment* (1944) (London: Verso, 1997).

14. For instance, the acclaimed French philosopher Jacques Rancière, who presents a surprisingly superficial reading of Debord in his *The Emancipated Spectator* (London: Verso, 2014), deliberately confusing Debord's concept of spectacle with a critique of theatrical *mise-en-scène*. Another French philosopher, Jacob Rogozinski, refers to Debord as a 'late Platonist at the moment of deconstruction'. His formula is precise in asserting Debord's estrangement from the intellectual fashion of his time, but the label of Platonist remains misleading. See Jacob Rogozinski, 'La vérité peut se voir aussi dans les images', in: Jacob Rogozinski and Michel Vanni (eds), *Dérives pour Guy Debord* (Paris: Van Dieren, 2011).

15. Debord, *Spectacle*, thesis 36, p. 14. Translation changed.

16. Stalinisation led to Lukács' work being banned not long after its publication in 1923. This subsequently led the author himself to reject his own book. Rediscovered in the post-war period, it would finally be translated into French in 1960.

17. Georg Lukács, trans. Rodney Livingstone, *History and Class Consciousness* (Cambridge, MA: MIT Press, 1972), p. 89.

18. Ibid., p.149.

19. It was only after unauthorised translations started to appear that Lukács finally agreed to a reprint of the book in German, in 1967, adding a preface where he departed from Hegelianism and rejected the idea of subject-object unity. See the 'Preface to the new edition (1967)', in Lukács (1972). Debord read the unauthorised French translation of 1960, prior to the publication of Lukács' self-critique.

20. Debord, *Spectacle*, thesis 112, p. 58.

21. On relationship between the SI and the different tendencies of the workers' movement, see chapter 5.

22. Debord, *Spectacle*, thesis 40, p. 16.

23. For a full development of these arguments, see Alastair Hemmens, 'Guy Debord, the Situationist International and the Abolition of Alienated Labour', in *The Critique of Work in Modern French Thought, from Charles Fourier to Guy Debord* (London: Palgrave Macmillan, 2019), pp. 137–66. See also chapter 13 of the present work.

24. Debord, *Spectacle*, thesis 25, p. 9. Translation changed.

25. Raoul Vaneigem, 'Commentaires contre l'urbanisme', *Internationale situationniste (IS)*, no. 6 (August 1961): 34.

26. Debord, *Spectacle*, thesis 158, p. 85.

27. As has been duly underlined by Tom Bunyard in his *Debord, Time and Spectacle: Hegelian Marxism and Situationist Theory* (Leiden: Brill, 2017). For an overview of Bunyard's arguments, see his contribution to this volume.

28. Debord, *Spectacle*, thesis, 159, p. 85.

29. Debord, *Comments on the Society of the Spectacle*, trans. Malcolm Imrie (London: Verso, 1998), thesis 3, p. 7.

30. Ibid., thesis 4, p. 9.

31. Ibid., thesis 17, pp. 50–1.

32. See Gabriel Zacarias, *No espelho do terror: jihad e espetáculo* (São Paulo: Elefante, 2018); Anselm Jappe, *La Société autophage* (Paris: La Découverte, 2017).

11

The Constructed Situation

Gabriel Zacarias

The 'situation' held a central place in Guy Debord's thought well before the foundation of the Situationist International (SI) in 1957. The word is, for example, already present in the very first texts that Debord published which appeared in the Lettrist journal *Ion* in 1952. These include the original script of *Howling in Favour of Sade* and, accompanying it, in the guise of a preface, 'Prolégomènes à tout cinéma future'. The latter concludes with a prognostic: 'all future arts will be disruptions of situations, or will not be at all'.[1] The phrase would appear once again in the final version of *Howling*, which was completed that same year. The film also tells us that 'a science of situations is to be constructed, which will borrow elements from psychology, statistics, urbanism and ethics. These elements must work together for a single absolutely new goal: the conscious construction of situations.'[2] The core of the *Situationist* project is already expressed in this formulation: the will to create deliberately, with the help of already existing science, the objective context in which subjects can act freely. Debord, however, originally struggled to define exactly what a situation is. After abandoning a project to create a 'Manifesto for the Construction of Situations' in 1953, it was the notions of *dérive* and psychogeography that were to become the focus of the first experiments carried out by the Lettrist International. Nevertheless, in 1957, the point at which the creation of a new avant-garde was about to be announced, Debord suggested to a group of artists gathered at the town of Cosio d'Arroscia that 'Everything leads to the belief that the main insight of our research lies in the hypothesis of constructions of situations.'[3] It was for this reason that the new movement was to be called 'Situationist' from then on. The definition of the constructed situation put forward in the first issue of the group's journal was however far from being exhaustive: 'A moment of life concretely and deliberately constructed by the collective organization of a unitary ambiance and a game of events.'[4] As Debord himself

would remark in 1960, the 'situation', despite being absolutely central, nevertheless remained the 'least clear' of the group's concepts.[5] The goal of this chapter therefore is to provide a more precise understanding of the different aspects of the concept, at least in part through an exposition of those different sources that informed its creation.

Theatre and the situation

The 'situation' was first of all a term that belonged to the world of theatre.[6] That theatre was an important point of reference for the Situationists, we can already see this in a text that appeared in the pre-Situationist journal *Potlatch* in 1954: 'The *construction of situations* will be the continual realisation of a great, deliberately chosen, game: the alternating movement through those theatrical sets and conflicts in which the characters in a tragedy die in the space of twenty-four hours.'[7] The desire for an active appropriation of tragic theatre certainly has echoes in the ideas of one of the most influential dramatists of the twentieth century: Bertolt Brecht (1898–1956). Brecht famously sought to develop techniques, and apply them to all of the different elements that make up a theatrical performance, that would break the audience's identification with the characters; in so doing, he hoped to make the audience conscious of the performative apparatus. Brecht termed this the 'distancing' or 'estrangement effect' (*Verfremdungseffekt*). Brecht put forward the technique in his *A Short Organum for the Theatre* (1949), several extracts of which were published in the French journal *Théâtre populaire* in 1955. The dramatist's ideas came to the forefront of cultural debate at this time and attracted the attention of the future Situationists.[8]

Debord, in fact, would refer to Brecht in highly favourable terms in 'Report on the Construction of Situations': 'In the workers' states, only the experiment led by Brecht in Berlin, in its questioning of the classical idea of theater [*spectacle*], is close to the constructions that matter for us today.'[9] The 'classical notion of theatre [*spectacle*]' was that of separated representation: the performance by a small number of actors of an adventure that the audience enjoys passively by identifying with the characters. Debord recognised that 'the most valid of revolutionary cultural explorations have sought to break the spectator's psychological identification with the hero, so as to incite this spectator into activity by provoking his capacities to revolutionize his own life'.[10] The constructed situation 'begins beyond the other side of the modern collapse of the idea of the theatre [*spectacle*]'.[11]

As Debord writes in the 'Report', culture is part of the more general context of alienation: 'it is easy to see to what extent the very principle of theater [*spectacle*] – non-intervention – is attached to the alienation of the old world'.[12] Breaking with the contemplative state, 'the situation is thus made to be lived by its constructors'.[13] There is, as such, a line of continuity between the notion of a constructed situation and avant-garde theatre which had questioned the separation between actors and spectators. 'The role of the "public", if not passive at least a walk-on, must ever diminish, while the share of those who cannot be called actors but, in a new meaning of the term, "livers", will increase.'[14] Here the construction of situations resembles a new kind of theatre without spectators, where each and every one must act, but not as actors in the traditional sense, since this participative theatre is no longer experienced as a performance but as a lived experience. Hence the appearance of this new term 'livers' which is understood as a dialectical supersession of the antithesis between actors and audience.

The theatre would serve once again as a model in what is perhaps the most programmatic text on the constructed situation: 'Preliminary Problems in Constructing a Situation', which appeared in the first issue of *Internationale situationniste* in 1958. In this text, the Situationists foresaw 'an initial period of rough experiments', the necessity for a 'temporary subordination of a team of Situationists to the person responsible for a particular project', foreseeing at the same time a 'director' of the situation.[15] However, the Situationists warn against the use of terms that are taken from the dramatic arts, the use of which they understand as a purely temporary necessity: 'These perspectives, or the provisional terminology describing them, should not be taken to mean that we are talking about some continuation of theatre.'[16] The Situationists subscribe, like many other avant-gardes, to the idea of the end of art, understood teleologically as an historical necessity. Their relationship with the theatre was understood on another level: 'It could be said that the construction of situations will replace theater in the same sense that the real construction of life has increasingly tended to replace religion.'[17] In this passage, just as in the passage cited above from the 'Report', we find the reasoning that is at the basis of the notion of 'spectacle', which would be later developed and complexified by Guy Debord. The passivity of the spectator is identified with that of alienation in general. The passivity of the flock before the priest and the worship of God are then the equivalent of the passivity of the audience at the cinema and its worship of actors.

Play and the situation

Given that the main thing that distinguished it from the theatre was active public participation, it is not at all surprising that the constructed situation was also understood as a 'great game'. Play, after all, is precisely a kind of active fiction in which each player plays a role. The Situationists' conception of play was certainly strongly marked by their reading of the Dutch historian Johan Huizinga's *Homo Ludens: A Study of the Play Element in Culture* (1938), which was first translated into French in 1951.[18] Huizinga described play as the basis of all culture. Play, he argues, serves a social function 'older and more original than civilisation',[19] hence one must 'view culture *sub specie ludi* [as a subcategory of play]'.[20] Debord read Huizinga's work closely and drew upon it when he was formulating the idea of the constructed situation.[21] In *Potlatch*, issue 20, it is stated that 'the tract "Build Yourself a Small Situation Without a Future" is currently posted on the walls of Paris, mostly in places that are psychogeographically suitable'.[22] By consulting Debord's reading notes, we see that the idea for the tract came to him as a result of reading Huizinga, specifically, the following passage:

> Play is separated from present life due to the place and length of time it occupies within it. Its isolation and limitation give it a third characteristic. It takes place literally. It is 'played to the end' within certain boundaries of time and space. It possesses its own logic and meaning in itself.[23]

The situation as a concept is therefore very similar to the structural definition that Huizinga gives to play. It is defined by these three central characteristics: spatial isolation, temporal limitation and self-referentiality. It has meaning only within its own borders. Play is defined therefore by its form and not by its objects. Huizinga, as a result, is able to apply this same definition to practices that are as different as sacred drama and sessions in law court. The situation, which is defined as a 'play of events', is, likewise, understood as a spatial-temporal unity.[24] Moreover, Debord expresses this quite clearly in his project to 'drive play to invade the world/present life against its current character, the way in which it takes place only in predetermined limits – above all from an ethical standpoint – and practically through the multiplication of qualitative and quantitative frameworks destined for play'.[25] From a certain angle, the entire Situationist project

appears to be contained in this simple phrase, where the expansion of the playful beyond the confines of play replace, in a homologous manner, what was, for the historical avant-garde, the expansion of art beyond the traditional confines of the museum.

Phenomenology and phenomeno-praxis

Debord, as we have seen, had been thinking about the situation since his Lettrist days. However, still, at the foundation of the SI, he never imposed a strict definition of the term. On the contrary, some years later, Debord would still note that 'the central notion of Situationist thought (the *situation*) is also the least clear, the most open, that is up for debate'.[26] In a 1960 letter to Patrick Straram, an ex-member of the Lettrist International who had left for North America, Debord speaks of the opening up of the idea of the situation by showing how the different conceptions of the SI members could be discerned: 'At different levels, more or less support- ing one another, we have the ideas of A. Frankin, Kotányi, Jorn, myself (not in chronological order, but in descending order of scope, of the defi- nition of the terrain that it encompasses, of its more or less immediate limits).'[27] In order to elucidate the concept, he starts with what is its 'current', 'non-constructed', 'situation'.[28] He is talking about the situation in which he finds himself at the time of writing the letter. Debord is per- forming none other than a phenomenological description that structures the situation on the basis of the perceptions of the subject. The subject is first of all situated in space (facing the West), then his different sensual perceptions follow: he sees two windows, he hears the noise of the trucks which mingles with music from a Vivaldi concert, he smells the scent of a glass of rosé. The difference is that the situation encompasses the subject's actions: he writes a letter. The action is not the contemplation of the visible phenomena of the objective world, nor is it a matter of contem- plating consciously manifest sensual information. To speak in Husserlian terms, there is no 'bracketing'.

For phenomenologists such as Sartre, who are heirs of Husserl, the situation was intersected with intention: at the moment of perception, the subject performs a cognitive framing through choosing the objects that interest him and, in this way, he orders the objective world – or, rather, its manifestations – in his consciousness. The above description of a 'non-constructed situation' shows us how close Debord's way of thinking was to Husserlian phenomenology. On this basis, Debord attempts an extra

step. With the notion of the constructed situation, Debord suggests that the ordering of the objective world which frames the subject's action must go beyond the perception of phenomena and become the very heart of practice. Some years later, the Situationists would return to their relationship with phenomenology and define their project as a 'phenomeno-praxis': 'Our time will replace the fixed borders of limit-situations, which phenomenology satisfied itself with describing, through the practical creation of situations. It will forever push back this frontier through the movement of the history of our realisation. We want a phenomeno-praxis.'[29] For the Situationists, the word situation described an 'activity', not an 'explanatory value', and one that concerned 'all levels of social practice and individual history'.[30] The Situationist relationship to phenomenology – particularly in its Sartrean-Existentialist form – can therefore be thought of as similar to Marx's appropriation of Hegelianism, at least if we are to judge by the following Situationist *détournement* of the famous line from his 'Theses on Feuerbach': 'We replace existentialist passivity with the construction of moments of life, doubt with ludic affirmation. *Up to now, philosophers and artists have only interpreted situations, the point is to change them.*'[31]

Existentialism and Lefebvre's theory of moments

The exact nature of the relationship between Debord and Existentialism, in particular the thought of Sartre, remains difficult to discern. Even Debord's archives contain very little that might help us to elucidate the question. Several critics have already noted the influence that Sartre may have had on the choice of the word 'situation'. Boris Donné, for example, goes so far as to claim that the origin of this choice is from a specific passage from Sartre's novel *Nausea* (1938): a conversation between Roquentin, the book's protagonist, and Anny, where the latter speaks of 'privileged situations'.[32] The claim has often been repeated, but there is little to support it beyond supposition. Debord, as we know from his earliest correspondence, was very familiar with Sartre's novels.[33] However, neither his correspondence nor his archives offer any definitive proof of the origins of his choice of the word 'situation'. It would no doubt be pointless to get lost in debates about its supposed origins. It is enough to simply recognise that the word 'situation' is part of the Sartrian philosophical lexicon and that Existentialism had a huge impact on the epoch in which Debord began his intellectual life. His conception of the 'constructed situation' was undoubtedly greatly marked by Existentialism in its desire to give the

subject back deliberate control over its existence. Nevertheless, Debord tried to distance himself as much as possible from the influence of Sartre, who was, moreover, an object of many derisive remarks in the pages of *Potlatch* and *Internationale situationniste*.

We could understand the *rapprochement* between the Situationists and the French sociologist Henri Lefebvre as part of that effort to distance themselves from Sartrian thought. Like Sartre, Lefebvre was a philosopher who laid claim to Marxism and, at the same time, concerned himself first and foremost with the transformation of everyday life. He proved himself nevertheless openly critical towards Existentialism.[34] This manifested itself notably in *La Somme et le reste* (1959),[35] in which Lefebvre, who had just left the French Communist Party, provided an account of his intellectual history. The Situationists Asger Jorn and André Frankin brought the book to the attention of Debord.[36] Having read and liked the book, Debord asked Frankin to write a text in which the concept of the 'constructed situation' would be compared with Lefebvre's 'theory of moments'.[37] This text, entitled 'The Theory of Moments and the Construction of Situations', would appear in the fourth issue of *Internationale situationniste*.[38] As the text was unsigned, it was probably written collectively.[39]

What, then, are the 'moments' that Lefebvre describes? In a long paragraph that Debord recorded in his notes, Lefebvre explains that 'moments' are 'substantial', 'although they cannot be defined as such under the classical model of substance (of being)', as they are 'neither interior (subjective) accidents nor operations but specific modes of communication, they are forms of presence'.[40] It is difficult to grasp exactly what Lefebvre means. The moment is essential, but not as the 'substance of being'. It is not therefore an ontic essence, but it is an essence all the same. The moment is not an accident, but, equally, it cannot be reduced to subjective will. It is ultimately defined as a 'form of presence'. Lefebvre attempts to clear up what he means in a parenthesis:

I would not have said categories of existence or 'existential' categories. I have not used this vocabulary; though there is a bit of that: I think that each 'moment' should not have to justify itself and prove its authenticity and establishes itself as a moment only in itself, in its existence, fact and value coincide.[41]

As Lefebvre himself makes explicit, to speak of 'forms of presence' is another way of speaking about the 'existential'. He avoids Existential-

ist language, but admits a degree of conceptual proximity. We can see therefore how dialogue with Lefebvre's theory becomes a means by which the Situationists could deal with the same questions posed by Sartrian philosophy, which are those of its own epoch. Moreover, this allowed them to avoid being assimilated into contemporary intellectual fashions, in which, for various reasons, they wanted to have no part.

It is useful to analyse further this relationship that the Situationists established between the notion of situation and Lefebvre's theory of moments. In the same paragraph recorded by Debord, after the passage cited above, Lefebvre provides some examples of 'moments': 'the moment of contemplation, the moment of struggle, the moment of love, the moment of play or that of rest, that of poetry and of art, etc.'.[42] Debord remarks of this that 'it is the generality [of] the moment thus conceived that makes it repeat'.[43] Next Lefebvre writes:

> every one of them has one or some essential properties and, most notably, this: that consciousness might be able to undertake it, to remain in it prisoner of an absolute 'substantiality', the free act is defined thus by the capacity to depend on oneself, to change the 'moment' through metamorphosis, and perhaps to create it.[44]

To this Debord adds in the margins a second comment: 'being in the perspective of this same creation, we want to elevate the "moment" to *artistic* objectivity'.[45] The ability to create moments would thus be the prerogative of freedom. This is what Debord was seeking to capture with his notion of the 'constructed situation'. Always in the perspective of making ideas effective, the situation is understood here as the objectification, through art, of that which Lefebvre conceived ideally with the concept of the 'moment'.

This raises some questions, however. Is there not a risk that of eliminating the specificity of experience by turning it simply into the objectification of moments whose essence is predetermined? Is this not to fall into the sort of Neo-platonism that is the enemy of a philosophy of *praxis*? It is this risk that Debord identifies as the 'generality' of the moment and which seems indeed to push Lefebvre towards the heaven of ideas. Lefebvre admits as much himself when he raises the problem of a typology of moments: 'As for the Platonist theory of Ideas, the question of the number of moments imposes itself.'[46] Debord comments in turn:

The rather delicate question of the 'number of moments' only poses itself to Henri Lefebvre because the moments are understood in terms of generally easily findable categories. The theory of moments should, in effect, be considered 'in terms of a unique philosophy and ontology'. It may (perhaps) eliminate historicity. But it is surely to be situated on the ethical-aesthetic framework. But here: the search to see clearly the limits of this stability to the point (Situationist ideas) of refusing the very idea of a lasting work [œuvre]. Moments constructed as 'situations' are points/moments of rupture, *revolutions of* (individual) *everyday life*.[47]

Let us note, finally, that if Debord speaks of 'artistic objectivity' it is as much in order to underline the concrete character of the situation – by opposing it against the ideal dimension of the moment – as it is to avoid the notion of an art work. The situation is the objectification – which brings the moment into effect – but it should not be the object. The risk announced by the problem of generality is not only that of a Neo-Platonic idealism. It is also the very material one of reifying experience through the work of art:

> The situation, as moment, 'can expand in time or be shortened'. But it wants to found itself on the objectivity of artistic production. Such artistic production radically breaks with enduring works. It is insepara-ble from its immediate consumption, as use value essentially estranged from conservation in the form of a commodity.[48]

The work of art was seen by Situationists as a reified objectification of past experiences, which would be degraded into a sellable commodity. Oppos-ingly, constructed situations were conceived as lived experiences that would not leave material traces, therefore avoiding commodification. As Debord would later find out, this identification between materiality and commodification was too reductive. The society of the spectacle would prove that experiences can also be commodified.

Desire and the situation

After examining the relationship between Situationist thought and its intellectual context, it might be possible to better grasp the nature of the constructed situation. It is worth returning at this point to the definition put forward in the 'Report on the Construction of Situations':

Our central purpose is the construction of situations, that is, the concrete construction of temporary settings of life and their transformation into a higher, passionate nature. We must develop an intervention directed by the complicated factors of two great components in perpetual inter-action: the material setting of life and the behaviours that it incites and that overturn it.[49]

The situation was therefore understood as the merger between the con-struction of the environment and the actions that result from it during a discreet period of time. In order to think through the construction of the 'setting', Debord put forward the notion of unitary urbanism – with which he sought to overcome the limitations of architecture, urbanism and ecology[50] – while the actions that took place in this specially arranged space would follow the model of play, free activity within a pre-established set of rules and of which the results are uncertain. These 'new species of games',[51] playful and non-competitive, would be organised around 'poetic subjects';[52] they could make use of provocation or be closer to theatrical play with the use of temporary scenarios.

The result of this interaction between décor and play, which comprise the constructed situation, should be the emergence of new modes of behaviour. In the conditions of currently existing urbanism, the *dérive* was one such example: 'A first attempt at a new manner of deportment has already been achieved with what we have designated the *dérive*, which is the practice of passionately disorienting oneself through rapid change of environments.'[53] The situation, however, has even more ambitious goals: 'the application of this will to ludic creation must be extended to all known forms of human relationships and must, for example, influence the historical evolution of emotions like friendship and love'.[54]

By tackling a 'revolution of mores' and feelings, Debord argues in favour of a conception of revolution that diverges radically from that held up to that point by the traditional left: 'revolution is not only a question of knowing the level of production attained by heavy industry, and who will be its master. Along with the exploitation of man, the passions, compensa-tions and habits that were its products must also die.'[55] For the Situationists, revolution meant changing the concrete way in which everyday life is lived. The constructed situation was their proposal for discovering new forms of life. Debord espoused a non-essentialist and historical concep-tion of desire: 'We must define new desires that reflect the possibilities of the present'[56] and, paraphrasing Marx once again, in this way defined the

immediate task of the Situationists: 'we have sufficiently interpreted the passions, today the point is to discover new ones'.[57]

In 'Preliminary Problems for the Construction of a Situation', these kinds of preoccupations are once again a central focus. Here the situation is defined as 'a unity of behaviours in time [...] made of gestures contained in a transitory décor'.[58] These gestures 'are the product of the décor and of themselves' and they 'produce other forms of décor and other gestures'.[59] The situation thus acquires the form of a continuous experiment, the goal of which is to tackle, once again, the problem of desire:

> The really experimental direction of situationist activity consists in setting up, on the basis of more or less clearly recognized desires, a temporary field of activity favourable to these desires. This alone can lead to the further clarification of these simple basic desires, and to the confused emergence of new desires whose material roots will be precisely the new reality engendered by situationist constructions.[60]

To begin from 'more or less clearly recognised desires', it was necessary, as usual, to turn to already existing science. One might then 'envisage a sort of situationist-oriented psychoanalysis in which, in contrast to the goals pursued by the various currents stemming from Freudianism, each of the participants in this adventure would discover desires for specific ambiances in order to fulfil them'.[61] Each Situationist engaged in the construction of situations must equally take his own experience into consideration and 'seek what he loves, what attracts him'.[62] This combination of psychoanalysis and self-understanding required a warning: 'what is important to us is neither our individual psychological structures nor the explanation of their formation, but their possible application in the construction of situations'.[63] It should not therefore be a 'method' for 'enumerating [...] the constitutive elements of the situations to be built'.[64] It is rather an inversion of psychoanalytical logic as, instead of clarifying the psychic conflicts of the individual, the idea is to identify desires and to objectify them in the ambiance of the situation so that they can be collectively shared. Even at this stage, this sharing is not understood as an end in itself, as it may bring about 'the confused appearance of new desires'.

The Situationists put forward an historical conception of human nature and a dialectical conception of the subject. The latter forms itself through the very process of transforming the objective world. This is very much in tune with Marx himself, for whom man 'Through this movement [...] acts

upon external nature and changes it, and in this way he simultaneously changes his own nature.'[65] These ideas are taken up again in an article in *Internationale situationniste* in order to define the subject as 'constructor of situations'.[66] For the Situationists, this meant going beyond the mere mastering of nature, which had been the touchstone of Western thought. In reference to Descartes, they propose that 'making ourselves masters and possessors of nature' is only an 'abstract idea of rationalist progress'.[67] The Cartesian subject was indeed abstract insofar as it was cut off from the material world. Consciousness, for Descartes, differed substantially from the *res extensa* which was seen as nothing more than malleable matter. For the Situationists, acting upon the world should no longer be understood only in terms of the imposition of the subjective will. This doesn't mean that they saw themselves at odds with Cartesian rationalism – their criticism of Surrealism shows precisely the opposite – but they proposed a subjective inflection of the mastering of nature, aiming for 'a practice of arranging the environment that conditions us'.[68]

A small situation for the future?

As contradictory as it might seem, the main proposal of the Situationist avant-garde was never really put into practice. Situations were certainly imagined, but the conflictual relations between the group and artistic institutions prevented situations from finding a place in museums and galleries.[69] It might also be explained by the difficulty of arriving at an experimental construction that was capable of matching the ambitious theoretical reflections around the constructed situation. Yet the lack of practical examples perhaps served to preserve the opening that notion put forward from the beginning. This, at least, is what Debord thought many years later. While reading about Stéphane Mallarmé's unfinished project for a 'total book',[70] Debord analogously reconsiders the value of the constructed situation as an unfinished project:

> It was better that Fourier never got to try out his phalansteries. It was better that Mallarmé dreamt of a book without realising these real 'representations'. It was better for us, in 1954–1960, to *talk* about situations than to try to build them. In all of these cases, the light of the goal had a meaning, to clarify a social destination, while the supposed and artificial goal itself, would be ridiculous *without the society*. Have we had

this society? The constructors of situations are in fact the *constructors of festivals*. But not today![71]

The interest that the notion of the constructed situation can still excite today – to which its constant reprising in the artistic milieu attests – might it be a sign that our society is closer to this society of 'festival constructors' that Debord dreamed of? It is unlikely that the author of *Commentaries on the Society of the Spectacle* would agree. He was, however, without a doubt correct that the goal imagined by the situation would clarify a social direction. The constructed situation manifested the will for a life marked by the constant change and by the unending accumulation of experiences. This is certainly close to the 'liquid life' that, Zygmunt Bauman argues, characterises the contemporary world.[72] In this case, however, where experiences appear as so many commodities ready to be consumed, the accumulation of experiences still appears as an accumulation of spectacles.

Notes

1. Debord, Œuvres (Paris: Gallimard, 2006), p. 46.
2. This phrase already appeared in the first version of the film script that appeared in *Ion* and was retained in the final version. See Debord, Œuvres, pp. 49, 62.
3. Debord, 'Report on the Construction of Situations' (1957), in *Texts and Documents*, p. 46.
4. SI, 'Definitions' (1958) in Situationist International, *Situationist International Anthology*, ed. and trans. Ken Knabb (Berkeley, CA: Bureau of Public Secrets, revised and expanded edition 2006), p. 51.
5. Ibid., Debord, *Correspondance*, vol. 2 (Paris: Arthème Fayard, 1999–2010), p. 35.
6. For a discussion of the theatrical dimension of the concept of the constructed situation, see Nicolas Ferrier, *Situations avec spectateurs. Recherches sur la notion de situation* (Paris: PUPS, 2012).
7. 'Une idée neuve en Europe', *Potlatch*, no. 7 (3 August 1954), in Debord, Œuvres, p. 147.
8. Brecht's work received a great deal of recognition in France in the 1950s. The Berliner Ensemble performed in Paris twice before the playwright's death in 1956. Likewise, Jean Villar's productions at the People's National Theatre, as well as articles by Roland Barthes and Bernard Dort in *Théâtre populaire*, brought attention to his work.
9. Debord, 'Report', p. 41. In French, 'spectacle' has the meaning of a theatre performance.
10. Debord, 'Report', p. 47.
11. Ibid.

12. Ibid.

13. Ibid.

14. Ibid.

15. SI, 'Preliminary Problems in Constructing a Situation', in *Situationist International Anthology*, p. 50.

16. Ibid. The Situationist André Frankin nevertheless wrote a Situationist play. Debord, moreover, enthusiastically approved of the text: 'To do a *détournement* of Shakespeare: It is a tale, not told, but lived by idiots full of sound and fury, signifying nothing', letter from Debord to Frankin, 31 October 1960, *Correspondance*, vol. 1, p. 43. Frankin's play, entitled *Personne et les autres*, was never performed and, unfortunately, none of the text seems to have survived.

17. 'Preliminary Problems in Constructing a Situation'.

18. Johan Huizinga, *Homo Ludens: A Study of the Play Element in Cutlture* (London: Routledge, 1980).

19. Ibid., p. 75.

20. Ibid., p. 5.

21. Debord's reading notes on Huizinga can be found in the file marked 'Philosophie' in the Guy Debord archives, Bibliothèque nationale de France, côte NAF 28630.

22. Ibid.

23. Johan Huizinga, *Homo Ludens*, p. 29.

24. 'Définitions', *Internationale situationniste (IS)*, no. 1 (June 1958): 13.

25. Debord's reading notes on Huizinga.

26. Debord, *Correspondance*, vol. 2, p. 35.

27. Ibid.

28. Ibid.

29. 'Le questionnaire', *IS*, no. 9 (August 1964): 24.

30. Ibid.

31. Ibid. My emphasis.

32. Boris Donné, *[Pour mémoires]: un essai d'élucidation des 'Mémoires' de Guy Debord* (Paris: Allia, 2004), p. 126.

33. Guy Debord, *Le Marquis de Sade a des yeux de fille, de beaux yeux pour faire sauter les ponts* (Paris: Librairie Arthème Fayard, 2004), p. 61.

34. Lefebvre expressed his points of divergence with Existentialism in his 1946 text *L'Existentialisme* (Paris: Éditions du Sagittaire, 1946).

35. Henri Lefebvre, *La Somme et le reste* (1959) (Paris: Economica-Anthropos, 2009).

36. Guy Debord, *Correspondance*, vol. 1, p. 242 and p. 312.

37. Ibid., p. 313.

38. 'Théorie des moments et construction des situations', *IS*, no. 4 (June 1960): 10–11.

39. Debord's own imprint is, nevertheless, quite visible in the text as many of the remarks he makes in his reading notes are taken up in it in their entirety. See Guy Debord archives, Bibliothèque nationale de France, côte NAF 28630, 'Notes et projets', 'Marxisme' file, 'Henri Lefebvre, Divers'.

40. Lefebvre, *La Somme et le reste*, p. 226.

41. Ibid.

182 The Situationist International

42. Ibid.
43. Fonds Guy Debord, Bibliothèque nationale de France, côte NAF 28630, 'Notes et projets', dossier 'Marxisme', subfolder 'Henri Lefebvre, Divers'.
44. Lefebvre, La Somme et le reste, p. 227.
45. Fonds Guy Debord, Bibliothèque nationale de France, côte NAF 28630, 'Notes et projets', dossier 'Marxisme', folder 'Henri Lefebvre, Divers'.
46. Lefebvre, La Somme et le reste, p. 238.
47. Fonds Guy Debord, Bibliothèque nationale de France, côte NAF 28630, 'Notes et projets', dossier 'Marxisme', folder 'Henri Lefebvre, Divers'.
48. 'Théorie des moments et construction des situations', p. 10.
49. Debord, 'Report', p. 44.
50. Ibid.
51. Ibid., p. 45.
52. Ibid., p. 47. Translation changed.
53. Ibid., p. 46. Translation changed.
54. Ibid., p. 46.
55. Ibid., p. 42. Translation changed.
56. Ibid., p. 42. Translation changed.
57. Ibid., p. 50. Translation changed.
58. See 'Preliminary Problems in Constructing a Situation', p. 49. Translation changed.
59. Ibid. Translation changed.
60. Ibid.
61. Ibid.
62. Ibid.
63. Ibid.
64. Ibid., pp. 49–50. Translation changed.
65. Karl Marx, Capital, vol. 1, trans. Ben Fowkes (London: Penguin, 1990), p. 284.
66. 'Le sens du dépérissement de l'art', IS, no. 3 (December 1959): 7.
67. Ibid.
68. Ibid.
69. See, for example, the exhibit that should have taken place at the Stedelijk Museum in Amsterdam in 1959. The reasons for its failure are reported in 'Die Welt als Labyrinth', IS, no. 4 (June 1960): 5.
70. In the last years of his life, the French poet Stéphane Mallarmé developed the idea of a 'total book' (livre total) simply entitled 'Book' (Livre). The traces of such a project were assembled and published by Jacques Scherer at Gallimard in 1957, which Debord read years later.
71. Fonds Guy Debord, Bibliothèque nationale de France, côte NAF 28630, 'Notes et projets', dossier 'Poésie, etc'.
72. See Zygmunt Bauman, Liquid Life (Cambridge: Polity, 2005).

12
Unitary Urbanism: Three Psychogeographic Imaginaries

Craig Buckley

More than any other post-war avant-garde, the Situationist International (SI) made the city vital to their political and aesthetic project. As they announced in the first issue of their journal, the city was the 'new theatre of operations' central to a revolutionary transformation of culture's function within capitalism. The discourse of unitary urbanism, elaborated through manifestos and actions, through experimental maps and projects for utopian cities, was central to this effort. Encompassing the experimental practices of psychogeography and the *dérive*, unitary urbanism was at once a critique of the massive planning operations that restructured European cities during the 1950s and 1960s and an impassioned set of aspirations for intervening in and redirecting such processes. A unitary theory and praxis of urban life bound the various strands of Situationist thinking together, yet there was never an enduring agreement about what was unitary about unitary urbanism. Rereading the corpus of texts that the SI developed around urban questions, and the substantial body of literature that has grown up around this topic, one has the opportunity to ask again how the 'unitary' within unitary urbanism was imagined.

A concept elaborated differently by multiple voices across the group's history, unitary urbanism was advanced in different keys and to different ends. The multiplicity of the concept could be seen as evidence of its lack of coherence. Yet the nuances and disagreements that surrounded the term are also an opportunity to recover a more dialogical understanding of unitary urbanism, and indeed a less unified historical picture of the SI. At a moment when the archives of many former members of the group are entering into the public domain, there is a unique opportunity to explore the diversity of conceptions across the SI in greater depth, not as 'fractional' tendencies at odds with the leadership of Guy Debord, but as

part of an unfinished, networked conversation that took place within and through this pivotal political and artistic avant-garde.[1] Rather than provide a review of the literature on the topic, the present chapter builds on existing scholarship to offer a new account of the network of relations in which unitary urbanism was articulated. Unitary urbanism was not itself unitary, it contained at least three different ways of imagining unitary ways of living within the city: unitary urbanism as ambiance, unitary urbanism as game, unitary urbanism as withdrawal. Each imaginary emphasised a different aspect of urban experience, and pointed to different ways of knowing the city.

Unitary ambiance

The most common point of departure for discussions of Situationist urban theory has long been Ivan Chtcheglov's 'Formulary for a New Urbanism', written in 1953 but only published half a decade later under the pseudonym Gilles Ivain in the inaugural issue of *Internationale situationniste* (*IS*).[2] Chtcheglov was part of the Lettrist International (LI), founded by Guy Debord in 1952 as the politicised splinter group of Isidore Isou's Lettrist movement.[3] The Lettrist International was part of an international bohemian scene that gathered in the underground taverns and immigrant bars around Paris's Saint-Germain-des-Prés neighbourhood in the immediate post-war years.[4] Chtcheglov's 'Formulary' praised the power of those few city blocks, and in its poetic longing for a radically different city premised on a different practice of everyday life, it articulated several elements that would be crucial for the emerging concept of unitary urbanism. As Simon Sadler has traced in detail, Chtcheglov's rejection of the Paris described in the literary works of Surrealism belied the strong formative role that Surrealist Paris played for the group.[5] The city's streets and places, Chtcheglov argued, retained a 'small catalytic power' that could be effectively intensified. Yet these were not the arcades, theatres, gardens and cafes described by Aragon and Breton, nor was their formal configuration or sociological profile their most important aspect. For Chtcheglov and the LI, it was the particular affective and emotional qualities of a locale and the manner in which these influenced behaviour that was paramount.[6] Secondly, the 'Formulary' suggested that these qualities could be the basis of a new constructive project, from 'new urban décors' and 'architectural complexes', to the 'arbitrary assemblage' of districts designed to produce feelings that ranged from the 'bizarre', the 'sinister' and the 'tragic', to the 'useful' and

the 'historical'. Thirdly, the main value of these affective complexes was the articulation of time, space, and behaviour in ways definitively at odds with dominant patterns of social organisation, most famously in the text's call for a practice of aimless and extended drifting, known as *dérive*. 'The more a place is set apart for the freedom of the game', Chtcheglov argued, 'the more it influences behavior and the greater its force of attraction'.[7] In its insistence that play and non-work were paramount for any new urbanism, the 'Formulary' stood in direct contrast to the urbanism of the inter-war modern movement, which had envisioned improving basic living standards, ensuring the efficient circulation of goods and people, and assigning work and leisure to separate spheres.

The sensibility of unitary urbanism was further decanted in the humble typewritten sheets of *Potlatch*, circulated by means of mimeograph to unsuspecting recipients by members of the LI from 1954 to 1957. Picking up Chtcheglov's appeal to spaces that exerted attraction and influence, the editors argued that the 'real revolutionary problem' of the 1950s was not the improvement of conditions of labour, whether in the factory or the home, but the problem of organising the surplus time freed from labour.[8] The counterpart of a truly liberated non-work time was a radically different and experimental way of living, to be pursued through the construction of situations and games, the 'passage from one conflicting décor to another', as well as 'an influential urbanism as a technique of ambiances and rela-tions'.[9] The notion of 'attraction' was drawn from the nineteenth-century utopian Charles Fourier, whose theory of passionate attraction was inte-gral to his theory of 'unitary architecture', emblematised in plans for ideal communities known as phalansteries.[10] Rather than a quality immanent to a class or created from a rational social contract, the unity described by the LI was a force of attraction exerted by a milieu. *Potlatch's* appeal to passion-ate attraction consciously re-appropriated an aspect of nineteenth-century utopian socialism derided by Marx and Engels, a reminder of how at odds their ideas were from the official Marxism espoused by the French Com-munist Party. Chtcheglov's call to 'build the hacienda' was not, however, a call to rebuild Fourier's *Phalanstère*. Instead, Lettrist engagement with the city sought to detect sites of particular affective and psychological intensity, places such as Claude-Nicolas Ledoux's rotunda at the base of the Canal de l'ourc or the Square des Missions Etrangères.[11] Indeed many of these favoured ambiances were threatened with demolition associated with urban redevelopment – such as the Limehouse neighbourhood in London and the rue Sauvage in Paris. The Lettrists not only vigorously

protested these plans, they also offered their own vision of urban interventions, from closing off streets leading to the Place de Contrescarpe to opening the tunnels of the Paris metro at night for urban drifting.[12]

These various currents only came together under the name 'unitary urbanism' in 1956, in a text presented at the 'First World Congress of Free Artists' held in Alba, Italy by Gil J Wolman of the Lettrist International. The Alba Platform asserted the 'necessity of the integral construction of the living environment according to a unitary urbanism employing the entire range of modern arts and technology'; the 'inevitable outmodedness of any renovation of an art within its traditional limits'; the 'recognition of the essential interdependence of unitary urbanism and future styles of living …'[13] Unitary urbanism was designed to appeal not only to members of the Lettrist International but also to the International Movement for an Imaginist Bauhaus, a group of artists committed to experimental art in the broadest sense under the leadership of Asger Jorn, as well as to the Dutch artist Constant, a former member of the CoBrA group who had turned away from easel painting to pursue a fusion of architecture and colour in the early 1950s. Both were steeped in, and highly critical of, the limited scope of post-war debates about a 'synthesis of the arts' which aimed to foster more engaged collaborations between painters, sculptors and architects. Fusing the Lettrist fascination with ambiance and urban attraction to a synthesis of the arts discourse, unitary urbanism aimed to go beyond collaboration, indeed to negate artistic specialisation in order to bring about a new and transformative synthesis between art and everyday life. Less than a year later, Debord expelled Wolman from the LI, yet he retained the term unitary urbanism, making it central to the formation of what was shortly to become the SI. In his 'Report on the Construction of Situations', a long programmatic text offered for debate at the group's founding meeting, Debord defined unitary urbanism as:

the use of all the arts and techniques as a means contributing to the composition of a unified milieu. [...] Secondly, unitary urbanism is dynamic, in that it is directly related to styles of behavior. The most elementary unit of unitary urbanism is not the house, but the architectural complex, which combines all the factors conditioning an ambiance, or a series of clashing ambiances, on the scale of the constructed situation.[14]

The emphasis on *milieu* and *ambiance* in the definition are noteworthy. The term *milieu* had long been associated with the conservative

nineteenth-century historian Hippolyte Taine, for whom it encompassed the combined influence that a broad range of conditions, from geography and climate to politics and society exerted on a work of literature.[15] Milieu was not urbanism in the sense of the hard surfaces of buildings and streets, it encompassed the less tangible interrelation of elements that make up a living environment in the broadest sense, from atmosphere and lighting to signs, to sounds, social dynamics, and nourishment. *Milieu* for Taine had been broadly geographic and quasi-natural, for the SI it was urban, aesthetic, mutable and technological, a surrounding subject to continual construction and change. The term *milieu* was also central to urban geography at mid-century, particularly in the work of Paul Chombart de Lauwe, whose attention to class and use of aerial photography, as Tom McDonough and Anthony Vidler have argued, were pivotal for Debord and the SI's emerging urban imaginary.[16] The group's emphasis on *milieu* and *ambiance* still merits further analysis, as they were understood not only as properties of urban space but as media intimately connected to the senses, whose agency needed to be analysed in order to be used constructively. The group may well have picked up the importance of these terms not only in urban geography, but also for phenomenological and psychopathological discourses, a discursive history that has been of great interest to recent media theory concerned to rethink questions of media and communication in environmental and elemental terms.[17] In this sense, *milieu* and *ambiance* carry an unresolved tension within Situationist urban discourse. Ambiances were specific unitary qualities within the city, qualities identified through the practice of psychogeography, which was defined as the study of the specific effects of a geographical milieu on emotion and behaviour.[18] Psychogeography was devoted to the interaction of milieu, ambiance and behaviours, and entailed immediate experiments with extended urban drifting, as well as secondary, theoretical elaborations of these *dérives*, and counter-mapping practices such as Debord's *Guide psychographique de Paris*, which remains one of the most emblematic works produced by the SI.[19] Insofar as urban ambiance was an affective, sensory and qualitative whole, its qualities as a medium could only be suggested by means of fragmented cartography, its ambient character resisted representation and instrumentalisation. If the attractive power of an ambiance resisted being broken up into discrete elements and made into a tool, how then was it to become the revolutionary medium sought by the SI?

Unitary as play

The concern for ambiance and milieu carried over into the second major site of unitary urbanist discourse, the *New Babylon* project initiated by the Dutch artist Constant in the late 1950s and developed for nearly two decades. *New Babylon* was a sprawling, multifaceted, and continually changing project for an urban megastructure of undetermined scale that was to transform everyday life into an endless experimental drift. *New Babylon*, Mark Wigley has argued, was a 'hyper-architecture', an effort to polemically exceed the accepted boundaries of the architecture, engineering and planning professions under the post-war welfare state, an architectural science fiction of expansive outlines and variable configuration that was envisioned and described through a similarly changing array of models, photographs, lectures, drawings, newspapers, exhibitions and films.[20] *New Babylon* has often been seen as identical with unitary urbanism, yet it might more appropriately be seen as but one articulation of the concept.[21] In contrast to early proposals that focused on the qualities of specific places, Constant's unitary urbanism entailed the 'conscious recreation of man's environment', which he identified with the production of a high-technology building erected above the existing urban and suburban landscape. Within this 'experimental terrain' the ambiances, the social interactions and the spaces were themselves subject to continuous change. If unitary urbanism took on a more utopian scale with *New Babylon*, it also became more pragmatic: in 1959 Constant, with other members of the SI's Dutch section – Armando, Anton Alberts and Har Oudejans – founded the Bureau of Unitary Urbanism in Amsterdam to lay the groundwork for *New Bablyon*'s realisation.[22] The bureau led the preparations for a large-scale exhibition – 'Die Welt als Labyrinth' – at Amsterdam's Stedelijk Museum in 1960. The exhibition envisioned transforming a portion of the museum into a disorienting and changeable maze composed of contrasting ambiances, an interior connected by means of walkie-talkies to Situationist teams undertaking extensive *dérives* in the streets of Amsterdam.[23] Due to conflicts with the Stedelijk, the SI withdrew at the last minute, and the exhibition never took place, yet the model of a participatory labyrinth designed by artists was taken up by the museum as the basis for two other influential exhibitions in the early 1960s.[24] Tensions between the Dutch section and the Paris-based members of the SI grew over the next year, and by the summer of 1960 Oudejans and Albert had been expelled and Constant had resigned. Rather than disappearing, unitary urbanism

was transferred again, taken up by the group's newly formed German section, which consisted of the Munich-based Spur Group, connected to the SI by Jorn.[25] The Spur Group were active as painters, as filmmakers, as organisers of 'situations', and as polemicists through the pages of their eponymous magazine and in manifestos distributed in the streets of Munich.[26] The importance of unitary urbanism to the German section is evident in a special issue of their magazine *Spur* that collected and translated a corpus of texts on unitary urbanism, the closest the SI ever came to compiling its discourse on the city. Yet even it was not complete; while it included the 'Formulary' of Gilles Ivain, a selection of texts from *Potlatch*, Wolman's speech at Alba, and a host of recent writings from the *IS* journal, it suppressed everything published by Constant. Yet the issue also provided evidence that ideas of unitary urbanism were spreading, as indicated by the inclusion of new texts by the Viennese architect Günther Feuerstein and the Spur member H.P. Zimmer.[27]

Much like Constant and Jorn, the Spur Group was inspired by Johan Huizinga's definition of play and games as an essential element of culture.[28] The group's sexually explicit and anti-clerical collages and texts pushed the boundaries of play to an extreme, resulting in the confiscation of their journal and charges of obscenity and blasphemy brought by the Church and the Bavarian state.[29] Constant and Debord's 'Amsterdam Declaration', prepared for the third Situationist congress in Munich in 1959, highlights what was distinct about this ludic conception of unitary urbanism and its appeal to the Spur Group; the appropriation and radical transformation of an urban milieu was not only to generate different behaviour, it was rooted in 'a new type of collective creativity'.[30] The emphasis on collective creativity had been present in Constant's writings since his CoBrA days of the late 1940s, and had been further inspired by Aldo van Eyck's numerous designs for Amsterdam playgrounds in the 1950s.[31] The question, however, was not simply to make more room for play, rather he argued that the creative freedom enjoyed by the artist as individual needed to be negated, in order for creativity to be asserted and realised at a collective level.[32] 'Unitary urbanism', he noted in 1960, 'is neither town planning, nor art, nor does it correspond to concepts like integration and synthesis of cultural forms.... I would prefer to define unitary urbanism as a very complex, very changeable, constant activity, a deliberate intervention in the praxis of daily life and in the daily environment …'[33] *New Babylon* was not a playground alongside everyday routine, it was to be an urban structure where everyday life was conceived as a creative game; less the suspension

of daily habits for the sake of play than the continual reinvention of life's practices, conventions and rules. If an ever-changing ideal of collective creation was the basis of the unitary in Constant's vision, the corollary was an insistence that such creativity entailed a correspondingly drastic transformation at the level of the urban environment. Constant's emphasis on collective urban creativity was later taken up by the artists and activists of the short-lived Provo movement that erupted across Dutch cities in 1966–67, and whose urban interventions were examined and critiqued by the SI and other groups of the period.[34] The ideal of collective creativity, in contrast to the qualities of ambiance, also raises a different set of questions about unitary urbanism. In its insistence on the 'game of life', New Babylon mirrored the centrality of games as a model for conceptualising a broad range of interactions – economic, linguistic, interpersonal and strategic – during the Cold War. While the rational and mathematical models of behaviour characteristic of economic game theory were at odds with those of New Babylon, the utopian appeal to collective creativity, as Constant himself later came to realise, did not sufficiently account for the role of antagonism. Understanding antagonism within a given game, as Pamela M. Lee has argued, remains crucial for assessing the Cold War legacies embedded in game theoretic models, a question that also remains key for thinking the imaginary of unitary urbanism put forward by Constant's New Babylon and its ongoing echoes in contemporary art, architecture and game design.[35]

Unitary withdrawal

It was in fact a greater emphasis on antagonism that characterised the conception of unitary urbanism that emerged within the SI following Constant's resignation. This conception was advanced by the Hungarian architect and urbanist Attila Kotányi, who was appointed to run the Bureau of Unitary Urbanism at the SI's fourth Congress in London in September 1961. Working with the Belgian writer Raoul Vaneigem, unitary urbanism took on several new features. Unitary urbanism was more closely aligned with an ideological critique of the concrete results of urban planning, it outlined an epistemological critique of the ways in which space was measured and represented, and it turned toward the spatial practices of urban struggle.

Kotányi's contribution to unitary urbanism was significant, yet of all the figures associated with the term he has received practically no attention.[36]

Born in Budapest in 1924, Kotányi received his diploma in architecture from the Technical University of Budapest in 1949. During the 1940s and 1950s Kotányi came into contact with currents of Western Marxism – particularly the writings of Karl Korsch – through a group known as the Budapest Dialogical School. During the same years, he was engaged as an architect in rebuilding war-damaged housing blocks and hospitals. A participant in the uprising against the communist regime in 1956, Kotányi fled Hungary with his family following the Soviet occupation. Emigrating to Belgium, he completed a Master's degree in urbanism under André Wogensky, a close collaborator of Le Corbusier. Kotányi's profile was unusual for an architect-urbanist, and a perfect fit for the changing puzzle that was the SI at the beginning of the 1960s.

'Critique of Urbanism', an unsigned text in the sixth issue of the *IS* journal in August 1961, highlights the alignment of unitary urbanism with ideological critique.[37] Rather than general critiques of the garden city tradition, of inter-war functionalist zoning or the influence of Le Corbusier, the article took aim at the specific example of Mourenx, a new town in the south-west of France. Built from scratch beginning in 1957 to house workers for a nearby gas plant, Mourenx was emblematic of the emergence of the suburban housing complexes developed by government agencies and private contractors beginning in the late 1940s known as 'Grandes Ensembles'. The article argued that 'modern capitalism's bureaucratic consumer society' was not a set of relationships within existing cities, but had begun to create surroundings that were strictly in accordance with its needs.[38] The SI's focus on Mourenx highlighted the importance of Henri Lefebvre, who was associated with the group during these years, and had studied the complex since its beginnings in the 1950s. Lefebvre influentially analysed it as an architectural and urbanistic projection of the class structure of the corporation; the complex's twelve-storey towers were for supervisors, its four-storey slab blocks for workers' families, and the surrounding detached housing for upper management.[39] Kotányi and Vaneigem's 'Elementary Program of the Bureau of Unitary Urbanism', in the same issue, extended Constant's critique of the family dwelling as basic element of planning discourses to a general indictment of the 'domestication of space under capitalism'.[40] The vision was one of more total control via urbanism; a city shaped strictly to the needs of the private family home and a domestic dwelling simultaneously subject to the 'permanent information network' of television and radio.[41] Whereas Constant sought to evoke a positive urban model founded on anti-domestic forms of

collective creativity, for Kotányi and Vaneigem the more urgent task was to foster dis-identification with the Grandes Ensembles and new towns understood as hegemonic behavioural models.

If the initial discourse on unitary urbanism had appealed to milieu and ambiance, and Constant had insisted on games and creativity, it is telling that Kotányi's first text in the journal emphasised the role of the urban gangs. 'Gangland and Philosophy', in *IS* 4, proposed replacing the concept of the neighbourhood with 'gangland', social organisation with 'protection', and society with 'racket'.[42] Drawing on a period account of the New York mafia, and implicitly, perhaps, on his experience in Hungary, he argued that a particular racket dominated territory not through force alone but by controlling basic information. 'The systematic falsification of basic information', Kotányi wrote, '(by the idealist conception of space, for example, of which the most glaring expression is conventional cartography) is one of the basic reinforcements of the big lie that the racketeering interests impose on the whole gangland of social space.'[43] Kotányi underscored the role of a Euclidean, metric, idealist conception of space as key to the power wielded through representational techniques of cartographic projection. The unities of ambiance that Debord visualised by cutting up maps in the 1950s found a consequent theorisation in Kotányi's critique of the hegemonic role of Euclidian geometry, which was not accepted as a neutral foundation of spatial representation, but seen as a technique that sustained coercive power relations in urban social space. The critical move was to shift from lived urban experience and the discourses of urban planning, to address the epistemological frameworks through which space was conceived.

In doing so, Kotányi echoed the writings of Jorn and Jacqueline de Jong, in particular Jorn's essay 'Open Creation and its Enemies'.[44] Jorn's and de Jong's fascination with topology in the later 1950s was part of a widespread interest in the subject, yet the bond between non-Euclidean geometry and 'open creation' in Jacqueline de Jong's magazine *The Situationist Times*, with its dense pages devoted to topological figures such as knots, labyrinths, rings and chains, espoused an intellectual, formal and editorial pluralist situationism polemically at odds with the strict regime of the Paris-based editors of *Internationale situationniste*.[45] Jorn had looked particularly to Henri Poincaré's conception of *analysis situs* – the first systematic treatment of algebraic topology – as the source for something he called 'situgraphy'. He questioned not the validity of Euclid's postulates about points, lines and planes, but the consequences of the general

equivalences these established between different entities. Jorn seized on Poincaré's notion of homeomorphism, a form of topological mapping in which the properties of one space can be transformed into another, entirely different space, through a process of continuous deformation. For Jorn, a situation was analogous to what he called the 'morphology of the unique', the manner in which a form could be transformed topologically into something entirely different yet remain unique. Accordingly, unity was not an identity underlying differences, it was a homeomorphic constancy that underlay changes in form and space.

An echo of this epistemological critique appeared in Kotányi and Vaneigem's 'Elementary Program of the Bureau of Unitary Urbanism', which sought to throw a bridge between a critique of Euclidean geometry and an appeal to political struggles in urban space. Its sixth point declared:

> All space is already occupied by the enemy, who have even domesticated the elementary rules of this space, its geometry, to their own purposes. Authentic urbanism will appear when the absence of this occupation is created in certain zones. What we call construction starts there.... Materializing freedom means beginning by subtracting a few patches from the surface of a domesticated planet.[46]

Appearing under the heading 'The Landing', unitary urbanism was likened to a tactical operation. Rather than the expansive, homogeneous, and newly built structure of Constant's *New Babylon*, whose scale implied the enormous capacities of a post-war welfare state, Kotányi and Vaneigem's vision of the unitary stemmed from the forces that subtracted and withdrew a portion of space from enemy control.

Unitary urbanism at this stage was drawn between two very different registers, geometric space and the physical stuff of a concrete site. The 'absence of occupation' in Kotányi and Vaneigem's manifesto could be read as a manoeuvre in the realm of representation and conception, whereas the task of 'subtracting a few patches from the surface of a domesticated planet' implied the occupation of physical sites. Kotányi had had first-hand experience of the insurgent seizure of territory from his participation in the Hungarian uprisings of 1956, and the Situationists themselves were attuned to increasingly policed urban space in the late 1950s. In 1958, group member Abdelhatif Katib had been arrested during his psychogeographic mapping of Les Halles, and was subjected to a nightly curfew imposed on the city's Algerian residents – a domestic police action that

was part of France's counter-insurgency operations during the Algerian war.[47] Insurgent struggles for independence had thrown off colonial rule over the previous fifteen years, from India in the 1940s, to Vietnam, Morocco, and Cuba in the 1950s, to the Congo and Algeria in the first years of the 1960s. Anti-colonial struggles in Morocco, Algeria, and Vietam were regularly present in *Potlatch*, and mass media imagery of the aftermath of uprisings from Algeria, Tokyo, Detroit, Paris, and Los Angeles would increasingly appear in the SI's publication during the 1960s, often détourned with the caption 'critique of urbanism'.[48] During these years the Tunisian-born Mustapha Khayati, who joined the SI in 1965, played a key role, coordinating and theorising the group's links with student movements in Strasbourg and Nanterre, and with revolutionary groups in North Africa and the Middle East.[49] Writing about resistance to the coup in Algeria in 1965, or about the urban uprisings in Watts, the SI theorised these not through the lens of national, religious or ethnic liberation, but as part of an international movement for worker self-management, a tradition of radical democracy that was localised and urban, at odds as much with the state as they were with transnational capital.

The turn toward unitary urbanism as a collective spatial practice of insurrection and occupation was most pointedly asserted, however, in the IS's revisionist embrace of the 1871 Paris Commune. Against the French Communist Party's interpretation of the Paris Commune as a heroic failure, the SI 1962 pamphlet *Sur la Commune* declared the 'fundamental failures' of the Commune – centrally, its inability to establish an enduring bureaucracy and representative government – to be its 'greatest achievements'.[50] The Commune was retroactively seized as an example of 'revolutionary urbanism', whose participants 'understood social space in political terms' by 'refusing to accept the innocence of a single monument'.[51] The concern for unitary urbanism and the reappraisal of the Commune were so close at this moment that Kotányi and Vaneigem transposed the critique of Euclidean geometry from the 'Elementary Program of the Bureau of Unitary Urbanism' wholesale into *Sur la Commune*. The urban reading of the Commune advanced by the SI would resonate in the later 1960s, and inform Kristin Ross's spatial history of the Commune and its relation to the poetics of Rimbaud.[52] The object of the Commune's struggle, she argued, was not over the means of production but against eviction from the city, a resistance enacted through the 'displacement of the political' onto areas of everyday life that seemed to be outside the political, from

the bricolage of the barricades, to the organisation of leisure and work, to approaches to housing and sexuality.[53]

During its earliest phases, unitary urbanism had been concerned with specific ambiances, looking to alter the collective psychological and behavioural effects produced by particular urban milieus. Under Constant, this discourse asserted the primacy of collective creativity and oriented itself toward the speculative construction of a future experimental city. Under Kotányi and Vaneigem, unitary urbanism oriented itself outwards to the landscape of contemporary urban insurrection, and backwards to reinterpret histories of urban revolution. Kotányi, however, would not be a member of the SI for very long. By 1963 he was expelled from the group for a text he argued had been entirely misunderstood, charged with seeking a 'return to myth' and 'colluding with religious thought'.[54] After Kotányi's expulsion, unitary urbanism recedes as an active term within the journal, and urban actions in the city were more readily conceived and analysed under the rubric of *détournement*. The group's attention to the urban nature of political struggle continued throughout its existence, most notably in the prominence their thinking gained during the strikes and occupations of May 1968.[55]

Unitary urbanism, Thomas Levin has argued, is 'the best prism through which to refract the group's double identity as an avant-garde movement and as a political formation'.[56] In the numerous refractions on the SI's urban theory and praxis there are many recurring patterns, but little consensus on the afterlife of this concept. David Pinder has argued strongly for the need to reclaim the significance of unitary urbanism as part of a broader legacy of oppositional utopianism relevant to contemporary urban theory and activism.[57] For Tom McDonough, the utopian dimension of unitary urbanism was marked by irresolution, caught between a fundamental critique of modernist architecture and planning on the one hand and an equally fundamental desire to radically reconstruct everyday life against the grain of post-war consumer capitalism on the other.[58] Anh Linh-Ngo, in turn, has warned that ideas central to unitary urbanism, such as collective creativity, need to be reassessed in light of their recuperation within contemporary city branding operations.[59] Unitary urbanism resonates beyond the specific histories of the SI as a facet of the broader mid-twentieth-century recognition of the centrality of urban space for grasping the transformation of capitalism. Recognising the different imaginaries contained within discourses of unitary urbanism may serve as a

point of departure for revisiting and unfolding the complex legacy of Situationist thinking about the city from the perspective of the present.

Notes

1. In 2013, Guy Debord's archives were declared a national treasure and acquired by France's Bibliothèque Nationale. The research for this chapter was greatly aided by collections in the Beinecke Rare Book and Manuscript Library, which currently holds papers related to numerous former SI and Lettrist International (LI) members, as well as fellow travellers, including: André Bertrand, Jacqueline de Jong, Attila Kotányi, Mustapha Khayati, Gianfranco Sanguinetti, André Schneider, Raoul Vaneigem and Gil J Wolman. I am grateful to Kevin Repp for his expertise and support in working with these collections. I am also grateful to the students in my seminars, from whom I have learned a great deal.

2. Gilles Ivain, 'Formulaire pour une urbanisme nouveau', *Internationale situationniste (IS)*, no. 1 (1958): 15–20. Translated as 'Formulary for a New Urbanism', in Situationist International, *Situationist International Anthology*, ed. Ken Knabb (Berkeley: Bureau of Public Secrets, 1981), pp. 1–5. The original manuscript, together with other texts by Chtcheglov has been published in Ivan Chtcheglov, *Écrits Retrouvées*, ed. Boris Donée and Jean-Marie Apostolidès (Paris: Éditions Allia, 2006).

3. The Lettrist movement, founded in the later 1940s by Isidore Isou, devoted itself to experiments in poetry, cinema and hypergraphic texts.

4. These sites, together with some members of the LI, appear in Ed Van der Elksen's photo-novel, *Love on the Left Bank* (London: André Deutsch, 1956). For a biographical account, see Jean-Marie Mension, *La Tribu: entretiens avec Gérard Berréby et Francesco Milo* (Paris: Éditions Allia, 1998). The milieu was central to Greil Marcus's *Lipstick Traces: A Secret History of the Twentieth Century* (Cambridge, MA: Harvard University Press, 2001).

5. See Simon Sadler, *The Situationist City* (Cambridge, MA: MIT Press, 1998), pp. 69–94.

6. Chtcheglov, 'Formulary for a New Urbanism', in *Situationist International Anthology*, p. 5.

7. Ibid., p. 4. All translations are the author's, unless noted otherwise.

8. Michèle Bernstein, André-Frank Conord, Mohammed Dahou, Guy Debord, Jacques Fillon, Véra, Gil J. Wolman, '... Une idée neuve en Europe', *Potlatch*, 7 (3 August 1954), reprinted in *Guy Debord présente Potlatch: 1954–1957* (Paris: Gallimard, 1985), pp. 50–1.

9. Ibid.

10. On the broad legacy of Fourier's concept of the *phalanstère* for architectural discourse, see Anthony Vidler, 'The New Industrial World: The Reconstruction of Urban Utopia in Late-nineteenth-century France', in *Scenes of the Street and Other Essays* (New York: Monacelli Press, 2011), pp. 244–57. Fourier was equally a reference for Le Corbusier's Unité d'habitation in Marseille. The latter was a favourite object of criticism for *Potlatch*, who remarked that

he was 'always inspired by the directives of the police'. 'Les Gratte-ciels par la racine', in *Guy Debord présente Potlatch*, pp. 37–9.

11. See 'Two Accounts of the Dérive', *Les Lèvres nues*, 9 (1956). Translation available at: www.cddc.vt.edu/sionline/presitu/twoaccounts.html; and Michèle Bernstein, 'Le square des missions étrangères', in *Guy Debord présente Potlatch*, pp. 109–10. See also Sadler, *Situationist City*.

12. See 'Protestation auprès de la redaction du *Times*', and 'Projet d'embellissement rationnels de la ville de Paris', in *Guy Debord présente Potlatch*, pp. 196–8, 203–7.

13. 'La Platforme d'Alba', *Potlatch*, 27 (2 November 1956), reprinted in *Guy Debord présente Potlatch*, pp. 246–9.

14. Guy Debord, 'Report on the Construction of Situations and on the International Situationist Tendency's Conditions of Organization and Action', in *Situationist International Anthology*, p. 38.

15. First published as Hippolyte Taine, *Histoire de la littérature anglaise* (Paris: L. Hachette et cie, 1863–4).

16. See Tom McDonough, 'Situationist Space', in *Guy Debord and the Situationist International: Texts and Documents*, ed. Tom McDonough (Cambridge, MA: MIT Press, 2002), pp. 241–66, and Anthony Vidler, 'Terres Inconnues: Cartographies of a Landscape to Be Invented', *October*, 115 (Winter 2006): 13–30.

17. A text of considerable interest is Leo Spitzer's crucial essay 'Milieu and Ambiance: An Essay in Historical Semantics', *Philosophy and Phenomenological Research*, 3(1) (September 1942): 1–42. For a helpful archaeology of the term, including its role in the psychopathology of Binswanger and Minkowski, see Jean-Paul Thibaud, 'Petite archéologie de la notion d'ambiance', *Communications*, 90 (2012): 155–74.

18. See for instance, Debord and Wolman's 'Dérive: mode d'emploi', and 'Définitions', *IS*, no. 1 (June 1958): 13.

19. The two most cited maps are Guy Debord, 'Guide psychogéographique de Paris: discours sur les passions de l'amour' (1957) and 'The Naked City' (also 1957). The maps were created for the first exhibition of psychogeography at the Taptoe gallery, in Brussels that year. Among the interpretations of these works see David Pinder, 'Subverting Cartography: The Situationists and Maps of the City', *Environment and Planning A*, 28 (1996): 405–27; Sadler, *The Situationist City*, 76–90; Tom McDonough, 'Delirious Paris: Mapping as a Paranoiac-critical Activity', *Grey Room*, 19 (spring 2005): 6–21.

20. Mark Wigley, 'The Hyper-architecture of Desire', in *Constant's New Babylon: The Hyper-architecture of Desire* (Rotterdam: Witte de With, Center for Contemporary Art, 1998), pp. 8–72.

21. The literature on *New Bablyon* is extensive, among the essential resources are Constant, *New Babylon: een projekt van Constant Nieuwenhuys* (Den Haag, 1974); Hilde Heynen, 'New Babylon: The Antinomies of Utopia', *Assemblage*, 29 (April 1996): 24–39; Jean-Clarence Lambert (ed.) *Constant: New Babylon: art et utopie: textes situationnistes* (Paris: Cercle d'art, 1997); Catherine de Zegher and Mark Wigley (eds) *The Activist Drawing: Retracing Situationist Architectures from Constant's New Babylon to Beyond* (Cambridge, MA: MIT Press, 2001); Tom McDonough, 'Metastructure: Experimental

Utopia and Traumatic Memory in Constant's New Babylon', *Grey Room*, 33 (fall 2008): 84–95; Ludo van Halem and Trudy Nieuwenhuys-van der Horst (eds) *Constant: Space + Colour: from Cobra to New Babylon* (Amstelveen: Cobra Museum, 2016).

22. The goal was to 'attract competent collaborators' and to make the 'step toward more carefully elaborated proposals, grounded in reality'. See, Constant, 'Inaugural Report to the Munich conference', *IS*, 3 (December 1959), trans. in Wigley, 'The Hyper-architecture of Desire', p. 101.

23. 'Die Welt als Labyrinth', *IS*, 4 (June 1960): 5–7.

24. On these exhibitions, see Janna Schoenberger, 'Ludic Exhibitions at the Stedelijk Museum: Die Welt als Labyrinth, Bewogen Beweging, and Dylaby', *Stedelijk Studies*, 7, https://stedelijkstudies.com/journal/ludic-exhibitions-at-the-stedelijk-museum-die-welt-als-labyrinth-bewogen-beweging-and-dylaby/. On the prevalence of labyrinths in the work of Constant and in post-war experimental art, and its connections to behaviourism see Eric De Bruyn, 'Constructed Situations, Dynamic Labyrinths, and Learning Mazes', *Grey Room*, 74 (winter 2019): 44–85.

25. The group included the painters Heimrad Prem, Helmut Sturm and Hans-Peter Zimmer, and the sculptor Lothar Fischer. Founded in Munich in 1957, the group was active until roughly 1965–66. They joined the German wing of the SI in 1959.

26. See *Spur*, 5 (Spezialnummer über den unitären Urbanismus) (Munich 1961). The issues were gathered together in reprint form in *Die Zeitschrift SPUR* (München: Gruppe Spur, 1962). On the group, see Jo-Anne Birnie Danzker and Pia Dornacherclude (eds) *Gruppe SPUR* (Munich: Hatje Cantz, 2006).

27. Günther Feuerstein, 'Thesen über die Inzidenten Architektur', *Spur* 5.

28. Initially published in Dutch in 1938, Johan Huizinga's classic text is *Homo Ludens: A Study of the Play Element in Culture* (London: Routledge, 1980). It was quickly translated into multiple languages.

29. Diedrich Diedrichsen, 'Persecution and Self-persecution: The SPUR Group and Its Texts – The Neo-avant-garde in the Province of Postfascism', *Grey Room*, 26 (winter 2007): 56–71.

30. 'Declaration d'Amsterdam', *IS*, 2 (December 1958): 31–2; translation in Wigley, *Constant's New Babylon*, p. 87.

31. On the roughly 700 playgrounds which van Eyck created between 1947 and the 1970s, see Liane Lefaivre and Ingeborg de Roode (eds) *Aldo van Eyck: The Playgrounds and the City* (Amsterdam: Stedelijk Museum, 2002).

32. Constant, 'Manifesto', *Reflex*, 1 (Sept.–Oct. 1948): n.p.

33. Constant, 'Unitary Urbanism', in Wigley, *Constant's New Babylon*, p. 132.

34. On Constant's interactions with Provo, see *Provo*, 4 (1966), dedicated to *New Babylon*. For an overview of the movement, see Richard Kempton, *Provo: Amsterdam's Anarchist Revolt* (Brooklyn, NY: Autonomedia, 2007) and Niek Pas, *Provo! Mediafenomeen 1965–1967* (Amsterdam: Wereldbibliotheek, 2015).

35. See Pamela Lee, 'New Games', in *New Games: Postmodernism after Contemporary Art* (Abingdon: Routledge, 2013), pp. 97–158. On the question of games in the SI, both the case of *New Babylon* and in Debord and Alice Becker-Ho's *Kriegspiel*, see Alice Becker-Ho and Guy Debord, *Le Jeu de la guerre: relevé des*

positions successives de toutes les forces au cours d'une partie (Paris: Gallimard, 2006), McKenzie Wark, *Gamer Theory* (Cambridge, MA: Harvard University Press, 2007) and Alexander R. Galloway, 'The Game of War: An Overview', *Cabinet* magazine, 29 (spring 2008), www.cabinetmagazine.org/issues/29/galloway.php

36. The biography sketched here is drawn from the materials in the Kotányi papers at the Beinecke Rare Book and Manuscript Library, Yale University.

37. Kotányi and Vaneigem, 'Programme élementaire du Bureau d'Urbanisme Unitaire', *IS*, 6 (August 1961): 18; translation in *Situationist International Anthology* (1981), pp. 86–89.

38. 'Critique de l'urbanisme', *IS*, 6 (August 1961): 3, trans. as 'Critique of Urbanism', Situationist International, *Guy Debord and the Situationist International*, ed. Tom McDonough (Cambridge, MA: MIT Press, 2002), pp. 103–14.

39. See Henri Lefebvre, 'Les nouveaux ensembles urbains: un cas concret: Lacq-Mourenx et les problèmes urbains de la nouvelle classe ouvrière', *Revue Française de Sociologie*, 1(2) (April–June 1960): 186–201; on Lefebvre's relationship to the Situationists, see Kristin Ross, 'Lefebvre on the Situationists: An Interview', *October*, 79 (winter 1997): 69–83. On Lefebvre's theories of urbanism, architecture and space see Lukasz Stanek, *Henri Lefebvre on Space: Architecture, Urban Research, and the Production of Theory* (Minneapolis, MN: University of Minnesota Press, 2011).

40. Kotányi and Vaneigem, 'Programme élementaire du Bureau d'Urbanisme Unitaire', p. 18.

41. Ibid.

42. Kotányi, 'Gangland et philosophie', *IS*, no. 4 (June 1960): 34, trans. 'Gangland and Philosophy', in *Situationist International Anthology* (1981), pp. 76–8.

43. Ibid.

44. Asger Jorn, 'La creation ouverte et ses ennemis', *IS*, 5 (1961): 29–50; English trans. in *Open Creation and its Enemies*, trans. Fabian Tompsett (London: Unpopular Books, 1994).

45. The *Situationist Times* published six issues between 1963 and 1967. On Jacqueline de Jong and her connections with the German and Scandinavian sections, see Karen Kurczinsky, 'A Maximum of Openness: Interview with Jacqueline De Jong', in Mikkel Bolt Rassmussen and Jakob Jakobsen (eds) *Expect Anything Fear Nothing: The Situationist Movement in Scandinavia and Elsewhere* (Copenhagen: Nebula, 2011), pp. 183–204. On the journal see Ellef Prestsæter (ed.) *These are Situationist Times! An Inventory of Reproductions, Deformations, Modifications, Derivations, and Transformations* (Oslo: Torpedo Books, 2019).

46. Kotányi and Vaneigem, 'Programme élementaire du Bureau d'Urbanisme Unitaire', p. 18.

47. See Abdelhafid Khatib's 'Attempt at a Psychogeographical Description of Les Halles', *IS*, 2 (December 1958). For a reading that highlights Khatib's account, see Soyung Yoon, 'Cinema Against the Permanent Curfew of Geometry', *Grey Room*, 52 (summer 2013): 38–61.

48. See for instance, Anon. (Mustapha Khayati and Guy Debord), 'Address to Revolutionaries of Algeria and of All Countries (1965)', in *Situationist International*

Anthology, pp. 189–94; 'The Decline and Fall of the Spectacle-Commodity Economy (1965)', in Situationist International Anthology, pp. 194–203; Mustapha Khayati, 'Contributions servant à rectifier l'opinion du public sur la révolution dans les pays sous-développés', IS, no. 11 (October 1967): 40–2.

49. A student at Strasbourg, Khayati has been credited with writing most of the anonymous pamphlet, De la misère en milieu étudiant: considérée sous ses aspects économique, politique, psychologique, sexuel et notamment intellectual ... (Strasbourg: AFGES, 1966).

50. Debord, Kotányi and Vaneigem, Sur la Commune (18 March, 1962). Translated as Theses on the Commune (London: Libertaria Bookshop, n.d.).

51. Ibid.

52. The split between Lefebvre and the Situationists came over claims that Lefebvre had plagiarised aspects of the Situationist analysis of the Commune. Lefebvre claimed that the text had initially been written on the basis of group discussions at his house in the Pyrenees. See Kristin Ross, 'Lefebvre and the Situationists'. For Ross's analysis of the Commune, see The Emergence of Social Space: Rimbaud and the Paris Commune (Minneapolis: University of Minnesota Press, 1988).

53. Ibid., pp. 32–46.

54. The unpublished internally circulated mimeograph was titled 'On the Exclusion of Attila Kotányi', www.notbored.org/kotányi-exclusion.html

55. For the Situationists own account of the May '68 events, see Rene Viénet (ed.) Enragés et situationnistes dans le mouvement des occupations (Paris: Gallimard, 1968). See also Pascal Dumontier, Les Situationnistes et mai '68: théorie et pratique de la revolution (Paris: G. Lebovici, 1990) and Kristin Ross, May '68 and its Afterlives (Chicago: University of Chicago Press, 2002).

56. Thomas Levin, 'Geopolitics of Hibernation: The Drift of Situationist Urbanism', in Situationistas: Arte, Política, Urbanismo, ed. Xavier Costa and Libero Andreotti (Barcelona: MACBA, 1996), p. 111.

57. See Pinder, 'Inventing New Games: Unitary Urbanism and the Politics of Space', in Loretta Lees (ed.) The Emancipatory City? Paradoxes and Possibilities (London: Sage, 2004), pp. 108–22.

58. Tom McDonough, 'Introduction', in Tom McDonough (ed.) The Situationists and the City (London: Verso, 2009), pp. 1–23.

59. Anh-Linh Ngo, 'Vom unitären bis situativer Urbanismus', Archplus, 183 (May 2007): 20–2.

13

The Abolition of Alienated Labour

Alastair Hemmens

The opposition of the Situationist International (SI) to work is arguably one of its most defining features.[1] Certainly, it was present from the very start. Debord and his Left Bank Parisian companions in the 1950s generally eschewed regular work and devoted themselves to a life on the margins. The Lettrist International (LI; which would go on to form the French section of the SI) gave voice to this Bohemian anti-work stance as early as 1953: 'We rise up against the punishments inflicted upon those persons who have grasped that it is absolutely not necessary to work.'[2] Debord, that same year, would make the argument in a much more categorical manner, scrawling, 'NEVER WORK', onto the wall of a Parisian street.[3] Ten years later, in the summer of 1963, he gave his call a more explicitly Marxian flavour, daubing the directive, 'Abolition of Alienated Labour', onto a pre-existing canvas of abstract art.[4] The critique of work, in particular the cult of labour, also formed an important stance from which the Situationists criticised, not only the capitalist West, but also the 'Communist' East. Raoul Vaneigem, for example, in *The Revolution of Everyday Life*, notes how the 'cult of work is honoured from Cuba to China' and that 'China prepares children for the classless society by teaching them [...] love of work'.[5] Indeed, Vaneigem uses the exaltation of labour as a measure with which to group together political ideologies from both ends of the political spectrum: 'wherever submission is demanded, the stale fart of ideology makes its headway, from the *Arbeit macht frei* of the concentration camps to the homilies of Henry Ford and Mao Tse-Tung'.[6] The Situationist critique of work was therefore an important point of demarcation both from the dominant social order but also from forms of what they believed to be pseudo-opposition to capitalism. No wonder then that the SI would call 'NEVER WORK' the 'preliminary programme

of the Situationist movement'.[7] In order to understand the importance of the critique of work to the SI, this chapter will examine the origins of the notion of 'alienated labour', explore some of the Situationists' contributions to the elaboration of that theory and provide an overview of some of its limitations.

The artistic critique of work

The initial source for the Situationist anti-work positions has its roots in the Romantic tradition and the history of modern art. The German Romantic philosopher Friedrich Schiller (1759–1805) laid the foundations for the critique of labour found in this tradition in his *Aesthetic Education* (1795). Schiller argues that modern society has separated mankind from its initial unity with its own nature and the natural world in general. He criticises the way in which modernity has reduced human relationships to 'an ingenious piece of machinery, in which out of the botching together of a vast number of lifeless parts a collective mechanical life results'.[8] The cause of such fragmentation and mechanisation is the way in which the Enlightenment has erected Reason above all other considerations leading to a life determined by need and use: 'today Necessity is master, and bends a degraded humanity beneath its tyrannous yoke. *Utility* is the great idol of the age, to which all powers must so service and talents swear allegiance.'[9] Schiller notes that human beings have essentially been instrumentalised into the working capacity: 'the community makes function the measure of a man'.[10] The result is that 'enjoyment was separated from labour, means from ends, effort from reward'.[11] Schiller goes on to contrast work with play: 'The animal *works* when deprivation is the mainspring of its activity, and it *plays* [...] when superabundant life is its own stimulus to activity.'[12] Work, for Schiller, is not only degraded in modernity, it is also characteristically unfree as it arises out of necessity. Schiller then promotes art as an alternative and solution to these modern ills. Within the work of art, the artist and her audience are able to engage in the free play of faculties that arise out of their true nature, as opposed to labour, where man acts out of constraint. These contentions, as many commentators have noted, in many respects anticipate Marx's critique of 'alienated labour',[13] discussed below, and we might add that all of the phrases cited above might have been lifted directly from any Situationist text from the 1950s or 1960s.

The Romantic conception of art – and its more or less explicit critique of modern labour – had a major impact on the cultural development of

the nineteenth century. The bourgeois individual found in art a realm of experience that obeyed a more playful, freer and more emotionally satisfying set of exigencies that transcended the world of money making and modern administration. Art, at this time, also became increasingly independent of its ties to religion and the state. It experimented, flush with its autonomy, with new models of behaviour and ways of seeing the world.[14] Communities of artists formed, particularly in urban centres such as Paris and London, around these Romantic artistic values. These 'Bohemians' generally eschewed work whenever possible, kept their own hours and pursued their own inclinations. They decried the boredom and utility of bourgeois life and, often, broke social taboos around the family and free love. Bohemia itself, ironically, became a subject for bourgeois fascination and fantasy for precisely these reasons. It represented a kind of utopian life of passion, drama and free creativity that contrasted strongly with the sober responsibilities of the administrator and businessman. Through the consumption of art, the bourgeois subject vicariously engaged then with a more unified experience than the one he or she would find outside the art gallery, the theatre and the opera house. The Situationists in France were, for their own part, very much the inheritors of the tradition of Parisian Bohemia, living on the margins of society, situating themselves largely in its traditional hot-spot of the Paris Left Bank and avoiding work at all costs.

The anti-art movements of the early twentieth century, however, would bring the Romantic conception of art into question. Increasingly, particularly in the context of the horrors of the First World War, art was perceived – even by artists – as an insufficient solution to the problems of modern life. Artistic avant-gardes sought to go beyond art and to 'realise' it in some sense within life itself. The Surrealists, in particular, championed the rejection of work and saw in the possibility of proletarian revolution an opportunity to realise their goals of making life a more interesting and passionate experience.[15] The Situationists represent a continuation and elaboration of the critique of work, and the celebration of art as an alternative, that was handed down from Romanticism through Surrealism. However, the Situationists, as we shall see, wanted to go much further than the Surrealists, both in terms of developing a clear Marxian theoretical framework for understanding 'alienated labour' and in the means by which art could be realised within everyday life through its suppression.

Alienated labour in the young Marx

The Situationist understanding of labour in capitalism as a form of 'alienated labour' has its roots primarily in the work of the 'young Marx', in particular, the *Economic and Philosophical Manuscripts*, which Marx wrote in Paris in the spring and summer of 1844. Marx, in these manuscripts, was seeking to resituate philosophical discussions of 'alienation' – the process and effect of estrangement of an object from its subject – within an analysis of socio-economic life under capitalism.[16] His conclusion is that social alienation in general derives first and foremost from the alienation of the productive capacity of human beings. Marx, in these manuscripts, initially identifies the origins of 'alienated labour' in the 'division of labour' that he understands to be an inevitable result of the social organisation of labour in all societies. Social labour, that is to say, requires a specialisation of tasks that leads to the emergence of an organising apparatus that has historically resulted in the division between social classes. Marx, at least in these texts, suggests therefore that some kind of alienation is inherent to labour to the extent that social organisation requires some decisions about production to take place outside of the control of the individual producer. In volume 3 of *Capital*, published decades later in 1867, Marx would also suggest that labour is an inherent form of alienation to the extent that it is 'necessary labour', that is, it arises out of a 'realm of necessity' as opposed to the 'realm of freedom', where human beings are able to engage in activity that is not born of the utilitarian constraints of basic survival.[17] Marx, although he is otherwise very positive about labour in general and even describes it in terms that suggest it is the essence of human life itself, implies therefore that, regardless of the social context, there are some inherently alienating aspects of labour that precede its alienation under capitalism.

Marx is, however, primarily concerned with labour in capitalism and, in particular, with the generalisation of wage labour as the condition of the worker. In capitalism, Marx argues, workers are forced to sell their productive capacity to those who own the means of production in order to survive. Marx describes several forms of alienation that result from this simple social fact. First, the immediate goal of the concrete activity in question – whatever that may be, fishing, tilling, making cloth and so on – ceases, for any of the social actors, to be important. Rather, labour becomes simply a means to an end outside it, that is, for the worker, a wage which permits her to reproduce herself and her family. Secondly, when

the worker is forced to sell her labour on the market, she finds that her productive capacities – her skills, her physical capabilities, her mind and so on – cease to be her own while she is at work and become the property of another person, or persons, outside of her. Her own movements and thoughts, that is to say, become estranged from her. Thirdly, the worker ultimately has no control over the conditions of the work, nor what is to be produced and she also has no control over the final product, the commodity, itself. All of these aspects of the productive process become alien to, or estranged from, her will and consciousness. Marx argues that, ultimately, this means the workers produce the very alien force that dominates them in the form of the capital and the means of production possessed by the capitalist class. Marx, moreover, is highly aware of the affective, or emotional, dimension of alienated labour:

> the fact that labour is *external* to the worker, i.e., it does not belong to his intrinsic nature; that in his work, therefore, he does not affirm himself but denies himself, does not feel content but unhappy, does not develop freely his physical and mental energy but mortifies his body and ruins his mind. The worker therefore only feels himself outside his work, and in his work feels outside himself. He feels at home when he is not working, and when he is working he does not feel at home.[18]

The existence of an 'alienated labour', as Marx terms it, also implies the existence of a non-alienated form of labour. Marx does not provide a great deal of detail about what such a form of labour might look like, but he does provide some notions on the subject and much more can also be inferred. First, Marx suggests, in *The German Ideology*, that the strict specialisation that has come to define the division of labour in capitalism ought to be overcome in order to permit the individual to exercise the full range of her faculties and inclinations: 'in communist society [. . .] nobody has one exclusive sphere of activity but each can become accomplished in any branch he wishes'.[19] Marx asserts that one could 'hunt in the morning, fish in the afternoon, rear cattle in the evening, criticise after dinner without ever becoming hunter, fisherman, herdsman or critic'.[20] Secondly, Marx, in *Capital*, suggests that the social side of the organisation of the division of labour does not have to take the form of a hierarchical relationship based on private property but could instead be based on a democratic free association of producers.[21] Labour, that is to say, is no longer 'forced', it is undertaken freely, under conditions agreed in advance,

and the products produced belong to those producing them. Thirdly, in the section of volume three of *Capital* discussed above, Marx suggests that the development of productive forces increasingly frees mankind also from the 'natural necessity' of labour, or 'necessary labour', permitting human beings to engage in whatever labours they are inclined to undertake.[22] A non-alienated labour implies therefore, at one and the same time, *freedom from* specialisation, *from* conditions of production that escape us, *from* labour as mere survival.

The spectacularisation of work

The Situationists came to Marx's critique of 'alienated labour' and his understanding of labour in general both through a direct reading of the texts mentioned above and through the work of Hegelian Marxists such as Georg Lukács (1885–1971) and Henri Lefebvre (1901–99). These latter authors in many respects provided a much-needed rediscovery of the theory of alienation in Marx – much neglected by the Marxism of the traditional workers' movement – and did so in a manner that sought to bring it up to date with contemporary changes in the world economy. The Situationist critique of work, at least in its Marxian inflection, could be understood as a continuation of these efforts. France, along with most of Europe and America, was undergoing an impressive and sustained economic boom, later given the moniker of the 'Thirty Glorious Years', that was driven by post-war reconstruction and the massive expansion of consumer markets both at home and abroad. The proletariat in the most developed capitalist countries – but also, albeit less successfully, on the other side of the iron curtain – increasingly worked not only to provide itself with the basic necessities, but to partake in the consumption of a new world of mass-produced objects – white goods, automobiles, TVs – and leisure activities – mass media, package holidays, sports – that in the nineteenth century had been either non-existent or beyond its reach. The meaning of and justification for work was therefore changing. Although the dominant ideology still insisted on its necessity in the name of 'survival', it also increasingly promoted labour as a means of self-realisation, and even individual self-expression, through high enough wages and low enough prices to permit the consumption of these commodities. Proletarian labour no longer necessarily signified material poverty.

The workplace had also transformed dramatically since Marx (though these changes were based on the expansion of many nineteenth-century

industrial trends). Rather than the family-owned workshops and smaller scale manufactories of the previous century, the tendency, in both East and West, was towards huge, often partly or fully state-owned, enterprises with large amounts of capital, run by a managerial class or *cadres*. Global competition led to immense increases in productivity thanks to new managerial techniques and the increasing incorporation of automation into the production process. The labour process became highly rationalised, broken down into the simplest gestures, constantly repeated and removing any sense of collective organisation on the part of the producers. Modern labour had managed to reduce the worker to a machine and, in the same movement, gradually used machines to displace her from the labour process altogether. Lukács, in particular, had linked these modern tendencies in the factory to the notion of a labour that was increasingly, even more so than in Marx's time, 'alienated'. The producer had been reduced to a mere passive spectator of her own activity.[23]

Debord first developed these themes of 'alienated labour' – applying Marx's ideas to the contemporary world – in a truly extensive manner in a 1960 text 'Preliminaries', co-written with Daniel Blanchard of Socialism or Barbarism (see chapter 5). Debord argues that the capitalist class 'dominates' production through 'monopolising' any understanding of the production process.[24] It achieves its monopoly through 'parcelling up' labour in order to 'make it incomprehensible to the person performing it'.[25] Debord argues that, as a result, labour is increasingly reduced to 'pure execution' and therefore rendered 'absurd'.[26] Vaneigem, in *The Revolution of Everyday Life*, likewise describes Taylorism as the 'death-blow' to what little enjoyment was left to nineteenth-century artisanal workers: 'It is useless to expect even a caricature of creativity from the conveyor belt.'[27] In the opening paragraph of his chapter, 'The Decline and Fall of Work', Vaneigem develops his argument into a blistering and brilliant depiction of post-war working life:

> What spark of humanity [...] can remain alive in a being dragged out of sleep at six every morning, jolted about in suburban trains, deafened by the racket of machinery, bleached and steamed by meaningless sounds and gestures, spun dry by statistical controls and tossed out at the end of the day into the entrance halls of railway stations [...] where the crowd communes in a brutish weariness?[28]

One could hardly imagine a better description of the phenomenology of 'alienated labour' in the present age.

It was, however, in the theorisation of the mass consumption of the products of such work in the post-war period that the Situationists proved themselves to be most original. The Situationists largely accepted the notion, found in Marx, that a certain aspect of the alienation found in labour precedes the division of labour in the form of the realm of necessity. Vaneigem, for example, in 'Banalités de Base' (1962), refers to 'nature's blind domination' of man,[29] a phrase that seems to refer to volume 3 of *Capital* in which Marx describes the metabolism with nature, in earlier historical periods, dominating man 'as a blind power'.[30] Vaneigem then goes on to say that 'The struggle against natural alienation gave rise to social alienation.'[31] Vaneigem appears here to be referring back to Marx's *Economic and Philosophical Manuscripts* as he goes on in the text to describe the emergence of alienation as a result of the private property relations that arise out of the hierarchical division of labour. Labour becomes alienated socially, therefore, in the hierarchically organised struggle against a 'hostile nature'.[32] At the same time, however, as in Marx, the socialisation of that struggle, in the development of productive technology, appears as a positive movement. It points towards a future where man's domination of nature is complete and 'necessary labour' has been reduced to a minimum. The Situationists believed that this goal, in the context of post-war consumer society, had finally been reached. 'NEVER WORK' was not just a drop-out stance, but a utopian potentiality based on the belief that it really was 'absolutely not necessary to work'. Although the Situationists therefore largely accepted that work may have been necessary at one point in time, they insist upon the fact that the development of productive forces has rendered it essentially moot. There was, moreover, and as a direct result, no longer any justification for the hierarchical division of labour: 'Once the bourgeoisie brings world-transforming technology to a high degree of sophistication, hierarchical organisation [...] becomes an anachronism, a brake on the development of human power over the world.'[33]

That 'anachronism' of alienated labour, however, remained the central focus of modern life. The Situationists therefore turned to the massive expansion of consumer society for an explanation. As Vaneigem writes in 1967:

Statistics published in 1938 indicated that the use of the most modern technology would reduce necessary working time to three hours a day.

Not only are we a long way off with our seven hours, but after wearing out generations of workers by promising them the happiness which is sold today on the instalment plan, the bourgeoisie (and its Soviet equivalent) pursue man's destruction outside the workshop.[34]

The pursuit of mankind beyond her place of work to which Vaneigem is referring is nothing less than the world of mass-produced commodities produced by the alienated labour in question. In essence, the Situationists argue that the entire goal of the expansion of consumer society was to create a new, 'artificial', realm of necessity based on pseudo-needs. The problem of 'survival' could thereby always be posed at a new level regardless of the degree of productive technology reached: 'The reduction of working time came just when the ideological variety show produced by consumer society seemed able to provide an effective replacement for the feudal myths destroyed by the young bourgeoisie.'[35] Vaneigem goes on to note sardonically that '[p]eople really have worked for a refrigerator, a car, a television set. Many still do, "invited" as they are to consume the passivity and empty time that the "necessity" of production "offers" them.'[36] Debord, in *The Society of the Spectacle*, makes exactly the same argument:

> what is referred to as a 'liberation from work', namely the modern increase in leisure time, is neither a liberation within work itself nor a liberation from the world shaped by this kind of work. None of the activity stolen through work can be regained by submitting to what that work has produced.[37]

The Situationist demand for the 'abolition of alienated labour' therefore also called for the suppression of consumer society as the latter existed solely to maintain labour in its alienated state. In many respects, this argument underpinned the essence of what the Situationists considered radical opposition to the 'Spectacle'.

Beyond alienated labour

The Situationist conception of what might replace 'alienated labour' in many respects represents a combination of the notions of free, non-alienated, activity first laid out in Schiller and Marx described above. First, with the suppression of commodity production and the spectacle of

consumerism, work itself would cease to be an important form of 'natural alienation' as basic needs could be easily provided for with very little actual labour. A proletarian revolution would, that is to say, effectively achieve the *freedom from* necessity and utility that both Schiller and Marx had identified as the origin of labour as opposed to play. Secondly, through the free association of producers in the form of workers' directly democratic organisation into councils (see chapter 4), the hierarchical division of labour would be suppressed, leaving the aforementioned producers *free to* define what it was they wanted to create, under what conditions, and to employ its products in the manner of its choosing. Such organisation would also permit the suppression of the fragmentation of human praxis by permitting everyone to engage in a range of productive and creative activities. This would, that is to say, realise Marx's idea of *freedom from* specialisation. Third, and finally, art, defined as the unified free spontaneous play of the faculties, would finally be realised as all social activity would take on the form of realising the will, consciousness and desires that belonged to the individual and the collective: 'the old specialisation of art has finally come to an end. There are no more artists because everyone is an artist. The work of art of the future will be the construction of a passionate life.'[38] The 'abolition of alienated labour' and the 'realisation of art' are, for the Situationists, therefore one and the same goal.

* * *

The Situationist critique of work is, as we have seen, in many respects the product of a merger of Hegelian Marxist theory with Romantic aesthetic theory. It was arguably the most powerful combination of ideas that the Situationist International ever launched into the revolutionary ferment of the 1960s. Certainly, opposition to labour permitted the Situationists to stand out from the vast majority of other 'radical' far-left organisations that sought simply to 'free' and even to 'realise' labour in a proletarian revolution.[39] It was also one of the aspects of the movement that was most attractive to the radicals of May '68 and had a major impact on cultural attitudes to work in the decades that followed. One might even say that the Situationist call to abolish labour remains its most radical demand today. Nevertheless, the concept of 'alienated labour' is problematical, as much recent scholarship has shown. First, anthropological research since the 1960s has largely debunked the idea that pre-modern societies were largely concerned with mere survival. If anything, as Marshall Sahlins has argued, hunter-gatherer societies appear to be ones of abundance without

a separation between work and play. The notion that the development of the means of production and the division of labour arise primarily out of a pre-social 'struggle with nature' therefore reveals itself to be little more than bourgeois ideology. Secondly, through the work of Marxian theorists such as Robert Kurz and Moishe Postone, the very concept and social reality of a transhistorical abstract 'labour', or labour in general, has been brought into question.[40] Labour would not, as in both the young Marx and Schiller, be an anthropological constant, but is rather, as Marx suggests in other parts of his work, historically specific to capitalism. Labour cannot therefore be 'alienated' from human beings as it is already, in itself, an alienating abstract, social form. The Situationists, however, cannot be criticised, at least from a historical perspective, for not grasping a critical theory that did not emerge until decades later.[41] Not only did they anticipate many aspects of what constitutes a radical critique of work today, they were also, particularly in their most categorically anti-work statements, far more radical than any of their contemporaries.

Notes

1. Some of the arguments put forward here are developed in Alastair Hemmens, 'Guy Debord, the Situationist International and the Abolition of Alienated Labour', *The Critique of Work in Modern French Thought* (London: Palgrave Macmillan, 2019), pp. 137–61. In the current chapter, however, I have chosen to contribute something new by focusing on different areas, in particular the work of Raoul Vaneigem and the roots of the Situationist understanding of 'alienated labour' in the young Marx and Romanticism.
2. LI, 'Manifeste', *l'Internationale lettriste*, no. 2 (February 1953).
3. Guy Debord, *Œuvres* (Paris: Gallimard, 2006), p. 89.
4. Ibid., p. 655.
5. Raoul Vaneigem, *The Revolution of Everyday Life*, trans. Donald Nicholson-Smith (London: Rebel Press, 2006), pp. 55, 46.
6. Ibid., p. 54.
7. *Internationale situationniste (IS)*, no. 8 (January 1963): 42.
8. Friedrich Schiller, *Aesthetic Education*, trans. Reginald Snell (Mineola, NY: Dover Publications, 2004), p. 40.
9. Ibid., p. 26.
10. Ibid., p. 40.
11. Ibid.
12. Ibid., p. 133.
13. See, for example, Daniel Hartley, 'Radical Schiller and the Young Marx', in Samir Gandesha and Johan Hartle (eds), *Marx and the Aesthetic* (London: Bloomsbury, 2017), pp. 163–82.

14. See Anselm Jappe, *The Writing on the Wall: On the Decomposition of Capitalism and its Critics*, trans. Alastair Hemmens (London: Zero Books, 2017), pp. 140–2.
15. See Hemmens, 'André Breton, the Artistic Avant-Garde and Surrealism's War on Work', *The Critique of Work*, pp. 105–32.
16. The discussion of alienation in these manuscripts is the subject of a great deal of existing literature too vast to cover here. For a good starting point, however, see Felton Shortall, 'Totality and Dialectic in Marx', in *The Incomplete Marx* (Aldershot: Avebury, 1994), pp. 94–111, Alvin Ward Gouldner, 'Alienation: From Hegel to Marx', *The Two Marxisms* (Oxford: Oxford University Press, 1980), pp. 177–98, and Chris Arthur, *The Dialectics of Labour* (Oxford: Blackwell, 1986).
17. Karl Marx, *Capital*, trans. Ernest Mandel (London: Penguin, 1991), vol. 3, pp. 958–9.
18. *Marx and Engels Complete Works* (*MECW*) (London: Lawrence and Wishart, 1975), vol. 3, p. 274.
19. *MECW*, vol. 5, p. 47.
20. Ibid.
21. 'an association of free men, working with the means of production held in common', Marx, *Capital*, vol. 1, trans. Ben Fowkes (London: Penguin, 1976), p. 171.
22. Marx, *Capital*, vol. 3, pp. 958–9.
23. See Anselm Jappe, *Guy Debord*, trans. Donald Nicholson-Smith (Oakland, CA: PM Press, 2018), pp. 23–4.
24. Debord, *Oeuvres*, p. 511.
25. Ibid.
26. Ibid., p. 512.
27. Vaneigem, *Revolution*, p. 54.
28. Vaneigem, *Revolution.*, p. 52.
29. Vaneigem, 'Basic Banalities' (1962), in Situationist International, *Situationist International Anthology*, ed. and trans. Ken Knabb (Berkeley, CA: Bureau of Public Secrets, revised and expanded edition 2006), p. 118. Translation changed.
30. Marx, *Capital*, vol. 3, p. 959.
31. Vaneigem, 'Basic Banalities, p. 118.
32. Vaneigem, *Revolution*, p. 77.
33. Ibid., pp. 216–17.
34. Ibid., pp. 54–5.
35. Ibid., p. 54.
36. Ibid.
37. Debord, *The Society of the Spectacle*, trans. Ken Knabb (Berkeley: Bureau of Public Secrets, 2014), thesis 27, p. 10.
38. Vaneigem, *Revolution*, p. 202.
39. Herbert Marcuse (1898–1979) was one of the few contemporary Marxist theorists to imagine a post-work society along similarly playful lines to the SI. See Gabriel Zacarias, '*Eros et civilisation* dans *La Société du spectacle*', *Revue Illusio*, 12/13 (2014): 328–43.

40. See Moishe Postone, *Time, Labour and Social Domination: A Reinterpretation of Marx's Critical Theory* (New York: Cambridge University Press, 1993) and Robert Kurz, *The Substance of Capital*, trans. Robin Halpin (London: Chronos, 2016).

41. The reinterpretation of Marx's mature critical theory undertaken by Postone and Kurz was greatly influenced by a re-examination of the *Grundrisse* (a collection of Marx's extensive preparatory notes written in the late 1850s). Although published in German in 1939, it was not published in French until 1967–8 and therefore seems to have had no influence on the SI.

14

Détournement in Language and the Visual Arts

Gabriel Zacarias

'The signature of the situationist movement, the sign of its presence and contestation within contemporary cultural reality (since we cannot represent any common style whatsoever), is first of all the use of *détournement*', writes the Situationist International (SI) in the third issue of its journal.[1] The practice of *détournement* was generically defined as the 'reuse of pre-existing artistic elements in a new ensemble'.[2] How could such a definition allow the Situationists to differentiate themselves from the multitude of avant-garde artistic practices which had been based on appropriation, from collage and assemblage to the readymade? Situationists were themselves aware of the contradiction: '*détournement* [...] has been a constantly present tendency of the contemporary avant-garde, both before and since the formation of the SI'.[3] Perhaps then the point was less of differentiating themselves, and more of positioning themselves in relation to the past and present of the artistic avant-garde. By the end of the 1950s, avant-garde art had a history, and even its own institutions, with many museums of modern art already established and still more spreading around the globe. What was then to become the mainstream version of the history of modern art was a linear and teleological narrative that reduced avant-garde experience to a series of successive aesthetic innovations, and which pointed towards abstraction as the highest form of art.[4] By championing *détournement* and the art of appropriation, the SI was creating an alternative genealogy for itself. Not being particularly interested in aesthetic innovations, the Situationists saw themselves as part of a lineage of disruptive avant-gardes, those that had questioned the very usages of art. Dada and Surrealism were the most obvious references, being frequently evoked in situationist texts. *Détournement* could evidently be compared to collage, a common practice of both groups, or with object appropriation, such as Surrealism's 'found object' or Duchamp's 'ready-made'.

It is a commonly accepted fact that the ready-made marks a turning point in the history of twentieth-century art. This is less a consequence of the original impact it had in the 1910s, being mostly a consequence of the importance post-war avant-gardes attached to it. The SI can be situated within this general movement in art for rediscovering and revalorising the ready-made. It was also the case for another Parisian avant-garde group of that time, 'Nouveau Réalisme', whose members had been relatively close to some Situationists.[5] All these groups had a relationship with past avant-garde art and intended to develop it in new directions. The art critic Pierre Restany, who organised Nouveau Réalisme, would clearly state in one of the group's manifestoes its will to recuperate Duchamp's ready-made, emptying it of its original negativity and turning it into 'the basic element of a new expressive repertoire'.[6] If the ready-made had originally signified a break with traditional notions of artistic creation and the art object, now it should be accepted as a new type of artistic creation and a new type of art object. The Situationists saw themselves at odds with this position, which they considered as a kind of 'recuperation' (see chapter 18). For them, the disruptive experiments of historical avant-gardes meant an irreversible rupture with artistic values. Art as an autonomous stance had lost its purpose, and the ready-made was a particular example of that general phenomenon. By blurring the frontiers that separated art objects from normal objects, it had metonymically blurred the line dividing art from life. The lesson Situationists took from the ready-made was thus the opposite of that of Nouveau Réalisme. For the latter it meant that every object could become an art object. For the SI it meant a general subversion of the normativity of objects, meaning that every object could be used differently. The main question, therefore, concerned the use that was given to things; a perspective that would fit well with the Marxist theoretical views the Situationists would soon embrace. If the commodity is a form of object in which the use-value is subjugated by exchange-value, *détournement* could be understood as a means of reasserting the use-value of objects.

This could only be done by moving beyond the artistic sphere. The SI saw itself prolonging the experience of the historical avant-garde, aiming to complete its unfinished project of reconciling art and life.[7] This was not the only possible political understanding of art. An opposite view of modernism stressed the autonomy of art as a form of resistance to economic and political imperatives, and, from that perspective, abstract art appeared to be a 'critical form' with its own self-referential concerns.[8] The

SI believed nevertheless that art had to be used for revolutionary purposes, and that conversely revolution had to be re-thought with the aid of art. Artistic autonomy did not suit their purposes, so they evoked a lineage of avant-gardes that had equally tried to tie up art and politics. *Détournement* was conceived in this perspective. It was connected to the Situationist understanding of spectacular society and its reification of language, and it would flourish as a political weapon in the May '68 uprisings.

The theory of détournement

A theoretical conception of *détournement* was originally put forward in a 1956 text, written conjointly by Guy Debord and Gil J Wolman,[9] which appeared in the Belgian Surrealist journal *Les Lèvres nues*.[10] Wolman was a founding member of the Lettrist International (LI), and very close to Debord. Both were practitioners of a type of collage art which the Lettrists called '*métagraphie*', and both had ventured into Lettrist cinema. Despite being titled 'A User's Guide to *Détournement*', the text bears little resemblance to a manual of practical methodology. It begins by asserting the 'deterioration' of art, which 'can no longer be justified as a superior activity'.[11] Sharing a materialist perspective, albeit a vague one, the authors relate this process to 'the emergence of productive forces that necessitate other production relations and a new practice of life'.[12] The deterioration of art was not seen as particularly negative. It meant that art could be used in a new manner. In total opposition to the notion of artistic autonomy, Debord and Wolman call for a political appropriation of art: 'the literary and artistic heritage of humanity should be used for partisan propaganda purposes'.[13] Brecht is then evoked as a more suitable predecessor then Duchamp. Demonstrating themselves to be consciously aware of the institutionalisation of the avant-garde, the authors note that the 'drawing of a mustache on the *Mona Lisa* is no more interesting than the original version of that painting'.[14] The artistic canon had been profaned and the high notion of artistic genius had been dethroned, but a new step was necessary beyond the negation of traditional values: 'we must now push this process to the point of negating the negation'.[15] Debord and Wolman call for a different form of art, liberated of 'all remnants of the notion of personal property'.[16] Everything could be used to create new meaning and to convey new ideas. It was no longer a matter of *ex nihilo* creation, but rather one of rearrangement. 'Any elements, no matter where they are taken from, can be used to make new combinations.'[17]

Despite the evident similarity of such ideas with avant-garde prac-
tices, the authors prefer to draw on a more distant predecessor: Isidore
Ducasse, known by the pseudonym of Comte de Lautréamont. Ducasse
was an obscure writer, who died young and left few writings. Surrealists
had been the ones who rediscovered Lautréamont and gave him a place
of honour in the history of subversive literature. In the *Surrealist Mani-
festo*, André Breton evokes Lautréamont as the primary example of what
Surrealist writing was seeking to achieve. He saw his use of metaphors
as an anticipation of free association and as a thorough rejection of Car-
tesian logic. Hence the motto Surrealists borrowed from Lautréamont to
define the beauty of casual encounters: 'beautiful like the chance meeting
of a sewing machine and an umbrella on an operating table'. By likewise
championing Lautréamont as a precursor, Debord and Wolman betray
their debt to Surrealism. At the same time, they make clear their profound
divergence from Breton's movement. Claiming that Lautréamont 'is still
partially misunderstood even by his most ostentatious admirers', they
highlight another aspect of his work.[18] Instead of recalling the metaphors
and associations of *Les Chants de Maldoror*, they turn to the practice of
plagiarism Lautréamont employs in his *Poésies*. Despite its title, the work
contains no poetry at all, consisting rather in the plagiarisation of moral
maxims from classical authors such as Pascal and Vauvenargues. Debord
and Wolman classify it as the 'application' of the 'method' of *détournement*
to 'theoretical language'.[19]

To summarise the two distinct positions, Surrealists saw Lautréamont
as the precursor of automatic writing, his illogical associations being the
equivalent of a revelation of the unconscious.[20] International Lettrists, on
the other hand, found in Lautréamont a precursor of *détournement*, con-
sciously changing the meaning of pre-existing literature. As disdainful as
Duchamp in his disregard for intellectual authority, Lautréamont would
furthermore open the way for a constructive and politicised use of appro-
priation. Calling for generalised plagiarism with the phrase 'plagiarism is
necessary, progress implies it', Lautréamont inaugurated a form of 'literary
communism' (as Debord and Wolman would call it) in total disregard for
intellectual property.[21] Most important of all, however, was that appro-
priation was not seen as an end in itself. It should have a communicative
purpose, it sought to convey a certain truth. This is how Debord and
Wolman understood Lautréamont's plagiarism in *Poésies*, which consisted
in frequently inverting the moral meaning of the appropriated maxims.

In this sense, when Debord and Wolman speak of 'détournement', or deviation, it is because they are aiming at a deviation of meaning, that is, re-signification. In complete contrast to Surrealist automatism, this meant an entirely conscious semantic operation. The authors even foresaw a series of laws that should guide the different kinds of détournement. It is not necessary to revisit them all, but some points are worth remembering. First of all, they discern two types of détournement that vary according to the kinds of material which were subject to deviation. 'Minor détournements' were those that consisted in the appropriation of material from low culture, for example photographs from magazines, newspaper headlines, extracts from comics or low-quality novels. 'Abusive détournements' are those that draw upon high cultural sources, transforming 'meaningful' material, like 'a slogan of Saint-Just or a film sequence from Eisenstein'.[22] This does not mean that Debord and Wolman are reiterating traditional social distinctions between high and low culture. On the contrary, it means that everything can be appropriated and re-signified, even those elements which are already meaningful in their original context. They also propose that any lengthy work should carefully balance these two types of détournement. As we shall see later in this chapter, Debord's cinema always applies this rule.

Another interesting point concerning the 'laws of détournement' is their relationship to memory. Debord and Wolman write that 'the principal power of a detournement is the direct result of the memory recalling it, either consciously or confusedly'.[23] The aim of détournement is not to erase the original. The element which is détourné acquires new meaning once it is inserted into a new semantic context. Nevertheless, the original meaning is still there, latent. Détournement is thus an operation of pluri-signification; it contains different layers of meaning. Moreover, it attains its maximum effect when the reader or spectator is able to grasp the whole sense of the operation, by recognising the original element and consequently the détournement of meaning which is introduced. This is a very important characteristic of détournement which helps us to understand how the Situationists concretely used it. If memory plays an important part, and if grasping the détournement is relevant, that means the choice of sources is related to the choice of a target audience. Détournement in Situationist texts and films indicates a shared literary and visual culture that informed the readers and the spectators the Situationists were trying to reach. To give just one clear and key example, when Debord opens The Society of the Spectacle with a détournement of Marx, he is addressing readers who

have read Marx, and stating his aim of providing a new understanding of Marxian theory.[24]

It is precisely because memory is so central to the practice of *détournement* that Debord decided to go back to citation in his final works. This might seem contradictory, especially if we recall the strong refusal of quotation that is stated in the 'User's Guide to Détournement': 'one can also alter the meaning of those fragments in any appropriate way, leaving the imbeciles to their slavish reference to "quotations".'[25] But in the absence of a shared literary culture informing a specific audience, *détournement* could no longer function properly. Debord had to go back to identifying his sources, without which the work of re-signification would remain invisible. He presented this as a necessity resulting from cultural decay, in a statement that still bears the marks of his former disdain for quotation:

> Quotations are useful in periods of ignorance or obscurantist beliefs. Allusions, without quotation marks, to other texts that one knows to be very famous, as in classical Chinese poetry, Shakespeare, and Lautréamont, should be reserved for times richer in minds capable of recognizing the original phrase and the distance its new application has introduced.[26]

Asger Jorn and détournement *in painting*

Asger Jorn was a Danish painter, with a prolific and diversified output, ranging from ceramics and engraving to tapestry and mural paintings. Before founding the SI, he had already been a founding member of the international avant-garde group CoBrA (1948–51), and had been active in the circles of the European post-war avant-garde for more than a decade. Aesthetically closer to Expressionism, his paintings were deeply gestural, with strong colours and impastos, but never entirely abstract, usually presenting simplified anthropomorphic figures. Considered strictly from an aesthetic perspective, his proximity to the Lettrist International group might seem surprising, since most of his artwork was distant from the Dadaist matrix that inspired the young Debord and his colleagues.[27] Nevertheless, after joining the SI, Jorn would engage in *détournement* on several occasions. First, by collaborating with Debord on two collage-books, *Fin de Copenhage* (1957) and *Mémoires* (1958). Both works combine appropriated sentences and images from newspapers, books and magazines, arranged

according to Debord's notions of 'minor' and 'abusive' *détournement*, with painterly interventions by Asger Jorn. Far from being purely decorative, the painting sets the text in motion and interferes in the reading, sometimes connecting dispersed sentences, and other times overshadowing the content of the text. The painting techniques chosen by Jorn are also to be noted. Abstract and colourful, made of splatters and drippings of paint, such painterly interventions mimicked characteristic techniques of Abstract Expressionism, a highly prominent artistic fashion at that time. But while in Abstract Expressionism gestural painting was presented as a high form of self-expression, rendering the work idiosyncratically tied to its maker, in Jorn's interventions, on the contrary, the same procedures were tied to reproducibility and standardisation. His use of abstract gestural painting went, then, in the opposite direction to the institutionalisation of high modernism.

Jorn would take a step further in that direction, applying *détournement* directly to existing paintings. The idea of modifying old paintings is something he had already in mind during the CoBrA period. Between 1949 and 1950, he experimented with modifications on art reproductions, like commercial postcards (in a similar fashion to Duchamp's 1919 *L.H.O.O.Q.*) and advanced the idea of creating a 'Section for the Improvement of Old Canvases' ('La Section d'amélioration des anciennes toiles').[28] But it was only as a member of the SI that he would put these ideas fully into practice. He held two exhibitions of 'Peintures détournées' at the Galerie Rive Gauche in Paris, in 1959 and 1962, with a series of what he called 'modifications' and 'disfigurations'. Those consisted of second-hand low-quality paintings that Jorn would buy at flea markets to then paint over. Jorn's paintings had many points in common with previous artistic experiments, especially those of Surrealism. The exploration of flea markets had been a common practice of Surrealists in their quest for 'found objects', and many Surrealist painters had explored forms of over-painting.[29] But Jorn's *détourné* paintings, partially self-mocking, were far from the grandiloquent claims of historical avant-gardes, and for the same reason departed from the general standards of late modernism. His modified paintings never entirely overshadowed the previous paintings, thus incorporating part of their former aesthetic qualities (or lack thereof). To a certain extent, Jorn welcomed the 'bad painting' into his own painting. Which meant, conversely, that his painting was never completely his own. The strong subjective quality of gestural painting was deflated by its juxtaposition with the pre-existing painting, markedly standardised. At the same time,

this did not mean refusing subjectivity in toto, since the overpainting bore the strong marks of Jorn's own pictorial style.

What is particularly interesting about Jorn's *détourné* paintings is how they seem to cross over traditional dichotomies around modern art. There is no clear distinction between high and low, no dispute between 'avant-garde' and 'kitsch'. On the one hand, Jorn's interventions on the canvas are very refined. The play of colours and the materiality of paint, the flow of the gestures and the intensity of the brushstrokes, all these carry the marks of modern art in its highest form, owing little or nothing to the most acclaimed painters of the 1950s.[30] On the other hand, by relying on the appropriation of low-quality commercial paintings, these works profane the credo of high modernism, refusing to embody its transcendental claims and its elitist cultural distinctions.

Détournement *in cinema*

In the 'User's Guide', cinema was presented as the art most suited to *détournement*: 'it is obviously in the realm of the cinema that *détournement* can attain its greatest effectiveness and, for those concerned with this aspect, its greatest beauty'.[31] This should not come as a surprise since cinema is an art of montage. But in traditional cinema the act of montage has to disappear, it must be invisible, so that the illusion of reality can be maintained. *Détournement*, in cinema, would mean precisely the opposite. It brings montage to the forefront, revealing the film as a construct and rejecting the illusion of reality.

The Situationists were not the only ones to envisage cinema in this way. When it comes to the history of cinema, *détournement* must be considered as part of a larger context in which similar cinematographic experiments gave rise to 'montage cinema' and to 'found-footage cinema'. We can think of names like Bruce Conner, Alberto Griffi and Chris Marker, as forerunners of montage cinema in the course of the 1950s, 60s and 70s. Even Pier Paolo Pasolini would venture into this domain with the exceptional experiment of *La Rabbia* (1963). But the Situationists can surely be counted as among the earliest and most conscious developers of montage cinema in the post-war context.

This is especially the case of Guy Debord, who made his way into cinema as early as 1952, and who had theorised *détournement* already in 1956. Debord's first film, *Hurlements en faveur de Sade* (1952), was a film without images. It can be seen as a Dadaist gesture of negating that art,

as is hinted by Isidore Isou's line in the film: 'Cinema is dead. No more films are possible. If you wish, we can move on to a discussion.' But it is important to remember that the text of the film was already composed of *détournements*. When Debord went back to making cinema at the turn of the 1960s, he started to work with the *détournement* of images. His two short films present a variety of *détournements* together with original filmed sequences. After a gap of more than ten years without making films, Debord finally created a long film, which was entirely composed of 'images détournées'. This was the cinematographic version of *The Society of the Spectacle*, which came out in May 1973. That same year, another former member of the recently dissolved SI, René Viénet, also launched a film entirely based on '*détournement*': *Can Dialectics Break Bricks?* Let us examine those two cinematographic experiments, each one indicating different uses of *détournement* in cinema.

The cinema of René Viénet

René Viénet had already argued in favour of the necessity of 'producing Situationist films' as a form of promoting a 'media guerrilla warfare' against spectacle. In 1973 he launched *Can Dialectics Break Bricks?*, which he presented as the 'first film in the history of cinema entirely détourné'. At a first glance, Viénet's film is apparently simple. It consists of an over-dubbed Kung-Fu film.[32] It resembles comical experiments, such as Woody Allen's *What's Up Tiger Lily* (1966). And there is undoubtedly a great deal of humour in Viénet's film as well. The content of the text, however, gives it a decidedly political and subversive tone. It is profoundly connected to the spirit of May '68. The conflicts it evokes are those of the French ultra-left and the revolutionary slogans it recalls are those that covered the walls of the occupied Sorbonne. The main character of the movie is the 'Dialectician' whose mission is to mediate the relation between class and its representation. In true Situationist vein, informed by anarchism, this means helping the proletariat to liberate itself from the subjugation of the 'bureaucrats' who represent them. What was originally the struggle of a subjugated Korean village against Japanese occupiers becomes here an anti-spectacular revolt. The Dialectician helps the unarmed proletariat – a martial arts master and his pupils, who 'organise everyday revolt' and 'exercise their radical subjectivities' – to fight against and defeat the armed bureaucrats.

Viénet's work therefore has little to do with the theory of *détournement* as a whole, in particular, its idea of balancing abusive and minor *détourne-ments*. Nevertheless, it can be seen as an application of one specific idea that was anticipated in the 1956 text. In the 'User's Guide', Debord and Wolman foresee a very simple form of cinematographic *détournement*. Replacing the sound track would permit recuperating films that were formally interesting but whose content was questionable (the example given was that of Griffith's *The Birth of a Nation*, an important film for the history of cinema but explicitly racist). Viénet's film is an application of this simple strategy. It is conceived as an example to be followed, as is made clear in the opening sequence of the film, where a female voice calls upon the audience to disseminate *détournement* in cinema: 'Let it be said: all films can be *détourné*: potboilers, Vardas, Pasolinis, Caillacs, Godards, Bergmans, as well as good spaghetti westerns and all commercials.' Its formal simplicity was therefore linked to a desire to provide people with a strategy that they could easily use. In this sense, it is true to the original intention of *détournement*, for, as Wolman and Debord had written, 'the cheapness of its products is the heavy artillery that breaks through all the Chinese walls of understanding'.[33]

Viénet would author two more movies in a similar manner. *The Girls of Kamare* was an appropriation of a Japanese 'pinky violence' film, a type of soft-porn mixed with violence.[34] This time Viénet only inserted new subtitles, keeping the original sound column. The film, which portrays conflicts in a girls' reformatory, became a very suitable scenario for the countercultural claims that Viénet continued to sustain in the vein of May '68. But that is not all. It also opposes colonialism and reflects demands of the feminist movement. The torture scenes in the film, orig-inally conceived to titillate the audience, are used by Viénet to denounce torture in the French colonies. In another scene, a character recalls the case of 'the last woman to be guillotined in France', Marie-Louise Giraud, sentenced to death by a collaborationist military court in 1943 for per-forming abortions – 'the judges are still alive', she asserts, in a call for reparation.[35] Viénet's film was also aimed at the industrialisation of por-nography, which was on the rise in the 1970s, as a counter-effect of the demands of '68. He indicts censorship and inserts footage of sex scenes in the film, shot in 16mm, which clearly differ from those of the original movie. 'Just have to organise an alternative distribution system of political porno films', claims one of the characters. In many senses, his film can be

seen as a continuation of the liberating demands of May, and as a reaction to its recuperation by the cultural industry.

Years later, Viénet would create a film that differed from the previous ones, and which was, in terms of form, closer to the films of Guy Debord. *Peking Duck Soup* is a documentary film composed of *détournements*. Its theme is the history of post-war China. It narrates the rise of Mao Tse-Tung, the years of the Cultural Revolution and those that followed up to the disappearance of the 'Chairman'. The Situationists were from the very beginning, fierce critics of the Maoist ideology in France.[36] Being a sinologist, Viénet was the main person responsible for informing the Situationist understanding of Maoist China. *Peking Duck Soup* is a remarkable documentary which employs vast archival material. It offers a well-informed and profoundly critical view of the China of Mao Tse-Tung, notably demystifying the Cultural Revolution. And as in all of Viénet's films, it still uses humour as a weapon.

The cinema of Guy Debord

The intention of making a cinematographic version of *The Society of the Spectacle* was publicly declared as early as 1969, in the last number of *Internationale situationniste*. Reinforcing the analogy between Debord's theory and that of Marx, the Situationists compared the intent of filming *The Society of the Spectacle* to Sergei Eisenstein's unrealised project of filming Marx's *Capital*.[37] One of the peculiar characteristics of Debord as an artist is that he never agreed to anything unless he was to have complete freedom to realise his goals. He got that chance at the end of the 1960s thanks to Asger Jorn's financial support. It would take him years to find the ideal conditions that would allow him to work on the filmed version of *The Society of the Spectacle*. This only became possible after he met Gérard Lebovici, founder of the publishing house Champ Libre, which would publish texts by many authors related to Situationist thought. Lebovici was originally a cinema agent, and since Champ Libre was already editing Debord's text, he agreed to produce his films as well, in so doing inaugurating a partnership that would last for more than a decade, resulting in several publications and films.[38]

Debord gave a lot of thought to how to turn his book into a film. He was very attentive to the nature of the medium, and he knew that certain strong passages from the book might not work as well on film. As he writes in a preliminary note, many of the 'beauties' of the film '(e.g. a phrase

of Marx or Hegel skilfully *détourné*)' could be 'powerless, useless' in the film.[39] The text, he notes, should now be revised with 'the images in mind'.[40] One of his first approaches was to revisit his own films in order to see what solutions he had found in the past. He was nevertheless disappointed, thinking that the short films had few strong sequences. He notes the 'importance of the music and of a certain mastery of images' (*maîtrise des images*).[41] But the intent of those films was entirely different. In his earlier films, Debord had wanted to represent the '*dérive*', hence his use of long filmed sequences of Parisian urban landscapes. The intent now was to represent spectacle, which was already a form of representation. He thus had to do the opposite: '*détourner*' instead of '*tourner*' (to film, in French). As he would write in a note, it was a matter of 're-appropriating what spectacle had stolen', the life that had been deported behind the screen. This meant that he needed to '*détourner le spectacle en bloc (quel travail!)*'.[42]

In order to turn his book into a film, Debord had to deal with three different sets of problems. First, that of adapting the text of the book to compose what he called the 'commentary' ('*commentaire*') – the text of the voice-over, which would be read by the author himself. Secondly, that of finding and choosing the images for the visual track – which implied memory, ideas and archival research. And finally, most important of all, he needed to find the correct way of bringing the images and the text into relation.

For the text of the film, Debord selected a third of the theses from his book. He did not make any changes in the content of the original text. Nevertheless, the order of the text was partially altered. The theses on *détournement*, for instance, were brought forward to the beginning of the film, producing an interruption of its initial rhythm. The idea was to present a self-reflexive intermezzo where the very form of the film was problematised. The end of the film also differs from that of the book. The concluding chapter of the book, 'Ideology Materialised', was entirely excluded. Conversely, the theses from chapter 4, 'The Proletariat as Subject and as Representation', were moved to the conclusion of the film. Debord chose to end his film with the discussion about revolution, for it was conceived as a call for revolution – or, more specifically, as a call for a multiplication of uprisings similar to that of May '68.[43]

The search for the images was also an interesting process. Lebovici had a team to undertake the necessary archival research. Debord would provide them with lists of themes and the kinds of images he wanted

them to find. His indications were sometimes very precise. He requested specific movies or advertising campaigns, like 'The 'Colgate White-Teeth' campaign from the 1950s with Geneviève Cluny')'. His list for newsreels is impressively similar to the one we find in the film: the meeting of 'Hitler at Nuremberg', 'discourses by Mao, Castro, Stalin', the 'footage of Séguy at Renault', images of 'grandes ensembles', 'strip-tease', 'pollution', 'the Earth seen from the Moon', 'the Watts riot', 'May '68'.[44] To a certain extent these lists are a testimony to Debord's memory as a spectator. Which also shows that Debord was indeed very attentive to particular manifestations of spectacle, despite the general character of his theory.[45]

The relationship between text and image was one of Debord's central concerns. He writes about it in several of his preparatory notes. What he wanted to avoid above all was to have images as mere illustrations of the thesis. At the same time, he also rejected arbitrary relationships, and did not want images that would have no relationship with the content of the thesis. He writes therefore that, for the greater part of the film, the relationship between text and images should remain 'distanced', 'indirect'.[46] A more direct relationship would only be justified when the aim was to 'shock' or to provoke the audience: 'e.g. Lenin or Castro as bureaucrats'.[47] Let us take a couple of examples from the opening sequence of the film to understand how this works in practice. The first image is that of the Earth seen from space. The whole planet transformed into an object of contemplation serves to exemplify the fact that 'in societies dominated by modern conditions of production, life is presented as an immense accumulation of *spectacles*' (§1). When spectacle is defined as 'the domain of false consciousness' and as 'the official language of separation' (§3), we see political personalities of that time and trade union leaders – notably Georges Séguy, general-secretary of the CGT, declaring the end of the workers' strikes in May '68. Debord then asserts that spectacle 'is not a mere decoration added to the real world' but rather 'the omnipresent affirmation of the choices that *have already been* made in the sphere of production' (§6), presenting us first with a fashion show and then an assembly line. Finally, the images of the war in Vietnam follow the claim that 'a critique that grasps the spectacle's essential character reveals it to be a visible *negation* of life – a negation that has taken a *visible form*' (§10). As we can see, it is always possible to identify a relationship between what is shown and what is said. The choice is never arbitrary, nor purely illustrative, and it tends to be more obvious when referring to a direct political critique.

A last important point to be noted about Debord's film, and one that distances it from the book, is the use made of autobiographical material. The spectacle is the real subject of the book, even in the grammatical sense. In the filmed version, on the other hand, we also see those who resist its domination. We see the uprisings of May '68 and some of the Situationists who played a part in it. History is narrated from the perspective of a subject who lived through it – Debord himself. What is particularly interesting is that personal experience is not represented through a direct first-person account, that is to say, in an autobiographical fashion. The presence of the author's subjectivity is rather constructed through the *détournement* of text and image. A central role is played by the *détournement* of cinematographic works. As Debord would make clear in a later note, the function of the *détournement* of films based on fiction in his work was not to denounce spectacle but to 'represent' real life, which he conceived dialectically as the 'overturning of the "artistic overturning of life"'.[48] Spanning from the 1930s to the 1950s, the chronological framework of the chosen films indicates that these were probably related to Debord's personal memory as a cinema goer. Some of them refer more strictly to his youth.[49] The choices therefore have an affective dimension. This should not come as a surprise, given that the purpose of cinema *détournement* is to refer, albeit indirectly, to Debord's own life. As he writes in *The Society of the Spectacle*, while 'The pseudo-events that vie for attention in spectacular dramatizations have not been lived by those who are informed about them', conversely 'this individual experience of a disconnected everyday life remains without language'.[50] He found a way of surmounting this absence of language through *détournement*. The appropriation of existing images to represent actual lived experiences would allow for reconciling life and representation, overcoming the gap between those two stances which characterise spectacle.

Perhaps nothing indicates better the gap between life and representation than erotic images. The more attractive they are the more the spectator feels the impossibility of actual fulfilment. This explains the persistent use Debord makes of 'pin ups' and 'cover girls' in the film *The Society of the Spectacle*. Seen from a distance, it betrays Debord's unreflective affinity with the predominant masculine gaze. But that does not mean his use of such iconography is entirely uncritical. On the contrary, if he dwells on it, it is precisely because he recognises the female body as one of the main targets of commodification. Hence the analogy he establishes between cover girls and the commodity. A series of 'commodity-girls'

('filles-marchandises', as he writes in his notes)[51] is used to make visible the triumph of the commodity form – 'the globalization of the commodity (which also amounts to the commodification of the globe)'.[52] But Debord's thought is dialectical, and thus he sees the falsehood of spectacular images as containing a certain truth. The true moment of the false can be recaptured through the practice of *détournement*. His appropriation of the images of the cover girls contains therefore the recognition of an actual beauty, which has been imprisoned by commodification. To this he opposes real life, similarly represented, but containing the truth of actual experience. The *détournement* of pin-ups must be seen then in relation and in contrast to the dedication to his wife, Alice Becker-Ho, portrayed in photographs at the opening of the film. As Debord writes in a note, one of the purposes of the film is precisely that of showing 'the real life that emerges from under the spectacle (theme evoked at the start by the dedication)'.[53]

After *The Society of the Spectacle*, Debord would further develop this subjective vein in his cinematographic works. The most significant work in this sense is certainly his film *In girum imus nocte et consumimur igni*. In this film, Debord takes himself as the main object of study, believing his life to be a feasible example of how it is possible to resist the spectacle and to live in a different manner. The use of literary references becomes increasingly important. Debord believes himself to be living in an epoch of cultural decay, where spectacle tends to erase historical knowledge. He then turns to revisiting the literary past as a way of recovering an under-standing of the world that is different to that of spectacular hegemony. Given the author's intent to reinforce a lyrical discourse centred on sub-jectivity, poetry stands out as an important source.[54] The *détournement* of cinema as a means of indirectly representing the author's life is present once again, as are the pictures of friends and lovers. The passage of time is the general theme of the film, which brings the particular experience of the author into relation with the general perception of social and cultural decay. The inexorable passing of time is evoked through the allegory of running water, reiterated through Chinese poetry as well as through the filmed sequences of the Venetian lagoon. Despite its melancholic tone, a final citation, an excerpt of a letter from Marx to Ruge, comes to turn des-peration into hope: 'You will not say that I have had too high an opinion of the present time; and if, nevertheless, I do not despair of it, that is only because it is precisely the desperate situation which fills me with hope.'[55]

Détournement *and language*

'*Détournement*', writes the Situationist Mustapha Khayati, 'confirms the thesis, long demonstrated by modern art, that words are insubordinate, that it is impossible for power to *totally coopt* [*récupérer totalement*] created meanings, to fix an existing meaning once and for all.'[56] As this passage clearly indicates, *détournement* was also conceived as part of a more general reflection on language. Not particularly an epistemological one, but rather a political one, which had as a presupposition that 'the problem of language is at the heart of all the struggles between the forces striving to abolish the present alienation and those striving to maintain it'.[57] The Situationists were harsh critics of the instrumentalisation of language, denouncing the advance of cybernetics and computer theory as efforts to reduce language to a mere set of practical instructions. They presented a perspective very similar to that of the critical philosophers of the Frankfurt School, seeing in the impoverishment of language a corresponding impoverishment of thought.[58] As they once wrote, 'the theorists of automation are explicitly aiming at producing an automatic theoretical thought by clamping down on and eliminating the variables in life as well as in language'.[59]

Their critique of the alienation of language can also be understood as an aspect of the more general critique of spectacle. If the society of the spectacle can be characterised by the separation between life and representation, language also appears in it as being increasingly deprived of its referentiality: 'Under the control of power, language always designates something other than authentic experience.'[60] The revolutionary perspective they embraced, that of creating workers' councils, could also be formulated in terms of creating 'poetic "soviets" or *communication councils*'.[61] In other words, a revolutionary project that aimed at changing life had to take equally into account the task of creating a new language: a truly communicative language, a form of language that related to 'authentic experiences'. The Situationists called this form of language poetry. It was in this sense that they expressed one of their most remarkable claims: 'The point is not to put poetry at the service of revolution, but to put revolution at the service of poetry. It is only in this way that revolution does not betray its own project.'[62]

For the Situationists, poetry was not a literary form, it had little to do with versification. Poetry was the form of language that could reach life. It was the opposite of the self-referential and tautological language of the spectacle, where language was 'put to work', subjugated to the equally tau-

tological needs of the commodity production system. For revolution to occur, it was therefore necessary to liberate language from its state of subservience to commodity production. This is why *détournement* was seen as the perfect weapon. *Détournement* was a means for stealing language back from the stronghold of power. It was a way of taking it out of 'work' and bringing it 'back into play'.[63] This is the sense in which *détournement* is used in Situationist texts. The Situationists were constantly seeking a different use of language, one that would point in the direction of poetry (in the sense mentioned above). This meant mobilising past literature in order to go beyond the limitations of spectacular language. But those past references had to be actualised in some way, they had to say something meaningful about present life. *Détournement* was a way of doing that because citations were integrated into the text, they had no force of authority, but rather depended on the meaning they conveyed.

The Situationists also saw *détournement* as a means of avoiding 'recuperation' and declared, with Raoul Vaneigem, their intent to 'popularise' the 'tactics' of *détournement*.[64] In a text published in October 1967, another situationist, René Viénet, reinforced that idea by offering a series of concrete examples of how to use *détournement* in a political struggle against spectacular language.[65] Viénet's text was a kind of guerrilla manual for a fight in the realm of language which would be put to use only months later. During the uprisings of May '68, the strategies advanced by Viénet – such as the *détournement* of comics, photo-comics and pornographic images – became widespread practices. The insubordination of words, of which Khayati had spoken, became visible in the numerous creative and subversive slogans that spread like fire over the walls of the Latin Quarter. *Détournement* had been popularised.

The posterity of détournement

After 1968, the use of *détournement* became a feature of the language of counterculture. Different social movements would embrace it in their own way. We would find it in feminist publications as well as in those of the gay liberation movement.[66] Years later, it would become an essential feature of punk aesthetics.[67] As one commentator has rightly said, the Situationists managed to 'reinvent the language of contestation'.[68] Nevertheless, with the passing of time, *détournement* also became something else. If Vaneigem's bet on a popularisation of *détournement* proved to be correct, the same cannot be said of his understanding that *détournement*

could not be recuperated. No longer a specific feature of the 'language of contestation', strategies of *détournement* are nowadays commonly used by advertisers and in political propaganda. The combination of recognisable images with short texts as a means for quickly conveying messages has become banal in the everyday use of social media and its simplified language. To a certain extent, *détournement* has also been recuperated and 'put to work'. How are we to understand such a process?

From a historical perspective, it is possible to see that the rise of strategies of appropriation in culture was related to the development of technologies of reproducibility. This was true from the invention of collage by the avant-garde, which relied on the use of newspapers, magazines and the cheap reproduction of images, onwards. The success of *détournement* is therefore connected to the fact that techniques of reproduction developed rapidly in the second half of the twentieth century. The Situationists themselves were not ignorant of this fact. Debord and Wolman advocated for *détournement* precisely because they believed that 'all known means of expression are going to converge in a general movement of propaganda'.[69] Time proved their prediction to be correct to a greater extent than they could have imagined. In that context, *détournement* became a common language. With the dissemination of mobile phones and laptops, practically everyone can play the game of re-signifying texts and images. This does not mean that *détournement* has lost its subversive uses, but it does mean that it can no longer be thought of as inherently subversive. In any case, precisely because it has been so widely popularised, it might be fruitful to go back to the Situationist theory and practice of *détournement*, which reveals nuances and complexities that are absent in many of its current uses.

Notes

1. 'Détournement comme négation et comme prélude', *Internationale situationniste (IS)*, no. 3 (December 1963): 10.
2. Ibid.
3. Ibid.
4. For a critique of that long-lasting narrative of modernism, see Hans Belting, *Art History after Modernism*, trans. C. Saltzwedel and M. Cohen (Chicago: University of Chicago Press, 2003).
5. Jacques Villeglé and Raymond Hains, for instance, were friends with members of the LI, frequenting the same bars of the Latin Quarter and often joining their *dérives*. Not surprisingly their art would go on to have similarities with *détournement* and with psychogeography, making tableaux

out of torn advertisement posters found in the streets. Yves Klein also had some proximity with Debord before Nouveau Réalisme, and even joined the First Exhibition of Psychogeography in Brussels in 1957 with his famous monochromes. See Guy Debord, Œuvres (Paris: Gallimard, 2006), pp. 280–1.

6. Pierre Restany, 'À quarante degrés au-dessus de dada' (Paris, May 1961), in Le nouveau réalisme (Paris: Union Générale d'Éditions, 1978), pp. 281–5.

7. Peter Burger's well-known definition of the 'historical avant-garde' could easily be applied to the SI, which demonstrates the reductive character of his distinction between 'historical avant-gardes' and 'neo-avant-gardes'. See Peter Bürger, Theory of the Avant-Garde, trans. Michael Shaw (Minneapolis, MN: University of Minnesota Press, 1984).

8. That was the position of the famous art critic Clement Greenberg, expressed in his classic essay 'Avant-Garde and Kitsch', Partisan Review, 6(6) (1939): 34–49, in which artistic autonomy appeared as a safeguard against the rise of fascism. In his Aesthetic Theory, Theodor Adorno would come to a similar position of resignation: 'art's autonomy remains irrevocable. All efforts to restore art by giving it a social function – of which art is itself uncertain and by which it expresses its own uncertainty – are doomed', in: Aesthetic Theory (London: Bloomsbury, 2013). For a comparison on the views of Debord and Adorno, see Anselm Jappe, 'Is There an Art after the End of Art?', in The Writing on the Wall, trans. Alastair Hemmens (London: Zero Books, 2017).

9. Despite not joining the SI, Wolman would continue to employ détournement, inventing variations on it such as the 'art scotch'. See Gil J Wolman. I am immortal and alive. Texts by Frédéric Acquaviva, Kaira M. Cabañas and Gil J Wolman (English edition, Barcelona: Museu d'Art Contemporani de Barcelona, 2010).

10. Guy Debord and Gil J Wolman, 'Mode d'emploi du détournement', Les lèvres nues, no. 8 (mai 1956).

11. Guy Debord and Gil J Wolman, 'A User's Guide to Détournement', in Situationist International, Situationist International Anthology, ed. and trans. Ken Knabb (Berkeley, CA: Bureau of Public Secrets, revised and expanded edition 2006), pp. 14–21.

12. Ibid., p. 14.
13. Ibid., p. 15.
14. Ibid.
15. Ibid.
16. Ibid.
17. Ibid.
18. Ibid., p. 16.
19. Ibid.
20. Let us note that the Surrealists, and Breton specifically, had a particular understanding of the 'unconscious' that differs in important respects from Freudian theory. They saw the unconscious as the place of a hidden truth, censured by moral boundaries, and waiting to be revealed. This is partially a consequence of the contextual reception of Freudian ideas in France, which were filtered through French psychology. See Elisabeth Roudinesco, Histoire de la psychanalyse en France (1925–1985) (Paris: Fayard, 1994), pp. 38–42.

21. Lautréamont's sentence 'plagiarism is necessary, progress implies it' is frequently quoted by Debord and the SI, from the 'User's Guide to Détournement' to thesis 207 of The Society of the Spectacle. It was originally published in the second volume of Poésies. See Isidore Ducasse (Comte de Lautréamont), Œuvres complètes (Paris: Gallimard, 1973), p. 306.

22. Debord and Wolman, 'A User's Guide to Détournement', p. 16.

23. Ibid., p. 17. Translation changed.

24. See chapter 10.

25. Debord and Wolman, 'A User's Guide to Détournement', p. 15. Translation changed.

26. Guy Debord, Panegyric, (vol. 1 1989, vol. 2 1997), trans. James Brook and John McHale (London: Verso, 2004), ch. 1. That which Debord formulates in terms of generalised ignorance can also be understood historically in terms of a cultural shift. And perhaps not only a negative one. If on the one hand literature lost the social importance it once had – which can certainly be regretted – on the other hand it also became diversified, expanding beyond the traditional Eurocentric canon that informed Debord and his generation.

27. What motivated Jorn's interest in the LI was their critique of urbanism and functionalism, which resonated with Jorn's own critical perspective vis-à-vis modern architecture. It was the Italian painter Enrico Baj who first showed Potlatch to Jorn, who then contacted André-Franck Conord. See Karen Kurczynski, The Art and Politics of Asger Jorn: The Avant-Garde Won't Give Up (Aldershot: Ashgate, 2014), p. 147.

28. He presents the idea in a letter to Constant. See Kurczynski, Art and Politics, p. 178.

29. We can think of major names of Surrealist painting, like Max Ernst and Joan Miró, or lesser known artists like Georges Hugnet and Henri Goetz. Goetz, notably, was a friend of Jorn, and had produced a series of 'Chefs-d'oeuvres corrigés' (Corrected Masterpieces) in 1938. See Kurczynski, Art and Politics, p. 178.

30. T.J. Clark once referred to Jorn as 'the greatest painter of the 1950s'. The dictum might sound like an exaggeration, but it is revealing when situated in its context. In a book devoted to questioning the very idea of modernism, Clark presents a 'defense of abstract expressionism' which relies on refuting traditional interpretations commonly associated with that form of art, such as those championed by the art critic Clement Greenberg. The work of Asger Jorn would certainly be of great use in the task of rethinking this period of modern art, and modernism as such, since, as I have stressed, it suspends many of its common dichotomies. See T.J. Clark, 'In Defense of Abstract Expressionism', in Farewell to an Idea: Episodes from a History of Modernism (New Haven, CT: Yale University Press, 1999).

31. Debord and Wolman, 'A User's Guide to Détournement', p. 19.

32. The original film was Tang shou tai quan dao (1972), directed by Kuang-Chi Tu.

33. Debord and Wolman, 'User's Guide to Détournement', p. 67.

34. The original film was Terryfing Girls Highschool: Lynch Law Classroom (1973), directed by Norifumi Suzuki.

35. It is important to remember there was a strong debate around abortion at that time in France, which would cease being considered a crime in the following year with the approval of the Veil Law.

36. See for example the text 'Le point d'explosion de l'idéologie en Chine', *IS*, no. 11 (1967). For an English version, see 'The Explosion Point of Ideology in China', in *Situationist International Anthology*, pp. 240–51.

37. 'Le cinéma et la révolution', *IS*, no. 12 (September 1969): 104–5.

38. The partnership would come to a tragic end with the mysterious assassination of Lebovici in 1984. By then, Lebovici had produced three of Debord's films, and had also established a cinema in the heart of Paris, 'Studio Cujas', where Debord's films were permanently projected. Shortly after the death of Lebovici, Debord chose to ban the projection of his films. See Debord, *Considérations sur l'assassinat de Gérard Lebovici* (Éditions Gérard Lebovici, 1985) (Paris: Gallimard, 1993), p. 42.

39. Fonds Guy Debord, Bibliothèque nationale de France, côte NAF 28630.

40. Ibid.

41. Ibid.

42. Ibid.

43. As we read near the end of the film, 'Pour détruire complètement cette société, il faut évidemment être prêts à lancer contre elle, dix fois de suite ou davantage, des assauts d'une importance comparable à celui de mai 1968', Debord, *Œuvres*, p. 1258.

44. Fonds Guy Debord, Bibliothèque nationale de France, côte NAF 28630.

45. This also means that his procedure was very different from that of similar films, like Pasolini's *La Rabbia* or Chris Marker's *Le fond de l'air est rouge*. In these two cases, the filmmakers had as a starting point a set of archival material from which they extracted a film. Debord had his own memory as a starting point, and then attempted to find the images in the archives.

46. Fonds Debord, Bibliothèque nationale de France, côte NAF 28630.

47. Ibid.

48. Debord, *Œuvres*, p. 1412.

49. This is the case, for example, of *The Prisoner of Zenda*, a film Debord talks about in a letter to Chtcheglov. The letter reveals a great deal about the multiple identifications Debord establishes with different films and which he then terms a 'mythic complex'. See Guy Debord, *Le Marquis de Sade a des yeux de fille* (Paris: Fayard, 2014). The same idea is reasserted in an article in *Potlatch*: 'consider how beautiful *The Prisoner of Zenda* becomes if you reimagine [the king of Ruritania] as King Louis I of Bavaria, Jacques Vaché in the form of Count Rupert de Hentzau, and the impostor [Rudolf Rassendyll] as none other than G.-E. Debord.' See *Potlatch*, no. 24 (24 November 1954), in Guy Debord, *Potlatch* (Paris: Gallimard, 1996), pp. 208–18.

50. Debord, *The Society of the Spectacle*, trans. Ken Knabb (Berkeley: Bureau of Public Secrets, 2014), thesis 157, p. 85.

51. Fonds Debord, Bibliothèque nationale de France, côte NAF 28630.

52. Debord, *Spectacle*, thesis 66, p. 27. A more literal, albeit more awkward, translation would retain the Hegelian language: 'the becoming-world of the commodity, which is also the becoming-commodity of the world'.

53. Fonds Debord, Bibliothèque nationale de France, côte NAF 28630.

54. I have analysed the presence of poetry in Debord's cinema in the article, 'Les enjeux de la poésie dans le cinéma de Guy Debord', in Laurence Le Bras and Emmanuel Guy (eds), *Lire Debord – avec des notes inédites de Guy Debord* (Montreuil: L'Échappée, 2016), pp. 377–88. For Debord's relation to poetry, see also Guy Debord, *Poésie, etc*, edited by Laurence Le Bras, with a postface by Gabriel Zacarias (Montreuil: L'Échappée, 2019).

55. *Marx and Engels Complete Works*, vols 1–50 (London: Lawrence and Wishart, 1975), vol. 3, p. 141.

56. Mustapha Khayati, 'Captive Words: Preface to a Situationist Dictionary' (1966), in *Situationist International Anthology*, pp. 222–8.

57. 'All the King's Men' (1963), in *Situationist International Anthology*, pp. 149–53.

58. See for example, Herbert Marcuse, *One-Dimensional Man* (London: Routledge, 2002) and Max Horkheimer *Eclipse of Reason* (London: Continuum, 2004).

59. 'All the King's Men', p. 153.

60. Ibid., p. 150.

61. Ibid., p. 151.

62. Ibid.

63. Ibid., p. 152.

64. Raoul Vaneigem, 'Basic Bananlities (part 2) (1963)', in *Situationist International Anthology*, pp. 154–73.

65. René Vienét, 'The Situationists and the New Forms of Action Against Politics and Art' (1967), in *Situationist International Anthology*, pp. 273–7.

66. In France, in the post-'68 context, we can think for example of publications like *Le Torchon brûle* or groups like the FHAR (Front Homossexuel pour une Action Révolutionnaire).

67. See Greil Marcus, *Lipstick Traces: A Secret History of the Twentieth Century* (London: Faber and Faber, 2001).

68. See Tom McDonough, *The Beautiful Language of My Century: Reinventing the Language of Contestation in Postwar France, 1945–1968* (Boston, MA: MIT Press, 2007).

69. Debord and Wolman, 'User's Guide to *Détournement*', p. 14.

15

The Situationists' Revolution of Everyday Life

Michael E. Gardiner

Behind the most radical elements in the student movement lie the fantastications, the lyric anarchy, the Dada gestures and search for hallucination which mark symbolist literature and the art and drama of the 1920s and 30s. The world is a collage subject to spontaneous rearrangement, a Kurt Schwitters assemblage to be taken apart and brushed into the corner. (George Steiner)

Introduction

When Steiner wrote these words in 1967, just a few months before Paris and indeed all France was caught up in the convulsive events of May–June 1968, he was doubtless unaware that this sensibility was perhaps best exemplified by a then-obscure politico-cultural organisation known as the Situationist International (SI). Existing officially between 1957 and 1972, the SI developed an intransigent and uncompromising critique of contemporary everyday life. As one of its main theorists, Raoul Vaneigem, put it: 'People who talk about revolution and class struggle without referring explicitly to everyday life, without understanding what is subversive about love and what is positive in the refusal of constraints, such people have a corpse in their mouth.'[1] In their total scorn for both consumer capitalism and what used to be called 'actually existing socialism', the Situationists exceeded the *outré* demands of even the most competing ultra-leftist groupings proliferating at the time. According to founding Situationist Guy Debord, the creation of the SI was fuelled by a shared belief that such an umbrella organisation, comprised of the most advanced avant-garde tendencies in contemporary society, had considerable potential to realise fully the earlier promise of Surrealism: namely, a synthesis of art and

daily life, and the actualisation of the creative potential of each and every human being. As with Henri Lefebvre, however, the Situationists felt it was necessary to identify socio-political analogues for Surrealist notions of purely aesthetic transgression and sublimity, including the festival, the *détourning* of urban space, and self-management (or *autogestion*). This project required a thorough understanding of post-war capitalism, with the goal of facilitating the theory and practice of constructing *situations*. Such freely constructed situations would end the alienation of daily life under capitalism by achieving a congruence between affective desire and the city's landscape, thereby 're-historicising' experiential time and ushering in an entirely new and radically participative mode of social life. To cite Debord: 'Our central idea is that of the construction of situations, that is to say, the concrete construction of momentary ambiances of life and their transformation into a superior passional quality. [...] The construction of situations begins on the ruins of the modern spectacle.'[2]

This chapter will be organised along the following lines. The first section will summarise the key elements of the SI's approach to everyday life, concentrating on Debord's account of the 'colonisation' of the everyday by the 'spectacular-commodity society', including the influence of Lefebvre, and the ways it can be potentially resisted. Next, the Situationists' reading of the everyday will be analysed in more critical terms, focusing on two arguably problematic areas: first, their lack of attentiveness to how daily life is experienced differentially by particular segments of society (as one might expect, issues of race and gender figure prominently here); secondly, some implications that flow from their extensive reliance on Hegelian, Marxist, and Existentialist notions of 'species being' and 'authentic' experience. A brief conclusion will follow.

The spectacle and everyday life

One of the paradoxes of the SI's approach to everyday life is that they rarely address what it means in anything approaching substantive detail. Accordingly, it must be read symptomatically through other concepts, especially their notion of the 'spectacle'. As Debord says in his major work from 1967 *Society of the Spectacle*, in modern capitalist society the entirety of life 'is presented as an immense accumulation of *spectacles*',[3] indicating that lived experience is superseded increasingly by the image, and participation by the passive gaze, leading to widespread social atomisation, estrangement,

and pacification. Yet, although the spectacle has typically been associated with the ubiquity of media and advertising in modern society, Debord explicitly cautions us that this is only its most 'superficial' aspect. The spectacle is not 'a mere excess produced by mass-media technologies' but rather a 'worldview [...] that has become an objective reality'.[4] Accordingly, the spectacle is perhaps less about media culture *per se* than an account of how 'gilded poverty' continues to manifest itself in the midst of supposed abundance. Whereas workers used to be left to their own devices after the labouring day ended, the cycle of untrammelled consumption requires that all socio-cultural practices, and indeed everyday *time* itself, be thoroughly commodified. In the society of the spectacle, then, the task of the mass media and advertising agencies is to generate an endless series of glittering and seductive images of plenitude, total satisfaction and personal fulfilment through acquisitive consumption. The spectacle represents a negation of life and the simultaneous affirmation of mere appearance; consequently, the world under late capitalism can no longer be grasped directly, but only through a series of *mediations* and spectral abstractions. Given this, Debord argues, the spectacle is best understood as a secularisation of religious and metaphysical illusions. Like religion, it banishes human powers to a nebulous, phantasmagorical world. 'The spectacle does not realize philosophy,' he writes, 'it philosophizes reality.'[5]

By its apparent perfection of domination, the spectacle projects itself as a totalising entity, the expression of a seamless and monolithic power, bolstering social atomisation, repressive control and hyper-specialisation. The spectacle takes on quasi-mythical status because it aims at a spurious unification of society, obscuring its underlying class-based conflicts. Under the reign of the spectacle, 'dominant images of need' become absorbed into each individual's psyche, gestures, and speech. This results in a totally manipulated and spectacularised environment, and the world *in toto* appears estranged and threatening. 'The spectator does not feel at home anywhere,' asserts Debord, 'because the spectacle is everywhere.'[6] Urban space has become homogenised and 'banalized', whereas time becomes linear and irreversible, reflecting the temporal succession of secular power and endless capital accumulation, and the emergence of a 'new immobility within history'.[7] Commodity time, consisting of 'abstract fragments' of fixed value, is unified and one dimensional, a 'specialized' time reflecting specific class interests. Lived temporality, incorporating the micro-narratives of daily resistance and struggle, is thereby expunged, resulting in widespread historical amnesia, what Debord calls modernity's

'false consciousness': 'pseudo-histories have to be concocted at every level of life-consumption in order to preserve the threatened equilibrium of the present *frozen time*'.[8]

Yet despite its ubiquity, the SI believed that the seemingly impregnable society of the spectacle had certain points of vulnerability that, if broached, could bring the entire system tumbling down like a house of cards. As Vaneigem suggested, 'All the springs blocked by power will one day burst forth to form a torrent that will change the face of the world.'[9] Anonymous spectacular power seeps into the most microscopic spaces of everyday social life; yet, at the same time, few accord the overarching system any real legitimacy, and social reproduction relies more on routinisation and *ressentiment* than active assent. Spectacular mystification (*contra* the later Baudrillard) *can* be challenged and reversed, but this necessitates a relentless attack on the 'general science of false consciousness' perfected by the spectacle.[10] '[E]mancipation from the material bases of an inverted truth'[11] is not a matter of correcting individual epistemic error, as the Enlighteners believed. Rather, it could only be effected through collective action on the part of marginalised and disaffected groups, the 'new proletariat', tasked with the revivification of daily life. In overcoming the ideological obfuscation and political inertia fostered by the spectacle, the popular masses could, through the realisation of 'practical theory', construct their own lived situation, and make history in conscious fashion. '[A]ll Situationist ideas are nothing other than faithful developments of acts attempted constantly by thousands of people to try and prevent another day from being no more than twenty-four hours of wasted time,'[12] Vaneigem suggested. Here, the principle of '*ultra-détournement*' is key – that is, the *détourning* of ordinary words and gestures to produce new, insurrectionary meanings, such as graffiti slogans, innovations in dress and mannerisms, but also vandalism, petty theft and looting, industrial sabotage, and squatting in abandoned properties.

But, in more specific terms, how did the SI grasp the nature of everyday life? Perhaps a useful way of addressing this question is to examine how Debord's thinking here is shaped by his engagement with Lefebvre's theorisation of the everyday, a project already well advanced by the formative years of the SI. 'Everyday life' is a recurring *leitmotiv* in Lefebvre's work, ranging from the publication of the first volume of *Critiques of Everyday Life* in 1947 (reissued with a substantial new 'Foreword' in 1958), through two additional volumes (1961 and 1981), the 1968 book *Everyday Life in the Modern World*, and many additional minor texts, culminating in his

final researches into the concept of 'rhythmanalysis'. Much of his work on everyday life is taken up with a critical attack on philosophical idealism and Western philosophy in general. According to Lefebvre, the everyday has traditionally been regarded as trivial and inconsequential in Western thought at least since the Enlightenment, which has valorised the supposedly 'higher' functions of human reason, as displayed in such specialised activities as art, philosophy and science. Idealist philosophies thereby represent a systemic denigration of everyday life and of the lived experience of time, space, and the body. Such an outlook had a distinct origin: it is an expression of *alienation*, a loss of control over 'species-specific' capacities and powers. However, this is not a timeless existential malaise, as many have supposed, but a result of the historical emergence of capitalism as a distinct socio-economic system. Daily life should be the domain *par excellence* whereby we enter into a dialectical relationship with the natural and social worlds in the most immediate and profound sense, through which essential human desires, powers, and potentialities are formulated, developed, and realised practically. Seemingly mysterious, yet at the same time substantial and fecund, everyday life is the crucial foundation upon which the so-called 'higher' activities of human beings, including abstract cognition and practical objectifications, are premised. Under capitalist modernity, unfortunately, social life becomes atrophied and utilitarian, dictated by the imperatives of production and the marketplace. People spend most of their lives constrained and defined by rigid, immobile social roles and occupational niches, and everyday life becomes the sphere of dreary and alienated 'everydayness', which takes the form of largely rote thoughts and performances. Consequently, 'Many men, and even people in general, do not know their own lives very well, or know them inadequately.'[13]

This helps to explain why Lefebvre invokes Hegel's maxim 'The familiar is not necessarily the known' when referring to the everyday. In so doing, Lefebvre strives to put his finger on something that, partly by virtue of its very pervasiveness in our lives, remains one of the most trivialised and misunderstood aspects of social existence. If under capitalism imaginative and creative human activity is transformed into routinised and commodified forms, this must be combated by cultivating a critical knowledge of the everyday, so as to ultimately effect a 'dialectical transcendence' of the present (*aufhebung*, to use the Hegelian term). Accordingly, those committed to transformative social change are admonished to look for the signs and foreshadowings of a transfigured social existence within the

seemingly trivial deeds and gestures of the everyday, 'to search documents and works (literary, cinematic, etc.) for evidence that a consciousness of alienation is being born, however indirectly, and that an effort towards "disalienation", no matter how oblique and obscure, has begun.' Only then can the critique of everyday life make a 'contribution to the art of living' and foster a genuine humanism, a 'humanism which believes in the human because it knows it'.[14] As such, Lefebvre counterpoises the alienated 'everydayness' of habitualised drudgery with the idea of everyday life as an improvisational, self-conscious, but also collective creation. In such a liberated everyday life, authentic human needs are catered to, living speech triumphs over a stultified, bureaucratised metalanguage, and a coherent 'style of life' emerges to supersede the fragmented, utilitarian culture that currently exists. This possibility can be glimpsed furtively in such events as the 1871 Paris Commune or May 1968. These are examples of what Lefebvre called the 'moment', decisive conjunctures which break, if only temporarily (at least to date), with the monotonous and relentless advance of 'official' history.

Despite what has been often supposed, Debord and his inner circle were never students of Lefebvre, who taught sociology at Strasbourg and later the University of Nanterre in the years leading up to 1968. However, key members of the SI and Lefebvre certainly socialised a great deal, and read each other's writings, until accusations of plagiarism eventually flew in both directions, and the relationship soured beyond repair. Lefebvre's impact can perhaps be seen most directly in Debord's 1961 text 'Perspectives for Conscious Changes in Everyday Life'.[15] Taking his cue from the first volume of Lefebvre's *Critique of Everyday Life*, Debord suggests that academicians and professional apologists for the *status quo* alike generally dismiss the everyday as the realm of triviality, or a vestigial anachronism relating to a more 'primitive' and now outmoded level of social existence – in any event, as an attribute of the marginalised 'other', never the specialist him – or herself. Yet even the most rarefied expert practices are connected intimately to the everyday, and, insofar as it constitutes the basic 'stuff' of human existence, we can never leave it behind entirely. Ignoring its centrality in social life, and its potential for experiential (and experimental) dynamism, represents a refusal to grasp the everyday *as* a totality, and to face up to the theoretical complexities and political implications that flow from this. For Debord, 'Every project begins from [everyday life] and every accomplishment returns to it.'[16] Accordingly, the everyday constitutes the 'ground zero' of transformational praxis, and putatively revolutionary

movements can only flout the everyday at their peril. This explains why the Situationists found considerable succour in seemingly 'trivial' acts of revolt and contestation. These *ultra-détournements*, as touched on above, were interpreted as latently revolutionary acts, signposts of a liberated consciousness and the collective refusal to accept passively the boredom and stultification induced by consumer capitalism. Not content to simply draw attention to such spontaneous acts of refusal, however, the SI asserts that, no matter how alienated or repressed an individual is, the wellspring of creative self-actualisation is a subversive capacity that everyone shares, regardless of their position within the spectacular hierarchy. The spectacle attempts to divert this collective energy by forcing it into pre-arranged and commodified forms. But an irrepressible creativity remains, which cannot be wholly co-opted or reified. It is the most efficacious vehicle through which the 'slave consciousness' propagated by the spectacle can be challenged and overturned, and is evinced in 'seething unsatisfied desires, daydreams in search of a foothold in reality, feelings at once confused and luminously clear, ideas and gestures presaging nameless upheavals'.[17] That desires stimulated by consumerism cannot be fulfilled within the present socio-economic organisation of society is the spectacle's 'Achilles' heel', a singular point of vulnerability that beckons its eventual downfall: 'The more oppression is justified in terms of the freedom to consume,' writes Vaneigem, 'the more the malaise arising from this contradiction exacerbates the thirst for total freedom.'[18]

Much of the preceding bears the imprint of Lefebvre's thinking, but there were hesitations and misgivings as well. For Debord, the chief limitation of Lefebvre's 'critique of everyday life' is that the latter eschews the immediate transformation of the everyday, preferring to view revolutionary change as a relatively distant, and hence endlessly deferrable goal. In the anonymous SI text from 1960 'The Theory of Moments and the Construction of Situations',[19] for instance, it is suggested that whereas the 'situation' is a palpable time/space of *realised* desire, one that manifests relatively enduring properties, the 'moment' (as Lefebvre conceives it) merely *intimates* the full instantiation of desire in some nebulous future, and is hence strictly temporal (and transient) in nature. Put differently, from the SI's perspective, the Lefebvrean moment is an opportunity for sparking a critical consciousness by bringing visions of a different way of life into brief (if indistinct) focus, but is not linked organically to concrete praxis orientated towards the realisation of 'absolute' goals in the here-and-now. Lefebvre's critique remains a somewhat abstract, indeed

'alienated' intellectual game, the technique of a poseur rather than the strategy of a genuine revolutionary. In contrast, Situationist critique in the service of demystification and transformation does not consist of special-ised concepts comprehensible only to an educated audience and designed to stimulate playful philosophical musings rather than directly transfor-mative action. Instead, the SI strove to operate as a catalyst, triggering the dissolution of 'false consciousness' perfected by the spectacle, enabling the masses to actualise their own liberation in and through the tangible everyday. Theirs is an 'immanent' rather than transcendental critique, even if dialectical, because it 'expose[s] the appalling contrast between the possible constructions of life and its present poverty'.[20] However much it evokes the historical experience of previous subaltern struggles against state and capital, Situationist thinking is eminently future-orientated in that it anticipates the arrival of an entirely new kind of everyday life. Paraphrasing Marx's *Eighteenth Brumaire*, one SI text asserted that 'The revolution of everyday life cannot draw its poetry from the past, but only from the future.'[21] Paradoxically, however, at least some of this emancipa-tory poetry would be culled from the past, because intimations of such non-commodified social relations could be glimpsed in pre-modern forms of gift-giving and 'nonproductive expenditure', especially the potlatch. At any rate, such a revolution casts off repetitive, stultified behaviour and the ethos of survivalism and sacrifice. Liberated from the despotism of special-isation, each person would be able to cultivate fully all the different sides of human nature, implying that genuine community can only be premised on the self-actualisation of each of its members. In the words of Sadie Plant, the SI therefore envisaged revolution as 'the first freely constructed game, a collective transformation of reality in which history is seized by all its participants'.[22]

The critique of the critique of everyday life

What emerges from the preceding discussion is that the SI, especially Debord, maintained a somewhat 'bi-polar' conception of everyday life. Under the thumb of the spectacular-commodity economy, it is the province of 'wasted time' *par excellence*, marked by boredom and deadening routine, isolation, and existential privation. Yet there is an irrepressible vitality inhering in the everyday, a utopian surplus that cannot be wholly subsumed by the capitalist monolith. This liberatory promise is registered in a dim, if often mystified awareness that this latent (yet immense) potential is being

squandered under current social conditions. In repressing this propensity towards autonomous self-realisation, the spectacle unwittingly fuels subjective disaffection and, ultimately, individual and collective revolt. What cannot be denied is that the SI developed a trenchant and insightful critique of the modern everyday. Any radical project that ignores the stultification of daily life in late capitalist society, the oppressive and repetitive character of alienated labour, and the perennially frustrated demand for freedom and happiness in the here-and-now, was, for the Situationists, a revolution not worth the effort. Furthermore, the SI went beyond interpretive diagnosis so as to articulate concrete strategies for sociocultural contestation, including such techniques as the *dérive* and *ultra-détournement* that, unlike for many of their subsequent imitators, were always understood as a means to much bolder emancipatory ends. They also managed to largely avoid the pandering elitism that marked many other avant-garde cultural and political movements. Perhaps what is most important about the Situationists, however, is their very intransigence: they argued vigorously and convincingly that a commodity-based economy was irredeemable, a barrier to human dis-alienation, individual freedom, and the achievement of genuine community.

This is not to suggest that Situationist theory as regards the everyday is wholly unproblematic, or that it can be taken up *holus bolus* in the current conjuncture without significant rethinking. As mentioned above, two lines of critical inquiry will be pursued here: first, the question of 'whose' everyday life is being referred to; and, secondly, some of the limitations of the SI's preference for authentic, unmediated social experience over more mediated (and 'mediatised') forms. To begin, the SI generally failed to take into account adequately the 'everyday life' of certain sectors of the population, most notably women, but also racial/ethnic and sexual minorities, and the intersectional overlappings between them. Partly, this can be explained by the very social composition of the SI itself, which was overwhelmingly (though not exclusively) male, white and heterosexual. Although the Situationists were committed passionately to the cause of Algerian independence, for instance, and championed decolonising movements elsewhere (Vietnam, Belgian Congo), they had many reservations regarding so-called 'Third-Worldism'. This scepticism was not entirely unfounded, especially given the veritable cult of Mao and, to a lesser extent, Che Guevara permeating the French left at the time. But, for commentators like Tom Bunyard,[23] it also indicates the presence of a Western-centric orientation that, in Debord's case in particular, echoes

Hegel's own humanistic grand narrative of overcoming alienation, one rooted firmly in the European experience. In terms of the everyday more specifically, however, there is arguably a deeper issue at play. As Greil Marcus notes, although references to 'everyday life' permeate the SI's writings, they studiously overlooked existing work that was concerned precisely with detailed, politically engaged accounts of the everyday, such as that of Walter Benjamin, Michel Foucault, or the *Annales* school, of a sort that might well have constituted useful historical and intellectual resources for the movement.[24] Nor did any given Situationist aspire to investigate daily life along the lines pioneered by these other writers, ethnographers, and theorists. To some extent, this can be explained by the SI's hostility to what they viewed as purely academic approaches to any topic that interested them, together with their clear preference for creating experiments in daily living, rather than merely writing about them. Nevertheless, there is a curiously (and ironically) abstract quality to the SI's references to the everyday; it is treated generally as a concept that is marshalled to put flesh on the bones of their ideas about revolutionary transformation, as opposed to a phenomenon to be investigated in its own right.

As regards gender *per se*, Rita Felski's insights have been productive. In her view, we are inescapably situated in an everyday lifeworld that is not entirely of our making, and which can never be wholly and self-consciously fabricated by us. As such, the everyday remains, to some extent, hidden from ourselves, and stubbornly resistant to the intellectual's conceit of rational mastery, that, in many respects, can be understood as a primarily masculine prerogative.[25] Symptomatic of this gender bias is the hostility to habit and routine evinced by most twentieth-century avant-gardes. The SI is no exception here: Situationist texts frequently identify 'habit' as one of the primary means through which we are inured to the 'gilded poverty' of life under the spectacle. As a way of 'defamiliarising' the taken-for-granted nature of our lifeworld, the SI advocates 'total *insubordination* to habitual influences',[26] so as to revivify routinised perceptions and responses and open up novel creative possibilities, especially through the introjection of chance and randomness. According to Felski, the problem here is that 'everyday life' in these accounts is contrasted typically with that which it is felt to lack, such as more visible and distinctive qualities as aesthetic experiences, extraordinary events, and historically significant happenings. Theories like those of the SI therefore project an idealised image of what they think the everyday should be, rather than strive to investigate its very

'everydayness'. Felski is quick to acknowledge that ingrained dispositions can, in certain circumstances, promote passive acquiescence to the status quo, and that critical reflection informed by theoretical work can play an important role in countering this. She nonetheless maintains that it is misguided to reject habit and routine out of hand, a stance that privileges the largely male perquisite of 'nomadic', non-purposive drift through urban environments, a notion traceable to the nineteenth-century *flâneur*. Arguably, this fetishises untrammelled novelty and perpetual movement at the expense of the more prosaic and habit-bound aspects of ordinary life. These mundane practices must be understood as skilled, embodied accomplishments that make social life *per se* possible, but, because generally carried out in domestic spheres, are typically overlooked. With certain caveats – both improvisation and repetition are necessary to the constitution of everyday life, which means that new assemblages of sense and meaning-construction are always (as least theoretically) possible – Felski's call to 'make peace with the everyday,' and to become more sensitive to the gender-blindness (for example) of much avant-garde theorising, especially as it relates to daily existence, has much to recommend it.

Our second area of inquiry concerns the SI's fidelity to a neo-Hegelian, humanistic Marxism, as well as its indebtedness to certain Existentialist themes, especially as they pertain to questions of subjectivity and resistance to the seductions of spectacular capitalism. Although some commentators have made much of Debord's penchant for nostalgic melancholia in the face of some putatively 'lost' human essence or quality, a careful reading of his *Society of the Spectacle* yields a more dynamic image of the human as a 'negative' entity, which undermines any conception of a static, eternal 'species being'. Yet, SI texts also refer frequently to the construction of 'artificial' or 'pseudo-' needs under consumer capitalism, implying the existence of unproblematically 'true' desires that are better aligned with what are perceived to be genuine human requirements and propensities. Similarly, belying its oft-overlooked connection to Sartrean Existentialism, SI writings abound with references to 'authentic' life, experiences, or desires. Writing in *The Jargon of Authenticity*, Theodor Adorno suggests that such appeals to 'authenticity' are questionable, because they are premised, not on socially mediated critical reflection, but rather some ineffable quality inhering in the subject. The 'authentic' subject is therefore deemed to be capable of sovereign self-possession, and of making wholly autonomous judgements with respect to standards of truth, beauty or justice, without recourse to considerations of objective

facticity or intersubjective validation. For Adorno, what initially presents itself as a critique of reification and alienation in the pursuit of radical self-determination ends up introducing quasi-natural necessity into the proceedings, by way of surrendering human action to a mystical decisionism. The 'jargon of authenticity,' writes Adorno, ultimately conflates an abstract and essentially solipsistic conception of existential 'freedom' with the 'absolute disposal of the individual over himself, without regard to the fact that he [sic] is caught up in a determining objectivity',[27] including the dense fabric of social connections in which we are inescapably enmeshed. Conforming largely to Adorno's account of the 'cult' of authenticity, in a 1960 text by Debord and Canjuers called 'Preliminaries Toward Defining a Unitary Revolutionary Program',[28] it is suggested that the spectacle operates by reducing 'authentic desires' to manufactured and manipulated needs, which are deemed inauthentic (and unsatisfying) because they are not subject to the standards of free, autonomous judgement, but that is itself not epistemically or ethically justified.

The Situationist argument that 'authentic' participation involves immediate rather than 'mediated' forms of existence, merits brief attention here. This position flows directly from their Romantic anti-capitalism, as well as their humanistic conceptualisation of everyday life, as shaped by Lefebvre's iconic writings on this topic. Of course, the SI had good reasons to eschew abstract theories and philosophies unconnected to the exigencies of the everyday, which they saw as both symptomatic of spectacular separation and a bulwark of technocratic managerialism. Yet, there is a danger here of fetishising immediacy as some sort of 'guarantor' of the value of direct, embodied perception and experience over and against other ways of knowing and doing. As Craig Ireland argues, whereas the notion of 'experience' used to be a specialised philosophical concept, in recent decades it has been taken up in a variety of disciplines and approaches, largely because it appears to constitute an antidote to abstract theorising or hyper-specialisation. However, the unreflective appeal to immediate experience carries with it certain tacit assumptions that naturalise social identity, which must always be understood as a thoroughly historical construct, and, while it can certainly be marshalled to progressive ends, is equally vulnerable to the consolidation of a 'neoethnic tribalism'.[29] And indeed, the current resurgence of authoritarian populism, manifested especially in the so-called 'alt-right,' is marked by an appeal to intrinsically valuable 'experience' and the sanctity of *their* everyday life, along regional or gender/racial/ethnic lines. This is an attempt to validate particularistic

identity claims in terms uncannily like, if only in form rather than content, those of many leftist groupings. The crux of the matter for Ireland is that, although by no means reducible to them, what seems to be raw, unfiltered everyday experience is hardly immune to the effects of mediatised ideology, the organisation of socio-cultural life by what Jürgen Habermas calls the 'steering media' of money, information and power, or myriad structural determinations of one kind or another. According to Ireland, then, it is not that everyday experience has no discernible 'truth-content' à la Adorno, but that it must be subject to rigorous critical examination rather than be deployed glibly so as to constitute the foundation of any 'properly' materialist theory.

It is worth noting before concluding this section that much SI theorising is marked by an opposition between two quite starkly opposed models of subjectivity. On the one hand, Situationist writings evince the desire for an entirely new form of post-capitalist existence rooted in what we might describe as a 'neo-communist' sensibility. Here, the goal is to supersede the isolated and 'petrified' self of spectacular society by what Frances Stacey calls a 'disarmoured and fluid subject, a radical subject'.[30] On the other, as Richard L. Kaplan notes, the SI's arguments regarding the perceived passivity of the broad populace and its *de facto* integration into the spectacle often fall back on a version of liberal subjecthood, which he characterises as an 'exaggerated notion of a self-sufficient, autonomous, self-legislating' subject. Echoing Adorno's comments above, for Kaplan such conceptions of 'freedom,' 'authenticity' or 'self-realisation' in the writings of the SI function to 'abstract the individual from subtending cultural traditions and the overarching social relations in which they are embedded'.[31] The Situationists thus oscillated between these very different accounts of subjectivity, neo-communist versus bourgeois-individualist – yet each, in its own way, susceptible to the 'jargon of authenticity'.

Conclusion

During the summer of 2018, France experienced yet another wave of mass strikes and demonstrations, this time in opposition to President Emmanuel Macron's neoliberal 'reforms' to French labour and employment laws, aiming predictably to tip the balance even more favourably towards the interests of capital. In the midst of this uprising, even more vigorously taken up later by the so-called Gilets Jaunes (Yellow Vests) movement, there have been many evocations of the struggles of fifty years previously,

but perhaps the most intriguing is the graffitied slogan 'Fuck '68'. This particularly vivid *ultra-détournement* is open to interpretation, of course, but a plausible reading is that the time for nostalgia is past, and that the current cycle of struggles, together with looming ecological and socio-economic catastrophe, might just make May '68 look like a dress rehearsal. Today, the Situationists are the avant-gardists most closely associated with the events of a half-century ago. They laudably rooted their thinking in everyday life, but it is equally clear that the 'everyday' is not what it used to be. It is a matter of vigorous debate as to whether, for example, the ubiquity of digital culture, or the apparent seamless integration of work and consumption under the aegis of globalised, networked techno-capitalism, can be accounted for in terms of the SI's original account of the spectacle. Although beyond the scope of this chapter, examples might include the increasingly opaque manner in which the everyday is subject to extensive algorithmic restructuring, or (relatedly) how the mundane use of networked digital technologies seems to modulate affect in ways that bypass the level of conscious reflection, thus effectively short-circuiting the formation of a potentially critical consciousness, mass or otherwise. Perhaps there has been a qualitative transformation in the socio-cultural life of late capitalism, demanding new theorisations of domination and exploitation so as to grasp potential lines of resistance to them, and, beyond that, the prospects for transformative social change. If this is at least plausibly the case, raising many complex and difficult questions as regards the nature of subjective experience, authenticity, agency and resistance, the key might not be to wax nostalgic over the SI and lament its fate, but, as McKenzie Wark argues cogently,[32] to follow the spirit if not the letter of their fraught, yet unabashedly 'utopian' quest to envision novel forms of social relations, and to forge connections between the singularities of our own daily lives and the abstract complexities of global capital. For only then might we discover a new 'Northwest Passage' leading out of the stultified everyday life of our benighted twenty-first century.

Notes

1. Raoul Vaneigem, *The Revolution of Everyday Life*, trans. Donald Nicholson-Smith (London: Rebel Press, 2006), p. 26.
2. Guy Debord, 'Report on the Construction of Situations and on the International Situationist Tendency's Conditions of Organization of Action', in Situationist International, *Situationist International Anthology*, ed. and trans.

Ken Knabb (Berkeley, CA: Bureau of Public Secrets, revised and expanded edition 2006), pp. 38, 40.

3. Debord, *The Society of the Spectacle*, trans. Ken Knabb (Berkeley: Bureau of Public Secrets, 2014), thesis 1, p. 2.

4. Ibid., thesis 5, p. 2.

5. Ibid., thesis 19 p. 6.

6. Ibid., thesis 30, p. 11.

7. Ibid., thesis 143, p. 78.

8. Ibid., thesis 200, p.107.

9. Raoul Vaneigem, 'Basic Banalities (Part 2)', in *Situationist International Anthology*, p. 161.

10. Debord, *Spectacle*, thesis 194, p. 104.

11. Ibid., thesis 221, p. 117.

12. Vaneigem, 'Banalities', p. 159.

13. Lefebvre, *Critique of Everyday Life*, vol. 1 (London and New York: 1991), p. 94.

14. Ibid., pp. 66, 199, 232.

15. 'Perspectives for Conscious Change in Everyday Life' is the text of a conference paper Guy Debord presented at the request of Henri Lefebvre to his research group 'Groupe de Recherches sur la Vie Quotidienne', directed by the sociologist on the margins of the French National Research Council (CNRS). The text was subsequently published in *Internationale situationniste* (*IS*), no. 6 (1961): 20–7.

16. Debord, 'Perspectives for Conscious Changes in Everyday Life', in *Situationist International Anthology*, p. 92.

17. Vaneigem, *Revolution*, pp. 193, 191.

18. Ibid., p. 192.

19. See 'The Theory of Moments and the Construction of Situations', *International situationniste*, no. 4 (June 1960), trans. Paul Hammmond, www.cddc.vt.edu/sionline/si/moments.html. See also Tom Bunyard, *Debord, Time and Spectacle: Hegelian Marxism and Situationist Theory* (Leiden: Brill, 2018), pp. 128–40; McKenzie Wark, *The Beach Beneath the Street: The Everyday Life and Glorious Times of the Situationist International* (London and New York: Verso, 2011), pp. 93–108.

20. SI, 'Instructions for Taking Up Arms', in *Situationist International Anthology*, p. 85.

21. Ibid., p. 85.

22. Sadie Plant, *The Most Radical Gesture: The Situationist International in a Postmodern Age* (London: Routledge, 1992), p. 71.

23. Bunyard, *Debord*, pp. 60–1.

24. Greil Marcus, 'The Long Walk of the Situationist International', in *Guy Debord and the Situationist International: Texts and Documents*, ed. Tom McDonough (Cambridge, MA: MIT Press, 2002), p. 15. Lefebvre is the obvious exception here, at least until he was ejected from the SI's orbit of influence.

25. Rita Felski, *Doing Time: Feminist Theory and Postmodern Culture* (New York: New York University Press, 2000), pp. 614–15.

26. Guy Debord, 'Introduction to a Critique of Urban Geography', in *Situationist International Anthology*, p. 11.

27. Theodor Adorno, *The Jargon of Authenticity* (Evanston, IL: Northwestern University Press, 1973), p. 128.

28. Guy Debord and Pierre Canjuers, 'Preliminaries Toward Defining a Unitary Revolutionary Program', in *Situationist International Anthology*, p. 389.

29. Craig Ireland, 'The Appeal to Experience and Its Consequences: Variations on a Persistent Thompsonian Theme', *Cultural Critique* 52 (2002): 86–107, p. 88.

30. Frances Stracey, *Constructed Situations* (London: Pluto Press, 2014), p. 82.

31. Richard L. Kaplan, 'Between Mass Society and Revolutionary Praxis: The Contradictions of Guy Debord's *Society of the Spectacle*', *European Journal of Cultural Studies* 15(4) (2012): 457–78, p. 459.

32. McKenzie Wark, *The Spectacle of Disintegration* (London and New York: Verso, 2013), p. 46.

16

Radical Subjectivity: Considered in its Psychological, Economic, Political, Sexual and, Notably, Philosophical Aspects

Alastair Hemmens

The Situationist International (SI) in many respects represented itself as the champion of the 'subject' at a time when the concept had started to go out of favour. The question of 'subjectivity', moreover, is at the heart of the way in which the Situationists treat issues surrounding human agency and its suppression in contemporary capitalist society. It is also, thanks to the influence they gained as a result of May '68, one of the main areas in which, for good or ill, certain Situationist ideas seem to have had a major and long-lasting cultural impact. Although the centrality of subjectivity to the Situationists is widely acknowledged, serious analysis of the Situationist 'subject' at a conceptual level has – with some important exceptions – rarely been a focus of critical analysis in the extant literature. Moreover, where the 'subject' is discussed, critics have largely focused the analysis on the work of Guy Debord. The notion of the 'subject', however, is an area in which Raoul Vaneigem, the other key theorist of the SI, stands out. Vaneigem brought many new ideas to the table that are either not found or not especially emphasised in the work of Debord. His notion of 'radical subjectivity', in particular, serves as a useful point of critical comparison with Debord and an area in which we can start to better understand his contribution to the SI as a whole.[1] This chapter, by drawing on the critical perspective provided by new critical theoretical analyses of the subject associated with the 'critique of value',[2] will provide a much-needed analysis of the genealogy, content and critical ambiguities of the notion of the 'radical subjectivity' put forward by Vaneigem and the SI more broadly.

The subject of history

The 'subject' that is discussed in this chapter cannot be reduced to the simple notion of the individual or social actor. Rather, the subject in question is a modern concept, and a social reality, that has a well-documented, albeit hotly contested, intellectual history.[3] Pre-modern conceptions of human being, in Europe at least, were largely centred around the relationship between the self in its worldly context – the body and its social context – and the supra-sensible world of the sacred. Humanity, as such, embodied a unity of the sacred and the profane.[4] The early modern period, however, saw the emergence of a new, 'secularised', conception of the self that both contributed to and was shaped by the dramatic social transformations underpinning the development of capitalist society. The work of the seventeenth-century French philosopher René Descartes (1596–1650), in particular, marks a turning point in theorisation of human being. Descartes introduces a strict division between the self – identified with pure consciousness – and the exterior world – including the body, nature and society: 'I think therefore I am.' The world exterior to the self is, in turn, conceived as abstract lifeless matter – a frigid, mechanistic, clockwork Newtonian universe – to be manipulated by consciousness. The modern 'subject' emerges therefore as a particular notion of self and human being that exists in abstraction from a passive, instrumentalised, abstract 'object'. Political and economic thinkers, such as Thomas Hobbes (1588–1679) and Adam Smith (1723–90), further contributed to this new conception of human being by presenting human society as comprised of atomised competing individuals engaged in the 'rational' pursuit of opposing economic interests. In practice, the full status of 'subject' – legally and politically – was largely only accorded to the white, property-owning, Europeans from whose actually existing social being the concept had originally sprung.

Such a conception of human being, however, clearly excludes large swathes of human experience, modes of social being, individuals and groups. Much of the political, economic and intellectual history of the nineteenth and twentieth centuries therefore comprised a reaction to the 'bourgeois subject'. Social movements developed that sought, in various ways, the full status of subjecthood for subaltern groups – servants, workers, women, people of colour – in the form of the right to vote, to participate fully in economic life and to enjoy greater social recognition. Likewise, cultural movements emerged that sought recognition for other

aspects of experience that did not fit the rationalist model. Romanticism, for example (see chapters 9 and 13), proclaimed passion, community and the transcendent values of art as integral aspects of an authentic conception of the subject. Post-Kantians, such as Hegel, sought to overcome the Cartesian dualist split between subject and object, in Hegel's case by making the subject its own object. However, they did so in a manner that, as Anselm Jappe argues, implicitly, and uncritically, retained the subject form within their own philosophical frameworks.[5] Although subject and object are reunited, the sensible world, in these philosophies, is still often reduced to a mere projection or emanation of the subject. These struggles for recognition – political, cultural and philosophical – led to the 'subject' – as something broadly to be contested and fought for – gradually emerging to contemporary observers as a material force: a conceptual and social form through which empirical social actors sought recognition and some form of agency.

Increasingly, particularly through Hegel's and Marx's respective philosophies of history (see chapter 4), the conceptual and social model of the 'subject' became associated with individual freedom, self-creation and self-determination. Rather than contingent forces driving the course of history, it was the 'subject', however defined, that transformed the world through exerting its control over society and the natural world. The development of productive forces, the increasing ability of the subject to 'dominate' its object, nature, consciously through technological and social control appeared to permit the subject to realise itself fully by extending the reach of its powers. These ideas became central to the early communist movement. Marx and Engels, in *The Communist Manifesto* (1848), argued that history could be defined as a history of class 'struggles' in which successive 'subjects', created by the development of productive forces, overthrew their oppressors and, in so doing, became the subjects that defined their own selves and the world around them. The proletariat, within this schema, was to be the final 'subject of history' that, by pursuing its class interests (which were thought to be diametrically opposed to those of the ruling class), would create a classless society.[6]

The Situationist subject

The Situationists as a whole were very much the inheritors of the intellectual history of the subject described above. It was, moreover, a position that they adopted in opposition to the dominant anti-capitalist intellectual and

political currents of the 1950s and 1960s. The Situationists were obdurate critics of structuralism and, later, semiotics. Debord, in *The Society of the Spectacle*, criticises structuralist discourse because it not only reduces the social individual to a mere effect of the social and linguistic structures which constitute the individual, but further illegitimately projects this reductive conception on to all past, present and possible human societies (even if some structuralists correctly draw attention to the way language and linguistic structure is inevitably implicated in the exploitative and oppressive structures of a given society).[7] Vaneigem, in *The Revolution of Everyday Life*, similarly criticises Existentialism for condemning the subject to a universe of suffering without socially grounding that suffering in social relations that can be overcome.[8] The Situationists saw these philosophical perspectives as forms of capitalist ideology to the extent that they tended to reduce subjective agency and objectify certain aspects of contemporary social conditions to the point of denying that revolution was possible and, perhaps even worse, because they tended to claim that ideology and the state were necessary forms of social mediation.

The question of the subject, and its commensurate subjectivity, equally posed itself within the organisation and goals of the contemporary workers' movement. As we saw in chapter 10, the Situationists criticised intellectuals of the various communist parties and unions, such as Lukács, for identifying the subject of history not with the workers themselves and their capacity to self-organise, but with the Party. In the 1960s, several large workers' movements took on a 'wildcat', self-organised and unsanctioned form that clashed directly with their own institutions. The winter of 1960–61, for example, saw an insurrectionary Belgian workers' strike take place that violently confronted union representatives for a lack of support.[9] The Situationists saw such events as evidence of the fact that the various representative forms of the workers' movement were nothing more than an alienation that had come to suppress the very subject of history it claimed to represent. The Situationists also criticised the traditional workers' movement for reducing the question of revolution to an objective process identified with the development of productive forces alone without radical subjective intervention. The state, according to Stalinist doctrine, would 'wither away' in some far distant future simply under the influence of industrial development. The result was that mainstream Marxism cared solely about quantitative development and the continuation of commodity production.

These criticisms at the ontological level of social being underwrite what is perhaps one of the most original aspects of Situationist theory: the emphasis that it places upon the phenomenological experience of the empirical subject. None of the dominant ideologies on the left – from Structuralism and Existentialism to the 'ultra-gauche' and the Party lines of the USSR and China – seemed to challenge the idea that life should be devoted to work and that 'everyday life' outside it should be devoted to the compensatory consumption of its products. The Situationists, that is to say, rejected the traditional discourse that criticised capitalism purely in terms of quantitative questions of pecuniary poverty and instead focused on the notion of the 'poverty of experience'.[10] The essence of Situationist critique and theory rested therefore in the observation that life in capitalism (be it liberal capitalism in the West or state capitalism in the East) was boring, humiliating, uninspiring, isolating, ugly, lacking in inspiration and, overall, pusillanimous:

> The struggle between subjectivity and that which corrupts it is, from now on, widening the terrain of the old class struggle. It revitalises and sharpens it. The desire to live is a political decision. Who wants a world in which the guarantee that we shall not die of starvation entails the risk of dying of boredom?[11]

The emphasis that the Situationists place here on qualitative subjective experience, rather than solely 'economic' or 'political' oppression (in the strictest senses), is arguably what separates them most clearly from other contemporary revolutionary tendencies. Revolution, for the SI, is no longer simply a question of demanding wage increases or better working conditions, but rather of a total transformation of phenomenological reality, that is, of directly lived experience, as a whole. The Situationist argument in favour of 'subjectivity' is therefore a conscious attempt to valorise individual liberty, emotion and creative spontaneity as an essential aspect of proletarian revolution. It also embodies a radical critique of a culture in which, as Debord identifies in the concept of the spectacle (chapter 10), individuals increasingly 'experience' qualitatively rich lives only vicariously through the consumption of images and only have access to illusory forms of agency that are confined to the dominant system. In other words, the subject and its subjectivity are alienated and displaced. The Situationists seek to re-centre revolutionary theory and practice around it.

The will to live

Vaneigem, of all the members of the SI, most thoroughly develops the position of the subject in capitalism as the central focus of his most influential work, *The Revolution of Everyday Life*, published in tandem with Debord's *The Society of the Spectacle* in the winter of 1967.[12] In the introduction to the book, for example, Vaneigem states that, 'although nothing stays there', '[e]verything starts from subjectivity'.[13] Indeed, throughout the book, Vaneigem insists that the 'subject' is the starting point for a real conception of what is needed for a radical transformation of objective conditions: 'Radical theory comes out of the individual, out of being as subject: it penetrates the masses through what is most creative in each person, through subjectivity, through desire for realisation'.[14] The ideas that Vaneigem puts forward, and the possible emergence of a radical subject, are therefore rooted in a belief that the empirical experience of the subject – what Vaneigem calls the '*vécu*', or 'lived experience', gives rise to an objective desire for and understanding of anti-capitalist revolution. Empirical subjects, individuals, need only become properly cognisant of their real daily experience of capitalism for them to become the collective subject of history.

Vaneigem founds his arguments on a transhistorical social ontology that draws upon both Hegelian Marxist and Romantic philosophies of the subject. Within the Hegelian Marxist schema, man is identified as a subject that transforms its object through a process of praxis, that is to say, a conscious practice.[15] The early Marx, as we saw in chapter 13, identifies the mediation of praxis with labour. The subject, mankind, in transforming its object, nature, also transforms itself by changing the conditions of its existence. Vaneigem explicitly refers to this theory with reference to Engels who shows that 'a stone, a fragment of nature alien to man, became human as soon as it became an extension of the hand by serving as a tool (and the stone in its turn humanised the hand of the hominid)'.[16] Vaneigem extends this logic to all forms of praxis: 'what is true for tools is true for all mediations'.[17] The subject, in this schema, is a being that differs from nature in its essential capacity to transform the world consciously and, in so doing, transform itself in a never-ending movement of self-determination. Human experience is comprised therefore of a totality of social mediations in which the individual, and, by extension, society as a whole, realises its consciousness in nature. This is the foundational concept that forms the basis for Situationist theory as Vaneigem

develops it. It is worth noting that the conception of subject as praxiological retains many core features of the Cartesian subject: the primary concept of human being, or the self, is abstracted from its social relations and, in turn, the object, nature, is an 'alien', passive, receptacle in which the subject realises itself.

Vaneigem, however, departs from the Hegelian Marxist model of subjectivity in several important respects. First, Vaneigem, unlike Marx, identifies human praxis – its 'species being' – with the notion of 'creation', rather than labour. His subjects are 'creators', not 'producers'. Vaneigem, moreover, uses 'creation' essentially synonymously in his system with the notions of play and poetry (in particular as the Greek *poiein*, 'to do/ to make').[18] The essence of the subject is identified therefore with the free, playful, spontaneous and entirely non-utilitarian transformation of the object. Vaneigem suggests, in other words, that the attributes that are usually accorded to art and the artist are in reality the essential characteristics of all human subjectivity.[19] Secondly, Vaneigem argues that the creative consciousness of the subject is preceded by, and commensurate with, an even more essential 'will to live'. The will is comprised of the desires, drives and impulses that arise within the subject as it is confronted with an objective reality that does not immediately conform to its wishes. The goal of human praxis is therefore for the subject to realise its 'will' through a conscious transformation of its object (and, in so doing, transform itself). The 'will' is the 'will to live' because Vaneigem – in a similar manner to Debord – identifies the free activity of the subject with 'life' itself (and, commensurately, passivity and alienation with 'death'). Indeed, Debord explicitly refers to the subject simply as the '*vivant*' ('one who lives' or the 'living'): 'The *subject* of history can be none other than the *vivant* producing itself, becoming master and possessor of its world.'[20]

Vaneigem develops the notion of the 'will' out of an engagement with the work of Arthur Schopenhauer (1788–1860) and Friedrich Nietzsche (1844–1900). Schopenhauer, in *The World as Will and Representation* (1818), argues that the subject is able to access a priori knowledge of the objective world – things in themselves – in the form of the sensations that arise in the body and which therefore precede conscious representation.[21] Schopenhauer concludes that the subject, and the world with it, is essentially comprised of a 'will to live' because an examination of these sensations suggests that, preceding consciousness, man, like animals and plants, is driven by biological desires to spread, multiply and satisfy its hungers. Schopenhauer concludes that the situation of the subject is

therefore a pessimistic one because it is condemned, by everything that drives it, to never be satisfied as new desires will always arise. Nietzsche, in contrast, embraces the Schopenhauerian notion of the 'will' as the wellspring of human creativity. Each human being is charged, in his philosophy, with realising its individual 'will' even in opposition to the dominant moral order and, in so doing, becoming a 'master'. The social opposition the 'will' faces, however, requires that it be a 'will to power', a will asserted over and against others, rather than simply a 'will to live'. Vaneigem adopts a similar schema, though jettisoning its implicit hierarchical structure, calling on his contemporaries, in an obvious reference to Nietzsche, to become 'masters without slaves'.[22]

The will to power

Vaneigem uses the Hegelian Marxist schema of a subject engaged in a praxis of self-realisation and self-transformation as the basis for his critique of alienation. Vaneigem argues that social alienation arises out of the socialisation of a pre-social 'natural alienation', that is, the subject is faced initially with a nature that is hostile to it and social hierarchies emerge as a first attempt to confront that hostility. The idea of an 'alien nature' in Situationist theory is, as we saw in chapter 13, closely tied to bourgeois notions, inherited from traditional Marxism, of pre-modern societies being defined solely in terms of basic survival. Vaneigem asserts that human beings adopted hierarchical social forms initially in attempts to combat nature.[23] Hierarchy, however, introduces alienation into human praxis or 'creation'. The creatively *conscious* dimension of praxis is lifted from the individual subject and placed under the control of a separate, hierarchically superior, subject. The dominated subject continues to transform its object – and, in so doing, transform itself – through the act of creation, but that process escapes its control: '"Mediation", says Hegel, "is self-identity in movement." But what moves can also lose itself. [...] As soon as mediation escapes my control, every step I take drags me towards something foreign and inhuman.'[24] The subject is therefore, paradoxically, alienated from its own essence, as self-determining consciously creative praxis, and, at the same time creates itself and the real world as an alien object, one determined by a socially superior subject, but which is, nevertheless, the result of its own activity.

Vaneigem, as we can see here, does not initially approach the alienation of the subject in capitalism from the perspective of its historical

specificity. On the contrary, capitalism is understood as another phase in a much longer history of 'power' that has its roots in the first socially stratified human communities. The alienation upon which power rests is the result of the 'abstraction' of the self-determining conscious element of the subject's 'mediation' with its object: 'Power is the sum of alienated and alienating mediations'.[25] Vaneigem argues therefore that the subject continues to exist beneath 'power', even that it continues to be expressed, but that it does so in a corrupted fashion that obeys the will of the ruling class. Creation is transformed into 'alienated labour'. Lived experience is replaced by the spectacular image. Consciousness of the self is transformed into 'ideology'. Vaneigem is in fact so attached to the notion of the subject as a self-determining creatively conscious praxis that he argues that even the very worst aspects of 'power' are ultimately the product of its 'creation': 'It is obvious that abstract systems of exploitation and domination are human creations, brought into being and refined through a corrupted, recuperated, creativity.'[26] We might also think of the Situationist phrase: '[Power] does not create, it recuperates.'[27] The critique of capitalism that Vaneigem develops is therefore primarily one of a *personal* domination – domination *by* a socially superior subject – that has deep ontological effects on the subject as such – that is, on both the empirical subaltern subjects but also human being in general. Vaneigem is, in this respect, very much the perfect anarchist: his critical framework is rooted in a critique of hierarchy *per se*.

Vaneigem argues that the alienation of the subject is commensurate with an alienation of its 'will to live'. Although, as we saw above, Vaneigem draws upon Nietzsche, he does so in a manner that is explicitly critical of the notion of the 'will to power' as a positive attribute of the subject.[28] Rather, for Vaneigem, the 'will to power' exists, but it is the alienated, corrupted, expression of the 'will to live' caught within a hierarchical social formation and forced to expresses itself primarily as a desire to dominate others: 'The will to power is the project of self-realisation falsified [...] It is the passion for creation, for self-creation, caught up in the hierarchical system, condemned to turn the mill of repression and appearances.'[29] Here Vaneigem turns the 'will to power' into an essentially psychological theory for explaining why, although every human being is ultimately deep down a 'subject', and therefore in some sense positive, individuals in hierarchical societies often display aggressive, predatory and destructive behaviours, seeking to dominate and destroy others. All of these behaviours are ultimately not inherent to the subject, or human being, as innately negative

destructive drives. Rather, they are the result of frustrated, creative, positive drives. The subject is, within this system, therefore preserved from any negative association with the worst aspects of human behaviour. It persists, beneath alienation, as an essentially positive being ready to be freed from the constraints that pervert it.

The notion of the alienation of the subject is absolutely central to the critical theory that the Situationists advanced in the 1950s and 1960s. Alienation effectively reduces the subject to the status of an object. The subject is instrumentalised, manipulated, passive. It is, like the Cartesian *res extensa*, effectively without a consciousness, meaning or will of its own. Just as the subject is associated with life, so both Vaneigem and Debord speak of alienated subjects and subjectivity in terms of the 'dead' and 'death'. Debord, in particular, emphasises the passivity of the alienated subject; its permanent state of 'non-intervention'. Indeed, Debord, much more so than Vaneigem, effectively captures the illusion of agency that 'power' provides to its alienated subjects precisely through inviting them to engage in activities that are mediated through alienated representations, such as political parties and consumerism. Vaneigem, in contrast, constructs the situation of the subject as a constant Manichaean struggle between life and death, freedom and constraint, the will to live and the will to power: 'Not a moment passes without each one of us experiencing, on every level of reality, the contradiction between oppression and freedom.'[30] Vaneigem, that is to say, paints a picture of a self that is absolutely at odds with itself; that, so long as it does not revolt against its alienated condition, must inevitably find itself forced to suffer.

Vaneigem identifies the historical specificity of alienation in capitalism with the particular way in which the bourgeoisie, in contrast to previous oppressing subjects, rules over society. Vaneigem argues that, in pre-modern societies, 'power' rests upon qualitative 'unifying myths' that permit the subject a certain degree of self-expression and rich experience. The rise of the bourgeoisie, however, is associated first and foremost with the spread and rationalisation of exchange. Vaneigem, in fact, refers to the bourgeoisie explicitly as 'the class of exchange'.[31] The unifying qualitative mediations of the pre-modern world are shattered, by virtue of the fragmentary and quantified nature of rationalised exchange, into a social totality in which every aspect of the self is broken up and reduced to the status of a passive abstract object: 'exchange pollutes all our relationships, feelings and thoughts. Where exchange dominates, only *things* are left, a world plugged into the organisation charts of cybernetic power: the world

of reification.'[32] Vaneigem is thinking here – on a phenomenological level – of typically modern social phenomena such as factory work and consumerism: 'The bourgeoisie traded in *being* for *having*, and so destroyed the mythical unity of being and the world as the basis of power. The totality fell into fragments. The semi-rational exchange of production equated creativity, reduced to labour-power, with an hourly wage-rate. The semi-rational exchange of consumption equates consumable life – life reduced to the activity of consumption – with the quantity of power needed to lock the consumer into his place in the hierarchical organisation chart'.[33] Vaneigem sees capitalism, then, as the rock bottom of the history of the self. The subject, in capitalism, is alienated to such a degree that it ceases effectively to be a subject and becomes instead an object: it is a 'thing', that 'has' rather than 'is', within a 'world of reification', that is to say, a world effectively without subjectivity.

The radical subject

Vaneigem, however, sees the alienation of the subject under capitalism as only one side of the story. The subject, in his schema, still persists as a positive reality underneath the weight of the history of reification. It constantly seeks to assert itself against alienation: in the form of language, in art, in love, in play and in contestatory social movements. Furthermore, the very existence of a suffering subject is itself only possible if the subject is, on some level, aware that all is not right with its mode of existence. The worse things get, the more the subject is forced to confront its own suffering. Pre-modern myths permitted the subject just enough qualitative richness to maintain a belief in hierarchical power, but a system in which everything is based on the mediation of the fragmentary, quantitative abstractions that arise out of exchange leaves it very little room for manoeuvre. Capitalism, in this sense, creates its own 'gravedigger' in the absolutely alienated subject of modern life. It forces the subject into such an abject state of reification that it must re-emerge to assert its right to self-determination, self-creation and the transformation of the world according to its will to live. Moreover, because capitalism has effectively extended its reach to every corner of the world, and democratised 'power', the empirical experience of the individual subject effectively becomes a collective experience of alienation upon which a radical solidarity can be formed. Vaneigem sees 'subjectivity' therefore as a radical position, in large part, because the phenomenological, empirical, experience of the

'subject' – due to the essential nature of the latter – tends to reveal the alienating reality at the heart of the totality of modern life. People already know, they are already conscious on some deep level, that the world as it currently stands needs to be overturned.

Vaneigem does not imagine the radical role of the subject of history then solely in terms of the 'seizure of the means of production'. Rather, the historic mission of the subject is to realise itself by throwing over every barrier, every limit – moral, social or physical – to the full realisation of its 'will to live'. His vision of revolution is one that seeks to realise every fantasy, dream and desire that arises in the self as a consciously creative self-constituting subject: 'all our dreams will come true when the modern world's technical know-how is placed at their disposal'.[34] The bourgeoisie, by essentially overcoming natural alienation through technological development, undermines the justification for the social alienation of the subject and, at the same time, provides the subject with the means to dominate nature: 'The bourgeoisie's accession to power signals man's victory over natural forces. But as soon as this happens [...] hierarchical social organisation [...] loses its justification'.[35] The objective world will, once the subject has reached its majority, fall entirely under its sway, be transformed, manipulated, re-created to reflect it absolutely. It will, in this sense, be the generalisation of the model of the 'constructed situation' and '*détournement*' (see chapters 11 and 14). The subject will have free rein to define itself and its environment. The result, and goal, of the victory of the subject of history, of the 'will to live', is a society of passionate creativity in which personal suffering, at least that which is socially produced (which, for Vaneigem, seems to be almost every form of suffering), will be overcome.

Vaneigem is evidently aware that there are problems in assigning a collective project of revolution to a subject that, within his schema, is so thoroughly individualised as to consider only itself as the centre of the social universe. He overcomes the problem by arguing that, although each subject is an individual, individuals share the common status of being as subjects: 'all subjectivities are different, but all contain an identical desire for complete self-realisation'.[36] Vaneigem sees this shared identity between subjects as the basis for what he calls 'radical subjectivity':

> Each individual subjectivity is rooted in the will to realise oneself by transforming the world, the will to live every sensation, every experience, every possibility to the full. It can be seen in everyone, its intensity

varying according to the degree of consciousness and determination. Its real power depends on the level of collective unity it attains without losing its variety. [...] Radical subjectivity is founded on the reflex of identity, on the individual's quest for himself *in others*.[37]

The essence of a 'radical' subjectivity is therefore the *conscious* realisation on the part of individual subjects that they can only realise themselves fully if everyone else is able to realise themselves fully. The shared experience of the frustrated 'will', of suffering under capitalist alienation, and the desire to realise oneself, one's 'will', through a total transformation of society can become the basis for the emergence of a collective subject of history overcoming the forces of order. The revolutionary subject is therefore no longer the proletariat united in poverty, but the proletariat united in the poverty of experience. A subject that, as Vaneigem concludes in the 1972 post-face to *The Revolution of Everyday Life*, has 'a world of pleasures to win, and nothing to lose but boredom'.[38]

The automatic subject

It is clear to see, more than fifty years on from the publication of *The Revolution of Everyday Life*, that Vaneigem – and other *soixante-huitards* like him – had a major impact on the cultural evolution of global capitalist society after May '68. Today the dominant model of subjectivity is no longer the morally strict, submissive, dutiful 'anal' type of Gaullist France. Contemporary society, on the contrary, is obsessed with the need to 'realise oneself', to reject hierarchical constraints and to pursue every fantasy. Vaneigem, in the 1990s, was even singled out by two French sociologists, Boltanski and Chiapello, as having contributed to the development of new, more horizontal, and playful management techniques.[39] Vaneigem, of course, recognised the possibility that his ideas and those of the SI more generally would be 'recuperated' (see chapter 18). However, we are not speaking here of the recuperation of one or two techniques or ideas, but of a whole model of self that has become revealed as a far more adequate reflection of capitalism than the old anally retentive bourgeois. The reason for this is that the 'subject', or 'subject form', of modern philosophy is, as Jappe argues, a concept that is founded upon and expresses the essentially fetishistic and destructive abstract social forms at the heart of capitalism.[40] Capitalism is a society founded upon the tautological, pointless and quasi-autonomous system of turning £100 into £110. It is the movement

of value or, at a more concrete level, money that is self-determining, self-constituting, that realises its abstract will in a humanity and nature that it treats as dead matter. 'Value' reveals itself, that is to say, as the entity that has all of the characteristics of the subject falsely attributed to human being as such by modern philosophy. The empirical 'subjects', in contrast, that is to say, the human beings that are caught in this system, are in reality only the 'objects' of the true subject, 'value'. They are only accorded the status of 'subjectivity' to the extent that they embody the characteristics of the subject and obey its 'will'. Jappe argues that, at the psychological level of the empirical social actor, the 'subject form', as a subjective expression of capitalist abstraction and destruction, expresses itself therefore as the pathology of narcissism: a reduction of the individual to an infantile stage where the external world appears only as an extension of the self.[41]

It is possible, as a result of this critique of the subject, to see the notion of 'radical subjectivity' as having contributed, at least in some part, to what today appears as the generalised culture of narcissism. Vaneigem regresses the 'true' self all the way back to the most basic abstract instincts: the 'will'. He, likewise, treats nature – and the whole world exterior to the individual will – as a passive abstract 'object', as material, to be manipulated, instrumentalised, in order to realise that will. Other people in his model are only properly recognised as extensions of the individual self. One could argue that, just as Jappe criticises the Cartesian model of self, so Vaneigem's schema represents a narcissistic regression to an infantile state where the external world is seen as only an extension of the self. Indeed, Vaneigem explicitly advocates narcissism in *The Revolution of Everyday Life*,[42] and, still as recently as 2008, expresses his support for the abolition of the incest taboo.[43] Vaneigem is, in this respect, very much following the Left Freudians; in particular, Wilhelm Reich, whose work he circulated within the SI. For Freud, mankind needed social taboos and models of behaviour in order to control our destructive impulses. In order to become an adult, a person has to learn to sublimate these impulses in less destructive, even creative ways, in order to control them and enter into mature relations with other objects in the world. Reich, in contrast, believes that it is the 'character armour' or defence mechanisms against these impulses built up within the bourgeois subject that leads them to express themselves destructively. Vaneigem is, in this sense, very much a follower of Reich.

Debord, in contrast, and as we have seen in other chapters, cannot be criticised quite as easily as Vaneigem for making these mistakes. Indeed,

as we saw in chapter 10, although Debord retains the tension between the proletariat as the subject of history and the spectacle as the true subject (akin to Marx's 'automatic subject'), his work ultimately presents a much more compelling case for the latter, a concept that is almost entirely absent in the work of Vaneigem. Moreover, although Debord desires much greater freedom, his notions of human being are generally much more concrete – rooted in the importance of real human community based on effective communication – and, although remaining committed to the realisation of a more passionate, creative, social life, he seems to have not entertained so many illusions about the radical potential of 'desire' in the abstract. On the other hand, Vaneigem's notion of radical subjectivity, to the extent that it brings attention to the affective oppression that capitalism creates – issues of boredom, stress and isolation – remains absolutely valid. Moreover, in many respects, the idea of a generalised 'construction of situations', that is, of an art realised in life – whether couched in the language of the 'radical subject' or not – potentially represents an important proposal for imagining the generalised social sublimation of our most destructive drives in favour of a more creative mode of social being.

Notes

1. Despite his evident importance for the field, serious critical discussion of Raoul Vaneigem remains marginal and his central role is largely reduced to a footnote in accounts of the SI.
2. My approach draws primarily upon the work of Anselm Jappe, in particular his most recent work on the critique of the subject form, *La Société autophage* (Paris: La Découverte, 2017).
3. See Jappe, *Autophage*, pp. 25–64. For a longer account of the history of the concept, albeit from a very different perspective, see Alain de Libera, *L'Invention du sujet moderne* (Paris: Vrin, 2015).
4. For a discussion of this anti- or non-dualism in medieval theology, see Jérôme Baschet, *Corps et âmes: une histoire de la personne au moyen âge* (Paris: Flammarion, 2016). Significantly, in most pre-modern Christianity, the soul was not thought to exist entirely separately from the body. Resurrection would therefore also mean the physical resurrection of the body, which is why, even today, the Catholic Church has specific rules around cremation and resisted the practice for a long time.
 Raoul Vaneigem, throughout his writing, demonstrates a particular fascination with Medieval theology and conceptions of self in relation to the world. *The Revolution of Everyday Life*, for example, contains a plethora of reference to the 'unifying myths' of pre-modern Christianity. Since the dissolution of

the SI, Vaneigem has gone on to write extensive works on Christian heresy, most notably, Raoul Vaneigem, *The Movement of the Free Spirit*, trans. Randall Cherry and Ian Patterson (New York: Zone Books, 1998), and *La Résistance au christianisme: les hérésies des origines aux XVIIIe siècle* (Paris: Fayard, 1993). The fact that Vaneigem extends his interests thus far underlines the fact that, as we shall see, the problem of the alienation of the subject, and resistance to it, is, for him, a transhistorical one.

5. Jappe, *Autophage*, pp. 56–7.

6. It should be stressed here that what is being provided is a gloss on the 'exoteric Marx' (who, nevertheless, became foundational to the traditional workers' movement from the end of the nineteenth century). One of the main contentions of the critique of value is that there are two competing tendencies within Marx, the first 'exoteric' that reaffirms many aspects of bourgeois ideology, and the second 'esoteric' that provides a categorical critique of capitalist social forms as such. See Alastair Hemmens, *The Critique of Work in Modern French Thought, from Charles Fourier to Guy Debord* (London: Palgrave Macmillan, 2019), pp. 6–33. Marx, moreover, moved away from much of his youthful Promethianism in later life and both he and Engels, through an interest in accounts of so-called 'primitive communism', began to rethink the view of the pre-modern past as entirely devoted to necessity.

7. Guy Debord, *The Society of the Spectacle*, trans. Ken Knabb (Berkeley: Bureau of Public Secrets, 2014), theses 196, 201 and 202, pp. 105, 107–8. On the Situationists and structuralism, see also Anselm Jappe, *Guy Debord*, trans. Donald Nicholson-Smith (Oakland, CA: PM Press, 2018), p. 129.

8. Raoul Vaneigem, *The Revolution of Everyday Life*, trans. Donald Nicholson-Smith (London: Rebel Press, 2006), p. 48.

9. See Alastair Hemmens, 'Le Vampire du Borinage: Raoul Vaneigem, Hiver '60, and the Hennuyer Working Class', *Francosphères* 2(2) (2013).

10. 'We believe that the role of theoreticians […] is to provide the facts and conceptual tools that will clarify […] the crisis, and the latent desires, as people live them: let us say, the new proletariat of this "new poverty".' 'Domination de la nature, idéologies et classes', *Internationale situationniste (IS)*, no. 8 (January 1963): 13.

11. Vaneigem, *Revolution*, p. 18. Translation changed.

12. Debord told Vaneigem that the combined appearance of *The Revolution of Everyday Life* and *The Society of the Spectacle* together functioned as the two sides of a Gothic arch. Debord, letter to Vaneigem, 8 March 1965, in *Oeuvres* (Paris: Gallimard, 2006), p. 681.

13. Vaneigem, *Revolution*, p. 18. Translation changed.

14. Ibid., pp. 100–1.

15. In Hegelian Marxism, of course, the subject is also 'objectively' determined by its historical conditions that, in an alienated society, are not of its own making.

16. Vaneigem, *Revolution*, p. 96.

17. Ibid.

18. Ibid., p. 200.

19. 'People usually associate creativity with works of art, but what are works of art alongside the creative energy displayed by everyone a thousand times a day? Alongside seething unsatisfied desires, daydreams in search of a foothold in reality, feelings at once confused and luminously clear [...]?' Vaneigem, *Revolution*, p. 191.

20. Debord, *Spectacle*, thesis 74, p. 32. Translation changed. This phrase, a *détournement*, is an explicit reference to Descartes who argues, in his *Discourse on Method* (1637), that, through the exercise of reason, mankind can become 'like the masters and possessors of nature'.

21. Debord performs another *détournement*, this time of Schopenhauer, with the title of the same chapter: 'The Proletariat as Subject and Representation'.

22. This is the title of chapter 21 of Vaneigem, *Revolution*, p. 204.

23. 'History is the continuous transformation of natural alienation into social alienation', Vaneigem, *Revolution*, p. 75. 'The struggle against natural alienation gave rise to social alienation', Vaneigem, 'Basic Banalities' (1962) in Situationist International, *Situationist International Anthology*, ed. and trans. Ken Knabb (Berkeley, CA: Bureau of Public Secrets, revised and expanded edition 2006), p. 118.

24. Vaneigem, *Revolution*, pp. 95–6.

25. Ibid., p. 96.

26. Ibid., p. 191. Translation changed.

27. The expression first appears in 'All the King's Men', *IS*, no. 8 (January 1963): 30. See also chapter 18 of the present book.

28. 'preventing the emergence of masters without slaves, Nietzsche sanctifies the permanence of the hierarchised world in which the will to live condemns itself never to be more than the will to power'. Vaneigem, *Revolution*, p. 240. Translation changed.

29. Ibid., p. 239.

30. Ibid., p. 18.

31. Ibid., p. 75. 'The blighting of human relationships by exchange and bargaining is clearly linked to the bourgeoisie', ibid., p. 76.

32. Ibid., p. 80.

33. Ibid., p. 81. Debord makes a similar point in *Spectacle*, thesis, 17, p. 5. See also Jappe, *Debord*, pp. 6–7.

34. Vaneigem, *Revolution*, p. 244.

35. Ibid., p. 77.

36. Ibid., p. 246.

37. Ibid.

38. Ibid., p. 279.

39. See Luc Boltanski and Eve Chiapello, *The New Spirit of Capitalism* (1999), trans. Gregory Elliott (London: Verso, 2007), pp. 101. See also, Hemmens, *Critique of Work*, pp. 173–4.

40. Jappe, 'Narcissisme et capitalisme', *Autophage*, pp. 65–138.

41. Ibid.

42. 'narcissism turned towards the outside world [...] can only lead to a whole-sale demolition of social structures', Vaneigem, *Revolution*, p. 255.

43. Vaneigem, in *Revolution*, seems to advocate incest between siblings just after advocating narcissism, ibid. In *Voyage à Oarystis* (2005), p. 75, the citizens of his utopian society have abolished the incest taboo between parent and adult child. This is shocking not only from an ethical point of view, but because, within Freudian psychoanalysis, it is imperative that a child accept that it cannot have sex with its mother in order to overcome its initial narcissism. This particular sequence, narcissism-incest, is therefore a telling one in *Revolution*.

17

The 'Realisation of Philosophy'

Tom Bunyard

In 1961, three Situationists – Guy Debord, Attila Kotányi and Raoul Vaneigem – stopped in Hamburg, while returning to Paris from Gothenburg. They were making their way back from the Situationist International's (SI's) fifth annual conference in Gothenburg, which had been marked by heated arguments concerning the SI's views on art. Over the course of 'two or three days', to quote Debord's later recollections, and in 'a series of randomly chosen Hamburg bars',[1] the three discussed issues that had been foregrounded by those arguments. The results of these discussions would later come to be known as the 'Hamburg Theses'.[2]

The 'Hamburg Theses' are, perhaps, one of the SI's most enigmatic works. They were never written down, so we cannot be sure of their precise content, but they are referred to several times in later Situationist publications. They were also clearly influential (Debord states that 'they marked the most important turning point in the history of the S.I.').[3] In 1962, and in the wake of the arguments in Gothenburg, the SI broke with all members who remained wedded to a traditional conception of art. In doing so, the group entered a new period of activity: one in which it moved beyond its initial engagements with avant-garde art and culture, became increasingly centred around Debord, and his concept of 'spectacle', and in which it began to devote far more of its energies to theorising and fomenting revolutionary social change. It would seem that the 'Hamburg Theses' distilled and clarified a great many of the issues that led to these developments. Yet all we know about the content of these 'Theses' is that their 'rich and complex conclusions', to quote Debord once again, 'could be reduced to a single phrase: "*The S.I. must now realise philosophy*".'[4]

Debord thus appears to have understood that phrase as an apt motif for a whole nexus of ideas, and for a distinct perspective on how to respond to them (that is, the set of issues concerning art, the diagnosis of 'spectacular' society, and the SI's revolutionary role, that would drive the group's

trajectory throughout the 1960s). If we can make sense of that phrase, we should, therefore, be able to gain some insight into that conflux of issues, and into the ways in which they informed the SI's development.

The statement is a reference to the young Marx's own comments on the need to 'realise' philosophy in praxis.[5] In brief, his remarks refer to the need to supersede modes of critical thought that merely *describe* social problems, and to the need to use such critical insights as means of actually addressing and resolving those problems. We will look at this idea in some detail later. But if we are to make sense of its relevance to the SI, we shall also need to address the way in which Debord understood it through the lens of his theory of 'spectacle'. This will require some brief engagements with the Hegelian dimensions of Debord's theory (for preliminary comments on the SI's relation to Hegelian philosophy, and for an introduction to the latter's basic claims and terminology, see chapter 4). This, I hope, will serve to explain how the Hegelian and Marxian ideas with which Debord was engaged at this time pointed towards a fundamental concern with praxis. Furthermore, it should also help to show how that concern informed the SI's development during the 1960s.

I should begin, however, with a brief discussion of the questions about art that formed the background to the 'Hamburg Theses'.

'There is no such thing as Situationism'

The tensions expressed at the SI's Gothenburg conference had been brewing for some time. Divisions had already emerged at the group's previous conference in London, where the SI had discussed its status as a political movement. In order to sharpen that discussion, Debord had requested each member to respond to a questionnaire. This asked if there were 'forces' in society that the SI could 'count on',[6] and if so, what those forces might be. The responses given revealed that members of the SI's German section (a group of artists named Gruppe Spur, who had recently joined the SI) were sceptical towards the view that the SI could, or even should, count on the existence of a revolutionary proletariat. Instead, they argued, the SI should place its faith in art, and in the ability of artists to 'take over the weapons of [cultural] conditioning'.[7] This proposal received sharp criticism at the London conference, and was eventually retracted, but it bolstered a growing suspicion that some members of the group were quite happy to operate within the extant art-world. The term 'Situationist', it seemed, was in danger of naming just another avant-garde movement.

In Gothenburg the following year, Vaneigem deliberately forced a confrontation on this issue. 'There is no such thing as *Situationism*,' he announced, 'or a Situationist work of art.'[8] Kotányi followed suit by proposing that artworks produced by Situationists ought to be termed 'antisituationist'.[9] That position was eventually accepted,[10] but it added further impetus to a growing division between the group's primarily German and Scandinavian artists, and the chiefly French theorists who were centred around Debord.

The stance adopted by Debord's side of the argument remained close, in its essence, to the ideas that he had set out in his 'Report on the Construction of Situations' of 1957 (the SI's founding text, and the source of the group's name). According to the 'Report', the next stage of cultural development – and thus the goal to be pursued by any contemporary avant-garde worthy of the name – lay in the unification of art and life. This unification had been glimpsed by past movements such as Dada and Surrealism, but only in a manner that remained entrenched *within* art.[11] Or, to phrase that in keeping with Marx's remarks about philosophy's 'realisation': those earlier avant-garde gestures had remained content to merely *describe* the need for art's unification with life, and thus fell short of 'realising' that unity (they thus remained merely 'philosophical', and fell short of philosophy's realisation in praxis). For Debord, the actualisation of any such unity between art and life required a step beyond the bounds of art. This was to be achieved through the construction of 'situations': moments of life that would be deliberately shaped and lived as artistic constructions (see chapter 11). Crucially, making situations thus meant producing moments of lived time, *not* static art objects. Moreover, these situations would afford indications towards a radically new, enriched, social existence: one in which art would cease to exist as something separate from everyday life (that is, as something that exists solely within the walls of a gallery), and in which it would instead become fused with the very conduct of social life as a whole. The task envisaged in the 'Report' is thus that of researching and fostering an entirely new social existence. So, in sum: the aim of the Situationist project, as conceived in the 'Report', was to afford a transition *beyond* art as it had previously been understood. The notion that 'Situationism' could ever denote just another name *within* the artistic pantheon was thus untenable from the very outset. The stance taken in Gothenburg was entirely consistent with this view (one can also see the roots here of Debord's later, more Hegelian view that the SI should

strive to be the *final* avant-garde, insofar as the group's aim was to conclude the history of avant-garde art by ending art itself).

The ideas set out in the 'Report' thus already invited the expulsions of 1962. If the goal of the contemporary avant-garde was, in essence the creation of revolution rather than that of art objects, the continued production of such objects would, necessarily, fall short of true avant-garde status. An initial observation concerning the enigmatic conclusion of the 'Hamburg Theses' is thus already possible: one dimension of the phrase concerns the simple fact that the SI needed to commit itself to the 'realisation' of its project, and this entailed the concrete actualisation of not only art, but also revolutionary change. This commitment hastened the impending break between Debord's faction and the S.I's artistic 'right [wing]', with its 'feeble insistence on continuing or simply repeating modern art'.[12] But if we are to take these observations further, we need to look at Marx's own remarks in some detail; and in order to approach them here, a further point needs to be made, concerning the importance of temporality.

Time and spectacle

As noted above, constructed situations were to be moments of lived time, and thus ephemeral. Indeed, Debord stated in the 'Report' that the 'Situationist attitude' involved 'going with the flow of time [*miser sur la fuite du temps*]'.[13] If the aim was to generalise Situationist activity and experience throughout society, then this would entail creating a social context characterised by that 'attitude'. The society to come, as envisaged by early texts such as the 'Report', would thus differ markedly from Debord's conception of the present, which he viewed as stifled by fixed patterns of behaviour. By the early 1960s, this tension between free, creative temporal experience on the one hand (associated with Situationist activity and experience), and a stifling social context on the other (associated with modern society), had begun to develop into Debord's mature conception of spectacular society.

The account of spectacle that Debord presented during the 1960s holds that all social activity has become channelled into templates and patterns of interaction that suit the needs of an autonomous economy (see chapter 10). To use the Hegelian and Marxian terminology that was now inflecting his views: human subjects had become separated from their ability to direct their own objective existence, insofar as their subjective actions and interactions had come to be ruled by the forms of value that their

own objective activity had produced. As a result, history itself (that is, the unfolding, future-oriented history of society as a whole) had become a seemingly separate object of contemplation. The society of the spectacle, in other words, is a society that has become separated from its capacity to shape its own future (hence Debord's description of the spectacle as a 'paralysed history', and as an 'abandonment of history based on historical time').[14] The antithesis of spectacle, therefore, is free, self-conscious, collective self-determinacy, through which this lack of 'historical life'[15] could be remedied.

These ideas were already present, albeit in nascent and less overtly Hegelian and Marxian form, in Debord and the SI's early views on art. And once that implicit content had been made overt, as a result of Debord's increased engagement with Marx and Hegel in the early 1960s, the basic problematic of modern society and culture could be understood in terms of the separation of subject from object. That separation was identified with stagnation and historical arrest; conversely, the resolution of that separation, via a condition of subject-object unity, was associated with self-determinate movement and change in time.[16]

So, to summarise: in early texts such as the 'Report', and in later theoretical writings about spectacle, Debord and the SI identify a state of separation from temporal flow, and argue for a new condition, characterised by total immersion in that temporal flux. In their earlier texts, fixed patterns of social behaviour were to fall away, and art – previously a means of *representing* life – would become a means of *making* life. Likewise, in Debord and the SI's later theory, fixed social structures would give way to self-determinacy, and representation would be replaced by instantiation: an entire social order composed of representations of all that life lacks was to be replaced by the actualisation of those visions and possibilities. In both cases, therefore, modes of representation that stand apart from the flow of time and historical activity (that is, art in the SI's early work, and spectacular society *per se* in their later texts) were to be superseded by direct, self-determinate immersion in the conscious creation of temporal experience. And with this in mind, we can now turn to Marx, and thereby return to the conclusion ascribed to the 'Hamburg Theses'.

The 'realisation of philosophy'

Marx's remarks concerning the need for philosophy's 'realisation' can be found in his early 'Contribution to a Critique of Hegel's *Philosophy of Right*'.

In the introduction to that text, he famously described 'religion' as the 'opium of the masses'. This is often assumed to mean that religion is a mere illusion, but his real point is in fact levelled against the assumption that religion can be dispelled by critical philosophical analysis. Such a view ignores the fact that the 'drug' of religion eases social pains and hardships. One must, therefore, address the material conditions that produce the demand for that 'drug'; and that means that critical thought needs to become a practical force. It must be 'realised', in the Hegelian sense of that term, and thus rendered concrete and *actual* (*wirklich*). Marx concludes by arguing that this could be achieved via a unification between critical philosophy and the revolutionary proletariat. Philosophy could clarify the social conditions faced by the proletariat, while the proletariat could turn philosophy's critique into practical action, and thereby abolish its own proletarian circumstances. For Marx, therefore, 'philosophy cannot realise itself without the supersession [*Aufhebung*] of the proletariat', just as 'the proletariat cannot supersede itself without the realisation [*Verwirklichung*] of philosophy'.[17]

The crucial point here is that a mode of thought *about* the world is to be changed into a mode of *practical* thought, engaged in actually *shaping* the world. Or, to put that in the terms used above: a condition of contemplative *separation* between subject and object is to be replaced with a condition of processual, transformative subject-object *unity*. Rather than observing and commenting on the world as a though it were a separate, immediately given object, subjective thought should unite with the latter through shaping it according to its own self-determinate wishes.

The connection between these ideas and the issues described above should be readily apparent, and a very simple observation about the conclusion of the 'Hamburg Theses' can already be made. Debord's turn to Hegel and Marx had, by this time, clarified his developing theory of spectacle, and had foregrounded a concern with the need to supersede *all* cultural forms that merely represent everyday life's dreams and passions while leaving the latter essentially unchanged. This informed the increased confidence with which the SI now spoke of the 'realisation' of art ('We are artists only insofar as we are no longer artists [*plus des artistes*]', they declared; 'we come to fulfil [*réaliser*] art',[18] so as to produce a 'society of *realised art*'),[19] but it also meant that their ambitions had broadened considerably. This can be clarified by looking at their conception of the proletariat.

The 'new' proletariat

As indicated above, Marx's remarks indicate that critical thought should (a) serve to clarify the forms of material privation that prompt recourse to images of divine pleasures; and (b) thereby assist the proletariat to effect a revolutionary change through which those dreams of heavenly happiness could take earthly form. The role of critical social theory, for Debord and the SI, was much the same; yet the nature of the privations with which they were concerned, the proletarians who suffered from those privations, and the palliative dreams that they sought to criticise, were all understood rather differently.

For Debord and the SI, the revolutionary agents of modern society could no longer be identified in strictly economic terms. Employing a rather eurocentric perspective on global capitalism, they essentially took the view that consumer society had alleviated much of the material poverty described by Marx. In addition, capitalism was held to have colonised all social relations to such an advanced degree that everyone, regardless of their position within the social structure, was now dominated by the dictates of capitalist value. Consequently, the SI came to view modern poverty as an effectively existential condition, and to regard as 'proletarians' all those who had lost control over the means of shaping their own life. This 'new' and effectively class-less proletariat essentially encompassed all who, 'regardless of variations in their degree of affluence',[20] now demanded *more* from life than modern society was prepared to provide.

Although unabashedly hedonistic and utopian, this demand was also historically contextual. For Debord and the SI, humanity's capacity to shape lived time was now far greater than it had been at any other moment in the past; and yet never before had that capacity been further removed from the conscious control of its producers. To quote *The Society of the Spectacle*: 'people [...] produce every detail of their world with ever-increasing power'; and yet the 'closer their life comes to being their own creation, the more they are excluded from that life'.[21] This meant that the real stakes of the modern revolution were not the means of material production, as in the classical Marxist account, but rather the means of shaping lived time. The demand, then, was to overcome the separation of human agents from their own collective power.

The latter point may become clearer if we note that spectacle is, in essence, separated social power. In brief, instances of spectacle arise when social agents become subordinate to concentrated loci of their own power,

and when those formations come to serve as models and templates for their behaviour and interactions (this is why Debord and SI did not just describe the media, or even the commodity alone, as spectacular; religion, hierarchy, revolutionary leadership and so on, were all viewed as instances of spectacle; see chapter 4 for further comments as to how this relates to Debord's reading of Hegel). *All* such formations involve the separation of subject from object (that is, they involve human subjects treating their own objective constructions as separate entities), and all thus fall short of the self-determination associated with the unity of subject and object.

By this stage in the SI's development, art was thus no longer the primary concern, as it had instead become just one element of a broader problematic of separated power. Art, in other words, was just one set of representations of life that needed to be employed as a means of making life (as Debord put it in *The Society of the Spectacle*: 'The point is to take effective possession of the community of dialogue and the game with time that up till now have merely been *represented* by poetic and artistic works').[22] But, as I hope is already apparent, by the early 1960s, it was not *just* art that needed to be 'realised' in lived praxis: in addition, *all* of society's technological, cultural and economic capacities needed to be wrested away from capital, and employed by their producers. All such forms of *representing* life's dreams and possibilities (through entertainment, commoditised desire, recuperated rebellion and so on) needed to be employed as means of *actualising* that potential.

Debord's use of the 'realisation of philosophy' as a distillation of the SI's ambitions at this time was thus apt: for it denotes a broad commitment to efforts towards moving away from the contemplative separation of subject from object, and towards the realisation of a condition in which the human subject takes itself and its world as the object that it works upon. By the early 1960s, he had arrived at the view that the basic premise at work in that classical, nineteenth-century demand – that of superseding the separation of a social power from the conscious, practical conduct of social activity – had become the defining problematic of the modern revolution in its entirety. The conclusion attributed to the 'Hamburg Theses' of 1961 is, therefore, indicative of this new, fiercely militant perspective, which would shape the SI's work throughout the 1960s.

Conclusion

The observations set out above should serve to explain statements such as the following, which was made by the SI in 1964:

> The Situationists consider that they must supersede [*hériter*] art –
> which is dead – and separate philosophical reflection ... because the
> spectacle that is replacing this art and this thought is itself the heir of
> religion. And just as was the case with the 'critique of religion' [in the
> nineteenth century] [...] the critique of the spectacle is today the pre-
> condition for any critique.[23]

Philosophy, art, and indeed *all* other forms of separated social power, now
needed to be appropriated and used in the conscious, creative control of
lived time. With that in mind, we should now be in a position to make
some final remarks about the 'Hamburg Theses'.

The contention that 'The S.I. must now realise philosophy' serves as a
motif for a whole set of issues. It encompasses the need to move beyond
art's representation of everyday life, and thus pointed the way to the
splits of 1962; it also reflects the growing importance of the concept of
spectacle at that time, and the vast revolutionary ambitions that that
concept entailed. But perhaps most importantly, it also bears relation to
the ferocious militancy of the SI's ideas: for it necessarily follows from
everything that has been said so far that the SI's *own* work needed to be
'realised' in praxis too. If it remained removed from practical action, as
a mode of contemplative observation on modern social ills, it would fall
short of the unity that it advocated. As Debord himself put it in *The Society
of the Spectacle*, while directly echoing Marx's own words concerning the
realisation of philosophy:

> The critical concept of the spectacle can also undoubtedly be turned
> into one more hollow formula of sociological political rhetoric used
> to explain and denounce everything in *the abstract*, thus serving to
> reinforce the spectacular system. It is obvious that these ideas alone
> cannot lead beyond the existing spectacle; at most, they can only lead
> beyond existing ideas about the spectacle. To actually destroy the society
> of the spectacle, people must set a practical force into motion. A critical
> theory of the spectacle cannot be true unless it unites with the practical
> current of negation in society; and that negation, the resumption of
> revolutionary class struggle, can for its part only become conscious of
> itself by developing the critique of the spectacle.[24]

Worries about the 'recuperation' and academic appropriation of this
material are not, therefore, just empty pieties: for in a very real sense,

the ideas that underlie it are inherently opposed to its reduction to a separated, contemplative, and thus solely 'philosophical' critique of the contemplation of separated power.

Notes

1. Guy Debord, 'Les Thèses de Hambourg en septembre 1961' (1989) in Situationist International, *Internationale Situationniste, édition augmentée* (Paris: Arthème Fayard, 1997), p. 703.
2. Anthony Hayes, 'Three Situationists Walk into a Bar; or, The Peculiar Case of the Hamburg Theses', *Axon*, 8 (2015).
3. Debord, 'Hambourg', p. 703.
4. Ibid.
5. 'Praxis' is an ancient Greek term that refers to the application of ideas in practical, transformative action; it is a major theme in the Hegelian Marxian tradition. See chapter 16.
6. SI, 'The Fourth Conference of the SI' (1960), in Situationist International, *Situationist International Anthology*, ed. and trans. Ken Knabb (Berkeley, CA: Bureau of Public Secrets, revised and expanded edition 2006), p. 82. Translation modified.
7. Ibid., p. 82.
8. SI, 'The Fifth SI Conference in Göteborg', in *Situationist International Anthology*, p. 115.
9. Ibid.
10. It was accepted by all but one member of the SI: Jørgen Nash, who would go on to become instrumental in the events that led to the exclusion of the Scandinavian artists in 1962.
11. Duchamp's 'Fountain' of 1917 affords a relevant example: it attacks art, perhaps even to the point of destroying it, and points to a world in which everyone could be an 'artist'; yet its ability to do so is utterly reliant on that which it attacks.
12. Debord, 'Hambourg', p. 703.
13. Guy Debord, 'Report on the Construction of Situations', in *Situationist International Anthology*, p. 42.
14. Guy Debord, *The Society of the Spectacle*, trans. Ken Knabb (Berkeley: Bureau of Public Secrets, 2014)., thesis 158, p. 85.
15. Ibid., thesis 143, p. 79.
16. We might think here of the *The Society of the Spectacle*'s later description of a 'subject of history' that would have 'no goal [*n'as pas d'objet*] other than the effects it works upon itself', and which would exist as 'consciousness of its own activity [*conscience de son jeu*]' (Debord, *Spectacle*, thesis 74, p. 32. Translation changed.
17. Karl Marx, *Early Writings*, trans. Tom Nairn (Middlesex: Penguin, 1975), p. 257.
18. SI, 'Questionnaire' (1964), in *Situationist International Anthology*, p. 179.

19. SI, 'The Bad Days Will End' (1962), in *Situationist International Anthology*, p. 114.
20. SI, 'Ideologies, Classes and the Domination of Nature' (1963), in *Situationist International Anthology*, p. 141.
21. Debord, *Spectacle*, thesis 33, p. 11.
22. Ibid., thesis 187, p. 100.
23. SI, 'Now, the SI' (1964), in *Situationist International Anthology*, p. 175.
24. Debord, *Spectacle*, thesis 203, p. 108.

18

Recuperation

Patrick Marcolini

Although the words *récupérer* and *récupération* have been a feature of the French language for centuries, the Situationists gave them a specific meaning, which, as linguists note, first emerged in common usage in the 1960s: 'to reconcile, to assimilate (a political adversary, an ideology, public opinion), most often in a deceptive or abusive manner', 'to neutralise an individual or group that possesses oppositional, differing or, sometimes, contestatory goals by bringing them around to your own objectives'.[1] It was a way of speaking that became very widespread after the 'events' of May '68. In a book written some years later, Jean Daniel, a left-wing French intellectual of the period, attests to the new meaning of the word, speaking of his 'fear of seeing what we called the "May movement" recuperated. We felt "recuperated" the moment that adults and politicians employed a single word of the Sorbonne [occupation].'[2]

Nevertheless, and despite what one might at first think, it was not the Situationists themselves who came up with this specific definition of the word 'recuperation'. Rather, as an extract cited in the sixth issue of *Internationale situationniste* demonstrates, the term had already taken on this new meaning at around the time that the Situationists thought to systematise it as a concept. The citation in question is of the Belgian literary critic Robert Kanters, who evokes the ambiguities and duplicitousness of the 'Angry Young Men', that is, the new generation of up-in-arms young British writers of the late 1950s and early 1960s. Kanters writes that, in spite of their professions of faith in non-conformity, 'they are completely recuperated by the literary society of their country'.[3] It is exactly the kind of thing that the Situationists absolutely wanted to avoid. As the Situationists themselves state, 'all official success (in the widest sense of the word: all success within the dominant mechanisms of culture) with which [our] ideas or those of one of [our] members might meet should be considered extremely suspect'.[4]

It is not by any means an exaggeration to say that the Situationist movement is, in large part, the result of a reconsideration of the various forms of subversion that appeared in the Western world in the first half of the twentieth century. Asger Jorn, from the very beginning, struggled against the way in which, in the context of the German post-war boom, the emancipatory ideals of the Bauhaus had been uprooted and put into the service of commercial production.[5] The Situationists, similarly, denounced the fact that Surrealism had been integrated into dominant culture. The business world had even adopted many Surrealist methods, such as automatic writing and its collective games, with American managers converting them into 'brainstorming' techniques.[6] In a collective text, 'The Bitter Victory of Surrealism', the Situationists conclude, 'Everything that constituted a margin of freedom for Surrealism has found itself recovered and used by the repressive world that the Surrealists had fought against.'[7]

Similarly, albeit in the realm of 'politics', Situationist writing very early on notes the growing participation of the institutions of the workers' movement in the regulation of capitalism. The theory of the spectacle (see chapter 10), would later come to explain this institutional integration through the system of alienated representation in the form of workers' parties and unions. However, even before the theory was fully developed, the Situationists denounce the recuperation that had taken place at an ideological level. Specifically, the fact that the demands of these organisations were expressed above all in the quantitative language of the economy:

We should not be demanding assurances that the 'minimum wage' [*minimum vital*] will be raised, rather we need to reject keeping the masses at a minimum of life [*minimum de vie*] [...] We should not be posing the question of increasing wages, but of the conditions imposed on the people in the West. We need to refuse struggling within the system to get minor concessions that are immediately put under threat or compensated for elsewhere in capitalism. The problem of the survival and destruction of this system is what needs to be posed radically. [...] The social struggle should not be bureaucratic, but passionate.[8]

The Situationists, informed by these various examples, wished to prevent the possibility of seeing their own ideas and analyses recuperated. This explains, for example, the gradual exclusion of artists from the SI between 1957 and 1962. These artists, despite themselves, remained attached to the art market, to the closed world of museums and galleries,

and, as a result, to the mechanisms of the cultural spectacle that the SI sought to destroy. The process of exclusions also imposed, as a preventative measure, a very clear line of separation between the SI and those who might distort Situationist ideas; specifically, the neo-avant-gardes that were emerging in the art world at that time around similar themes (the city, architecture, everyday experience and so on), but also the contemporary left-wing intelligentsia which was seeking to renew itself in a manner that Debord and his comrades felt to be either deceitful or insufficient, depending on the case (the journal *Arguments*, for example, which was led by philosophers and sociologists such as Roland Barthes and Edgar Morin, was the object of continued mockery and attacks from the Situationists). In fact, the Situationists had identified art and culture as the privileged terrain upon which the new capitalism would seek to neutralise and reabsorb everything that stood against it by using it to feed its own autonomous development.

As Debord would later underline at the end of the movement, the question of language was always at the centre of Situationist thinking about recuperation.[9] The Situationists pointed to the fact that 'the most corrosive concepts', when they are taken up by the powerful, managers and thinkers integrated into the system, 'are emptied of their contents, [and] put back into circulation, in the service of maintaining alienation'.[10] As they summarise in a beautiful metaphor, 'Words forged by revolutionary critique are like the weapons of partisans abandoned on the battlefield: they come to serve the counterrevolution; and, like prisoners of war, they are subjected to the regime of forced labour.'[11]

The Situationists, however, frequently use the concept of recuperation to describe the way in which power itself functions and in all historical eras, from Antiquity to the present day. The Situationists summarised the theory in an oft-repeated phrase: 'Power does not create, it recuperates.'[12] Moreover, as Raoul Vaneigem insists, it recuperates everything, or, at the very least, everything that emerges from the creativity of the will to live, 'this free-floating energy, which should serve the blossoming of individual life',[13] which expresses itself equally in art, love and play. Vaneigem, for example demonstrates how the Christian doctrine of the 'redemption of the soul is nothing other than the will to live mediated, emptied of its real content, recuperated by myth.'[14] He notes, likewise, how capitalism, to the same extent that it represses our innate playfulness in order to bend human beings to the discipline of labour, strives to 'recuperate [playfulness] back into the sphere of profit': 'As a result, we have seen, over the

past decade or so, the joys of escape convert into tourism, adventure turn into scientific missions, the game of war become operational strategy, the taste for change satisfy itself with a change in taste'.[15]

Recuperation functions through a kind of scotomisation in both senses of the word: a distorted vision and a more or less deliberate omission. It corrupts the desires and values that it takes hold of by suppressing the revolutionary perspective in which they would find their logical realisation and authentic meaning. Vaneigem suggests exactly this when he writes, 'if it gives up on extending a praxis of radically overturning the conditions of life [...] a positive project has no chance of escape from being taken over by the negativity that currently reigns over social relations; it is recuperated, inverted, like the reflection in a mirror'.[16] Recuperation is, in a certain sense, the evil twin of *détournement*: like *détournement*, it is a 'fragment ripped from its context' that one can 'doctor in any way that one likes' in order to 'change its meaning'.[17] However, rather than liberate the subversive truth contained in a content that dogma and tradition have frozen, recuperation falsifies the explosive material that it takes hold of in order to transform it into ideology. In fact, as the metaphor Vaneigem employs above makes clear, the fundamental schema through which the Situationists understand recuperation rests upon Marx's concept of ideology, that camera obscura which projects the world upside down. Recuperation is therefore a matter of inversion. Rather than a *détournement*, it is a *retournement*, an about turn. As such, recuperation links up with the concept of spectacle, which poses, according to the famous Debordian formula, that 'in a world that has *really been turned upside down*, the true is a moment of the false'.[18]

The problem of recuperation underwent a new development after May '68. The 'events' afforded the Situationists much greater visibility and led to an unprecedented diffusion of their ideas. Many students and young intellectuals laid claim to Debord and Vaneigem. At the same time, many figures on the French intellectual scene incorporated this or that Situationist concept or theme into their thinking. In *The Real Split in the International*, the text that marked the dissolution of the SI in 1972, Debord and Sanguinetti launched a counter-attack in the form of an all-out critique of the 'pro-Situationists'. These supposed supporters of the SI, they argue, belonged, by virtue of their social condition, to the new petite bourgeoisie whose intrinsic function is to keep the spectacular machine turning. In *Précis de recuperation* published four years later, Jaime Semprun, who was by that time in contact with Debord, traced the way

in which French intellectuals, who were more or less explicitly influenced by them, had twisted Situationist ideas and those of the critique levied at society by May '68 more generally.[19] His targets include many of the key figures of the emerging postmodern movement, such as Michel Foucault and Jean-François Lyotard, as well as the economist Jacques Attali, who was, at that time, an advisor to the future socialist president of the French Republic, François Mitterrand, and is today a regular in state leadership circles at a national and international level.

Already in 1966, however, *Internationale situationniste* had noted an unexpected and highly precipitate example of the recuperation of Situationist ideas that was to come. It did not come, in this case, from those apparently opposed to the system, but from the very heart of capitalism itself. The journal cites, with cold irony, a brochure by Club Med, a French company that had just been floated on the stock market that same year. Club Med's business model essentially consists in offering all-inclusive paid holidays to holiday villages spread throughout the world; exactly the kind of new capitalist leisure that Debord and his comrades had been condemning since the early of the 1950s. The company, as these extracts from the brochure demonstrate, promotes its getaway packages in a language that utterly exudes 'Situationism'. Club Med describes, for example, a client who has purchased a stay in one of its many resorts:

> if he lets the unforgettable taste for play and festival return to him, which consists in gradually improvising rules that are used once and just as quickly dropped, he may re-establish the communication he has lost with others. [...] Reinstating this game means gambling that each individual, when approached by strangers with open faces, can cease being the docile or wary spectator of his own life and, on the contrary, become its creator.[20]

Unfortunately, it was only a prelude. With the benefit of hindsight, today it is obvious that a great deal of the Situationists' ideas have been incorporated into the system that they sought to destroy. The Club Med example demonstrates that the SI's call for a 'civilisation of leisure and play' anticipated,[21] by barely any time at all, the arrival of mass consumer travel and tourism. Moreover, these calls also anticipated the way in which play itself has been incorporated into many areas of social life. Playful mechanisms are, for example, today used in marketing, management and education. Likewise, the Situationist call for organising into groups and networks, as

an alternative to the vertical and hierarchical structures of mass politics and Fordist labour, finds itself the originator of contemporary forms of organising labour into teams. Contemporary capitalist ideology claims, in this way, to level and dissolve power relations through networks of all kinds (though in reality it does nothing more than redistribute them in a more insidious, and therefore effective, manner).

Similarly, postmodern capitalism has recognised the creativity of ordinary men and women, another central theme of Situationist propaganda, as a profitable resource. Today it is integrated into the system as an *obligation*, a *demand*, made upon the contemporary worker, who is supposed to be imaginative, original, polyvalent and capable of coming up with outside-the-box solutions to the problems posed by the permanent transformations of the market and social relations. The Situationists also put forward a certain notion of freedom as mobility: they cultivated the taste for wandering and drifting, engaged in the search for those places most favourable to the expansion of a passionate life, against all attachment to property, to country and to outdated modes of behaviour. Today, however, nomadism and mobility have become the transcendental conditions of capitalist development. Workers are expected to abandon all attachment to place and their original communities. They are expected to adapt to the fluctuations of the market by moving and changing jobs. The same is also true for social elites who, having thrown their fate in with the internationalisation of exchange, are prepared to jump on the first plane that comes along in order to sort out some business or save time.

The Situationists claimed to be bringing the 'economy of desire', supposedly a driving force behind social transformation, into opposition against classical capitalism's economy of need.[22] However, the idea that desire is intrinsically subversive became the leitmotif of advertisers and other market propagandists with the emergence of what some have called seductive capitalism. In other words, a specific market whose diurnal face includes the leisure industry, fashion, entertainment and mass culture, and whose nocturnal face covers pornography, drugs and prostitution. Ultimately, communication, participation, the taste for adventure and self-realisation, all of which the Situationists claimed to be subversive values, have become today integral parts of the dominant ideology. Meanwhile, the practice of *détournement* has become the very motor of the advertising and culture industries.

The Situationists were, of course, completely conscious of the possibility that they might see their ideas recuperated by the socio-economic

system that they were fighting. They knew the 'risk of not differentiating [ourselves] clearly enough from *modern* trends in explaining and imagining the new society to which capitalism has led us, those trends, which, under different guises, are those of integration into this society'.[23] They provide the following explanation: 'Our project formed *at the same time* as modern trends towards integration. There is therefore direct opposition, and also a degree of resemblance, in so far as we are truly contemporary. We have not, particularly recently, sufficiently guarded ourselves against these things.'[24] However, despite realising the error of their ways, they write not long after: 'We should not, for all that, quit the extreme peak of the modern world simply to not resemble it in anyway, or even to avoid teaching it anything that could be used against us. It is perfectly normal for our enemies to succeed in using us partially.'[25] And, with a pirouette, they add: 'Just like the proletariat, we cannot claim to be unexploitable under current conditions.'[26]

This pronouncement, however, is still problematical. One cannot help but think that, if the recuperation of the SI was possible, it is because the Situationists, by their own admission, shared a certain number of assumptions with the powers that be; in particular, a belief in the irreversible character, and even the positive development of, the technological developments under way. In a 1958 text, for example, the Situationists evoke 'a race between free artists and the police to experiment with and develop the use of the new technologies of conditioning.'[27] However, if there is indeed a race to the finish line, those taking part have to agree on what direction they are running in … In 1964, they add:

> The road to perfect police control over all human activities and the road to the infinite free creation of all activities are the same: it is the same road of modern discoveries. We are inevitably on the same road as our enemies – most often ahead of them – but we have to be on it, without ambiguity, *as enemies*. The best will win.[28]

More explicitly still: 'The accumulation of production and ever-greater technical capacity still moves faster than nineteenth-century communism foresaw. We remain, however, stuck and overequipped at the prehistoric stage.'[29] Anticipating the 'grandiose *possible development* which might press upon the existing economic infrastructure', the Situationists, from here on out, wished to reconcile 'technical society with the imagination of what we can make of it'.[30] However, this description of technological

development as a predetermined, unidirectional, process – a straight line upon which one can move only more or less quickly, but from which one cannot, under any circumstances, deviate – falls within the bourgeois ideology of progress. It does not recognise the fact that technology is not a neutral tool and that it is intrinsically tied up with the structures of power from which it emerges.[31] This poor understanding of technological development is rooted in a Marxist legacy that the SI had not sufficiently criticised and the French ideology of the post-war boom, the so-called 'Thirty Glorious Years'.[32] These factors, at the very least, limited the Situationists from properly criticising this development and prevented them from imagining other technological choices that would be more appropriate to a society emancipated from the economy and the state.

The later evolution of Debord's thought, from the start of the 1970s until his death in 1994, most notably his critique of the destruction of the environment, of industrial forgery and digitisation, demonstrate that he came to recognise the problem of technological development in capitalism. In 1978, six years after the dissolution of the SI, Debord stated that 'Theories are made only to die in the war of time.'[33] In so doing, he implicitly invites us to forge new weapons to help us to understand and combat contemporary society. If we do indeed wish to undertake such a task, it may well be useful to reflect on what ultimately appears as one of the lessons of the history of the SI: in the revolutionary game of war, it is always good to think ahead and to ask oneself what, in our own ideas, might contribute to the creation of a world that is even worse than the one we are attacking.

Notes

1. 'Récupérer', in Alain Rey (ed.), *Dictionnaire historique de la langue française* (Paris: Dictionnaires Le Robert, 1998), pp. 3123–4, and in Bernard Quemada (ed.), *Trésor de la langue française. Dictionnaire de la langue du XIXe et du XXe siècle, 1789–1960* (Paris: CNRS/Gallimard, 1990), https://cnrtl.fr/definition/r%C3%A9cup%C3%A9rer.
2. Jean Daniel, *Le Temps qui reste* (Paris: Stock, 1973), cited in *Trésor de la langue française*.
3. Robert Kanters, *L'Express*, 13 July 1961, cited in *Internationale situationniste* (*IS*), no. 6 (August 1961): 29.
4. SI, 'Défense inconditionnelle', *IS*, no. 6 (August 1961): 15.
5. Asger Jorn, *Pour la forme* (1957) (Paris: Allia, 2001).
6. 'Amère victoire du surréalisme', *IS*, no. 1 (June 1958): 3–4.
7. Ibid., p. 3.
8. 'Le minimum de la vie', *Potlatch*, no. 4 (13 July 1954).

9. Guy Debord, note to the 1971 edition of Jorn's *Pour la forme* in Debord, *Œuvres* (Paris: Gallimard, 2006), pp. 1081–2.
10. 'Les mots captifs' (1966), *IS*, no. 10 (March 1966): 54.
11. Ibid.
12. The expression first appears in 'All the King's Men', *IS*, no. 8 (January 1963): 30 and is later repeated in 'Les Mots captifs'.
13. Raoul Vaneigem, *The Revolution of Everyday Life*, trans. Donald Nicholson-Smith (London: Rebel Press, 2006), p. 238.
14. Ibid., p. 81.
15. Ibid., p. 332.
16. Raoul Vaneigem, 'Banalités de base', *IS*, no. 7 (April 1962): 39.
17. These are the definitions of *détournement* that one finds in Guy Debord, *The Society of the Spectacle*, trans. Ken Knabb (Berkeley: Bureau of Public Secrets, 2014), thesis 208, and Debord and Gil Wolman, 'Mode d'emploi du détournement', *Les Lèvres nues*, no. 8 (May 1956): 2–3.
18. Debord, *Spectacle*, thesis 9, p. 4.
19. Jaime Semprun, *Précis de récupération illustré de nombreux exemples tirés de l'histoire récente* (Paris: Champ Libre, 1976).
20. 'L'emballage du "temps libre"', *IS*, no. 10 (March 1966): 61.
21. 'L'urbanisme unitaire à la fin des années 50', *IS*, no. 3 (December 1959): 14.
22. 'Les mauvais jours finiront', *IS*, no. 7 (April 1962): 16–17.
23. 'Maintenant, l'IS', *IS*, no. 9 (August 1964): 3.
24. Ibid.
25. Ibid, p. 4.
26. Ibid.
27. 'La lutte pour le contrôle des nouvelles techniques de conditionnement', *IS*, no. 1 (June 1958): 8.
28. 'Maintenant, l'IS', p. 4.
29. 'Domination de la nature, idéologies et classes', *IS*, no. 8 (January 1963): 3.
30. Ibid. p. 7, 'Les mauvais jours finiront', p. 17.
31. This point has been highlighted by several different critics, most notably: Gianfranco Marelli, *L'Amara vittoria del situazionismo* (Pisa: BFS Edizioni, 1996); Barthélémy Schwartz, 'Dérives d'avant-garde', *Oiseau-Tempête*, no. 6 (Winter 1999–2000; Paris: Ab Irato): 33–6 ; Jean-Marc Mandosio, *Dans le chaudron du négatif* (Paris: Editions de l'Encyclopédie des Nuisances, 2003); Patrick Marcolini, *Le Mouvement situationniste: une histoire intellectuelle* (Paris: L'Echappée, 2012).
32. See Céline Pessis, Sezin Topçu and Christophe Bonneuil (eds), *Une autre histoire des Trente Glorieuses: modernisation, contestations et pollutions dans la France d'après-guerre* (Paris: La Découverte, 2016).
33. *In girum imus nocte et consumimur igni* (1978), in *Œuvres*, p. 1354.

19
Internationalism

Bertrand Cochard

As the product of the fusion between the Lettrist International (LI), the International Movement for an Imaginist Bauhaus (IMIB) and the London Psychogeographical Society, the Situationist International (SI) proudly stated its internationalist ambitions from the very beginning. Certain observers, in its own time and even to this day, took every opportunity to assert the purely nominal, if not laughable, character of these ambitions. The French journalist Jacques Godbout described the SI in an article in *Liberté* in 1960 as 'this Situationist International that is international in name only'. This condescending statement earned him a mention in the fifth issue of *Internationale situationniste*.[1] Between its foundation in 1957 and its dissolution in 1972, however, the SI really did count among its membership militants from all over Europe who were organised into national sections (Germany, Belgium, Denmark, France, the Netherlands, Italy and the United Kingdom). There was, for a brief time, even a section in the United States as well as an Israeli member, Jacques Ovidia, and ties to the Congo through Ndjangani Lungela (see chapter 7). Likewise, thanks to the Situationists Abdelhafid Khatib and Mohamed Dahou, the group had links with Algeria, which, at that time, was in the middle of its war of independence. In the 'Situationist news' section of the sixth issue of *Internationale situationniste*, the group pointed out that, of the 'twenty highly industrialised countries' in which modern society had its 'base', the Situationist movement was active in eleven of them.[2]

The internationalism of a movement cannot, however, be reduced to its international presence or the composition of its members. An examination of the origins of the concept, most notably its appearance in *The Communist Manifesto*, will demonstrate that internationalism should be understood as a practical programme for coordinating workers' struggles, but also as a theoretical position founded upon an objective analysis of the international situation in the capitalist era and as a critique of the

nationalist ideologies that falsely set workers against one another despite their shared interests. The internationalist position, since its formation within socialist thought, was therefore composed of three main elements: theoretical, political and organisational. First, internationalism is founded upon the theory that capitalist development has led to the suppression, at least on an economic level, of the frontiers between nations and, in so doing, redefined the class struggle. Secondly, internationalism, as such, functions as a prism or a mode of interpretation through which social phenomena can be understood on an international scale. It implies, moreover, a polarising vision of social conflict that brings *proletarian* interests into opposition with those of the *bourgeoisie* (whose own convergent interests are supposedly reinforced by the identification of the working class as common enemy). Third, and finally, it includes practical discussions over what would constitute the most effective form of organisation for destroying the convergence of bourgeois interests and for ensuring the success of the revolution.

The first objective of this chapter is to identify the Situationists' position on the 'original' internationalism of the workers' movement, specifically, that of the International Workingmen's Association (IWA, 1864–76), while highlighting as much as possible the composite character of the latter. The second objective will be to identify the theoretical sources of the Situationists' internationalism, which, as we shall see, are made up of a patchwork of different traditions, including Marxism, Bakuninism, Babeufism and Councilism.

Theory

Although the history of internationalism can be traced back to the Enlightenment and the French Revolution's call for a 'brotherhood of nations', not to mention figures such as Robespierre and the 'orator of mankind', Anarcharsis Cloots,[3] it is probably Flora Tristan's work *The Workers' Union* (1843) that represents the first milestone in socialist internationalism. Even so, it was not until Marx and Engels' *The Communist Manifesto* in 1848 that the theoretical foundations of proletarian internationalism became well established. The foundations of historical materialism are embodied in the gap between the motto of the German League of the Just (1836–47), 'All men are brothers', and that which concludes the *Manifesto*, 'Proletarians of all countries, unite!' Internationalism, as Michael Löwy argues, is not a 'moral principle', nor a 'revolutionary

categorical imperative', nor, even more emphatically, is it some kind of pious wish that would make it 'similar to Christian brotherhood, and just as ineffective'.[4] Its *anti-ideological* character separates it from neighbouring ideologies (such as cosmopolitanism, universalism and fraternalism). Proletarian internationalism is not a doctrine, a mere *spectacle*, separated from material production. Internationalism, before it becomes a theoretical object, is the product of capitalist development, the *spatial dynamic* of which has rendered the division between nations obsolete;[5] in so doing, it has equally revealed the 'nation' to be a ruse designed solely to mask the fact that the bourgeoisie has, to employ the words of Marx and Engels, created the world 'after its own image'.[6] The generalisation of the proletarian condition under the effects of the international division of labour, the rise of productive forces, the spread of the salary form, and the opening up of international markets reveals the 'economic unification of the world by the capitalist system'.[7] Internationalism is therefore an objective process. Proletarian internationalism is the coming into being of a consciousness of this process and the European revolutions of 1848 were the catalyst.

The 'Report on the Construction of Situations', which served as a manifesto for the SI during its foundation, demonstrates a clear demand that the consequences of capitalist development be understood on a scale that, if not wholly international, is at least European. The difference, however, is that, where Marx and Engels stress *economic* unification, the Situationists see *cultural* unification as the primary concern of revolutionary action. The first lines of the third issue of *Internationale situationniste*, which is comprised of a *détournement* of a passage from *The Communist Manifesto*, express the same concern:

> Bourgeois civilisation, which has now spread over the entire planet, and the supersession of which has been achieved nowhere, is haunted by a spectre: the questioning of its culture, which appears within the modern dissolution of all its artistic means.[8]

The development of productive forces, which at the time meant the totality of technical means for 'dominating nature, permitting and demanding superior cultural constructions',[9] has resulted in a 'decomposed culture' (*culture décomposée*). The *division of artistic labour* in European nations – the supposedly avant-garde experiments that were simply repeating the already completed process of destroying modern art and the proliferation

of spectacles that attempted to mitigate the qualitative poverty of everyday life – was the new objective condition that demanded the problem of culture be reconceived 'in terms of worldwide unity'.[10] No national action, limited to a single artistic discipline or separated from the integrated construction of new modes of life, would be tolerated anymore.[11] Furthermore, the Situationists quickly carried out the 'purge of the Italian section' for having upheld 'reactionary and idealist theses', '*atomis[ed]* problems' and stood in the way of 'unitary Situationist activity'.[12]

However, this focus on cultural alienation did not last. The *rapprochement* with militant groups such as Pouvoir Ouvrier in the early 1960s (see chapter 5), the arrival of new members such as Raoul Vaneigem and Attila Kotányi, and the discovery of heterodox Marxism in the form of Lukács and Pannekoek led the Situationists towards a *total* critique of capitalism, the principal marker of which was the adoption of the notion of the 'socio-economic formation'.[13] If, as Lukács states in *History and Class Consciousness*, 'The primacy of the category of totality is the bearer of the principle of revolution in science',[14] then it was incumbent upon the Situationists to reveal the 'dialectical relationship between culture and politics' and to work towards closer international coordination between artistic avant-garde movements and radical anti-Stalinist movements.[15] The emphasis placed on the link between culture and politics – of which the Amsterdam declaration was the first step, but which became more prominent during the fifth conference of the SI in Gothenburg – led to the famous 'split of 1962' that Debord would evoke in the following terms some time later: 'it would be too simplistic to describe [the split] in terms of an opposition between "artists" and "revolutionaries", but [the split] did largely overlap with such a confrontation'.[16] This split – presaged by the resignation of the Dutch architect Constant and the exclusion of the Italian painter Pinot-Gallizio – represented a reorientation of the SI's cultural internationalism towards an internationalist position that takes on all dominated sectors of existence. This reorientation expressed itself as a gradual recasting of the concept of spectacle – one that reconnects with the demiurgic character of the bourgeois described in *The Communist Manifesto*: the spectacle constructs a *world* in its own image, it is a 'worldview that has actually been materialised, that has become an objective reality'[17] – and, symbolically, by the 'decision taken by the Gothenburg conference to from now on term all of the artistic production created by members of the SI anti-Situationist'.[18]

Politics

As the title of the first section of *The Communist Manifesto*, 'Bourgeois and proletarians', makes clear, although internationalism assumes an objective analysis of the economic transformation of the world – internationalism, transnationalism and globalisation constituting three complementary processes – and a conscious realisation by the proletariat, this conscious realisation presumes a similar transformation is imputed to another class, that is, the bourgeoisie: 'The history of all hitherto existing society is the history of class struggles.'[19] Struggle is polarised here between the capitalist class and the working class. However, one of the peculiarities of the working class, according to Marx and Engels, is precisely that it is composed of workers who have no national interests to pursue, that is to say, no interests which might lead to the introduction of tensions and splits between proletarians of different nations. As Marx and Engels write in *The German Ideology*:

> while the bourgeoisie of each nation still retained separate national interests, big industry created a class, which in all nations has the same interest and with which nationality is already dead; a class which is really rid of all the old world and at the same time stands pitted against it.[20]

'Working men have no country', as the two authors remind us in the *Manifesto*, written just three years later.[21] The absence of a need to defend particular national interests and the identification of a shared class enemy constitute, in this sense, the two pillars upon which international workers' struggles converge. Internationalism functions here, strategically, as the common revolutionary horizon destined to unify two markedly different tendencies.[22] An alarmist discourse, which stressed the urgency for such a struggle on an international level, would become tied to the idea of the need for a convergence of workers' struggles. The first significant example of this alarmism would be expressed by a worker, Henri Tolain, at the first congress of the IWA in 1866: 'Pushed by the demands of the times, by the force of things, capital is being concentrated, organising itself into powerful financial and industrial associations. If we are not on our guard, this power will soon reign in unchecked tyranny.'[23]

The Situationists, at least until the early 1960s, believed that, as an international avant-garde, it first had to recruit from the most advanced artistic currents in the critique of the cultural decomposition and the

project of superseding capitalist civilisation: urbanism from the Nether-
lands, industrial painting from Italy, psychogeography from France and
England, etc. The SI therefore saw itself as a platform for the unification
of radical artistic hotbeds, cementing them together through a shared
interest in Unitary Urbanism. As an early Situationist text, 'Theses on the
Cultural Revolution' states:

> An international association of Situationists could be thought of as a
> union of workers in an advanced cultural sector, or, more exactly, as
> a union of all those who demand the right to a labour that current
> social conditions obstruct; therefore, as an attempt to organise cultural
> professionals.[24]

The Situationists therefore do not hesitate to perform a *détournement*, one
more time, the principles and modes of expression of proletarian interna-
tionalism, which, thereby, find themselves once again put back into play:
'The revolutionary players of all countries can unite in the SI in order to
begin escaping the prehistory of everyday life.'[25]

Here the conflict is polarised not so much between workers and
capitalists but more between those who support the spectacle, which
proletarianises individuals through the expropriation of the means of
constructing their everyday lives, and revolutionary artists, who, in
announcing the creation for a new civilisation, place these means in the
service of the construction of situations. The alarmist tone is equally
present as the Situationists describe themselves as engaged in a 'race
between free artists and the police in order to experiment and develop
the new techniques of conditioning'.[26] The '1962 split' therefore translated
itself into attempts to link up with revolutionary movements that brought
the totality of capitalism into question. It was no longer simply a question
of criticising cultural decomposition. Rather, it was necessary to attack the
proliferation of commodities, bureaucratisation and, in general, all forms
that reproduce what appeared to be the fundamental human relationship
in the spectacular-commodity society: that between order givers and order
takers.

The SI proposed, thenceforth, just as much to defend certain insur-
rections (those of Neapolitan workers, the Merlebach miners, Aarhus
dock workers, Zengakuren, etc.) as to work, in both theory and practice,
towards helping these struggles to triumph by bringing their true goals
to light. Many of the 'current event' texts written by the SI in the 1960s

therefore refer back to its internationalism from the perspective of a philosophy of praxis, that is to say, action aimed at destroying the false forms of consciousness in which certain 'wildcat' or spontaneous revolts became trapped. The Watts rioters, for example, believed they were struggling against racism within the strict limits of a single nation. According to the SI, however, in reality it was the world itself that had been transformed by the commodity that was being put into question.[27] As Debord explains in *The Society of the Spectacle*, 'Fallacious archaic oppositions are revived – regionalisms and racisms which serve to endow mundane rankings in the hierarchies of consumption with a magical ontological superiority.'[28] Marx, in 1870, likewise insisted on the propensity of the ruling class to create artificial antagonisms between workers of different nationalities in order to ensure its continued domination.[29] The internationalism of the IWA, like that of the SI, presents itself therefore precisely as a struggle against fallacious oppositions that hinder the oppressed from properly grasping their collective interests.

This radicalisation resulted in deep tensions within the SI between those members who held to a more 'Bakuninist' than 'Marxist' approach to proletarian internationalism – as, for the SI, it was the Lumpenproletariat that constituted the new revolutionary force and not those workers who, exteriorising their power in parties and unions, contributed to the 'constant reinforcement of capitalist society'[30] – and those who were more sceptical about this new force. Although it was Constant who, from this latter perspective, first expressed profound reserves, it was probably the German section, in the figure of Heimrad Prem at the fourth conference of the SI in London, that developed this critique the furthest.

Organisation

As internationalism consists primarily in the coordination of diverse regional and national movements, it is the question of what type of organisation that should be adopted which has, without a doubt, produced the most significant internal conflicts. The IWA originally took on the form of an 'inter-strikers agency',[31] but the need for a shared revolutionary programme – a programme that seeks to overturn the socio-economic system that produces social conflicts, and not to attenuate or reconcile them – led inevitably to questioning the initial autonomy of national sections. Should the IWA centralise decisions? This would have the merit of preventing any confusion from emerging around the real revolutionary

horizon, but it also posed the risk of taking an authoritarian turn. Should it, on the contrary, maintain its federalist principles? This would have the benefit of preserving national sections from the potential arbitrariness of a central power, but it exposed the workers' struggle to the threat of fragmentation. The opposition between centralists and federalists, between authoritarians and anti-authoritarians, the history of which is largely crystallised in the history of the conflict between Marx and Bakunin, therefore brings the notion of internationalism into question from within. This question of organisation, which goes to the heart of the problem of representation and to the challenge posed by something like the *appearance of a collective*, constitutes one of the principal lines of tension in the history of the SI.

The SI began serious reflection on the issue of its own organisation at the London conference. This conference, which led to the creation of a 'Central Council', began a discussion that would last until the dissolution of the SI in 1972. It would also feed into the abundant literature that insists upon the paradoxically Stalinist character of the group and of its supposedly unquestioned leader, Guy Debord. The creation and operation of this Central Council was explained in the following manner:

> Every member of the SI will be able to take part in the activities of this Council, which, after each meeting, must immediately communicate the information gathered and the decisions taken to everyone. The essential feature of this institution, however, is that a decision by a majority of its members – chosen at each Conference – will be enough to commit the entirety of the SI. The federal conception of the SI, founded upon the autonomy of national sections, which was originally imposed by the Italian section at Cosio d'Arroscia, is therefore abandoned. Such a body, clearly debating the management [*direction*] of the SI, seemed preferable to the arbitrariness of an uncontrolled *de facto* centralism, which, from the moment that it engages in real collective action, is inevitable in a movement that is so geographically scattered.[32]

Heimrad Prem, once more, criticised this process. He defended the autonomy of national sections and, in so doing, articulated a demand that, significantly, 'met with several objections in the name of the unity and the very internationalism of the Situationists'.[33] Prem assumes a role here that would later be dramatised by the Danish Situationist Jorgen Nash, who,

likewise, would attack what he saw as an authoritarian turn within the SI that was antinomic to the very principles of the movement.

Debates over the question of the organisation of the SI led it to clarify its sources and to find, in the workers' council movement (see chapter 5), the organisational form that best suited its theoretical and practical positions.[34] If, as the French anarchist Jura Federation had argued in its own time, 'future society will be nothing other than the universalisation of the organisation that the International has itself adopted',[35] for the SI, only workers' councils were up to the task of taking on the heavy task of 'establishing new human relationships' at the heart of the revolutionary organisation that it wanted to be.[36] The direction of this decision was that the SI would only recognise the value of social struggles that adopted such a programme. This would lead Vaneigem, in the eleventh issue of *Internationale situationniste*, to insist upon the importance of the *axial function* of the SI:

> The SI must act as an axis, which, receiving its movement from the revolutionary impulses of the entire world, precipitates, in a unitary manner, the radical turning of events.[37]

Considering itself to be at once a 'Conspiracy of Equals',[38] as a libertarian and councilist organisation, as fiercely opposed to all forms of political representation and as the heirs to the Marxian theory of class struggle, the SI produced a composite internationalism that drew directly upon the most radical tendencies of the history of the workers' movement.

Notes

1. 'L'opinion commune sur l'I.S., cette année (revue de presse)', *Internationale situationniste (IS)*, no. 5 (December 1960): 18.
2. 'Renseignements situationnistes', *International situationniste (IS)*, no. 6 (August 1961): 39.
3. See Mathieu Léonard, *L'Émancipation des travailleurs: une histoire de la Première Internationale* (Paris: La Fabrique, 2011), pp. 15–24. For a longer genealogy of internationalism, see Théodore Ruyssen, *Les Sources doctrinales de l'internationalisme* (Paris: PUF, 1954), vol. 3.
4. Carlo Rossi (pseudonym of Löwy), 'Qu'est-ce que l'internationalisme? Les fondements objectifs de l'internationalisme', *Contretemps. Revue de critique communiste*, 10 (May 2004): 148.
5. See Franck Fischbach, *La Privation de monde: temps, espace et capital* (Paris: Vrin, 2011), pp. 67–76.

6. Karl Marx and Friedrich Engels, *The Communist Manifesto*, trans. Samuel Moore (Harmondsworth: Penguin, 2002), p. 224.

7. Rossi (pseudonym of Löwy), 'Qu'est-ce que l'internationalisme ?', p. 148.

8. 'Notes éditoriales', *IS*, no. 3 (December 1959): 3.

9. 'Définitions', *IS*, no. 1 (June 1958): 14.

10. 'La troisième conférence de l'IS à Munich', *IS*, no. 3 (December 1959): 20.

11. Debord's 1959 'Notes pour le "manifeste" anti-Cobra' very clearly demonstrates the importance given to artistic action that transcends national borders. Indeed, Debord believes that the principal flaw of the CoBrA movement, among the many others that he deplores, is probably 'The institutionalisation of CoBrA as a Dutch *national* modern art [...]; today then this national content means provincial, when Europe itself is only the minimum starting point for the progress of a new culture, the first that poses itself in terms of world unity'. Debord, *Oeuvres* (Paris: Gallimard, 2006), p. 500.

12. This is in reference to the first wave of exclusions from the SI. These were decided upon at the second conference of the SI in Paris in January 1958. Walter Olmo, Elena Verrone and Piero Simondo, the excluded representatives of 'italo-experimentalism', would soon be joined by the Dutch architects Anton Alberts and Har Oudejans, who were excluded for agreeing to construct a church in the Netherlands.

13. 'We fully understand that the culture to be destroyed will only truly fall with the totality of the socio-economic formation that supports it.' 'Notes éditoriales', *IS*, no. 5 (December 1960): 5.

14. Georg Lukács, *History and Class Consciousness: Studies in Marxist Dialectics*, trans. Rodney Livingstone (Cambridge, MA: MIT Press, 1972), p. 27.

15. 'Discussion sur un appel aux intellectuels et artistes révolutionnaires', *IS*, no. 3 (December 1959): 24.

16. 'La 8ème conference de l'IS', *IS*, no. 12 (September 1969): 106.

17. Debord, *The Society of the Spectacle*, trans. Ken Knabb (Berkeley: Bureau of Public Secrets, 2014), thesis 5, p. 2.

18. 'Du rôle de l'IS', *IS*, no. 7 (April 1962): 19.

19. Karl Marx and Friedrich Engels, *The Communist Manifesto*, trans. Samuel Moore (London: Penguin, 2002), p. 219.

20. Karl Marx and Friedrich Engels, *The German Ideology* (1846) in *Marx and Engels Complete Works*, vols 1–50 (London: Lawrence and Wishart, 1975), vol. 5, pp. 73–4.

21. Marx and Engels, *Manifesto*, p. 241.

22. As Léonard argues throughout his work, this convergence of workers' struggles, which necessarily assumes the existence of common demands, was far from ever being realised within the IWA. This was the case from its very beginning – with infighting between Proudhonists, trade unionists, Blanquists, 48ers, etc. – until its end, which was marked by the conflict between Marx and Bakunin.

23. Cited in Léonard, *L'Émancipation*, p. 32.

24. Guy Debord, 'Thèses sur la révolution culturelle', *IS*, no. 1 (June 1958): 21, thesis 4.

25. 'Manifeste', *IS*, no. 4 (June 1960): 36. The SI, in this same manifesto, announces that it is preparing a 'seizure of UNESCO', which is seen as a symbol of the 'global, unified, bureaucratisation of art and all culture' (ibid., p. 37).

26. 'La lutte pour le contrôle des nouvelles techniques de conditionnement', *IS*, no. 1 (June 1958): 8.

27. 'Le déclin et la chute de l'économie spectaculaire-marchande', *IS*, no. 10 (March 1966): 3.

28. Debord, *Spectacle*, thesis 62, p. 25.

29. For example, Marx, in a letter to Mayer and Vogt on 9 April 1870, describes the opposition between English and Irish workers: 'This antagonism is kept artificially alive and intensified [...] This antagonism is the secret of the English working class's impotence.' *Marx and Engels Complete Works*, vols 1–50 (London: Lawrence and Wishart, 1975), vol. 43, p. 475.

30. Debord, *Spectacle*, thesis 114, p. 61.

31. Léonard, *L'Émancipation*, p. 99.

32. 'La quatrième conférence de l'IS à Londres', *IS*, no. 5 (December 1960): 22. After the sixth conference in Anvers in 1962, the SI decided to erase the division into national sections in order to build the group into a 'single united centre'. 'Renseignements situationnistes', *IS*, no. 8 (January 1963): 67.

33. Ibid.

34. A significant article in the seventh issue of *Internationale situationniste*, in April 1962, 'Les mauvais jours finiront', invites us to 'rediscover the full truth and to re-examine all of the oppositions between revolutionaries, the neglected possibilities', from Marx and 'Luxembourgism' to 'the anarchist positions of the First International, Blanquism' etc., p. 12.

35. Cited in Léonard, *L'Émancipation*, p. 282. The quote is from a circular in which the Federation attacks the authoritarianism of the General Council of the IWA.

36. 'Instruction pour une prise d'armes', *IS*, no. 6 (August 1961): 3.

37. Raoul Vaneigem, 'Avoir pour but la vérite pratique', *IS*, no. 11 (October 1967): 37.

38. 'the SI can only be a Conspiracy of Equals, a general staff [*état major*] that desires no troops', 'L'opération contre-situationniste dans divers pays', *IS*, no. 8 (January 1963): 27.

Bibliography

Acquaviva, Frédéric, *Isidore Isou* (Neuchâtel: Éditions du Griffon, 2018).

Acquaviva, Frédéric, *Lemaître: une vie lettriste* (Paris: Éditions de la Différence, 2014).

Adorno, Theodor, *The Jargon of Authenticity* (Evanston, IL: Northwestern University Press, 1973).

Adorno, Theodor and Max Horkheimer, *Dialectic of Enlightenment* (London: Verso, 1997).

Alix, Frédéric, *Penser l'art et le monde après 1945: Isidore Isou, essai d'archéologie d'une pensée* (Dijon: Les presses du réel, 2017).

Amair, Jean et al., *A Socialisme ou Barbarie Anthology: Autonomy, Critique, Revolution in the Age of Bureaucratic Capitalism*, ed. David Ames Curtis (London: Eiris, 2018).

Amóros, Miguel, *Les Situationnistes et l'anarchie* (La Taillade: Éditions de la roue, 2012).

Apostolidès, Jean-Marie, *Guy Debord: Le Naufrageur* (Paris: Flammarion, 2015).

Aragon, Louis, *Paris Peasant*, trans. Simon Watson Taylor (London: Pan, 1980).

Arthur, Chris, *The Dialectics of Labour* (Oxford: Blackwell, 1986).

Audoin, Philippe, 'Singes de nature', *L'Archibras*, no. 6 (December 1968).

Baugh, Bruce, *French Hegel: From Surrealism to Postmodernism* (New York: Routledge, 2003).

Baum, Kelly, 'The Sex of the Situationist International', *October*, 126 (fall 2008).

Bauman, Zygmunt, *Liquid Life* (Cambridge: Polity, 2005).

Belting, Hans, *Art History after Modernism*, trans. C. Saltzwedel and M. Cohen (Chicago: University of Chicago Press, 2003).

Bernstein, Michèle, 'About the Situationist International', *Times Literary Supplement*, September (1964).

—— 'Éloge de Pinot-Gallizio', in *Pinot Gallizio* (Paris: Bibliothèque d'Alexandrie, 1960).

——*All the King's Horses* (1960), trans. John Kelsey (London: Semiotext(e), 2008).

Bolt Rasmussen, Mikkel, 'The Situationist International, Surrealism, and the Difficult Fusion of Art and Politics', *Oxford Art Journal*, 27(3) (January 2004): 365–87.

—— 'The Spectacle of de Gaulle's Coup d'état: The Situationists on de Gaulle's Coming to Power', *French Cultural Studies*, 27(1) (2016).

Boltanski, Luc and Eve Chiapello, *The New Spirit of Capitalism* (1999), trans. Gregory Elliott (London: Verso, 2007).

Bourseiller, Christophe, *Vie et mort de Guy Debord* (Paris: Plon, 2001).

Bracken, Len, *Guy Debord: A Critical Biography* (Venice, CA: Feral House, 1997).

Breton, André, 'Evolution du concept de liberté à travers le romantisme' (1945), *Conjonction: Surréalisme et Révolte en Haïti*, 194 (June 1992).

——'Introduction' (1933), in Achim d'Arnim, *Contes bizarres* (Paris: Julliard, 1964).

——'Second Manifesto of Surrealism', in *Manifestoes of Surrealism*, trans. Richard Seaver and Helen R. Lane (Ann Arbor, MI: University of Michigan Press, 1972).

——'The Second Manifesto of Surrealism', in Charles Harrison and Paul Wood (eds), *Art in Theory: 1900–1990* (Oxford: Blackwell, 1996).

——*La Clé des champs* (Paris: Pauvert, 1967).

——*Mettre au ban les partis politiques* (Paris: L'Herne, 2007).

——*Perspective cavalière* (Paris: Gallimard, 1970).

Brillant, Bernard, *Les Clercs de 68* (Paris: PUF, 2003).

Bunyard, Tom, *Debord, Time and Spectacle: Hegelian Marxism and Situationist Theory* (Leiden: Brill, 2017).

Bürger, Peter, *Theory of the Avant-Garde*, trans. Michael Shaw (Minneapolis: University of Minnesota Press, 1984).

Cabañas, Kaira, *Off-screen Cinema: Isidore Isou and the Lettrist Avant-garde* (Chicago: University of Chicago Press, 2014).

Canonne, Xavier, *Surrealism in Belgium, 1924–2000* (Brussels: Mercatorfonds, 2007).

Castoriadis, Cornelius, '"The Only Way to Find Out If You Can Swim Is to Get into the Water": An Introductory Interview' (1974), in *The Castoriadis Reader*, ed. David Ames Curtis (Oxford: Blackwell, 1997).

——'General Introduction' (1972), in *Cornelius Castoriadis: Political and Social Writings*, vol. 1, *1946–1955*, ed. David Ames Curtis (Minneapolis: University of Minnesota Press, 1988).

——'Modern Capitalism and Revolution' (1960–61), in *Cornelius Castoriadis Political and Social Writings*, vol. 2, *1955–1960*, ed. David Ames Curtis (Minneapolis: University of Minnesota Press, 1988).

——'Socialism or Barbarism' (1949), in *Cornelius Castoriadis, Political and Social Writings*, vol. 1, *1946–1955*, ed. David Ames Curtis (Minneapolis: University of Minnesota Press, 1988).

Châtelet, François, 'La dernière internationale', *Le Nouvel observateur*, 3 January 1968.

Chérel, Emmanuelle, 'Les intrigues de la double capture: le contre-jeu au Jeu de la guerre Counter-game at the Game of War' (in French): http://penserdepuislafrontiere.fr/les-intrigues-de-la-double-capture.html (accessed 20 December 2019).

Ciliga, Anton, *Lénine et révolution: les 'Maîtres' du pays. Qui commande en URSS?*, trans. Guy Vinatrel (Paris: Spartacus, 1948).

Clark, T.J., 'In Defense of Abstract Expressionism', in *Farewell to an Idea: Episodes from a History of Modernism* (New Haven, CT: Yale University Press, 1999).

Clegg, John, 'Black Representation after Ferguson', *The Brooklyn Rail*, 3 May 2016: https://brooklynrail.org/2016/05/field-notes/black-representation-after-ferguson (accessed 13 April 2019).

Coadou, François (ed.), *Fragments pour Isidore Isou* (Paris: Art Book Magazine, 2017).

Danesi, Fabien, *Le Cinéma de Guy Debord* (Paris: Paris-Expérimental, 2014).

de Jong, Jacqueline, *Undercover in Art* (Amsterdam: Ludion, 2005).

de Libera, Alain, *L'Invention du sujet moderne* (Paris: Vrin, 2015).

Debord, Guy, 'Prolégomènes à tout cinéma futur', *Ion*, no. 1 (Paris, April 1952).

—— *Correspondance*, vols 0–7 (Paris: Arthème Fayard, 1999–2010).

—— *In girum imus nocte et consumimur igni* (Paris: Gérard Lebovici, 1990).

—— *Le Marquis de Sade a des yeux de fille, de beaux yeux pour faire sauter les ponts* (Paris: Librairie Arthème Fayard, 2004).

—— *Lettres à Marcel Mariën*, ed. François Coadou (Paris: La Nerthe, 2015).

—— *Œuvres* (Paris: Gallimard, 2006).

—— *Œuvres cinématographiques complètes* (Neuilly-sur-Seine: Gaumont Video, 2005).

—— *Poésie, etc*, ed. Laurence Le Bras, with a postface by Gabriel Zacarias (Montreuil: L'Échappée, 2019).

—— *Stratégie*, ed. Laurence Le Bras, with a preface by Emmanuel Guy (Montreuil: L'Échappée, 2018).

—— *Complete Cinematic Works: Scripts, Stills, Documents*, trans. Ken Knabb (San Francisco, CA: AK Press, 2003).

—— *Comments on the Society of the Spectacle*, trans. Malcolm Imrie (London: Verso, 1998).

—— *The Society of the Spectacle*, trans. Ken Knabb (Berkeley: Bureau of Public Secrets, 2014).

Debray, Régis, *Modeste contribution aux discours et cérémonies officielles du dixième anniversaire [de mai 68]* (Paris: Maspero, 1978).

Devaux, Frédérique, *Le Cinéma lettriste: 1951–1991* (Paris: Paris expérimental, 1992)Donné, Boris *[Pour mémoires]: un essai d'élucidation des 'Mémoires' de Guy Debord* (Paris: Allia, 2004).

Dreyfus-Armand, G., Frank R., Lévy M.-F., Zancarini-Fournel M. (eds), *Les Années 68: le temps de la contestation* (Paris, Complexe/IHTP, 200).

Ducasse, Isidore (Comte de Lautréamont), *Œuvres complètes* (Paris: Gallimard, 1973).

Dumontier, Pascal, *Les Situationnistes et mai 68: théorie et pratique de la révolution (1966–1972)* (Paris: Ivrea, 1995) (Paris: Ed. Gérard Lebovici, 1990).

Duwa, Jérôme, *Surréalistes et situationnistes, vies parallèles* (Paris: Editions Dilecta, 2008).

Ferrier, Nicolas, *Situations avec spectateurs: recherches sur la notion de situation* (Paris: PUPS, 2012).

Felski, Rita, *Doing Time: Feminist Theory and Postmodern Culture* (New York: New York University Press, 2000).

Feuerstein, Pierre, *Printemps de révolte à Strasbourg, mai–juin 1968* (Strasbourg: Saisons d'Alsace, 1968).

Fijalkowski, Krzysztof, 'Architecture', in *The International Encyclopedia of Surrealism*, vol. 1, ed. Michael Richardson et al. (London: Bloomsbury, 2019), pp. 404–8.

—— with Michael Richardson and Ian Walker, *Surrealism and Photography in Czechoslovakia: On the Needles of Days* (Farnham: Ashgate, 2013).

Fischbach, Franck, *La Privation de monde: temps, espace et capital* (Paris: Vrin, 2011).

Flahutez, Fabrice, 'L'héritage surréaliste, la lecture de Breton', in Laurence Le Bras and Emmanuel Guy (eds), *Guy Debord: un art de la guerre* (Paris: BnF/Gallimard, 2013).

—— with Fabien Danesi, Emmanuel Guy, *La Fabrique du cinéma de Guy Debord* (Arles: Actes-Sud, 2013).

—— Julia Drost and Frédéric Alix (eds), *Le Lettrisme et son temps* (Dijon: Les presses du réel, 2018).

—— *Le Lettrisme historique était une avant-garde* (Dijon: Les presses du réel, 2011).

Gerd-Rainer, Horn, *The Spirit of '68: Rebellion in Western Europe and North America, 1956–1976* (Oxford: Oxford University Press, 2007).

Gibbons, Andrea, 'Salvaging Situationism: Race and Space', *Salvage*, 30 November (2015): http://salvage.zone/in-print/salvaging-situationism-race-and-space (accessed 15 April 2019).

Gonzalvez, Shigenobu, *Guy Debord ou la beauté du négatif* (Paris: Mille et Une Nuits, 1998).

Gottraux, Phillipe, '*Socialisme ou Barbarie': un engagement politique et intellectuel dans la France de l'après-guerre* (Lausanne: Éditions Payot, 1997).

Grant, Ted, 'France in crisis', *Socialist Fight*, 29 May (1958).

Guy, Emmanuel, '"Par tous les moyens, même artistiques": Guy Debord stratège modélisation, pratique et rhétorique stratégiques', unpublished doctoral thesis (Université de Paris 13 and Université de Paris Nanterre, 2015).

Haider, Asad et al., 'The Castoriadis–Pannekoek exchange', *Viewpoint Magazine* 1 (2011, 2013), www.viewpointmag.com/2011/10/17/issue-1-occupy-everything/ (accessed 20 December 2019).

Hartley, Daniel, 'Radical Schiller and the Young Marx', in Samir Gandesha and Johan Hartle (eds), *Marx and the Aesthetic* (London: Bloomsbury, 2017), pp. 163–82.

Hastings-King, Stephen, 'L'Internationale Situationniste, Socialisme ou Barbarie, and the Crisis of the Marxist Imaginary', *SubStance* 28(3), issue 90 (1999).

Hayes, Anthony, 'How the Situationist International Became What It Was', unpublished PhD thesis (Australian National University, 2017).

—— 'Three Situationists Walk into a Bar; or, The Peculiar Case of the Hamburg Theses', *Axon*, 8 (2015).

Hegel, Georg Wilhelm Friedrich, *The Philosophy of History* (New York: Dover Publications, 2004).

Heinrich, Michael, *An Introduction to the Three Volumes of Karl Marx's Capital* (2004), trans. Alexander Locascio (New York: Monthly Review Press, 2012).

Hemmens, Alastair, 'Le Vampire du Borniage: Raoul Vaneigem, Hiver '60, and the Hennuyer Working Class', *Francosphères* 2(2) (2013).

—— *The Critique of Work in Modern French Thought, from Charles Fourier to Guy Debord* (London: Palgrave Macmillan, 2019).

Horkheimer, Max, *Eclipse of Reason* (London: Continuum, 2004).

Huizinga, Johan, *Homo Ludens: A Study of the Play Element in Cutlture* (London: Routledge, 1980).

Hussey, Andrew *The Game of War: The Life and Death of Guy Debord* (London: Jonathan Cape, 2001).

——with Will Self, *Guy Debord: La Société du spectacle et son héritage punk* (Paris: Globe, 2014).

Hyppolite, Jean, *Etudes sur Marx et Hegel* (Paris: M. Rivière, 1955).

——*Introduction to Hegel's Philosophy of History*, trans. Bond Harris and Jacqueline Spurlock (Gainesville, FL: University Press of Florida, 1996).

——*Logic and Existence*, trans. Leonard Lawlor and Amit Sen (Albany: State University of New York Press, 1997).

——*Studies on Marx and Hegel*, trans. John O'Neill (London: Heineman Educational Books, 1969).

Ireland, Craig, 'The Appeal to Experience and Its Consequences: Variations on a Persistent Thompsonian Theme', *Cultural Critique* 52 (2002): 86–107.

Isou, Isidore, 'Appendice sur le débat passé et futur du ciné-club', *Ion*, no. 1 (Paris, April 1952).

——*Contre l'Internationale situationniste* (Paris: HC-d'arts, 2000).

Janover, Louis, *Surréalisme et situationnistes au rendez-vous des avant-gardes* (Paris: Sens & Tonka, 2013).

Jappe, Anselm, 'Debord, lecteur de Marx, Lukács et Wittfogel', in Laurence Le Bras and Emmanuel Guy (eds), *Lire Debord* (Paris: L'Echappée, 2016).

——'Is There an Art after the End of Art?', in *The Writing on the Wall*, trans. Alastair Hemmens (London: Zero Books, 2017).

——*La Société autophage* (Paris: La Découverte, 2017).

——*Guy Debord*, trans. Donald Nicholson-Smith (Oakland, CA: PM Press, 2018).

Jay, Martin, *Downcast Eyes: The Denigration of Vision in Twentieth-century French Thought* (Berkeley, CA: University of California Press, 1994).

Jorn, Asger, 'Image and Form' (1954), in Ruth Baumeister (ed.), *Fraternité avant tout*, trans. Paul Larkin (Rotterdam: 010 publishers, 2011).

Joubert, Alain, *Le Mouvement des surréalistes, ou, Le Fin Mot de l'histoire: mort d'un groupe, naissance d'un mythe* (Paris: Maurice Nadeau, 2001).

Kaplan, Richard L., 'Between Mass Society and Revolutionary Praxis: The Contradictions of Guy Debord's *Society of the Spectacle*', *European Journal of Cultural Studies* 15(4) (2012): 457–78.

Kaufmann, Vincent, *Guy Debord: Revolution in the Service of Poetry*, trans. Robert Bononno (Minneapolis: University of Minnesota Press, 2010).

Kelly, Michael, *Hegel in France* (Birmingham: Birmingham Modern Languages Publications, 1992).

Koyré, Alexandre, *Études d'histoire de la pensée philosophique* (Paris: Gallimard, 2006).

Kurczynski, Karen, *The Art and Politics of Asger Jorn: The Avant-Garde Won't Give Up* (Surrey: Ashgate, 2014).

Kurz, Robert, *The Substance of Capital*, trans. Robin Halpin (London: Chronos, 2016).

Lapaque, Sébastien, 'Guy Debord, info ou intox?', *Le Figaro*, 26 March 2013.

Lefebvre, Henri, *La Somme et le reste* (Paris: Economica-Anthropos, 2009).

——*Le Temps des méprises* (Paris: Stock, 1975).

——*Dialectical Materialism* (London: Jonathan Cape, 1968).

Lemaître, Maurice, 'Mise au point dans l'affaire Chaplin', in *Carnets d'un fanatique, dix ans de lettrisme* (Paris: Jean Grasset, 1959).

Léonard, Mathieu, *L'Emancipation des travailleurs: une histoire de la Première Internationale* (Paris: La Fabrique, 2011).

Lettrist International, *Potlatch* (Paris: Allia, 1996).

Lewino, Walter, *L'Imagination au pouvoir: photographies de Jo Schnapp* (Paris: Eric Losfeld Ed., Le terrain vague, 1968).

Löwy, Michael and *Morning Star: Surrealism, Marxism, Anarchism, Situationism, Utopia* (Austin: University of Texas Press, 2009).

—— with Robert Sayre, *Romanticism Against the Tide*, trans. Catherine Porter (London: Duke University Press, 2001).

—— pseudonym Carlo Rossi, 'Qu'est-ce que l'internationalisme: les fondements objectifs de l'internationalisme', *Contretemps: Revue de critique communiste*, 10 (May 2004).

Loyer, Emmanuelle, *Mai 68 dans le texte* (Bruxelles/Paris: Complexe, 2008).

Ludivine, Bantigny, *1968: de grands soirs en petits matins* (Paris: Seuil, 2018).

Lukács, Georg, *History and Class Consciousness: Studies in Marxist Dialectics*, trans. Rodney Livingstone (Cambridge, MA: MIT Press, 1972).

Lyotard, Jean-François, *Political Writings*, trans. Bill Readings and Kevin Paul Geiman (Minneapolis: University of Minnesota Press, 1993).

Mandosio, Jean-Marc, *Dans le chaudron du négatif* (Paris: Editions de l'Encyclopédie des Nuisances, 2003).

Marc'O, 'Le cinéma nucléaire ou l'École Oienne du cinéma', *Ion*, no. 1 (Paris, April 1952).

Marcolini, Patrick, *Le Mouvement situationniste: une histoire intellectuelle* (Paris: L'Échappée, 2012).

Marcus, Greil, *Lipstick Traces: A Secret History of the Twentieth Century* (London: Faber and Faber, 2001).

Marcuse, Herbert, *One-dimensional Man* (London: Routledge, 2002).

Marelli, Gianfranco, *L'Amara vittoria del situazionismo* (Pisa: BFS Edizioni, 1996).

Mariën, Marcel, *Le Déméloir* (Brussels: Les Lèvres nues, 1978).

Martos, Jean-François, *Histoire de l'Internationale situationniste* (Paris: Champ Libre, 1989).

Marx, Karl, *Early Writings*, trans. Tom Nairn (Middlesex: Penguin, 1975).

—— *Capital*, vol. 1, trans. Ben Fowkes (London: Penguin, 1976).

—— *Capital*, vol. 3, trans. Ernest Mandel (London: Penguin, 1991).

—— with Friedrich Engels, *Marx and Engels Complete Works*, vols 1–50 (London: Lawrence and Wishart, 1975).

—— with Friedrich Engels, *The Communist Manifesto*, trans. Samuel Moore (Penguin: 2002).

—— *Œuvres complètes de Karl Marx, Correspondance K. Marx–Fr. Engels* (Paris: Alfred Costes, 1931–47).

Massoni, Dominique, 'Surrealism and Romanticism', in *Revolutionary Romanticism*, ed. Max Blechman (San Francisco: City Lights, 1999), pp. 193–6.

McDonough, Tom, *The Beautiful Language of My Century: Reinventing the Language of Contestation in Postwar France, 1945–1968* (Boston, MA: MIT Press, 2007).

Meessen, Vincent, ed., *The Other Country/L'Autre Pays* (Brussels: WIELS, 2018).

Mension, Jean-Michel, *The Tribe*, trans. Donald Nicholson-Smith (San Francisco: City Lights Books, 2001).

Merrifield, Andy, *Guy Debord* (London: Reaktion Books, 2005).

Nougé, Paul, 'La solution de continuité', *Les Lèvres nues*, no. 1 (1954).

Pannekoek, Anton, *Workers' Councils* (1948/1950) (Oakland, CA: AK Press, 2003).

Papaïoannou, Kostas, *Marx et les Marxistes*, texts chosen and introduced by Kostas Papaïoannou (Paris: Gallimard, 1965).

—— *Hegel* (Paris: Société d'édition les belles lettres, 2012).

Passerini, Luisa, 'Le mouvement de 1968 comme prise de parole et comme explosion de la subjectivité: le cas de Turin', *Le Mouvement social*, no. 143, special issue *Mémoires et Histoires de 1968* (avril–juin 1988): 39–74.

Péret, Benjamin, 'La poésie au-dessus de tout', *Bief*, no. 1 (November 1958).

Pessis, Céline, Sezin Topçu and Christophe Bonneuil (eds), *Une autre histoire des Trente Glorieuses: modernisation, contestations et pollutions dans la France d'après-guerre* (Paris: La Découverte, 2016).

Philippe, Artières and Michelle Zancarini-Fournel, *'68, une histoire collective 1962–1981* (2008) (Paris: La Découverte, 2018).

Pierre, José, *Surréalisme et anarchie: les 'billets surréalistes' du 'Libertaire'* (Paris: Plasma, 1983).

Pinder, David, 'Urban Encounters: *Dérives* from Surrealism', in Elza Adamowicz (ed.) *Surrealism: Crossings/Frontiers* (Oxford/Bern: Peter Lang, 2006), pp. 39–64.

Plant, Sadie, *The Most Radical Gesture: The Situationist International in a Postmodern Age* (London: Routledge, 1992).

Postone, Moishe, *Time, Labor and Social Domination: A Reinterpretation of Marx's Critical Theory* (New York: Cambridge University Press, 1993).

Quemada, Bernard (ed.), *Trésor de la langue française: dictionnaire de la langue du XIXe et du XXe siècle, 1789–1960* (Paris: CNRS / Gallimard, 1990).

Rancière, Jacques, *The Emancipated Spectator* (London: Verso, 2014).

Restany, Pierre, 'À quarante degrés au-dessus de dada' (Paris, May 1961), in *Le nouveau réalisme* (Paris: Union Générale d'Éditions, 1978), pp. 281–5.

Rey, Alain (ed.), *Dictionnaire historique de la langue française* (Paris: Dictionnaires Le Robert, 1998).

Rogozinski, Jacob, 'La vérité peut se voir aussi dans les images', in Michel Vanni and Jacob Rogozinski (eds), *Dérives pour Guy Debord* (Paris: Van Dieren, 2011).

Rosemont, Franklin and Charles Radcliffe (eds) *Dancin' in the Streets! Anarchists, IWWs, Surrealists, Situationists & Provos in the 1960s – As Recorded in the Pages of the Rebel Worker & Heatwave* (Chicago: Charles Kerr, 2005).

Roudinesco, Elisabeth, *Histoire de la psychanalyse en France (1925–1985)* (Paris: Fayard, 1994).

Rubio, Emmanuel, 'Du surréalisme à l'IS, l'*Esthétique* en héritage', *Mélusine*, 28 (2008): 95–124.

Rumney, Ralph, *The Consul* (London: Verso, 2002).

Sartre, Jean-Paul, *Being and Nothingness*, trans. Hazel Barnes (London: Routledge, 2003).

Schiller, Friedrich, *Aesthetic Education*, trans. Reginald Snell (Mineola, NY: Dover Publications, 2004).

Schwartz, Barthélémy, 'Dérives d'avant-garde', *Oiseau-Tempête*, 6 (winter 1999–2000; Paris: Ab Irato): 33–6.

Seddiki, Yalla, 'Les Lettristes, Les Lèvres nues et les détournements', *Mélusine*, 28 (2008) : 125–35.

Seidman, Michael, *The Imaginary Revolution: Parisian Students and Workers in 1968* (New York: Berghahn Books, 2004).

Semprun, Jaime, *Précis de récupération illustré de nombreux exemples tirés de l'histoire récente* (Paris: Champ Libre, 1976).

Sheringham, Michael, *Everyday Life: Theories and Practices from Surrealism to the Present* (Oxford: Oxford University Press, 2006).

Shortall, Felton, *Incomplete Marx* (Aldershot: Avebury, 1994).

Situationist International, *Guy Debord and the Situationist International: Texts and Documents*, ed. Tom McDonough (Cambridge, MA: MIT Press, 2002).

—— *The Situationists and the City*, ed. Tom McDonough (London: Verso, 2010).

—— *Internationale situationniste, édition augmentée* (Paris: Arthème Fayard, 1997).

—— *Pour en finir avec le travail*, CD 33 tours (éd. musicales du Grand Soir, distribution RCA, 1974, réédition EPM musique en 1998).

—— *Textes et documents situationnistes 1957–1960* (Paris: Allia, 2004).

—— *The Real Split in the International*, trans. John McHale (London: Pluto Press, 2003).

—— *Situationist International Anthology*, trans. Ken Knabb (Berkeley, CA: Bureau of Public Secrets, revised and expanded edition 2006).

Socialisme ou Barbarie, 'Questions aux militants du P.C.F.', *Socialisme ou Barbarie*, no. 20 (December 1956–February 1957).

Stewart, Jon (ed.), *The Hegel Myths and Legends* (Evanston, IL: Northwestern University Press, 1996).

Stracey, Frances, *Constructed Situations* (London: Pluto Press, 2014).

Surrealists, 'The Platform of Prague' (1968), in *Surrealism against the Current: Tracts and Declarations*, ed. and trans. Michael Richardson and Krzysztof Fijalkowski (London: Pluto, 2001).

—— José Pierre (ed.), *Tracts surréalistes et déclarations collectives 1922–1969*, vol. 2, *1940–1969* (Paris: Eric Losfeld, 1982).

Trotsky, Leon, *The Revolution Betrayed*, trans. Max Eastman (New York: Dover Press, 2004).

Tzara, Tristan, *La Fuite, poème dramatique en quatre actes et un épilogue*, Paris, Théâtre du Vieux-Colombier, 21 janvier 1946 (Paris: Gallimard, 1947).

van der Linden, Marcel, 'Socialisme ou Barbarie: A French Revolutionary Group (1949–65)', *Left History* 5(1) (1997).

Vaneigem, Raoul, *La Résistance au christianisme: les hérésies des origines aux XVIIIe siècle* (Paris: Fayard, 1993).

—— (pseudonym Jules-François Dupuis), *Histoire désinvolte du surréalisme* (Nonville: Paul Vermont, 1977).

—— *Rien n'est fini, tout commence* (Paris: Allia, 2014).

—— *The Revolution of Everyday Life*, trans. Donald Nicholson-Smith (London: Rebel Press, 2006).

—— *The Book of Pleasures*, trans. John Fullerton (London: Pending Press, 1983).

—— *Voyage à Oarystis* (Blandain: Éditions de l'Estuaire, 2005).

—— *The Movement of the Free Spirit*, trans. Randall Cherry and Ian Patterson (New York: Zone Books, 1998).

Viénet, René, *Enragés and Situationists in the Occupation Movement, France, May '68*, trans. Richard Parry and Hélène Potter (London: Rebel Press, 1997).

Walker, Ian, *City Gorged with Dreams: Surrealism and Documentary Photography in Interwar Paris* (Manchester: Manchester University Press, 2002).

Wark, McKenzie, *The Beach Beneath the Street: The Everyday Life and Glorious Times of the Situationist International* (London and New York: Verso, 2011).

Ward Gouldner, Alvin, *The Two Marxisms* (Oxford: Oxford University Press, 1980).

Williams, Philip, 'How the Fourth Republic Died: Sources for the Revolution of May 1958', *French Historical Studies* 3(1) (Spring 1963).

Wollen, Peter, 'Bitter Victory: The Art and Politics of the Situationist International', in Elisabeth Sussman (ed.), *On the Passage of a Few People through a Brief Moment in Time*, exhibition catalogue, Musée national d'art moderne, Centre Georges Pompidou, Paris, France, 21 February–9 April 1989 etc.

Wolman, Gil, *Gil J Wolman: I Am Immortal and Alive*, texts by Frédéric Acquaviva, Kaira M. Cabañas and Gil J Wolman (English edn, Barcelona: Museu d'Art Contemporani de Barcelona, 2010).

Zacarias, Gabriel, '*Eros et civilisation* dans *La Société du spectacle*: Debord lecteur de Marcuse', *Revue Illusio*, 12–13 (2014): 329–43.

—— 'Expérience et représentation du sujet: généalogie de l'art et de la pensée de Guy Debord', unpublished PhD thesis (Université de Perpignan Via Domitia and Università Degli Studi di Bergamo, 2014).

—— 'Les enjeux de la poésie dans le cinéma de Guy Debord', in Laurence Le Bras and Emmanuel Guy (eds), *Lire Debord – avec des notes inédites de Guy Debord* (Montreuil: L'Échappée, 2016), pp. 377–88.

—— *No espelho do terror: jihad e espetáculo* (São Paulo: Elefante, 2018).

Notes on Contributors

About the Editors

Alastair Hemmens is Lecturer in French Studies at Cardiff University School of Modern Languages. His research focuses on critical theory and modern European intellectual and cultural history. His most recent work is *The Critique of Work in Modern French Thought, from Charles Fourier to Guy Debord* (London: Palgrave Macmillan, 2019). He has translated a number of theoretical works by the philosopher Anselm Jappe, including *The Writing on the Wall: On the Decomposition of Capitalism and its Critics* (London: Zero Books, 2017), and he has previously edited a collection of essays, *L'Extrême littéraire* (Cambridge: CSP, 2012). He has written extensively about the Situationists, including a PhD thesis on the life and work of Raoul Vaneigem, and, in 2014, he was awarded a Leverhulme Early Career Fellowship.

Gabriel Zacarias is Professor in the Department of History at the University of Campinas, Brazil. He has been a Fellow of the Erasmus Mundus Program, in Italy and in France, and is currently a Visiting Research Fellow at Yale University, where he studies the archives of the Situationist International at the Beinecke Library. He has written extensively about the Situationists, including a PhD thesis on the life and work of Guy Debord. He has studied Guy Debord's archives at the French National Library (BnF), contributing to the volume *Lire Debord* (Paris: L'Échappée, 2015) and writing the postface to the edition of Guy Debord's notes on literature, *Poésie, etc* (Paris: L'Échappée, 2019). His most recent work is *No espelho do terror: jihad e espetáculo* (São Paulo: Elefante, 2018), an essay of critical theory that seeks to understand recent terrorist attacks as part of the crisis of late capitalism.

About the Contributors

Anna Trespeuch-Berthelot is lecturer in modern history at Caen-Normandy University in France. She is the author of *L'Internationale Situationniste. De l'histoire au mythe (1948–2013)* (Paris: Presses Universitaires de France, 2015). The book is based on her doctoral thesis which examines the history of the Situationist International and its reception. Her current research considers environmental movements and the global diffusion of warnings about environmental crises since 1945.

Anselm Jappe teaches aesthetics at the Sassari Fine Arts Academy in Sardinia, Italy. He is a key theorist of the critique of value-dissociation and also a leading researcher on the Situationist International. His key work on the Situation-

ists, *Guy Debord* (1993), has been translated into many languages and was recently republished in a new English-language edition (Oakland, CA: PM Press, 2018). He is also the author of numerous works of anti-capitalist critical theory, including, *Les aventures de la marchandise. Pour une critique de la valeur* [2003] (Paris: La Découverte, 2017), *The Writing on the Wall: On the Decomposition of Capitalism and its Critics* (London: Zero Books, 2017) and *La société autophage. Capitalisme, démesure et autodestruction* [2017] (Paris: La Découverte, 2020).

Anthony Hayes is a writer and independent scholar based in Canberra, Australia. He has been a student of Karl Marx and the Situationists for three decades. At various times he has dabbled in revolutionary praxis, punk rock, science fiction and film work. He completed a PhD thesis at the Australian National University in 2017 in which he examined the transformation of the Situationist International into an explicitly revolutionary communist organisation in the early 1960s. Currently, he blogs his ongoing research at *The Sinister Science*.

Bertand Cochard teaches at the Sophia-Antipolis University of Nice. He has a PhD in philosophy from the École normale supérieure de Lyon. His doctoral thesis was devoted to the subject of 'Guy Debord and Philosophy'. His research focuses on the philosophical roots of Debord's thought and, in particular, on the relationship between time and spectacle. He is the author of several articles on Guy Debord and the Situationist International.

Craig Buckley is an Associate Professor in the Department of Art History at Yale University. His research interests centre on the history of modern architecture and the experiments of the avant-gardes, as well as on print history, media theory, and the politics of architecture. He is the author of *Graphic Assembly: Montage, Media, and Experimental Architecture in the 1960s* (Minneapolis, MN: University of Minnesota Press, 2019), and editor of *After the Manifesto: Writing, Architecture, and Media in a New Century*, (GSAPP, 2014), Utopie: *Texts and Projects 1967–1978*, (with Jean-Louis Violeau) (MIT Press, 2011) and *Clip/Stamp/Fold: The Radical Architecture of Little Magazines 196X–197X* (with Beatriz Colomina) (Actar, 2010).

Fabrice Flahutez is Professor of the History of Art at the University of Lyon-Saint-Etienne in France. He is the author of many books and articles on Lettrism and the Situationist International, including *Le lettrisme historique était une avant-garde 1945–1953* (Dijon: Les presses du réel, 2011), as well as several edited volumes with Fabien Danesi and Emmanuel Guy, *La fabrique du cinéma de Guy Debord* (Paris: Actes-Sud, 2013), and *Le Lettrisme et son temps* (Dijon: Les presses du réel, 2018) . He is currently working on the 'Global Surrealism' exhibition at the Tate Modern and the MET New York, as well as curating 'Lewis Carroll and Surrealism' at the Strasbourg Museum of Modern and Contemporary Art.

Krzysztof Fijalkowski is Professor of Visual Culture and teaches on the BA Fine Art programme at Norwich University of the Arts. His research and writing focus on the history, theory and practice of international Surrealism, with a range of particular interests including Surrealist activity in Central and Eastern Europe, Surrealism's post-war histories, and its relationships with design. He has also participated in the activities of contemporary Surrealist groups in the UK, France, Czechia and Spain. Recent publications include, as co-editor and contributor, *Surrealism: Key Concepts* (Abingdon and New York: Routledge, 2016) and *The International Encyclopedia of Surrealism* (London: Bloomsbury, 2019).

Michael Gardiner is Professor of Sociology at The University of Western Ontario, Canada. His research interests include the political economy of affective life, the everyday and utopianism. Author of several books and numerous book chapters and journal articles, his latest major publications include, *Weak Messianism: Essays in Everyday Utopianism* (Bern: Peter Lang, 2013) and *Boredom Studies Reader: Frameworks and Perspectives* (co-edited with Julian Jason Haladyn) (London and New York: Routledge, 2017).

Michael Löwy is Emeritus Director of Research at the Centre national de la recherche scientifique in France. His research covers a wide range of Marxist thought as well as the anticapitalist currents within Romanticism. He is the author of a number of ground-breaking works that have been translated into many languages. His most recent works to appear in English include, *Morning Star: Surrealism, Marxism, Anarchism, Situationism, Utopia* (Austin, TX: University of Texas Press, 2009), *The Theory of Revolution in the Young Marx* (Leiden: Brill, 2003), *Fire Alarm: Reading Walter Benjamin's 'On the Concept of History'* (London: Verso, 2005) and, with Robert Sayre, *Romanticism against the Tide of Modernity* (Durham: Duke University Press, 2000).

Nedjib Sidi Moussa is a social scientist, historian and writer. He received a PhD in Political Science from Panthéon-Sorbonne University in 2013. His research focuses on radical commitments around relations between France and Algeria, both during and after colonial rule. His main publications include, *La Fabrique du Musulman. Essai sur la confessionnalisation et la racialisation de la question sociale* (Paris: Libertalia, 2017) and *Algérie. Une autre histoire de l'indépendance. Trajectoires révolutionnaires des partisans de Messali Hadj* (Paris: PUF, 2019). He has also recently edited a collection of Situationist texts, *Adresse aux révolutionnaires d'Algérie (et autres textes)* (Paris: Libertalia, 2019).

Patrick Marcolini is a philosopher and intellectual historian. He is lecturer in aesthetics at Paul Valéry University of Montpellier and a member of the RIRRA21 research group. He is the author of *Le Mouvement situationniste. Une histoire intellectuelle* (Paris: L'échappée, 2012) and, with Cédric Biagini, editor of the second volume of *Divertir pour dominer. La culture de masse contre les peuples* (Paris: L'échappée, 2019). His current research focuses on the artistic

and political legacy of the Situationist movement, as well as the intellectual trajectory of Guy Debord after the dissolution of the Situationist International.

Ruth Baumeister is an architect, researcher, and writer who specialises in post-war European avant-gardes in architecture and art. Since 2014, she has held the professorship of Architecture History and Theory at Aarhus School of Architecture, Denmark. In 2015, she guest-curated the exhibition 'What Moves Us? Le Corbusier and Asger Jorn' at Museum Jorn, Silkeborg. She is the editor of *Fraternité Avant Tout: Asger Jorn's Writings on Art and Architecture* (Rotterdam: naio10 Publishers, 2011), co-editor of *The Domestic and the Foreign in Architecture* (Rotterdam: naio10 Publishers, 2007) and author of *De l'architecture sauvage* (Rotterdam: naio10 Publishers, 2014), *Asger Jorn in Images, Words and Forms* (Zurich: Scheidegger & Spiess, 2014) and *What Moves Us? Le Corbusier and Asger Jorn in Art and Architecture* (Zurich: Scheidegger & Spiess, 2015).

Sophie Dolto is a doctoral candidate in French and Francophone Studies at the University of Pennsylvania. She has an undergraduate degree in Modern Literature and a Masters in Comparative Literature from the Sorbonne (Université Paris IV). Her research focuses on the work of Jean-Patrick Manchette, a radical crime fiction writer of the 1970s, as well as the political and aesthetic practices of the twentieth-century avant-gardes. Her current research project examines the contemporary political and cultural influences, including the Situationist International, that shaped Manchette's work.

Tom Bunyard is a Senior Lecturer in the Humanities Programme at the University of Brighton. His research focuses primarily on the theoretical work of Guy Debord and the Situationist International, in particular, the concept of 'spectacle'. His most recent work on the subject is *Debord, Time and Spectacle: Hegelian Marxism and Situationist Theory* [2017] (Chicago, IL: Haymarket Books, 2018). The book traces the genealogy of Debord's theory through its primary theoretical and philosophical influences in an effort to reconstruct and evaluate its underlying conceptual framework. In so doing, the book places particular emphasis on the Hegelian and existential dimensions of Debord's work, and focuses on his concerns with historical agency.

Index

counter-revolution, 74, 107, 108, 110, 283
Courbet, Gustave, 142
Cravan, Arthur, 30
creativity, 3, 11, 32–3, 67, 98, 99–100, 189–90, 192, 195, 203, 207, 210, 230, 237, 240, 242, 245, 256–62, 263, 265, 266, 268n19, 273, 278, 283, 286
Crevel, René, 145n2
crime, 35, 95, 136n39, 234n35
crisis, 21, 41n34, 75–6, 85, 87n14, 88n18, 89n37, 96, 101, 108, 267n10
critique of value, 252, 267n6
Cuba, 32, 110, 194, 201
cultural decomposition, 52–3, 294–5
Cultural Revolution, the, 224
cybernetics, 25, 229, 262–3
Czarism, 82
Czechoslovakia, 36

d'Arnim, Achim, 141, 142
Dada(ism), 2, 8, 10, 27–31, 34–5, 36, 39n6, 39n10, 43, 46, 47, 71, 214, 219, 221, 236, 272
Dahou, Mohamed, 103, 105–6, 110, 114, 290
Daniel, Jean, 282
Daumier, Honoré, 142
Dax, Adrien, 40n18
de Chirico, Giorgio, 30, 36
de Gaulle, Charles, 73
de Jong, Jacqueline, 11, 16n29, 118–20, 124, 130, 132, 134, 192, 196, 199n45
Debord, Guy
 'Preliminaries Toward Defining a Unitary Revolutionary Program', 76, 207, 247
 'Report on the Construction of Situations', 30–1, 39n5, 69n14, 72, 89n39, 126, 169, 176–7, 186, 272, 292
 Commentaries on the Society of the Spectacle (1988), 6, 144, 160–5, 180

Critique of separation, 115n22
Guy Debord, son art et son temps (1994), 6
Howling in Favour of Sade (1952), 44, 47, 167, 221
In girum imus nocte et consumimur igni (1978), 6, 45, 144, 228
Society of the Spectacle, The (1967), 2, 4, 10, 20–5, 55, 63–7, 97, 100, 122, 149–60, 209, 218, 237–8, 246, 255, 257, 267n12, 276–8, 296
Society of the Spectacle, The (film, 1973), 45, 124, 222, 224–7
Debray, Régis, 94
decolonisation, 104
décor, 25, 177, 178, 184, 185
democracy, 24, 95, 139, 160, 161, 194, 205, 210, 262
Democratic Republic of Congo (DRC), 109
Democritus, 21
dérive, 12, 35–6, 38, 41n27, 47, 52, 104, 119, 168, 177, 184, 185, 186, 187, 188, 225, 231n5, 244, 246, 286
Descartes, René, see Cartesianism
Desnos, Robert, 145n2
détournement, 12, 15n16, 20, 23, 23–4, 25, 32, 34, 34–5, 39n2, 44, 45, 52, 78, 90n51, 95, 99, 123–4, 142, 149, 151, 165, 173, 181n16, 194, 195, 214–31, 231n5, 232n9, 239, 242, 244, 249, 263, 268n20, 268n21, 284, 286, 289n17, 292, 295
Detroit, 113, 194
Diafer, Ait, 105
dialectic, 28, 34, 39n5, 56, 57, 66, 82, 150, 155, 162, 164, 170, 178, 222, 227, 228, 240, 243, 293
diaspora, 104
disenchantment, 138
Dort, Bernard, 180n8
draft resistance, 111, 112
Drakabygget, 130–3, 137n63

186, 189, 192–3, 219–21, 224,
233n27, 233n29, 233n30, 282
Joubert, Alain, 37, 38
Joyeux, Maurice, 83–4, 91n79
Jura Federation, 298
Jutland, 134

Kambalu, Samson, 9
Kant, Immanuel, 154, 254
Kanters, Robert, 281
Kashamura, Anicet, 109
Katib, Abdelhafid, 103, 106, 114, 193,
199, 290
Kautskyism, 81
Khayati, Mustapha, 16, 24, 95, 103,
110–1, 194, 196, 200n49, 229,
230
Kiesler, Frederick, 36
kitsch, 125, 221
Klein, Yves, 232n5
Knabb, Ken, 13, 100
knowledge, 2, 19, 21, 63, 83, 154–5,
162–3, 163, 228, 240, 258
Kojève, Alexandre, 67
Korea, 222
Korsch, Karl, 20, 22, 24, 191
Kotányi, Attila, 16, 80, 134n2, 172,
190–3, 194–5, 196n1, 199n36,
270, 272, 293
Koyré, Alexandre, 66
Kung-Fu, 222
Kurz, Robert, 211, 213n41

L'Archibras, 38
La Jeune Taupe, 111
labour, see work
Labriola, Antonio, 20, 22
Landauer, Gustav, 139
language, 12, 30, 37–8, 100, 109, 216,
227, 229–31, 255, 262, 283
Latin Quarter, 4, 104, 120, 230, 231n5
law, 99, 128, 132, 138, 143, 146n19,
171, 233n35, 248
Le Brun, Annie, 38, 40n16, 42n41
Le Corbusier, 36, 191, 196n10
Le Glou, Jacques, 91n79, 96
Le Masque et la plume, 4

Le Monde libertaire, 83–4
Le Nouvel observateur, 4
Le Reste, Loic, 84, 92n83
Lebovici, Gérard, 5, 16n32, 94, 224,
225, 234n38
Leeds, 38, 145
Lefebvre, Henri, 12, 19, 20, 21, 22, 54,
65, 69n18, 91n60, 139, 174–6,
181n34, 191, 199n39, 200n52,
206, 237, 239–40, 241, 242–3,
247, 250n15
Lefort, Claude, 74, 75, 88n22
Left Freudianism, 265
Legrand, Gérard, 32
Leiris, Michel, 145n2
leisure, 72, 73, 76, 79, 123, 156, 185,
195, 206, 209, 285, 286
Lemaître, Maurice, 44, 45, 46, 48,
49n15
Lenin, Vladimir, 22, 23, 77–8, 80, 82,
84, 87n6, 91n61, 108, 226
Leninism, see Lenin
Les Lèvres nues, 33–4, 216
Lettrism, 10–11, 27, 30, 39n6, 43–8,
104–6, 114, 168, 172, 184, 185–6,
196n3, 216
Lettrist International, 15n24, 27–34,
35, 37, 39n3, 39n4, 40n19, 41n31,
46, 49n13, 103, 104–6, 106,
120–1, 168, 172, 184–6, 196n1,
196n4, 201, 216, 219, 231n5,
233n27, 290
Lewino, Walter, 98
Libertarian Communist Federation
(FCL), 83, 91n77
Lindell, Peter Albert (Katja), 118, 124,
125, 126, 130–4, 137n49, 137n59,
137n63, 137n64
literature, 4, 7, 28, 31, 32, 33, 34, 37,
43, 71, 131, 138, 141, 149, 184,
187, 216, 217, 218, 219, 228, 229,
230, 233n26, 236, 241, 281
Littérature, 143
lived experience, 31, 52, 53, 81, 159,
161, 162, 170, 176, 227, 237, 240,
256, 257, 260

praxis, 51, 56, 157, 173, 175, 183,
189, 195, 210, 241, 242, 257–8,
259–60, 271
Prem, Heimrad, 124, 198n25, 272, 277,
278, 279n5, 284, 296, 297
private property, 131, 159, 205, 208158
production, 12, 23, 25, 64, 71, 74–5,
79, 89n37, 125, 128, 151, 153,
156–60, 163, 177, 188, 194,
204–6, 207, 209–11, 212n218,
216, 226, 230, 240, 255, 262,
263, 276, 282, 287, 292
means of production, 25, 64, 74,
159, 194, 204–5, 211, 212n21,
263
productivism, 90n55
productivity, 159, 207
progress, 12, 140, 155, 156, 179, 217,
233n21, 288
Projektgruppe Gegengesellschaft,
102n17
proletariat, *see* workers
propaganda, 96, 126, 150, 159, 216,
231, 286
pro-Situs, 5, 100, 284
prostitution, 286
protest, 9–10, 32, 94, 95, 97, 112, 138,
185–6
Protestantism, 132
Proudhonism, 299n22
Provo movement, 190, 198n34
psychoanalysis, 30, 178, 269n43
psychogeography, 12, 35, 41n28, 52,
105, 168, 171, 183, 187, 193,
197n19, 199n47, 231–2n5, 290,
295
punk, 6, 230

Queneau, Raymond, 145n2

racism, 112, 113, 223, 296
radio, 4, 191
Radio France, 4
Rancière, Jacques, 166n14
Raphael, Max, 20, 22
rationalisation, 138, 156, 107, 207, 261
rationalism, 140, 143, 179

readymade, 214–5
reason, 59–62, 67, 155, 202, 240,
268n20
recuperation, 9, 13, 29, 31, 37, 41n34,
78, 81, 86, 98, 195, 215, 224, 230,
264, 278, 281–7, 289n19
reformism, 22, 80, 90n43, 113
regionalism, 296
Reich, Wilhelm, 20, 265
reification, 12, 20, 23, 48, 108, 110,
138, 156–7, 176, 216, 242, 247,
261–2, 262
religion, 25, 62, 131, 132, 138, 143,
151, 170, 194, 195, 203, 238, 275,
277, 278
Renaissance, 162
Renault, 104, 226
representation, 23, 28, 62, 73, 76, 77,
78, 81, 82, 115, 129, 152–4, 154,
158, 160, 161, 163, 164–5, 169,
179, 187, 190, 192, 193, 194, 222,
225, 227–8, 229, 255, 258, 261,
274, 275, 277, 278, 282, 297, 298
Restany, Pierre, 215
revolt, 5, 25, 27, 28, 30, 37, 80, 108,
111–2, 113, 139, 143, 144, 145n10,
222, 242, 244, 261, 296
revolution, 2, 3, 4, 9, 11, 12, 13, 22,
23, 31, 33, 37, 38, 42, 52, 53,
63, 64, 71, 72, 72–3, 74, 75, 77,
78, 79–82, 82–5, 85–6, 88n20,
88n29, 90n48, 97, 99–101, 104,
105–6, 107–8, 109–11, 112,
113, 114, 122, 126, 132, 134n2,
139–40, 142, 143, 144, 149, 157,
159–60, 169, 177, 183, 185, 187,
194, 195, 203, 210, 216, 222, 224,
225, 229–30, 236, 241–3, 243–5,
255, 256, 257, 263–4, 270, 271,
273, 275, 276, 277, 278, 283, 284,
288, 291–2, 292, 293, 294, 295,
296, 298
Révolution internationale, 110, 113,
117n43
Revolutionary Action Anarchist
Groups (GAAR), 83, 91n77
Revolutionary Surrealism, 33